How Birds Fly

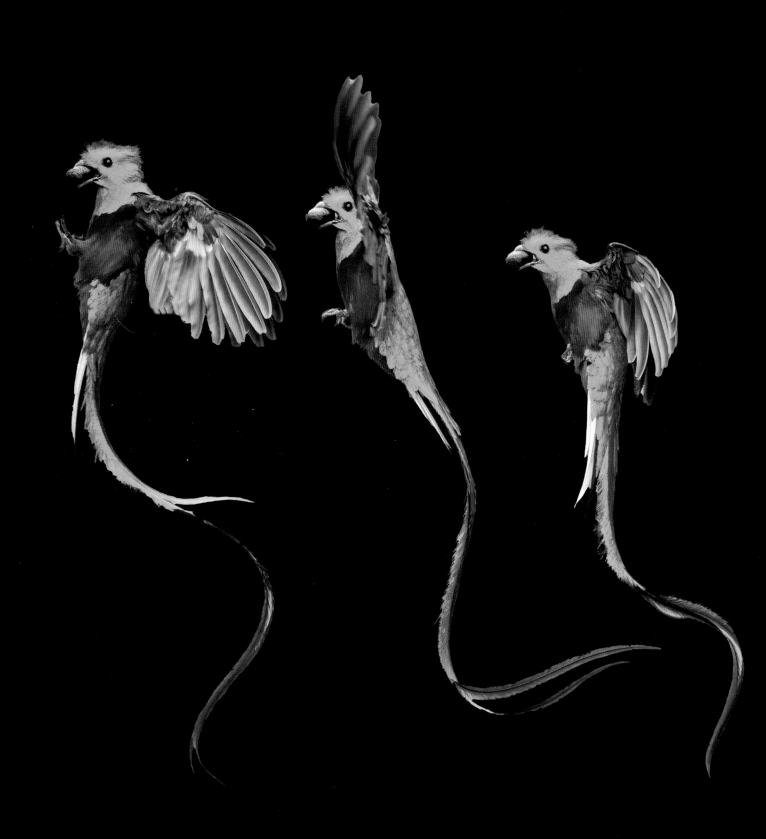

How Birds Fly

The Science & Art
of Avian Flight

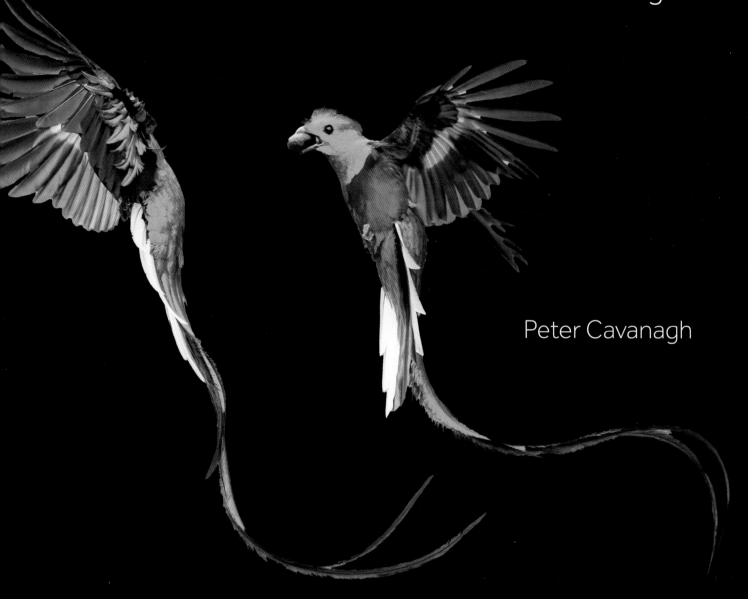

Peter Cavanagh

FIREFLY BOOKS

A FIREFLY BOOK

Published by Firefly Books Ltd. 2024

First printing

Library of Congress Control Number: 2024935758

Library and Archives Canada Cataloguing in Publication
Title: How birds fly : the science and art of avian flight / Peter Cavanagh.
Names: Cavanagh, Peter, author.
Description: Includes bibliographical references and index.
Identifiers: Canadiana 20240352653 | ISBN 9780228104865 (hardcover)
Subjects: LCSH: Birds—Flight.
Classification: LCC QL698.7 .C384 2024 | DDC 573.7/9818—dc23

Published in the United States by
Firefly Books (U.S.) Inc.
P.O. Box 1338, Ellicott Station
Buffalo, New York 14205

Published in Canada by
Firefly Books Ltd.
50 Staples Avenue, Unit 1
Richmond Hill, Ontario L4B 0A7

Cover and interior design: Hartley Millson

Printed in China | T

Front cover and title page: A male Resplendent Quetzal (*Pharomachrus mocinno*).
San Gerardo de Dota, Costa Rica. May. IUCN category: Near Threatened

Back cover: A pair of Bare-faced Go-away-birds (*Crinifer personatus leopoldi*).
Serengeti National Park, Tanzania. August. IUCN category: Least Concern

FSC
www.fsc.org
MIX
Paper | Supporting
responsible forestry
FSC® C104723

DEDICATION

For Dorothy Ann Cavanagh

A practitioner of photography
and a fountain of kindness
to all those fortunate
enough to have flown in her orbit.

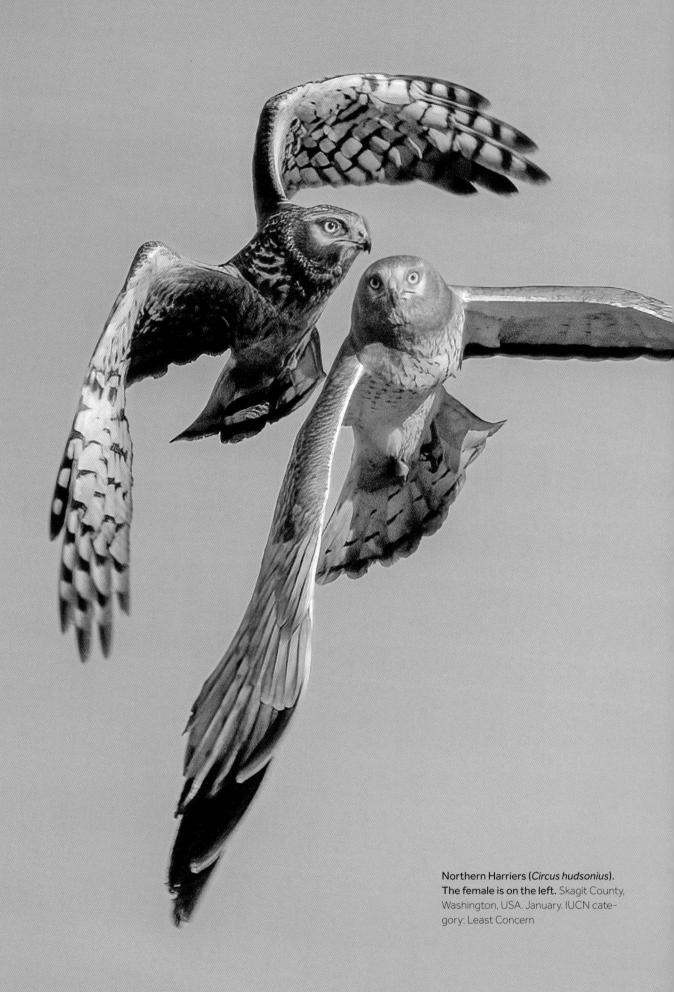

Northern Harriers (*Circus hudsonius*). The female is on the left. Skagit County, Washington, USA. January. IUCN category: Least Concern

CONTENTS

PREFACE

> *To travel like a bird, lightly to view*
> *Deserts where stone gods founder in the sand*
> *Ocean embraced in a white sleep with land,*
> *To escape time, always to start anew.*
> — CECIL DAY-LEWIS, "O DREAMS, O DESTINATIONS"

Bird flight is beautiful to behold but mysterious in nature. Almost everyone enjoys the thrill of watching birds fly, but few people have more than a vague notion of what makes bird flight possible. In this book, I will pull back the veil of mystery surrounding bird flight and explain its many facets in a way that is accessible to all people who love birds.

The book has emerged over the last decade from my passion as a photographer of flying birds, some of which formed the basis for my previous book, *100 Flying Birds: Photographing the Mechanics of Flight*. It gradually became clear to me that many of the secrets of bird flight were revealed in the more than 800,000 images that I have taken. I started, earnestly and somewhat reverently, following the work of researchers who study bird flight. I interpreted my images based on their findings and through my own prism as a scientist who has studied the anatomy and biomechanics of human movement. My insights were also informed by many hundreds of hours flying small airplanes, being buffeted by the same aerodynamic forces that birds face in their daily lives. These experiences, coupled with a strong desire to bring bird flight science to the attention of bird-watchers, gave me the inspiration to write this book.

Who has not woken from a dream to realize that they had been flying? I believe that this reflects how deeply flight, and the desire to fly, is embedded in our subconscious. My hope is that your envy, enjoyment, and wonder of bird flight — and your own bird-watching — will be enhanced and informed by reading this book.

Peter Cavanagh
Lopez Island, 2024

IUCN Red List

Each time a new bird is mentioned in this book, its conservation status will be indicated by the category assigned on the International Union for Conservation of Nature's Red List of Threatened Species. These categories, in ascending order of extinction risk, are as follows:

- Not Evaluated
- Data Deficient
- Least Concern
- Near Threatened
- Vulnerable
- Endangered
- Critically Endangered
- Extinct in the Wild
- Extinct

More information can be found here:
https://www.iucnredlist.org

It is estimated that there are 3 billion fewer birds in North America than there were 50 years ago. An awareness of the risk status of today's birds is presented to encourage conservation efforts on behalf of birds worldwide.

The wing motions of a European Goldfinch (*Carduelis carduelis*) are captured
in this rear-curtain flash image as the bird climbs out from a feeder.
Bourne, Lincolnshire, UK. December. IUCN category: Least Concern

CHAPTER ONE

"He who has a WHY to live for can bear almost any HOW.
— FRIEDRICH NIETZSCHE (1889)

Why Birds Fly

HAVE YOU EVER HAD AN ABSOLUTELY BRILLIANT idea only to discover that someone else had thought of it first? Bird flight is a lot like that. By the time bird ancestors such as the feathered dinosaur *Archaeopteryx* took flight about 150 million years ago, flapping flight had already appeared on at least two separate and unrelated occasions. And there was more to come!

The process of independent reinvention, which biologists call convergent evolution, can be understood in similar terms to the "new" bright idea that is actually an old idea. Innovation in human thought occurs in response to a pressing need, while innovation through evolution is a response to the pressure to survive. When bats, the last group of animals to fly, developed the ability to fly more than 50 million years ago, it was a new and completely independent event owing no debt or dependence to the insects, pterosaurs, and birds that had all independently developed flight capabilities many millions of years earlier (except, ironically, in the flight skills that bats developed to hawk insects).

It is hardly surprising that flight as a form of locomotion has been a recurring theme in Earth's biological history. The ability to fly radically enhances an animal's chances to survive and thrive in at least six important ways. This book is about how birds fly, but the reason why they fly also needs to be explored, since the *why* clearly preceded the *how*.

10

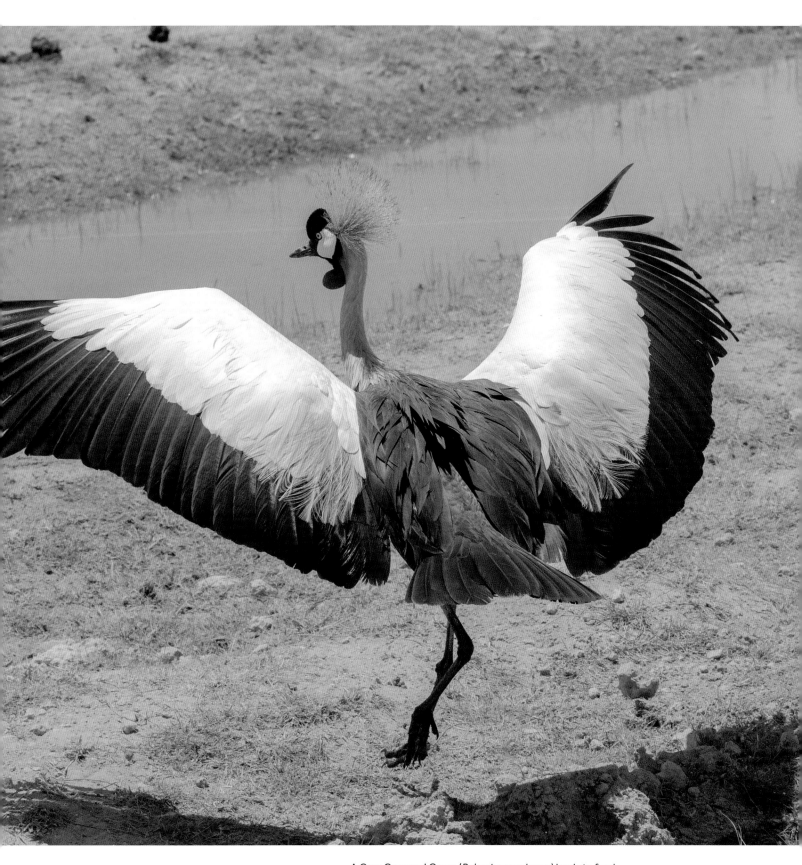

A Gray Crowned Crane (*Balearica regulorum*) lands to feed.
Amboseli National Park, Kenya. October. IUCN category: Endangered

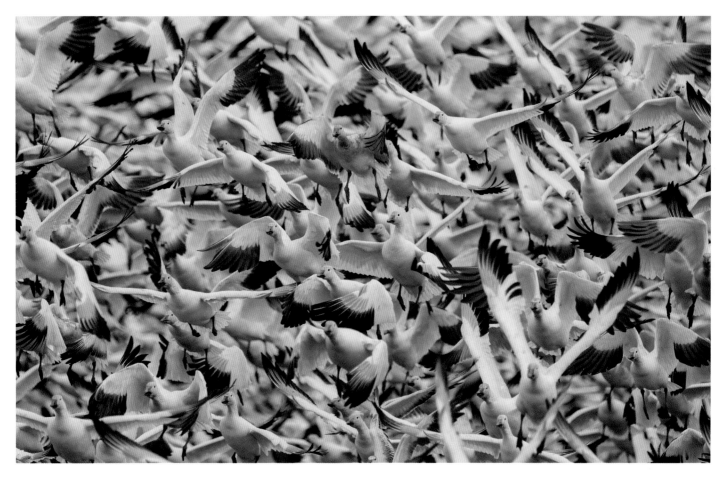

A frenzy of Snow Geese (*Anser caerulescens*) takes flight. A single Bald Eagle (*Haliaeetus leucocephalus*) leaving a tree near where several thousands of these birds are foraging is enough to send the entire flock skyward. Skagit County, Washington, USA. March. IUCN category: Least Concern

Escaping Predators

The most urgent reason to fly is to escape death from the jaws of a predator. Ecologists have developed a measure called flight-initiation distance, which can be thought of as a radius of personal space in which a bird is comfortable conducting its daily affairs. Once this bubble is penetrated by a potential predator, human or non-human, the bird will fly, hopefully extending its life by avoiding a lethal encounter. The blizzard of Snow Geese (*Anser caerulescens*) shown above is an example of such behavior. When they are foraging shoulder to shoulder in

wintering farm fields, Snow Geese stay vigilant. If birds on the periphery of the flock see danger in the form of a raptor entering their airspace, they take off, and their response rapidly propagates throughout the flock. I have experienced this multisensory blast several times as a screaming cloud of geese darkened the sky in a mass escape.

Capturing Prey

Of course, not all birds are prey. Many birds, such as the raptors that threaten Snow Geese, are predators, and flight allows them to take their prey swiftly and

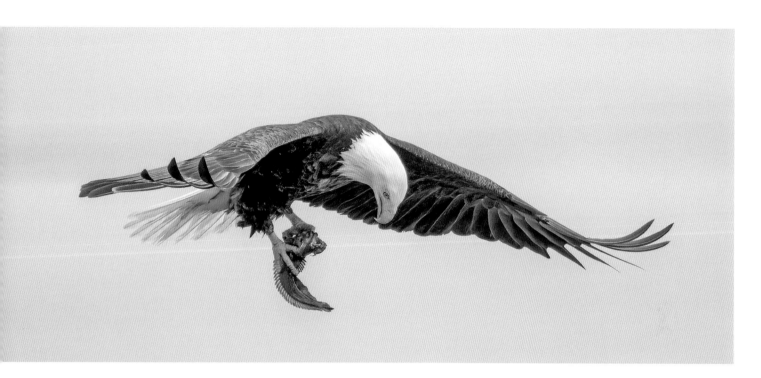

A Bald Eagle (*Haliaeetus leucocephalus*) carrying a Midshipman Fish (*Porichthys notatus*) that it has picked up from an oyster bed exposed by the ebbing tide. Seatback, Washington, USA. June. IUCN category (bird and fish): Least Concern

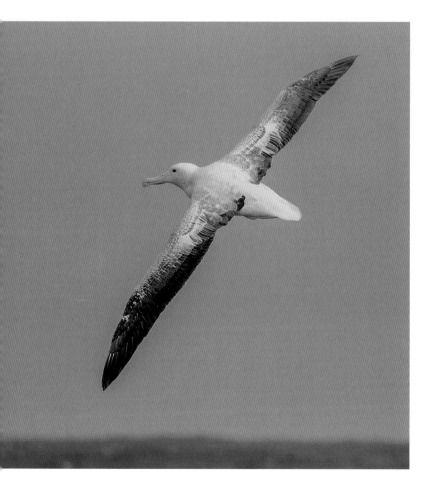

An adult Snowy (Wandering) Albatross (*Diomedea exulans*) many hundreds of miles from land on a foraging trip over the Southern Ocean. En route to South Georgia. October. IUCN category: Vulnerable

often surreptitiously. A fascinating aspect of raptor flight is the complex set of calculations that the bird makes in order to intersect moving prey. For example, Harris's Hawks (*Parabuteo unicinctus*) do not simply "chase the tail" of their quarry. They fly a trajectory that has been likened to the guidance algorithm of a ballistic missile (see page 189).

Extending Home Range

Flying greatly extends a bird's foraging range, which ecologists call the home range for an individual bird (this is distinct from species range, which is the territory occupied by all members of a particular species). One of the most extreme home ranges is the huge foraging territory of Snowy (Wandering) Albatrosses (*Diomedea exulans*).

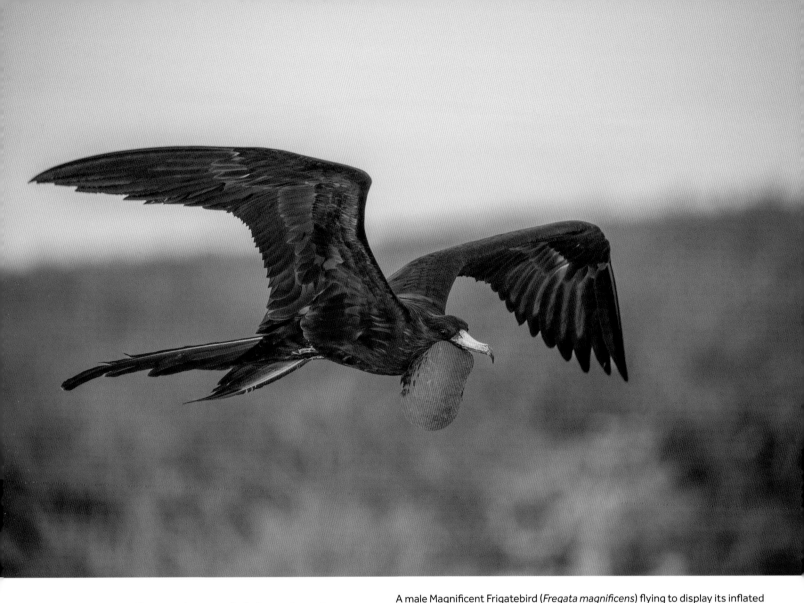

A male Magnificent Frigatebird (*Fregata magnificens*) flying to display its inflated gular pouch to any interested female birds in the neighborhood.
North Seymour Island, Galápagos Islands, Ecuador. October. IUCN category: Least Concern

One study recorded that, when there were chicks at the nest, adult Snowy Albatrosses covered an average of about 6,000 km (3,728 miles) during each 11.6-day foraging trip, ranging as far as 1,534 km (953 miles) from the nest.[1] Their prey, mainly various types of squid, are widely distributed, and studies have shown an astonishingly low capture rate of only one prey item per 3.6 hours of foraging. Assuming the Snowy Albatross does not over-look available prey, this low density of preferred food highlights the role that flight plays in its survival: If the bird were restricted to a small feeding area, it would have to change its dietary pref-erence or it would not survive. This is quite the opposite of "patch" feeding, where a high concentration of prey (such as a shoal of fish) enables a bird to stay and feast in a relatively local area.

On the other end of the foraging extreme, songbirds have home ranges that can be quite small. For example, Dark-eyed Juncos (*Junco hyemalis*) with young in the nest were found to have a home range that averaged 0.8 ha (2 acres), equivalent to a square with 91 m (300-foot) long sides. But this range is still about twice as large as that of a similarly sized rodent, like the Deer Mouse (*Peromyscus maniculatus*),

showing how flight can extend the possibilities for foraging.

Attracting a Mate

Flying enables some species to perform dramatic aerial displays, so they can strut their stuff during courtship. Male and female Red-tailed Hawks (*Buteo jamaicensis*) and Bald Eagles (*Haliaeetus leucocephalus*) engage in aerobatic bonding dances, sometimes locking talons and pirouetting toward the ground. Common Swifts (*Apus apus*) take airborne romance one step further by copulating in the air, although they sometimes prefer firm ground.

Female Magnificent Frigatebirds (*Fregata magnificens*) cruise over areas where males are roosting. The latter will display their bright red hyperinflated gular sacs, often by tipping their heads back so the entire sac is visible from the air. Desperate males, like the one shown on page 14, will sometimes

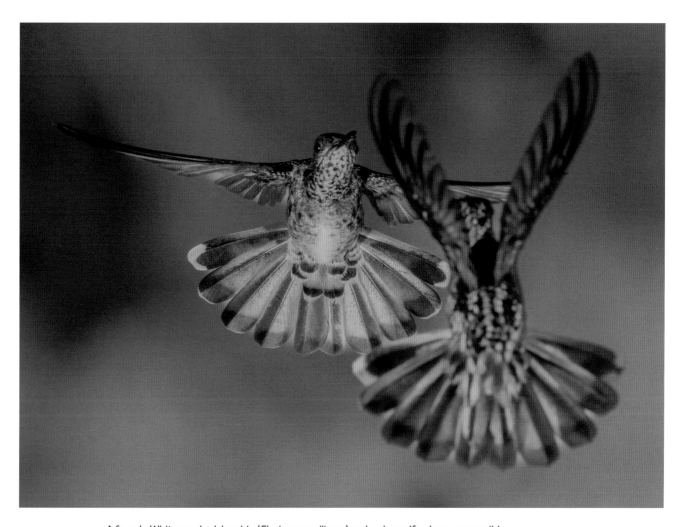

A female White-necked Jacobin (*Florisuga mellivora*) makes herself as large as possible to fend off an intruder from a food source she is defending. If her display fails, then she may chase and attack with her bill. Flight can definitely be a weapon of war.
Rancho Naturalista, Costa Rica. April. IUCN Category: Least Concern

tire of waiting to be chosen and will overfly roosting females. The redness of the pouch is an "honest" sexual signal, meaning it is a true indicator of the male's hormone levels and readiness to mate.

Defending Territory

When threatened, the graceful flight of many birds can be transformed into a full-scale flying assault. Corvids are notorious for attacking humans whom they perceive to be intruding on their territory, and gulls and terns will dive-bomb anyone who comes near their ground-nesting sites. But birds attacking birds is a more common occurrence, and it usually happens when there is a threat of predation to chicks in the nest. I have seen bewildered herons battered about the head by fast-flying terns, and perching Bald Eagles (*Haliaeetus leucocephalus*) mobbed by wave after wave of American Crows (*Corvus brachyrhynchos*) that were nesting nearby. Hawks and owls are often the targets of mass attacks by mobs of songbirds, who take safety in their numbers and their agility even though one or more of them could end up on the larger bird's menu.

Hummingbirds are notoriously territorial and aggressive about defending their food sources. Much to the frustration of photographers waiting to capture images of various species attending a flower or feeder, a single bird will frequently perch nearby and ferociously chase away every other

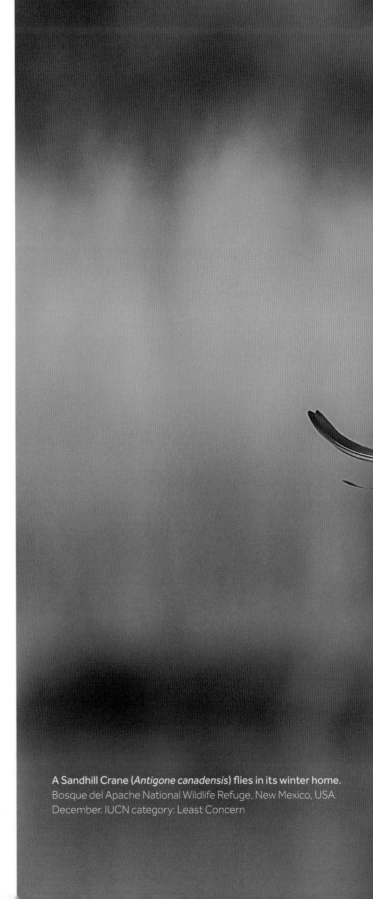

A Sandhill Crane (*Antigone canadensis*) flies in its winter home. Bosque del Apache National Wildlife Refuge, New Mexico, USA. December. IUCN category: Least Concern

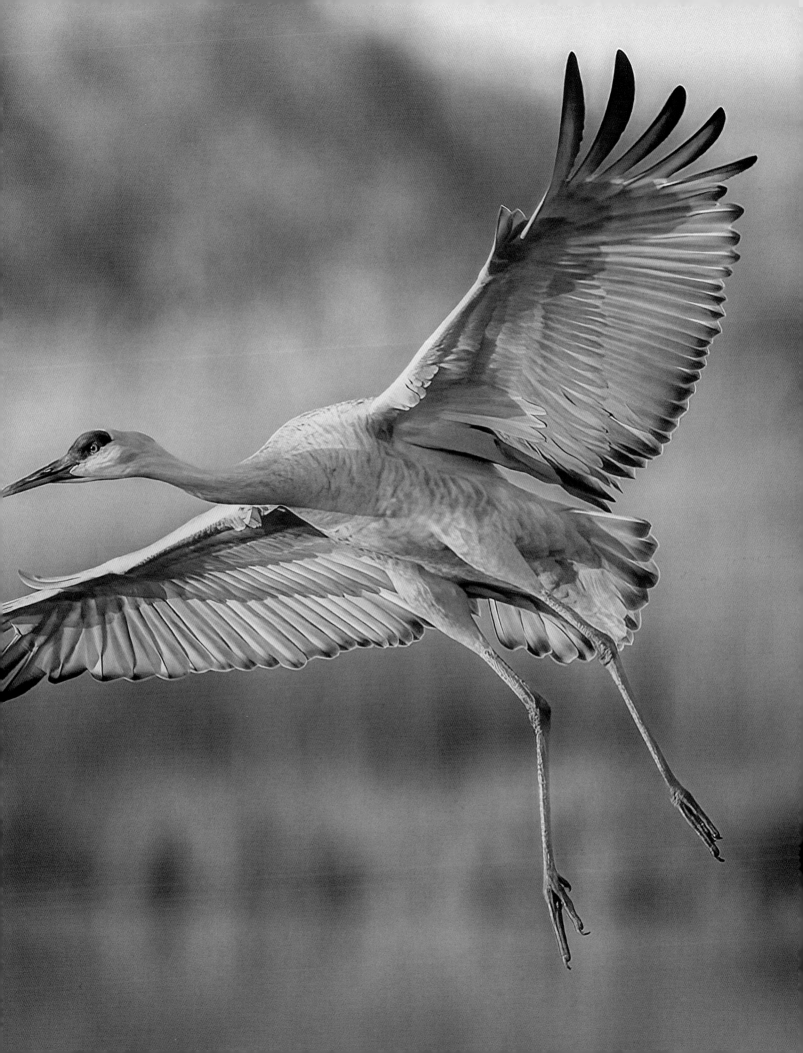

approaching bird, conspecific or not, sometimes following them for a long distance to ensure that they clear the area. This may start with an aggressive flying display to dissuade an interloper.

Migration

Flying allows birds to migrate, so they can avoid the bad weather and lack of food that would make it difficult to survive the winter. I took the photograph on the previous page of a Sandhill Crane (*Antigone canadensis*) in its winter quarters at Bosque del Apache National Wildlife Refuge in New Mexico, United States. Hundreds of thousands of these birds make annual round trips along America's Midcontinent, Pacific and Eastern Flyways, traveling approximately 250 km (155 miles) per day. The western populations breed during the summer in Siberia, the Canadian Arctic and the American and Canadian Midwest. Their paths converge over the Dakotas before diverging to wintering sites in Texas, New Mexico, Arizona, and Mexico. On the northbound spring trip, it has been estimated that more than half a million Sandhill Cranes mass for an extended stopover in late March on the Platte River in central Nebraska.

Why Leads to *How*

Bird flight evolved because of compelling needs to escape from predators, improve hunting performance, extend foraging range, find a mate, defend territory, and enable migration. Once these life-saving and life-giving advantages were operating, there was a strong tendency to favor flight during the evolution of avian ancestors — something biologists call a positive selection pressure. This led to the almost 11,000 species of flying birds in our 21st-century skies. Now that we know the *why*, the stage is set to explore *how* birds began to fly.

From the Lab Features

At the end of each chapter, I highlight one research paper relevant to the chapter topic to provide the reader with an insight into how avian research is done.

FROM THE LAB
How do neighboring species share a feeding range?

THE QUESTION	How do sympatric birds (different species that live in the same geographical area) share a feeding range?
THE AUTHORS	Christina Petalas, Thomas Lazarus, Raphael Lavoie, Kyle Elliott, and Mélanie Guigueno from McGill University, Quebec, Canada
THE SOURCE	"Foraging Niche Partitioning in Sympatric Seabird Populations," *Scientific Reports* 11, no. 1 (2021): 2493, PMID: 33510235, DOI: 10.1038/s41598-021-81583-z.
THE HYPOTHESIS	A division of food resources and feeding locations among species allows for stable communal living.
THE EXPERIMENT	GPS tracking devices were attached to incubating breeding adult birds — 11 Razorbills (*Alca torda*), 23 Black-legged Kittiwakes (*Rissa tridactyla*) and 16 Common Murres (*Uria aalge*) — nesting on an island in Quebec's Betchouane Bird Sanctuary in the Gulf of Saint Lawrence in northern Quebec, Canada. Data were available for 122 foraging trips. Food identification was done visually for Razorbills, Murres, and Atlantic Puffins (*Fratercula arctica*). The Kittiwakes' diet could not be assessed because they regurgitated their food during chick feeding.

THE RESULTS

There was a clear separation between species in the average distance flown from the nest to forage for food:

Capelin and Sandlance formed the main food sources for all three birds observed: 64% for Common Murres, 86% for Puffins, and 94% for Razorbills.

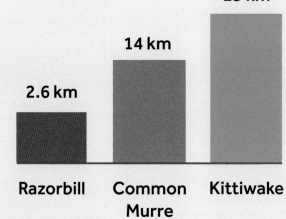

Figures redrawn from Petalas et al.

THE CONCLUSIONS	The separation of feeding sites is an example of niche differentiation, which allows sympatric (neighboring) species to reduce competition for resources. The long distances traveled by Kittiwakes presumably reflect their lower energy costs of flight, due to their reduced wing loading.

> When we see any structure highly perfected for any particular habit, as the wings of a bird for flight, we should bear in mind that animals displaying early transitional grades of the structure will seldom continue to exist to the present day, for they will have been supplanted by the very process of perfection through natural selection.
>
> — CHARLES DARWIN (1859)

The Evolution of Bird Flight

U NTIL THE MIDDLE OF THE 19TH CENTURY, THE origins of birds and bird flight were considered to be settled facts — they were divine creations. John Ray, a fellow of Trinity College, Cambridge, who had considerable knowledge of ornithology, summed up the prevailing opinion in 1701, when he wrote of birds and other *Bodies with a Sensitive Soul*: "Let us take notice of and admire [God's] infinite Wisdom and Goodness in the Formation of them." Ray dismissed the notion of extinction and declared that of all animals that had been created, "there is not to this day one Species lost." There was even a date for creation, 4004 BCE, provided by Irish Archbishop James Ussher in the 1650s.

Starting in the early 19th century, Earth began offering up fossilized remains of extraordinary animals, some of them with wings. By 1834, Richard Owen, a renowned British biologist, had coined the term *dinosaur* (from the Greek for "terrible lizard") based on the fossils he had seen. The tidy existing dogma of finite creation without extinction began to crumble.

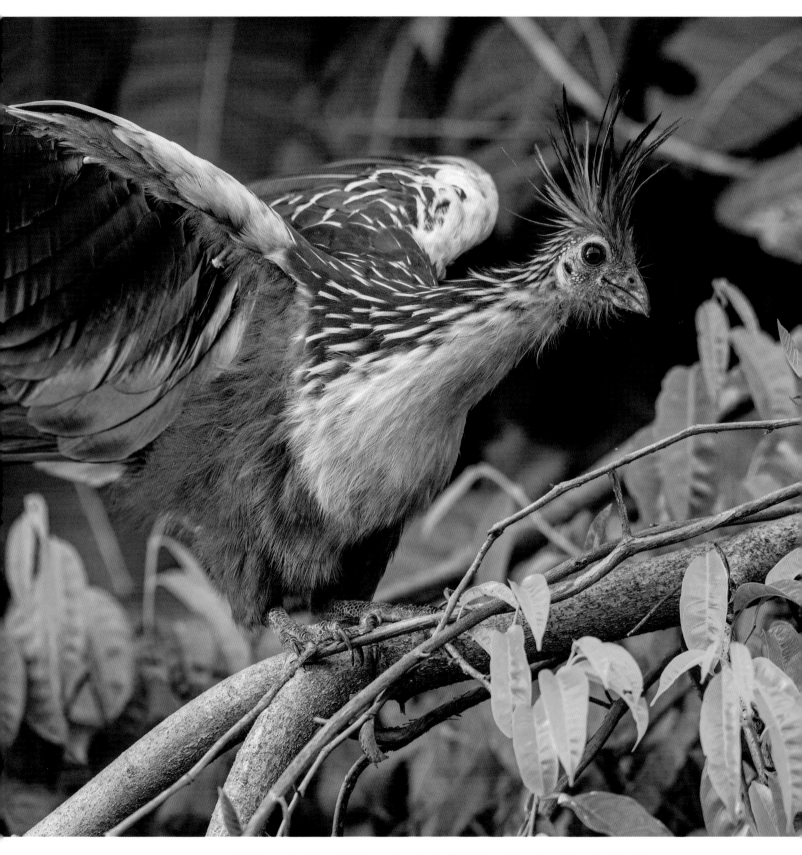

A glimpse of what early birds may have looked like? The relationship of the extant Hoatzin (*Opisthocomus hoazin*) from South America to other birds continues to perplex scientists. One study proposes that it is the oldest lineage of any living bird, dating back 62 million years.

Tambopata, Peru. May. IUCN category: Least Concern

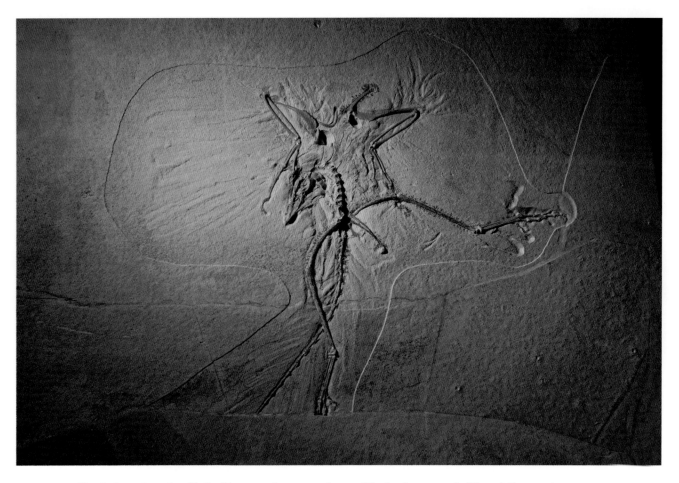

The *Archaeopteryx* fossil in the Thermopolis museum is one of the best preserved of the existing specimens. The skull, wings, and feet are particularly striking, and the wing and tail feather impressions are clearly visible. Wyoming Dinosaur Center, Thermopolis, Wyoming, USA.

Image courtesy of Brian Switek

Charles Darwin's magnum opus, *On the Origin of Species by Means of Natural Selection, or the Preservation of Favoured Races in the Struggle for Life*, was published on November 24, 1859, fomenting turmoil in the scientific and religious communities.

An Ancient Wing Arrives in London

A small, fossilized skeleton was about to enter this polarized maelstrom. In 1862, Karl Friedrich Häberlein, a Bavarian physician and amateur paleontologist, decided that it was time to monetize his considerable fossil collection, and he found a customer in the British Museum. What the museum wanted most was a fossil specimen of a headless, lizard-like winged creature with a long tail, claws on the wings, and obvious imprints of feathers. This "London specimen," presently in the Treasures Gallery of London's Natural History Museum, was given the genus name *Archaeopteryx*, meaning "ancient wing" or "ancient feather" in Greek. Eventually, twelve mostly two-dimensional specimens, which dinosaur expert Louis

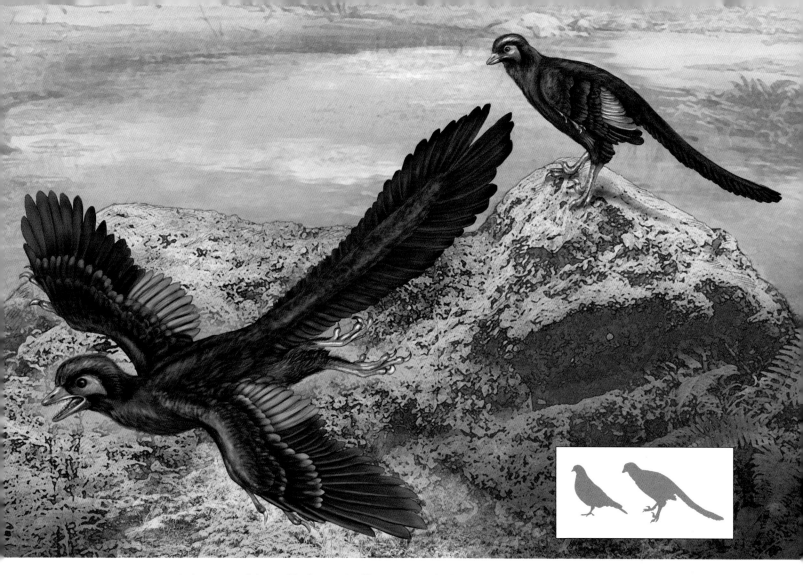

Archaeopteryx lithographica from 150 million years ago. In this and subsequent restorations, a silhouette of a Rock Pigeon (*Columba livia*) is provided for approximate size comparison.

Chiappe has described as looking like scientific "roadkill,"[1] were found at or near the German town of Solnhofen. These included the one on page 22, now known as the Thermopolis specimen, which also came from a private collection.

An account of each specimen and the controversies surrounding the place *Archaeopteryx* should occupy in the bird tree of life are chronicled in an excellent book by Peter Wellnhofer[2] and in accounts of more recent fossil finds in China that may usurp the preeminence of *Archaeopteryx* as the most "basal" bird.[3] The first *Archaeopteryx* specimen,

estimated to be about 150 million years old, was hailed in 1862 by many as a missing link between birds and reptiles, although we now know it marks a transition from dinosaurs to birds. Among *Archaeopteryx*'s reptilian characteristics were its long tail, lacking fused vertebrae, primitive shoulder joint, snout, teeth, clawed hands and distinctly dinosaurian hip joints. The bird-like features of *Archaeopteryx* included wings with typical avian feathers, a relatively large brain, and feet showing a partially reversed toe, intermediate to the full reversal seen in modern birds. The specimen, however, did not show

the keel-shaped sternum (breastbone) typical of modern flying birds. Also, the bones in the wrists, hands and feet were not fused, as they are in today's birds.

Many skeptics received news of *Archaeopteryx* and its supposed transitional pedigree with disbelief and disdain. Richard Owen, a distinguished contemporary of Darwin who had published a highly negative anonymous review of *On the Origin of Species*, was the first to examine the specimen in London, and he declared it to be "a 'longtailed' bird, albeit a very primitive one" and not at all transitional in nature. Thomas Henry Huxley later pointed out that Owen had mistaken the bottom surface of the fossil for the top surface, and he also listed a number of other interpretation errors.

Somewhat surprisingly, Darwin and his allies did not publicly embrace *Archaeopteryx* as evidence of evolution or "transmutation" of one species into another. Owen's broadside was the start of more than 150 years of often passionate argument about *Archaeopteryx* and its place in avian ancestry. This has included now discounted conspiracy theories by Nobel Prize–winning astronomer Sir Fred Hoyle and five others (none of them paleontologists), who declared that the London specimen was a hoax designed to embarrass Darwin.

Are Birds Descended from Reptiles?

In 1926, an influential and quite remarkable book titled *The Origin of Birds*, by Danish artist and amateur paleontologist Gerhard Heilmann, redirected the debate regarding avian origins, moving it away from dinosaurs and toward a group of Triassic reptiles. Heilmann was reportedly shunned by Danish ornithologists, who considered him to be an "upstart," but his book was a work of real scholarship and his drawings are quite exquisite.[4] What led Heilmann astray was the fact that the dinosaurs known in his time lacked clavicles (collarbones). The contemporary belief was that once a feature was lost, it could not be regained in descendants. From their perspective, modern-day birds, all of which have clavicles, cannot have evolved from dinosaurs, which did not. We now know that anatomical and functional characteristics can be lost, only to reappear through the process of convergent evolution. Almost contemporaneously with the publication of Heilmann's book, fossils of dinosaurs with clavicles were found, but that did not immediately change minds about avian origins.

Heilmann's theory that birds were descended from early reptiles held sway for almost 50 years, until a single-page article by renowned Yale University paleontologist John Ostrom (1928–2005) appeared in the scientific journal *Nature* in 1973. The article caused a thunderous echo that we still hear today. Ostrom had spent several years studying the fifth specimen of *Archaeopteryx* (now known as the Haarlem specimen) after finding it incorrectly labeled as a pterosaur in a museum in the Netherlands. He had earlier written

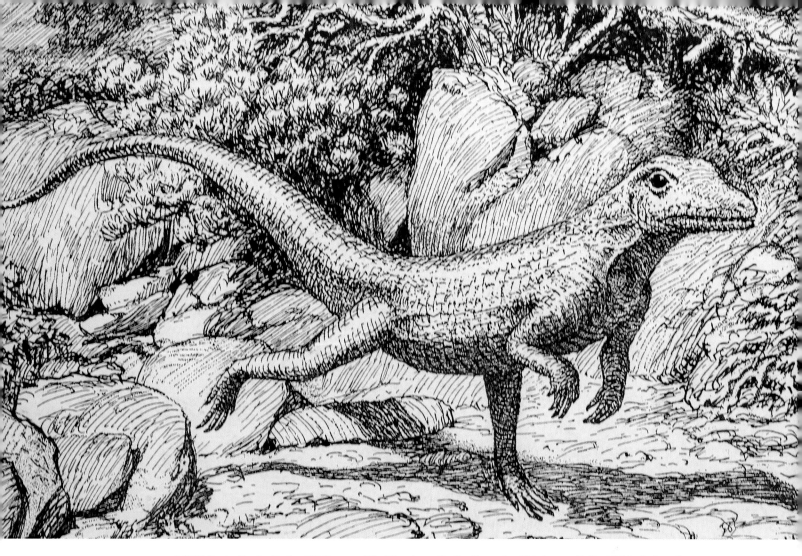

A 1926 illustration by Gerhard Heilmann of the Triassic reptile *Ornithosuchus* ("bird crocodile"), which he believed could be an ancestor of birds from 185 million years ago. He remarked that it "is light in structure and nimble in movement, as we should expect to be the case in a bird-ancestor, and the tapering head is very bird-like."

an exhaustive monograph on a theropod dinosaur from Wyoming called *Deinonychus antirrhopus* (which means "counterbalancing terrible claw"). It is hard to imagine a more qualified individual than Ostrom to establish the dinosaur-bird linkage, and he did not disappoint. In his one-pager that changed the world of avian science, Ostrom listed 21 well-established anatomical similarities between *Archaeopteryx* and *Dienonychus*, pointed out two brand-new shared features that others had failed to see, and ended with a statement that remains largely unchallenged to this day: "The only reasonable conclusion is that *Archaeopteryx*

must have been derived from an early or mid-Jurassic therapod."[5]

Whether or not *Archaeopteryx* was capable of flapping flight and exactly how it became airborne are questions that continue to be debated today. Recent scholarship has found that many theropod dinosaurs were "flight capable," based on calculations of wing loading and lift potential.[6] This work suggests that there was greater experimentation with wing-assisted locomotion before theropod flight evolved than previously thought and that there may have been at least three separate occurrences of flight in this group of dinosaurs.

A Dinosaur Dissenter

Radical ideas invariably attract dissenters. In the field of paleontology, differences of opinion have often turned vitriolic and sometimes personal. The curator of the Division of Birds at the Smithsonian National Museum of Natural History, Storrs Lovejoy Olson (1944–2021), embarked on what in retrospect seems like a scorched-earth campaign to kill the theory that birds descended from therapod dinosaurs. In 1999, Olson sent a broadside to the National Geographic Society excoriating them for publishing what turned out to be a fake (composite) specimen of an early bird — and he was correct. However, he could not resist adding a pugnacious sting in his tail when he observed that the "melodramatic assertion [that birds descended from dinosaurs] had already been disproven by recent studies of embryology and comparative morphology." This opinion did not stand the test of time, as the torrent of fossil finds over the next 20 years, many from China, rooted the origins of birds firmly in the line of therapod dinosaurs.

The fossil record of early birds and their precursors has been a generous fountain of knowledge. Building on John Ostrom's work, one can travel through the early Jurassic period, from about 180 million years ago up to the critical extinction event 66 million years ago (the K-Pg extinction) to chart important landmarks in the origins of birds and bird flight.[7]

Counterbalancing Terrible Claw (*Deinonychus antirrhopus*)

Most people know at least one therapod maniraptoran dinosaur: The velociraptor was recreated (featherless and at somewhat greater than actual size) using CGI in the *Jurassic Park* movies. Maniraptorans ("hand thieves") were agile, bipedal, long-tailed, and named for their long arms and three-fingered hands.

Deinonychus antirrhopus (Counterbalancing Terrible Claw) was a maniraptoran and dates from about 115–108 million years ago, about 35–42 million years after *Archaeopteryx*. Its relationship to the avian lineage is likely through an (as yet unknown) earlier therapod ancestor from 170–180 million years ago, a common ancestor of *Deinonychus* and later birds. *Deinonychus*, first found in Montana, probably weighed 70–100 kg (154–220 pounds) and was 2.4 m (about 8 feet) long

Although feathers were not found in the *Deinonychus* fossils, they have been inferred to exist from findings in similar genera. *Deinonychus* is not thought to have been flight capable, but it may have used its feathered arms for "stability flapping" while pinning down prey or for "mantling" (encircling prey with its wings, which is a behavior seen in raptors today).[8]

Among the most striking features of therapod anatomy that John Ostrom identified as *Archaeopteryx*-like in *Deinonychus* were the three-"fingered" hands and four-"toed" feet, the relative

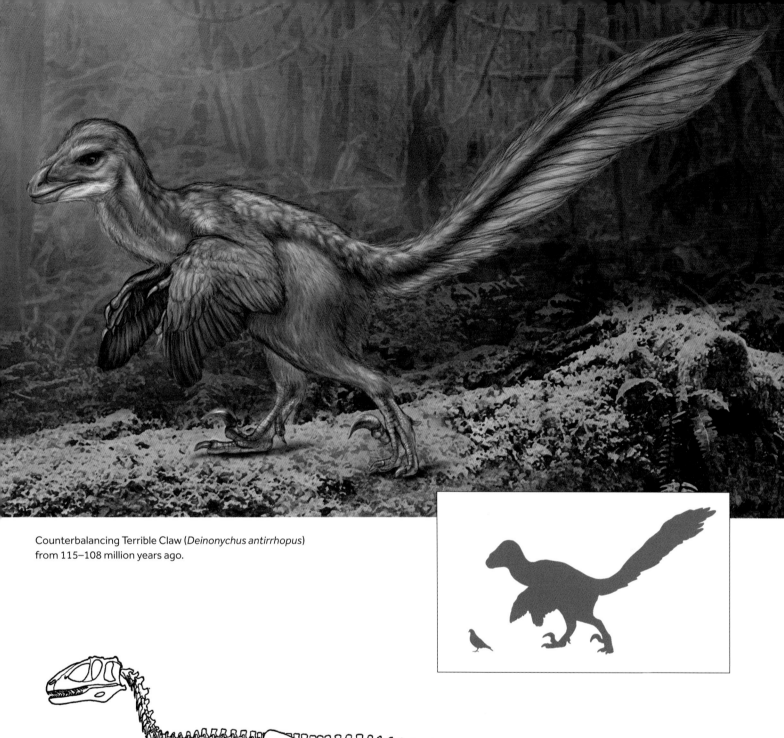

Counterbalancing Terrible Claw (*Deinonychus antirrhopus*) from 115–108 million years ago.

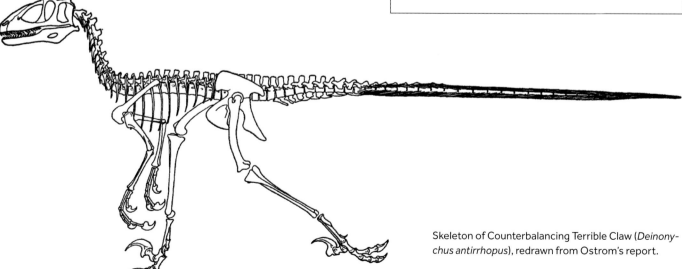

Skeleton of Counterbalancing Terrible Claw (*Deinony-chus antirrhopus*), redrawn from Ostrom's report.

27

Huxley's Near Bird (*Anchiornis huxleyi*), sometimes called a "four-winged dinosaur" because of the feathers on its arms and legs. This species is believed to have lived 161–151 million years ago.

proportions of the long bones of the upper limb, very narrow shoulder blades (scapulae), and moon-shaped wrist bone.

Huxley's Near Bird (*Anchiornis huxleyi*)

The crow-sized Huxley's Near Bird (*Anchiornis huxleyi*) definitely fits into the category of "evolutionary experiments" that were left out of the lineage that leads to modern birds. Some observers have called this, and its sister taxon Small Thief (*Microraptor*), "four-winged dinosaurs" because feathers were associated with the fossils' forelimbs and hindlimbs. Based on its

bony anatomy, experts have placed *Anchiornis* among the Wounding Teeth (*Troodontid*) therapod dinosaurs. This group probably became extinct at or before the K-Pg extinction.

This small, toothed dinosaur, named for "Darwin's bulldog" Thomas Henry Huxley, was found in China's northeastern Liaoning province and dated between 161–151 million years ago. This places *Anchiornis* a few million years before *Archaeopteryx*, and it is thought to be very close to the dinosaur-bird transition. When you look at the restoration of *Anchiornis* above and compare it with *Archaeopteryx*

(see page 23), you may be forgiven for thinking that these two creatures look very similar. This "near bird" dinosaur was probably living alongside *Archaeopteryx* or its close ancestor during a time with "much evolutionary experimentation and ferment." Future paleontologists will likely find many other variations on the therapod "near-bird" body plan.

The feathers on the forelimbs of *Anchiornis* are much more extensive and multilayered than those on its hindlimbs. The primary feathers are symmetrical and have thin shafts; both features contrast with modern birds but are more similar to the feathers of *Archaeopteryx*. The covert feathers are also much more extensive than in today's birds.

Could *Anchiornis* have traveled by flapping flight? Probably not. A biochemical analysis of the feathers on *Anchiornis*'s forelimbs found that they contain a mixture of two structural proteins (α- and β-keratins) in a combination that represents "an intermediate stage in feather evolution" and that would likely have had inadequate flexibility to withstand the forces of flapping flight. However, the possibility that *Anchiornis* could glide from a high perch is a very real one.

The picture that has emerged from *Anchiornis* and other feathered dinosaurs is that organisms capable of some sort of flight may have appeared and disappeared many times before the line leading to today's birds expanded so dramatically. For example, about 120 million years ago, the *Microraptor*, a

species of *Dromesaurid*, another group of therapod dinosaurs, had long feathers on all four limbs and on its tail, and it may have been capable of flight. Another specimen, *Pedopenna*, a maniraptoran therapod that dates from approximately 152 million years ago, had heavily feathered feet and upper extremities.

The evolution of avian flight was not a simple, linear process. There were likely many false starts along the way. This prompted one observer of the discovery of *Anchiornis* to remark, "what a gloriously messy business it is to tease apart the evolutionary tangles that we retrospectively anoint as an 'origin.'"

Holy Confucius Bird (*Confuciusornis sanctus*)

The Holy Confucius Bird (*Confuciusornis sanctus*), dated some 30 million years after *Archaeopteryx* (about 120 million years ago), is an important flighted species because it shows a number of advanced features. The most obvious is the presence of a toothless beak. There is also a major structural refinement in the skeleton, as shown in comparison to *Archaeopteryx* (see page 30). The long, lizard-like tail of *Archaeopteryx*, consisting of mobile individual bony segments, is represented by a bony plate, called a pygostyle ("rump pillar"), which resembles a fusion of many small segments. In modern birds, this is the bone to which tail feathers are attached, and it is sturdy enough to withstand the aerodynamic forces applied to the tail in flight. Although *Confuciusornis sanctus* had a long tail, the two elongated feathers

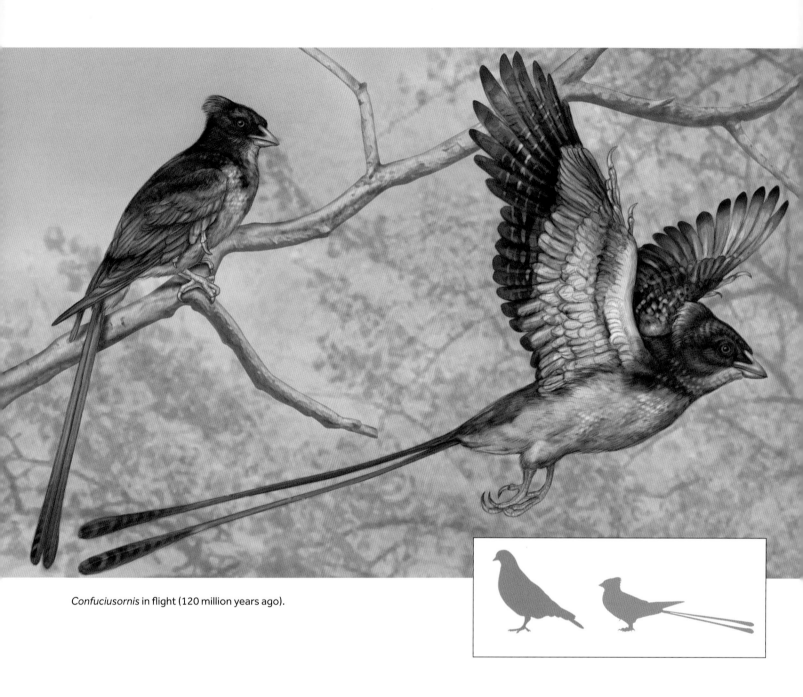

Confuciusornis in flight (120 million years ago).

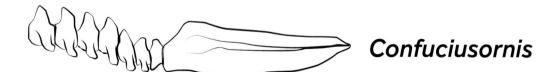

Archaeopteryx

Confuciusornis

Comparison of the tail skeletons of
Archaeopteryx and *Confuciusornis*,
redrawn from Rashid et al.[9]

were not aerodynamically useful: Long tails are found today in tropicbirds, Resplendent Quetzals, and some hummingbirds and flycatchers. The actual bony tail is quite short.

There are, however, a number of characteristics that *Confuciusornis sanctus* does not share with modern-day birds. For example, its skull had many primitive features, and there was no large, bony keel on the sternum, which in modern birds is important for the attachment of flight muscles. The alula, or "thumb wing," was also absent. Indeed, three clawed "fingers" were present mid-wing, and these were probably used for climbing.

Confuciusornis is a much-studied bird, primarily because thousands of specimens, many with well-preserved feathers, have been discovered. The most exciting find was over 1,000 adult individuals in a thin layer of an ancient lake bed. Several hundred of these fossils were in an area of about 100 m² (1,076 square feet), suggesting a mass mortality event. Researchers have inferred how this bird flew based on its skeletal structure and by analyzing its wing feathers. They found the shaft diameter of the long primary feathers to be much reduced compared to similarly sized modern birds, and this has led some to believe that *Confuciusornis* was limited to gliding rather than flapping flight.

Pan's Grasping Bird (*Rapaxavis pani*)

Pan's Grasping Bird (*Rapaxavis pani*), found in China in 2009 and dated at 122–120 million years ago, is a member of a huge group of early birds that has been called "opposite birds" (Enantiornithes). The name refers to the three-dimensional curvature of the articulating ends of two shoulder-girdle bones (the scapula and coracoid), which is reversed in these birds compared to modern birds. Fossil remains of opposite birds have been found on every continent except Antarctica. They were an extremely diverse and prolific group of multiple species and varying sizes.

Unusually, the fossil of Pan's Grasping Bird was described in the scientific literature twice, before and after it was apparently worked on by an "amateur" who damaged the specimen. Despite these complications, it is a truly magnificent object in which many skeletal structures are positioned as they were in life, not disrupted, fragmentary, or randomly rearranged as is so often the case. It is a small bird (dwarfed by the modern-day pigeon). Songbird size was a feature of the early opposite bird lineage, which represents a departure from earlier birds.

Pan's Grasping Bird was named for its clawed feet, which strongly suggest it spent time perching in trees. Like its ancestors, Pan's Grasping Bird had teeth, but it did not have claws on its wing. The fusion of the terminal vertebrae into a pygostyle is clearly visible, suggesting the presence of a tail that was actively used in flight. Determining the flight behavior of Pan's Grasping Bird is complicated by the presence of a pair of small triangular bones that are almost unique, but there is enough

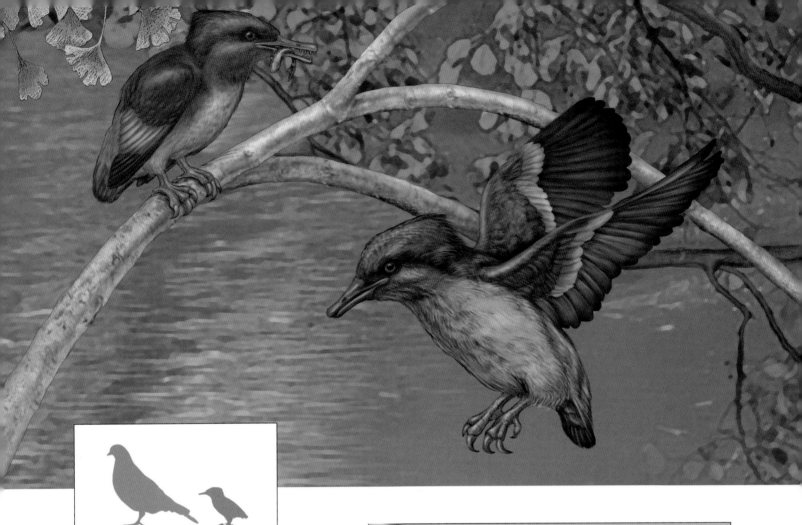

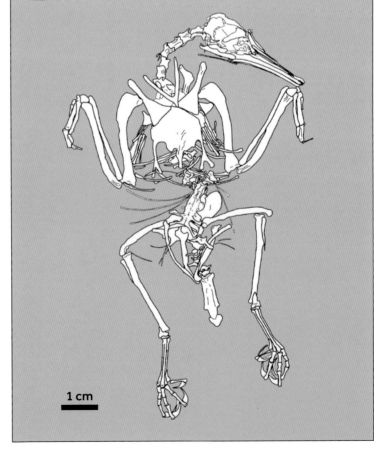

Pan's Grasping Bird (*Rapaxavis pani*), dated to 122–120 million years ago.

A sketch of the "exquisitely preserved" fossil after restoration. The scale bar is 1 cm (½ in.). Redrawn from Jingmai O'Connor et al., "Anatomy of the Early Cretaceous Enantiornithine Bird Rapaxavis pani," *Acta Palaeontologica Polonica* (2011): 463-475, DOI: 10.4202/app.2010.0047.

1 cm

evidence to suggest that this bird was a competent flyer.

One of the most spectacular finds associated with this group is not a fossil, but a bird preserved in Burmese amber dated to approximately 100 million years ago, just 13 million years younger than Pan's Grasping Bird. The bird, most likely immature, was covered in downy feathers, but several flight feathers can be clearly seen with advanced imaging techniques. This specimen provides a unique opportunity to visualize not only skeletal material but also soft tissue and feathers from an animal that existed millions of years ago.

Different Fish Bird (*Ichthyornis dispar*)

The Bone Wars in the late 19th century were an early example of the extreme competitiveness that seems to be an inescapable thread in the fabric of paleontology. Two towering scientific figures of the time, Edward Drinker Cope of Philadelphia and Othniel Charles Marsh of Yale, were bent on a path of mutual intellectual and financial destruction. Their battlegrounds were the newly discovered fossil beds of the American West, and their weapons were deceit, bribery, and bullying. This story attracted the attention of author Michael Crichton, who wrote a fictionalized account of their battles in "Dragon's Teeth," the third posthumous manuscript found among his papers.

Despite its rancor, the scientific fruits of this unseemly academic rivalry were remarkably bountiful, none more famous to bird enthusiasts than the first specimen of the now well-known Different Fish Bird (*Icthyornis dispar*), which Marsh described in an extensive 1880 monograph.[10] Marsh proudly sent a copy to Charles

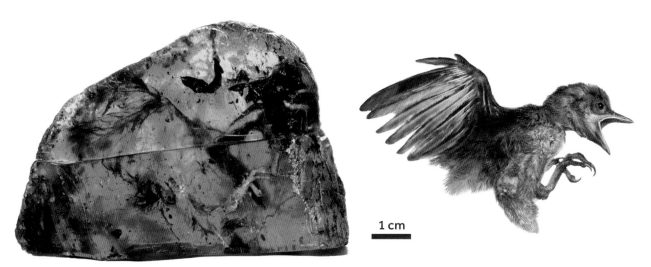

1 cm

A photograph and an artist's restoration of an amber-encased immature "opposite bird." The scale bar measures 1 cm (½ in.).[11]

Imago / Alamy Stock

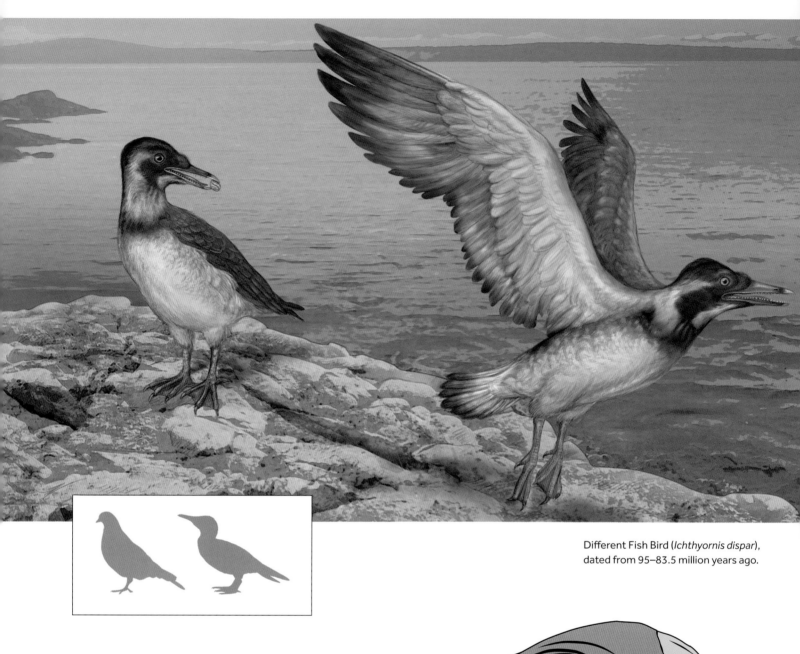

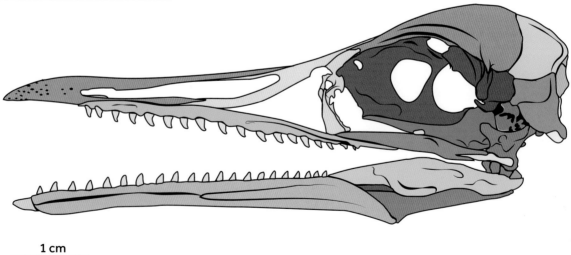

Different Fish Bird (*Ichthyornis dispar*), dated from 95–83.5 million years ago.

1 cm

A skull of the Different Fish Bird reconstructed from four specimens and other contemporary birds, redrawn from Field et al. The colors represent various anatomical regions. The teeth, bill, and brain shape indicate the transitional nature of this bird and place it very close to the line leading to present-day birds.[12]

Darwin, who responded: "Your work on these old birds, & on the many fossil animals of N. America has afforded the best support to the theory of evolution, which has appeared within the last 20 years."

Marsh and other paleontologists found more than 100 toothed bird specimens between 1870 and 1880. Remarkably, it took almost 125 years — until Julia Clarke decoded the giant jigsaw puzzle of fossils in Yale's Peabody Museum — to define the characteristics of *Ichthyornis* more closely.[13] As the illustration of the many-toothed crocodilian *Ichthyornis* skull on the opposite page shows, this early bird, dated to between 95–83.5 million years ago, is remarkable because, as Marsh himself declared, it serves "to break down the old distinction between Birds and Reptiles."

A recent examination of the remains of 40 specimens of this bird from the former Western Interior Seaway of the United States has enabled researchers to develop a fairly clear idea of how *Ichthyornis* foraged and flew.[14] *Ichthyornis* was a powerful underwater swimmer, possibly a plunge diver like the Northern Gannet (*Morus bassanus*), and soared much like the seabirds of today.

Royal Western Bird (*Hesperornis regalis*)

The flightless Royal Western Bird, dated to 83.5–78 million years ago, is another paleontological treasure found by Marsh, in Kansas (over two seasons,

in 1871–1872). In his monograph, Marsh described the find as "a gigantic swimming bird [...] essentially a carnivorous swimming Ostrich." Later researchers have described it more like a flightless loon or a large flightless cormorant.

This marine bird had powerful legs that it likely used for underwater propulsion, although there is some debate over the structure of its feet, which may have been either lobed or webbed. Its "wings," abbreviated and not flight-capable, were probably used for steering underwater. The Royal Western Bird had a full complement of "hooked" teeth on its upper mandible and half a row on its lower jaw, which were perfectly suited to a piscivore. This bird has been called the last of the toothed birds, based on subsequent finds. This designation also hints at the notion that, despite being flightless and having teeth, this bird is a very late example of the transition to modern birds, due to its many other "derived" characteristics. One author has described the Royal Western Bird and its near relatives as "the closest outgroup of modern birds," meaning that it and all today's birds very likely share a common ancestor that had the features we now recognize as modern.

So why was the Royal Western Bird flightless? Did it evolve from a long line of flightless ancestors or from a line of flighted birds? It is an example of secondary flightlessness, meaning that its ancestors were flying birds that evolved toward flightlessness under selection

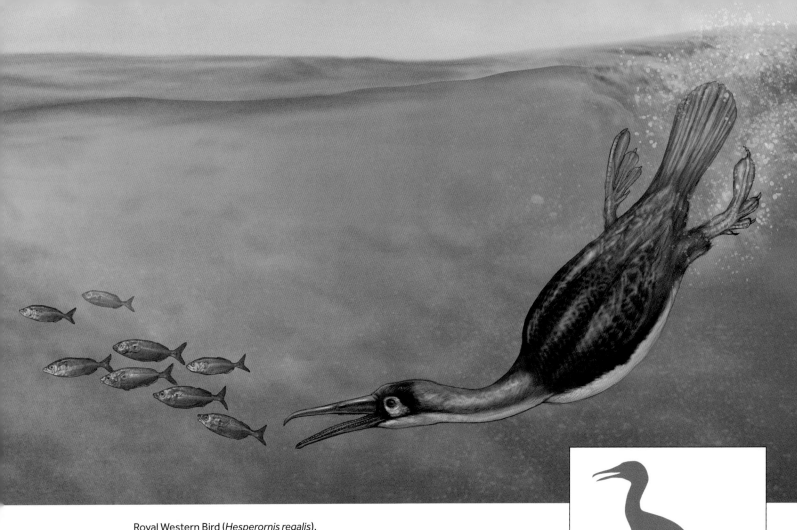

Royal Western Bird (*Hesperornis regalis*),
dated from 83.5–78 million years ago.

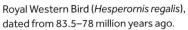

3.8 cm

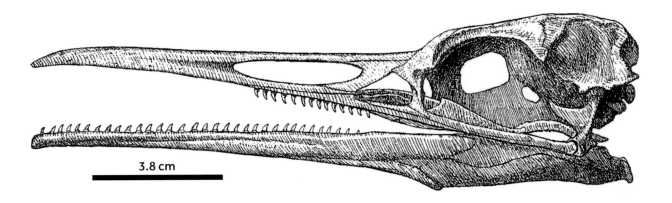

An illustration of the skull of *Hesperornis regalis* by Gerhard
Heilmann showing the bird's hooked teeth. The scale bar is
3.8 cm (1½ in.).

pressure. This happens most frequently on islands when terrestrial predators are absent and swimming ability is more important for survival than flying. Such conditions favor the development of lower-extremity propulsive ability at the expense of wings, which could be a hydrodynamic disadvantage when swimming underwater. Read more about this in chapter 11 (Losing Flight), starting on page 250.

Asteria's Bird
(*Asteriornis maastrichtensis*)

The name of this early bird indicates its critical location in time, right at the cusp of the K-Pg extinction. In Greek mythology, Asteria ("the starry one") was the Olympian goddess of falling stars. By one account, she was pursued romantically by Zeus, and to escape his affections, she transformed herself into a quail and swam away in the Aegean Sea. The symbolism here is that Asteria's Bird, which is somewhat quail-like, may — by its evolutionary transformations — have been able to escape the K-Pg extinction caused by a "falling star."

Greeted in the popular press as the "Wonder Chicken" and "Turducken" after it was first reported in 2020, this bird was hailed by its discoverers as being close to the last common ancestor of all current waterfowl and landfowl (Galloanserae). It is thought to have weighed about 400 g (just under 1 pound) and to have been about 30 cm (1 foot) tall. The specimen, which was found in Belgium, is dated rather precisely to 66.8–66.7 million years old, less than 2 million years before the K-Pg extinction event. Measurements of the skull, which was mostly intact in three dimensions, showed a close relationship with living ground birds. One leg bone was present, but there were no shoulder girdle or wing bones, so we know nothing of the flight ability of Asteria's Bird. However, we can assume that, like existing ground birds, Asteria's Bird preferred to forage on the ground but could, when necessary, fly capably.

Becoming Bird-Like

As paleobiologists assess the flight capabilities of early birds based on fossils, they focus their attention on certain key anatomical features present in modern-day birds. The obvious externally visible signals include the keeled breastbone, the fused terminal vertebrae (pygostyle) that replaced the long, multi-jointed tail (such as that of *Archaeopteryx*), the absence of mid-wing claws, and the fusion of bones in the hand and pelvis. Enhanced brain size in relation to body weight is also an important characteristic, since the complexities of flight require more neuronal processing power. The more subtle changes that indicate enhanced flight capacity include the triosseal canal (a tunnel that encloses the tendon of the muscle that raises the wing), a wrist that has the capacity to rotate (to pronate and supinate), and the positioning of a mobile shoulder joint toward the bird's spine.

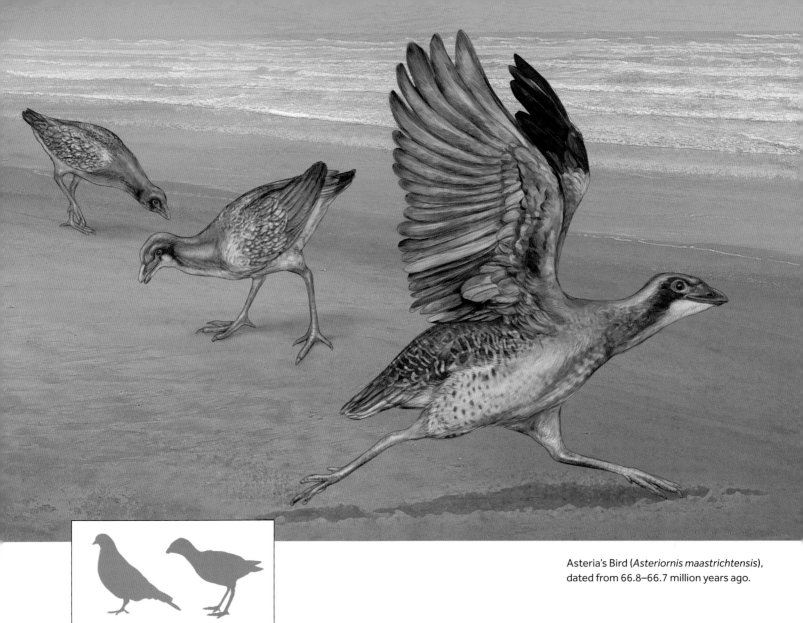

Asteria's Bird (*Asteriornis maastrichtensis*), dated from 66.8–66.7 million years ago.

An illustration showing the digitally segmented and colored skull of Asteria's Bird. It did not have teeth but had a bill, which was not preserved in the specimen. Redrawn from Daniel J. Field et al., "Late Cretaceous neornithine from Europe illuminates the origins of crown birds," *Nature* 579 (2020): 397–401, DOI: 10.1038/ s41586-020-2096-0.

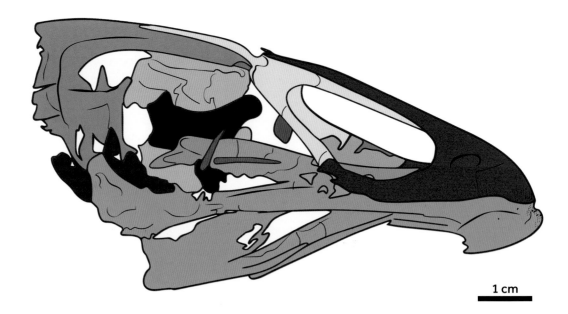

1 cm

Brains for Flight

The evolution of flapping flight required much more sophisticated control systems than terrestrial dinosaurs possessed. The rhythmic oscillation of the wings during flight is only the outward sign of what neuroscientists call sensory-motor integration — a process in which signals from a variety of sensors are analyzed and used to adjust the program controlling flight muscles. Amy Balanoff from Johns Hopkins University in Baltimore, Maryland, led a multidisciplinary team of scientists that used advanced imaging to study the role of different regions of the pigeon brain during flight.[15] These authors found that the cerebellum, a region of the brain renowned for its role in coordination of complex movements, was particularly active during flight. When coupled with observations that avian precursors showed a progressive expansion of the cerebellum, the study provides compelling evidence that development of this region of the bird brain was a key factor in enabling the evolution of powered flight.

Placing Early Birds into a Tree of Life

Early avian phylogenetic trees (more commonly called "trees of life") were mostly based on the subjectively assessed characteristics of fossil skeletons, such as the shape of a breastbone, the positioning of the toes, and the presence or absence of fused bones. This was later supplemented by mathematical analysis of a matrix of such characteristics. Trees can also be built using molecular phylogenetics in living (extant) birds, a technique which emerged in the mid-20th century. The concept of a molecular clock is used to estimate the time that has elapsed since two related species diverged from a common ancestor. This involves large-scale comparisons of DNA (both nuclear and mitochondrial) using software packages that generate thousands of trees. Statistical methods are then used to select the "best" tree.

The simplified phylogenetic tree on page 40 contains many nuggets of information regarding the evolution of birds and bird flight. Perhaps the most striking feature is all the Xs along the red line at 66 million years ago. None of the early birds that we have considered (with the possible exception of Asteria's Bird) survived the K-Pg extinction event. Also, none of them are in the direct line to modern-day birds — they each shared a (presently unknown) common ancestor before they diverged from the line leading to one of the most important features of this diagram: the red asterisk at about 100 million years ago that indicates the last common ancestor of all of today's living birds. This as yet undiscovered early bird is the common ancestor of the three groups that we know crossed the Rubicon of the great extinction to give rise to all modern birds — the "new birds," or Neoaves. The completely flightless ratites and the flighted

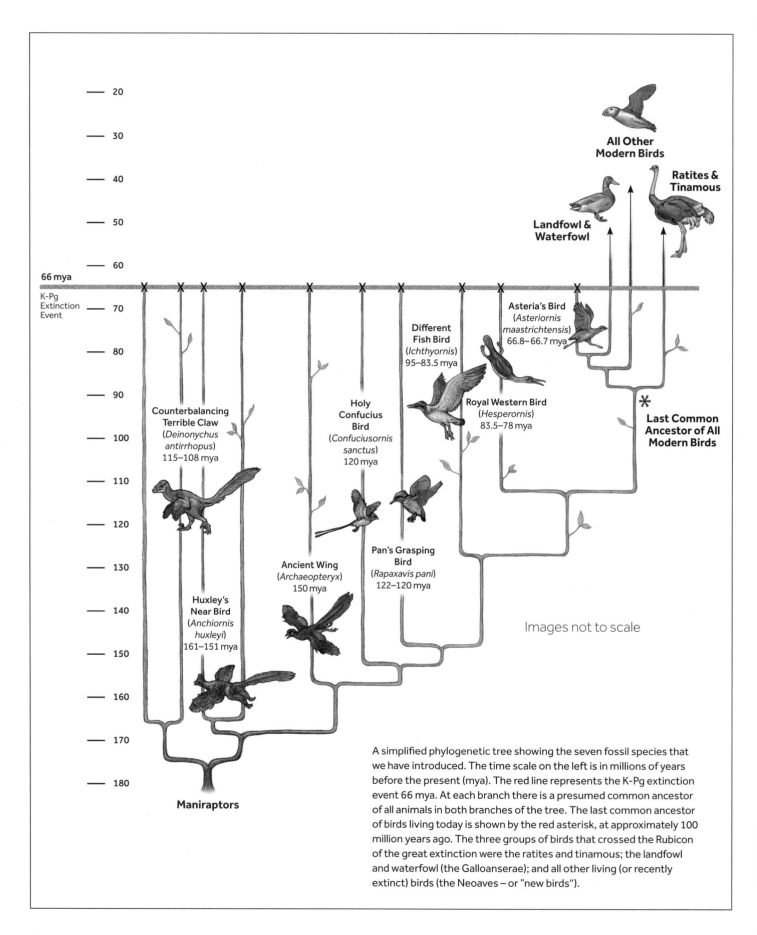

— 20

— 30

— 40

— 50

— 60

66 mya
K-Pg
Extinction
Event

— 70

— 80

— 90

— 100

— 110

— 120

— 130

— 140

— 150

— 160

— 170

— 180

**All Other
Modern Birds**

**Ratites &
Tinamous**

**Landfowl &
Waterfowl**

Asteria's Bird
(*Asteriornis
maastrichtensis*)
66.8–66.7 mya

**Different
Fish Bird**
(*Ichthyornis*)
95–83.5 mya

**Counterbalancing
Terrible Claw**
(*Deinonychus
antirrhopus*)
115–108 mya

**Holy
Confucius
Bird**
(*Confuciusornis
sanctus*)
120 mya

Royal Western Bird
(*Hesperornis*)
83.5–78 mya

✳
**Last Common
Ancestor of All
Modern Birds**

**Pan's Grasping
Bird**
(*Rapaxavis pani*)
122–120 mya

Images not to scale

Ancient Wing
(*Archaeopteryx*)
150 mya

**Huxley's
Near Bird**
(*Anchiornis
huxleyi*)
161–151 mya

Maniraptors

A simplified phylogenetic tree showing the seven fossil species that
we have introduced. The time scale on the left is in millions of years
before the present (mya). The red line represents the K-Pg extinction
event 66 mya. At each branch there is a presumed common ancestor
of all animals in both branches of the tree. The last common ancestor
of birds living today is shown by the red asterisk, at approximately 100
million years ago. The three groups of birds that crossed the Rubicon
of the great extinction were the ratites and tinamous; the landfowl
and waterfowl (the Galloanserae); and all other living (or recently
extinct) birds (the Neoaves – or "new birds").

(but often preferentially walking or running) tinamous are the most ancient branch. Landfowl and waterfowl (the Galloanserae) share a common ancestor with all other modern birds.

How Did Early Birds Get Airborne?

If Sherlock Holmes had gone on to a have a second career as a scientist, he would likely have become a paleontologist. It is a discipline that requires supreme powers of deduction, often based on very limited evidence.

As a graduate student in the Anatomy department at the Royal Free Medical School in London, I vividly recall the morning that John Russell Napier, a famous professor of paleoanthropology, came striding into the faculty tearoom and emptied out a single small fossil foot bone onto the table from a balsawood matchbox. "So," he boomed, "tell me how the owner of this bone walked!" As most of us started sweating profusely and stared vacantly at the fossil in embarrassed silence, Professor Napier proceeded to pronounce that the owner in question was indeed a bipedal human ancestor and belonged to a new species that he had named *Homo habilis* ("handy man"). The problem with such a bold statement is that it can never categorically be proven right or wrong, and this has led to paleontology becoming one of the most contentious of scientific disciplines. (*Homo habilis* was, in fact, excluded from the genus *Homo* by subsequent researchers.)

It is no surprise, then, that there are competing theories of how the first birds took flight, based on both the fossil evidence and studies of existing birds. Historically, the various factions have camped behind one of two banners: the tree-down platoon (the arboreal theory) and the ground-up brigade (the cursorial theory).[16] More recently, two more theories have emerged, positing that pouncing predation and wing-assisted incline running are major mechanisms by which pre-birds could have transitioned to flight.

The arboreal theory holds that early birds were able to climb trees, or perhaps lived in trees, from which they could thrust themselves with outstretched wings. The resulting glide provided access to an extended feeding area. Eventually, these gliding flights were extended by the ability to generate thrust through flapping.

The theory has no doubt been influenced by observing many present-day birds perch in high places as they scan for available food sources and predators and use gravity to assist their takeoff. But biologists generally have issues with comparisons of modern and ancient species, particularly because the early birds likely had markedly different anatomies and flight mechanics. In particular, arboreal birds would have been expected to develop anatomical adaptations suited to living in trees, such as feet that could curl around small branches and mobile upper and lower extremity joints. In a detailed anatomical study, these features were not found in many early birds assumed

to be capable of flight.[17] *Archaeopteryx*, however, does show arboreal adaptions in the claws on the hands and feet.

The cursorial theory holds that flight became possible when bipedal bird ancestors developed the ability to use their feathered upper limbs to stabilize themselves by leveraging aerodynamic forces while running. Such running could have occurred during an escape from a predator attack. The combination of the high speed at which the animal ran and the improved lift-generating capacity of their wings facilitated takeoff.

However, experts have raised some significant arguments against this theory. Notably, estimates of the maximum running speed of some early birds together with calculations of available lift from their wings predict that takeoff could not have occurred in still air. Although birds can take off with zero ground speed if the oncoming wind is strong enough, being able to escape predators only on windy days is not a long-term survival strategy! The proponents of the theory have noted that early birds known to be fliers did not possess the equipment to climb trees, so they believe that a cursorial origin of flight is more likely than an arboreal one.

The pouncing predator hypothesis is really a simplification of the arboreal theory that does not require an arboreal lifestyle: Pre-bird dinosaurs lay in wait for their prey in some elevated hiding place, perhaps on top of a large boulder. At the right moment, they would glide down and capture the unsuspecting target. Over time, evolution rewarded the animal's ability to

maneuver during descent and extend the attack through gliding, and eventually through flapping, to improve the likelihood of a kill. Extension of the wings before impact could also have reduced the force of landing, because increasing profile drag would slow the animal down.

The most recent addition to the theories of flight evolution is wing-assisted incline running. This view has been driven by observations of young birds that are not yet able to fly. When faced with the challenge of gaining height on a ramp, young birds move by a combination of running and flapping their developing wings. Even though the birds cannot yet fly, their wings appear to produce lift on the downstroke that assists in the climb by reducing the force needed from the legs. The argument is that by studying young developing birds, we are seeing a fast replay of evolutionary changes that happened over millions of years and eventually led to flapping flight. The view that present-day development mimics evolutionary changes is a controversial one, but the observations and calculations regarding wing-assisted running are compelling. In addition, modern-day chicks are born with large flight muscles (pectorals), unlike the ancestorial therapods.

It is possible that several, or indeed all, of these competing theories are correct. We have seen that there was not one template for the design of early avian anatomy, and there may not have been one mechanism for flight initiation. For example, flapping flight is a much more energetic form of

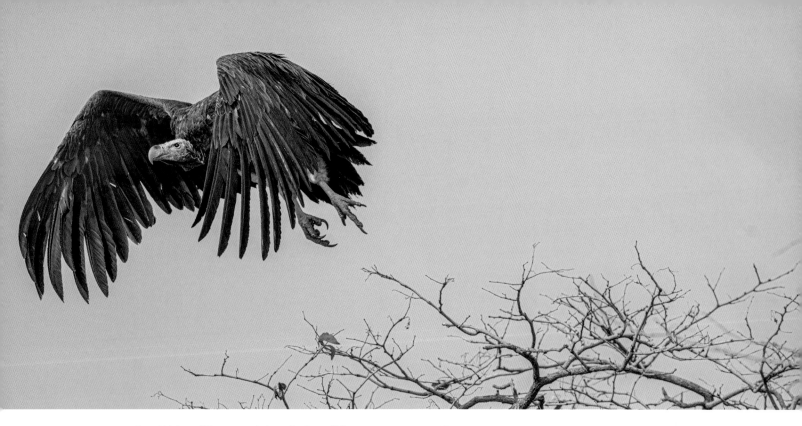

A Lappet-faced Vulture (*Torgos tracheliotos*) takes off from a treetop perch. For present-day birds, high perches provide a place to scan for feeding opportunities, but they may also have been essential to enable early birds to take flight. Tree-climbing ability would, of course, have been essential.
Etosha National Park, Namibia. September. IUCN category: Endangered

A White-naped Crane (*Antigone vipio*) on a takeoff roll.
Izumi, Japan. January. IUCN category: Vulnerable

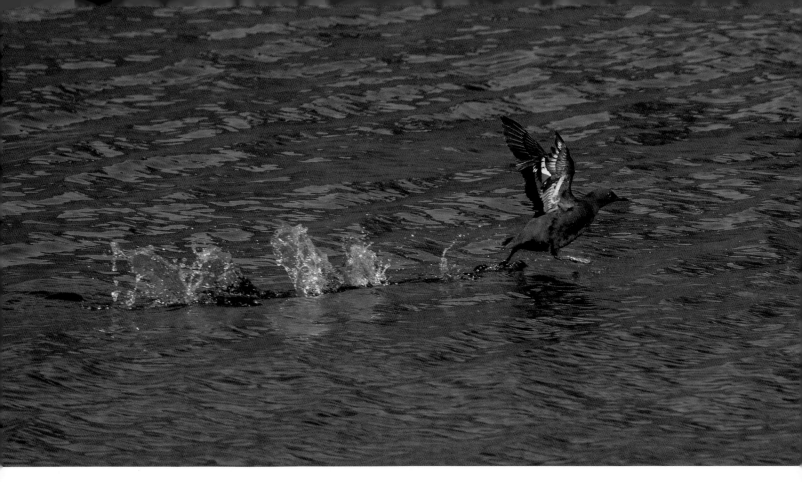

A Pigeon Guillemot (*Cepphus columba*) struggles to take flight by "running" on the water and flapping its wings until it develops sufficient lift for a takeoff.
Haro Straight, San Juan Islands, Washington, USA. March. IUCN category: Least Concern

locomotion than gliding, and it would have required well-developed muscular and respiratory systems. A much more fruitful approach may be to treat each early feathered specimen in its own right and infer from anatomy and biomechanics how each one may have taken off. There does not need to be a single answer to the question of how birds first took flight. Indeed, there may have been multiple evolutions of flight, with different means of getting airborne.

The Chicxulub Impactor and the K-Pg Extinction

On June 6, 1980, one of the most consequential papers in the history of earth science was published in the venerable journal *Science*.[18] The senior author was Luis Alvarez, a renaissance figure who had already won the 1968 Nobel Prize in physics for his work on resonance states in particles. This new foray into earth science was outside his wheelhouse (although his son, a coauthor on the paper, is a geologist). The scientists sampled exposed limestone sediments dated to 66 million years ago in three different parts of the world (Italy, Denmark, and New Zealand). They found concentrations of the metal iridium that were 30, 120, and 60 times higher than background levels. Iridium is rare on Earth but abundant in asteroids. In what became known as the "Alvarez hypothesis," the authors posited that an asteroid approximately

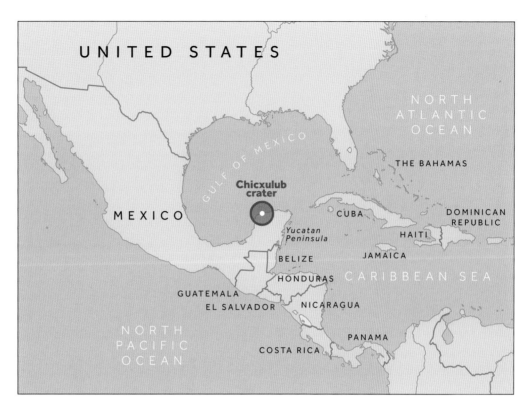

The current location of the Chicxulub crater in Mexico's Yucatán Peninsula.

10 km (6.2 miles) in diameter impacted Earth, resulting in years of cataclysmic worldwide climate change. This was, they believed, the cause of the great extinction of more than 75 percent of all species then present on the planet, including the large dinosaurs. The widely used term "K-Pg" represents the junction between the Cretaceous (*Kreide* is German for "chalk"), which is a geological period from 145 to 66 million years ago, and the Paleogene (from the Greek for "ancient-born"), which is a geological period from 66 million years ago to 23 million years ago.

The Alvarez hypothesis was not readily accepted by paleontologists. In fact, it sparked a prolonged and sometimes fractious debate over a 30-year period. Alvarez was himself an active combatant in these wars and is reputed to have said: "I don't like to say bad things about paleontologists, but they're really not very good scientists [...] They're more like stamp collectors." There is some support for competing theories that contend the extinction was caused by contemporaneous volcanism in India or multiple impacts of extraterrestrial objects. However, in 2010 a consensus conference of 41 experts came out firmly in favor of Alvarez's theory, concluding that "The temporal match between the ejecta layer and the onset of the extinctions and the agreement of ecological patterns in the fossil record with modeled environmental perturbations (for example, darkness and cooling) lead us to conclude that the [...] [Chicxulub] impact triggered the mass extinction."

Reconstructions of what happened on the day of the impact and over subsequent years provide a glimpse

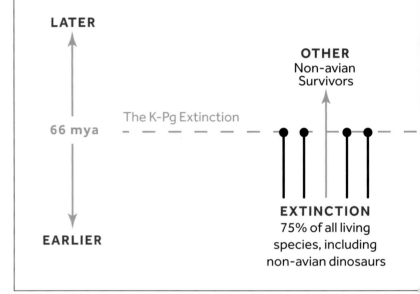

Representative modern-day descendants of the three groups of birds that survived the K-Pg extinction.

Landfowl and waterfowl (Galloanserae): Graylag Goose (*Anser anser*). Iceland. May. IUCN category: Least Concern

Neoaves: Great White Pelican (*Pelecanus onocrotalus*). Tarangire National Park, Tanzania. July. IUCN category: Least Concern

Ratites and tinamous: Little Tinamou (*Crypturellus soui*). Colombia. January. IUCN category: Least Concern

LATER

66 mya — The K-Pg Extinction

EARLIER

OTHER
Non-avian
Survivors

EXTINCTION
75% of all living
species, including
non-avian dinosaurs

into why this event caused such biological devastation. Ecological damage likely occurred in several phases. The immediate consequences of the impact included a megatsunami with a vast reach that may have had mile-high waves close to the impact zone; the injection of massive dust, glass spheres, and aerosols into the atmosphere; and a heat shock wave that traveled for thousands of miles and resulted in wildfires that destroyed both the forest canopy and the understory. Next, the sun was likely obscured by soot from fires and dust from the impact for up to two years. The airborne dust may have persisted for up to 15 years. This caused rapid cooling and prevented photosynthesis, leading to a widespread die-off in plant life. Finally, the oceans rapidly acidified as acid rain fell.

The Avian Survivors

The Chicxulub impact resulted in a selective, rather than total, extinction of life, wiping out about 75 percent of all species that existed at the time, including all non-avian dinosaurs, pterosaurs, ammonites (marine mollusks), some marine bivalves, most marine reptiles, and many species of early birds. Inhabitants of the proverbial ark that carried some species across the divide included alligators and crocodiles, frogs and salamanders, snakes, small lizards and turtles, small mammals, and, of course, early representatives of the three lines of birds: landfowl and waterfowl (Galloanserae), ratites (large flightless birds) and tinamous, and Neoaves, which are the ancestors of all other birds. Researchers also distinguish birds based on the characteristics of the palate: the Paleognaths ("old jaws") have a more primitive structure than the Neognaths ("new jaws"). The latter

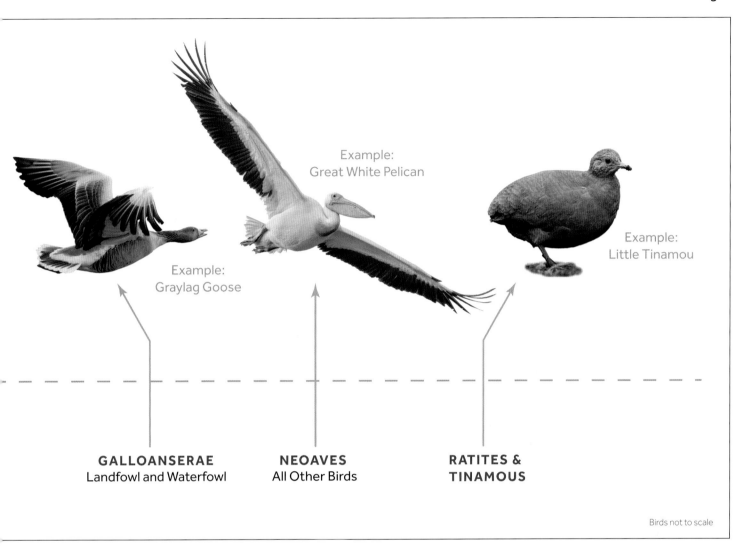

Example:
Great White Pelican

Example:
Graylag Goose

Example:
Little Tinamou

GALLOANSERAE
Landfowl and Waterfowl

NEOAVES
All Other Birds

**RATITES &
TINAMOUS**

Birds not to scale

group contains all living birds except the ratites and tinamous.

In a stroke of geological bad luck, the avian fossil record for the first 10 million years after the extinction is maddeningly sparse. The most definitive method of finding out exactly which birds survived and which did not is therefore unavailable. Informed speculation about the characteristics that would have maximized chances of survival include birds that were of small body size, such that their caloric demands were modest; birds that did not depend on trees for their livelihood, since there was likely a great collapse of forests; species with flexible food needs, particularly seed and insect eaters rather than carnivores, whose food sources had been lost; and birds that could fly, presumably to locate food sources still available in a devastated landscape. There are also indications that relatively large brain size may have played a role in survival. The most diverse and numerous group of pre-extinction birds, the "opposite birds" (Enantiornithes such as *Rapaxavis*), were obviously not matched to these survival criteria, and there is, as yet, no record of their existence after the extinction event.

The Bird Big Bang

Imagine being among a small group of survivors after an apocalypse. Your first instinct would likely be to find a safe place to live that had all the elements you needed for survival: food, water, a favorable climate, and few, if any, predators. That appears to be exactly what the surviving avians did. This process is sometimes called ecological release: the freedom to live a new lifestyle, free from prior environmental constraints. There were likely many new niche environments, and birds dispersed into these locations, undergoing a process known as adaptive radiation, which an authority in the field defines as follows: "Adaptive radiation is the evolution of diversity within a rapidly multiplying lineage. It can cause a single ancestral species to differentiate into an impressively vast array of species inhabiting a variety of environments."[19]

One of the most celebrated examples of adaptive radiation in modern-day birds is the group of 18 species known as Darwin's finches, which are endemic to the Galápagos Islands. Descended from a common ancestor 1–3 million years ago, these birds have speciated and developed unique bill sizes and shapes suited to their preferred food source. I photographed the three birds opposite on Genovesa Island in the northern fringe of the Galápagos Islands. The Large Ground-Finch is the only one of these birds that can eat large seeds, thanks to its enormous beak, which dominates its head. The Small Ground-Finch feeds on seeds appropriate to its bill size, while the Cactus-Finch is a specialist feeder on prickly pear cactus pulp. The speciation of Darwin's finches has been illuminated by the lifetime work of two biologists, Rosemary and Peter Grant.[20] Their work has sometimes been described as documenting "natural selection in real time," as populations of the various finches were shown to wax and wane depending on the availability of their preferred food sources.

This kind of morphological and behavioral adaptation to new environments and new food sources helps us understand the mechanisms that led to the great diversity in avian structure and function that we see today. Waders developed elongated lower limbs and long, curved bills; nectar feeders evolved wings and metabolic profiles that allowed them to hover in front of their preferred flowers; and the wings of soaring birds became large enough to reduce wing loading and allow them to ride thermals. Just like Darwin's Large Ground-Finch, the beaks of parrot ancestors became "nutcrackers," and the emerging passerines developed an operatic repertoire of songs to mark their territories and attract mates. Similarly, some birds that found flight unnecessary for survival lost the ability to fly. It is generally agreed that shortly after the Great Extinction there was an explosion of new configurations and new species in the Neoaves (the new birds), whose lineages lead to almost every one of the present-day bird families. This was nothing less than a veritable avian Big Bang.

Three of the 18 species of Darwin's finches, which exemplify adaptive radiation. The three birds photographed here lived on the same island, and each has a different size and shape of beak adapted to its particular niche food source.

Left: Small Ground-Finch (*Geospiza fuliginosa*)
IUCN category: Least Concern

Bottom left: Genovesa Cactus-Finch (*Geospiza scandens*)
IUCN category: Vulnerable

Bottom right: Large Ground-Finch (*Geospiza propinqua*)
IUCN category: Least Concern

All birds: Genovesa Island, Galápagos Islands, Ecuador. October.

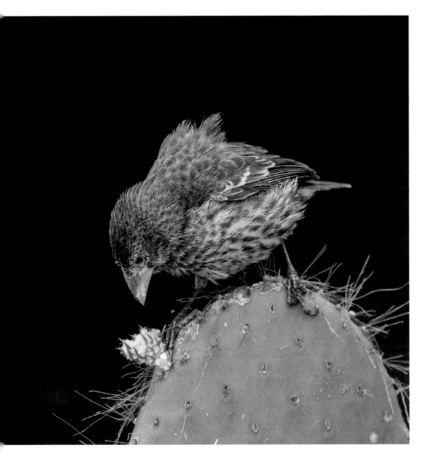

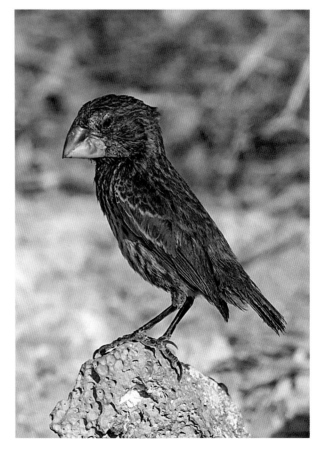

Getting Slimmer and Smarter

One major factor that led to adaptive radiation was an increase in the size of birds' brains in relation to their body size. Daniel Ksepka and a team of 36 colleagues from around the world collected information on brain size and body size in extant birds and early bird fossils.[21] Their results show a pattern of increasing relative brain size in birds after the K-Pg extinction. This was mostly achieved by decreasing body size, but in corvids (known to be among the most intelligent bird groups) both brain and body enlarged, with brain growth outpacing body growth. These researchers believe that having relatively larger brains was a key factor in the rapid expansion of species.

The diversification of bird species started slowly but increased explosively over time. It has been estimated that there were only approximately 100 species of birds 50 million years ago, but this increased to 1,000 species at about 20 million years ago, and then to the current 11,000 in the last great expansion.[22]

Bird Families

Experts still disagree about the relationships between bird families established by phylogenetic analysis. Different approaches result in different birds being grouped together into a clade (the common ancestor and all surviving birds). The diagram opposite is a powerful representation of the avian tree of life — or, more aptly, a "wheel" of life, since the linear tree has been folded into a circular pattern. Time is represented from approximately 90 million years ago, at the center of the wheel, to the present day, on the outer edge.

The three groups of K-Pg extinction survivors we have reviewed are labeled (A) the ratites, (B) landfowl and waterfowl (Galloanserae), and (C) all other birds (the Neoaves), respectively. The last common ancestor of all birds is the star at the very center of the wheel. Four long, straight lines without any branches indicate the ancient roots of the shorebirds, Hoatzin, cranes and rails, and turacos. The multiple branches of land birds reflect the dramatic radiation that occurred in this group. We also find that there are some strange bedfellows: hummingbirds and swifts are closest relatives, and they are related to nocturnal birds (including the nightjars), suggesting that hummers and swifts may have evolved from nocturnal ancestors. Bee-eaters and woodpeckers are related, as are albatrosses and penguins and flamingos and grebes. A robust feature of several different trees of life that have been recently generated are groups of Neoaves known as the "Magnificent Seven," shown by Roman numerals on the diagram.

Only 29 bird silhouettes are shown in this very simplified tree to represent all living birds, but scientists have already calculated and drawn incredibly detailed "super-trees" where the ancestries of thousands of birds are

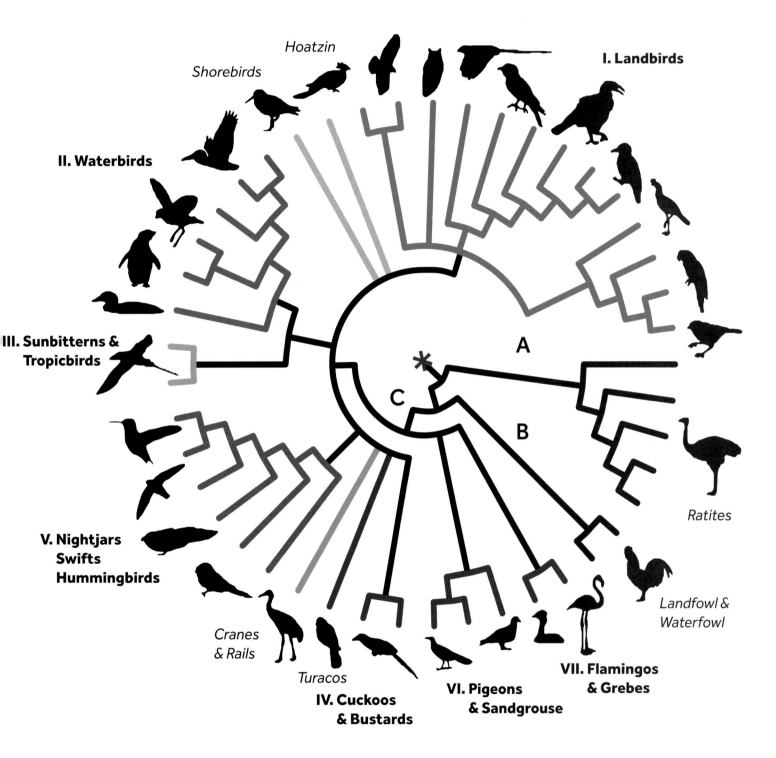

Hoatzin

Shorebirds

I. Landbirds

II. Waterbirds

**III. Sunbitterns &
Tropicbirds**

A

C

B

**V. Nightjars
Swifts
Hummingbirds**

Ratites

*Landfowl &
Waterfowl*

*Cranes
& Rails*

Turacos

**IV. Cuckoos
& Bustards**

**VI. Pigeons
& Sandgrouse**

**VII. Flamingos
& Grebes**

A circular representation of the bird tree of life calculated by phylogenomic analysis of mostly non-coding DNA. The last common ancestor of all birds is shown by the red asterisk. Time is represented radially from approximately 90 million years ago (center) to the present day (periphery). Redrawn from Braun and Kimball.[23]

Distant relatives

The penguins and albatrosses, members of Group II of the Magnificent Seven, share a common ancestor dating to more than 60 million years ago. The common ancestor of Group I, the bee-eaters and woodpeckers, is estimated to have lived approximately 45 million years ago.

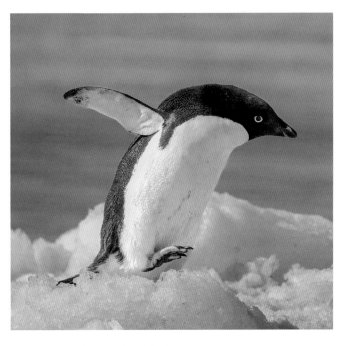

Adelie Penguin (*Pygoscelis adeliae***)**
Antarctica. November. IUCN category: Least Concern

Black-browed Albatrosses (*Thalassarche melanophris***)**
Southern Ocean. October. IUCN category: Least Concern

Little Bee-eater (*Merops pusillus***)**
Arusha National Park, Tanzania. July. IUCN category: Least Concern

Pileated Woodpecker (*Dryocopus pileatus***)**
Lopez Island, Washington, USA. August. IUCN category: Least Concern

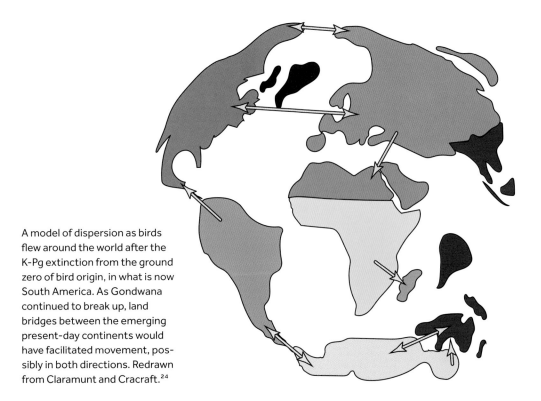

A model of dispersion as birds flew around the world after the K-Pg extinction from the ground zero of bird origin, in what is now South America. As Gondwana continued to break up, land bridges between the emerging present-day continents would have facilitated movement, possibly in both directions. Redrawn from Claramunt and Cracraft.[24]

shown. This is highly complex "big data" science that will likely lead to a tree showing the evolutionary history of every living bird and many extinct ones.

Where Did Modern Birds Originate?

In a study of sweeping reach and complexity using both genetics and fossil analysis, scientists from the American Museum of Natural History have proposed that the location of ground zero, where modern birds originated, was western Gondwana, at a time when the current continents of South America and Antarctica were connected.[24] After the K-Pg extinction, the radiation of birds around the world started, initially eastward by land routes along the Trans-Antarctic corridor to the connected landmasses of eastern Antarctica and future Australasia

before the infamously turbulent Drake Passage formed. Northward radiation to present-day North America may have occurred via an early land bridge. Flight was obviously a permissive factor in dispersion, but the assumption of long overwater flights is not essential to explain dispersal. Some of the persuasive evidence for this theory is the presence of parrots, passerines, and ratites with deep roots in the avian tree of life in both Australasia and the Americas. Similarly, there are nightjars and their allies in South America and related frogmouths and owlet nightjars in Australia. The screamers of South America and their relatives, the magpie geese of Australia, offer further confirmation. New species appeared because of what biologists call "vicariance," the separation of similar populations by some physical barrier such as the emerging oceans. Dispersion is reduced and isolation is increased when habitats are fragmented.

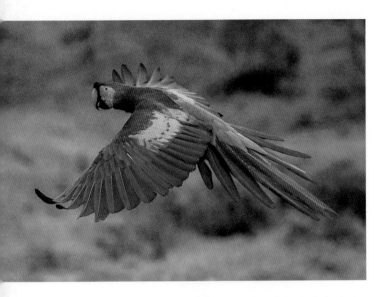

Macaws in the Americas and the 50 species of parrots in Australasia are now separated geographically by 14,000 km (8,700 miles). They probably shared a common ancestor in South America 60 million years ago. This species is the Scarlet Macaw (*Ara macao*). Costa Rica. April. IUCN category: Least Concern

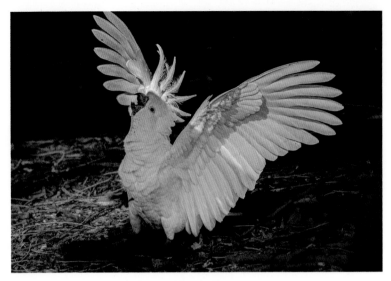

Sulphur-crested Cockatoo (*Cacatua galerita*)
Sydney, Australia. April. IUCN category: Least Concern

Each isolated group then adaptively radiated to maximize survival opportunities in their new environments, just like Darwin's finches in the Galápagos Islands. Climate change may have played a significant role in speciation of birds. Cooling climates are known to drive dispersion and the isolation of populations, which leads to speciation. Another competing hypothesis is that some species adapted to cooler environments and were then able to expand into temperate and cold areas.

North America then became the reservoir for birds that were to populate and diversify in Europe, Africa, and Asia. Land bridges between North America, Greenland, and Europe were probably the principal routes of dispersion, and species later spread to Africa. The dispersion to Asia may have occurred across a Beringian land bridge from North America, a theory supported by the closely related fossils of cranes that have been found on both continents. The presence of fossils of similar mammals in both continents

also supports this theory. As long as these land bridges remained open, avian flow could have occurred in both directions without the need to postulate prolonged overwater flight.

Out of Australia?

The most explosive radiation in the entire avian tree of life is that of the passerines, the perching birds, with more than 6,000 extant species. One group of resarchers has suggested that this clade originated not in South America but in Australasia, almost 20 million years after the K-Pg extinction.[25] Although both possibilities point to a southern origin, a stronger case can be made that songbirds (the oscines) originated in Australia and dispersed by transoceanic flights to the remainder of the world. Given the ever-improving analysis techniques and the uncertainty about landmass connections, we should probably expect all the theories discussed in this chapter to be at least updated, and at the most thoroughly revised, on a regular basis.

FROM THE LAB
Was *Archaeopteryx* capable of flapping flight?

THE QUESTION	Was *Archaeopteryx* capable of flapping flight or was it just a glider?
THE AUTHORS	Dennis Voeten, Jorge Cubo, Emmanuel de Margerie, Martin Röper, Vincent Beyrand, Stanislav Bure, Paul Tafforeau, and Sophie Sanchez from various universities. The experiments were conducted at the European Synchrotron Radiation Facility, Grenoble, France.
THE SOURCE	"Wing Bone Geometry Reveals Active Flight in *Archaeopteryx*," *Nature Communication* 9, no. 1 (2018): 923, DOI: 10.1038/s41467-018-03296-8.
THE HYPOTHESIS	The geometry of the avian wing skeleton is diagnostic of the stress regime during life through the application of beam theory mechanics. The cross-sectional profiles of the wing bones of *Archaeopteryx* may reveal this early bird's pattern of flying.
THE EXPERIMENT	The actual fossilized upper and forearm bones of the 5th, 7th, and 9th *Archaeopteryx* specimens (known as the Eichstätt, Munich, and Bürgermeister-Müller specimens, respectively) were examined using an advanced X-ray technique (PPC-SRµCT). A variety of other fossils from animals with known locomotor patterns were previously scanned for comparison (pterosaurs, dinosaurs, modern-day birds, a crocodile, etc.) Reconstruction was required because several of the bones were crushed.
THE RESULTS	The measurements and comparisons showed that the architecture of *Archaeopteryx*'s wing bones consistently exhibits a combination of cross-sectional geometric properties uniquely shared with flying birds, particularly those that occasionally utilize short-distance flapping.

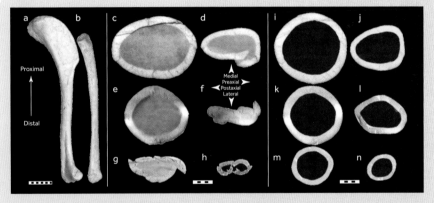

Reconstructed scans of the humerus (a) and ulna (b) and their cross sections from an Archaeopteryx *specimen.*

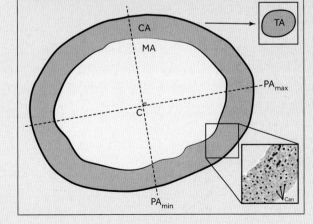

Some of the measurements taken, including the cortical area and length of the mechanical (principal) axes.

Figures redrawn from Voeten et al.

THE CONCLUSIONS	*Archaeopteryx* was capable of flapping flight, probably for short distances, but used a flight stroke that was smaller than that of modern birds.

CHAPTER THREE

> "Come, let's spread our wings and see where they may take us.
> — RICHARD DAWKINS (2021)

Flight Equipment

The Engineering Challenge

IT IS DEFINITELY NOT YOUR TYPICAL ENGINEERING STUDENT design project: The aircraft you are to design and build must weigh no more than three paper clips, it must be about the same length as a small crayon, and it must be capable of crossing the Gulf of Mexico without refueling. For bonus points, the basic design should be scalable by a factor of about 2,000 in mass. These design criteria describe the 3.5-g (⅛-ounce) Ruby-throated Hummingbird (*Archilochus colubris*). The scaled-up version would be the 6,460-g (14-pound) Golden Eagle (*Aquila chrysaetos*). You might meet both in Texas or Mexico during migration season.

Anatomy is the science of body structure, and it is something dear to my own heart, as I spent three years in a (human) anatomy department in the center of London during my graduate studies. In times past (including my own), hands-on cadaver dissection was a rite of passage, but most students today learn their anatomy much more efficiently from an app, usually based on segmented 3-D images from an MRI. In this chapter, I have used images from the Biosphera pigeon anatomy app, which veterinary medicine students use to hone their avian anatomical skills.[1] Of course, the various structures have a unique design in every species of bird, and this is where morphology (the science of size and shape) enters the picture.

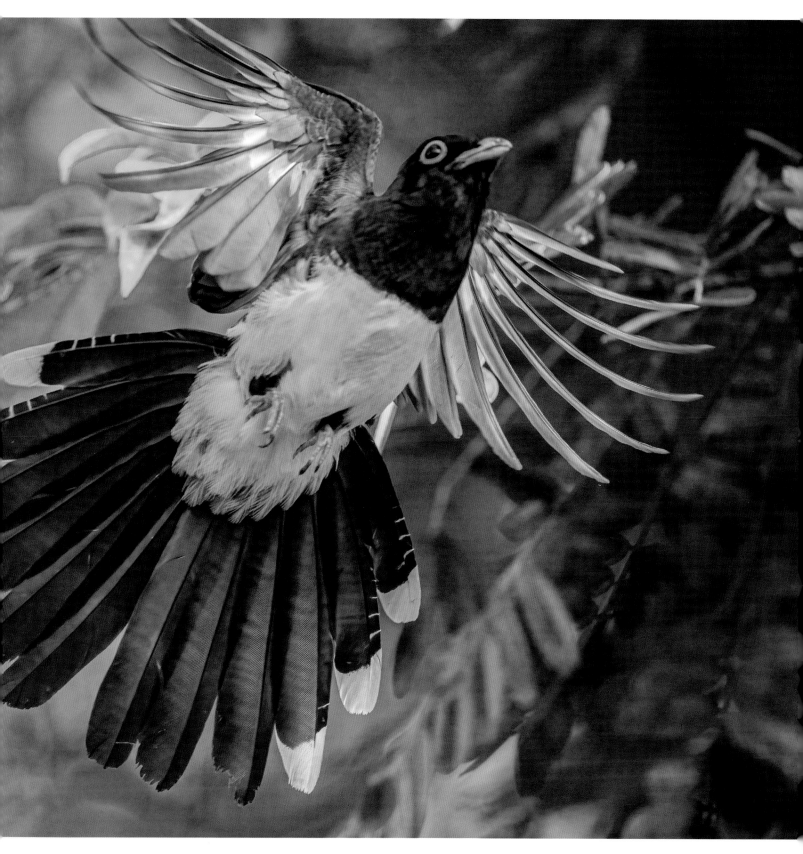

A male Black-headed Trogon (*Trogon melanocephalus*) shows
off the components of his flight equipment.
Sittee River, Belize. December. IUCN category: Least Concern

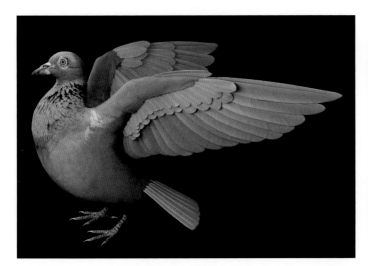 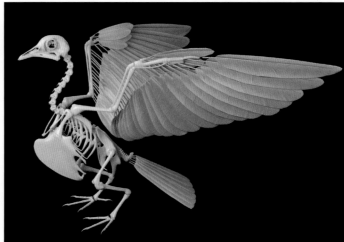

The bones and flight feathers of a Rock Pigeon (*Columba livia*) revealed from a layered MRI scan in the Biosphera 3-D app. Notice how the flight feathers of the wings attach to the bones of the two outer "arm" segments (the forearm and hand), ending at the elbow. The leading edge of the wing's inboard section is formed by soft tissues rather than bone. The very prominent keel of the sternum (breastbone), to which some major flight muscles attach, is also called the carina.

Images courtesy of Biosphera

Bones and Muscles

The musculoskeletal system is always a good starting point when learning how an animal functions. As dinosaurs morphed into birds, a number of distinctly avian skeletal characteristics emerged. The maniraptoran forelimbs, which were well suited for grasping, became wings, which required sturdier attachments to the body and dramatically larger muscles, as the bird's entire body weight needed to be supported. Flight demanded some completely new skeletal designs. Most vertebrate tetrapods have the same basic anatomical template, with the shapes and sizes of the various bones and muscles adapted to the animal's lifestyle. This allows us to make ethnocentric comparisons to structures in our own body.

The Shoulder Girdle

The human shoulder girdle consists of a partial ellipse of bone made up of the clavicles (collarbones), with the top of the sternum (breastbone) acting as a keystone. The hemispherical head of the humerus (the upper arm bone) nests in a cavity on the scapula (the shoulder blade), which floats on the back of the rib cage and is tied down with layers of muscle. There are analogous structures with different forms in the avian skeleton, but there are also several uniquely avian designs. Notably, a bird's sternum has a huge keel, its collarbones are a thin wishbone (the furcula), and a bone not found in humans — the coracoid — forms a robust strut connecting the shoulder and sternum. Although the avian scapula and furcula are part of the

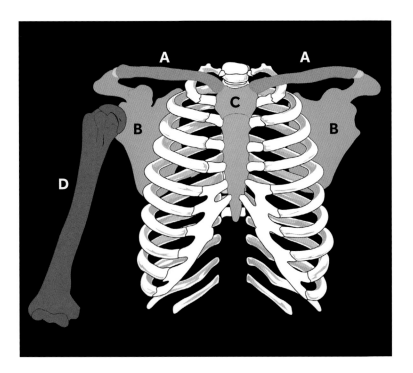

The human shoulder girdle: the clavicles (A), the scapulae (B), and the top of the sternum (C), which acts as a keystone. The head of the humerus (D) nests in a depression in the scapula.

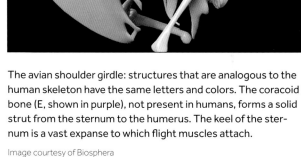

The avian shoulder girdle: structures that are analogous to the human skeleton have the same letters and colors. The coracoid bone (E, shown in purple), not present in humans, forms a solid strut from the sternum to the humerus. The keel of the sternum is a vast expanse to which flight muscles attach.

Image courtesy of Biosphera

shoulder joint, the head of the humerus is primarily supported by the end of the coracoid, which is a solid pillar grounded in the sternum, providing more stability than the human design.

The Furcula

Turkey eaters know that the furcula (or wishbone) is very springy, so it does not come as a surprise that, in life, this bone appears to act as a biological spring. More than 35 years ago, Farish Jenkins and his colleagues collected X-ray movies of European Starlings (*Sturnus vulgaris*) flying in a wind tunnel and measured the furcula's cyclic bowing in synchrony with the birds' wingbeats. They concluded that the furcula acts like a bellows for

an air sac that fills and empties as it is deformed by the flight muscles. The furcula's shape has been shown to vary between species according to the bird's flight style, so there are likely more secrets yet to be learned about the role of this strange, springy structure.

Lessons from Carving a Turkey

The overall bony framework makes a lot of sense when the major muscles that control wing flapping are examined. Anyone who has carved a roasted chicken or turkey knows that there is a huge amount of muscle (meat) attached to the keel of the sternum and that the large surface area of the keel anchors this muscle mass. In a stroke of anatomical genius, the major muscle

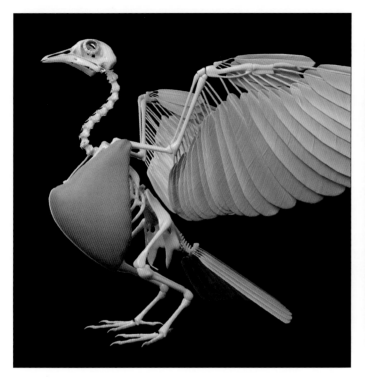

The depressor of the humerus, the multi-component pectoralis major muscle, is the top layer of muscle on each side of the keel.

Image courtesy of Biosphera

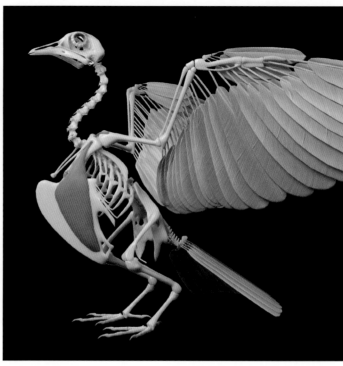

The second layer (under the pectoralis major) is the wings' elevator, the supracoracoideus muscle.

Image courtesy of Biosphera

that elevates the wing (the supracoracoideus) and the one that depresses it (the segmented pectoralis major) both originate from different regions of the sternum. This would be like having our biceps (an elbow flexor) and triceps (an elbow extensor) on the same side of our arm rather than one muscle in front and the other in the back, as is actually the case. The avian arrangement only works because the wing elevator muscle has a long tendon that wraps around an anatomical pulley — called the triosseal (meaning "three bones") canal — above the shoulder.

The major players in flapping flight are the muscles that sweep the wing down (the depressors, notably the pectoralis major). Elevating the wings, ready for the next flapping cycle, is a much easier task, since the force of air on the recovering wing usually assists the upstroke. The wing depressor muscles are many times stronger than the wing elevators, and they occupy most of the real estate on the keel, overlapping with additional attachment to the furcula (wishbone) and the ribs. The pectoralis muscles can make up more than 17 percent of a bird's total body mass, compared to less than 1 percent in humans.[2] This is a dramatic statement of the dominance of equipment used for the downstroke of flapping flight in the design of a bird.

Muscle Action and Structure

The lever arm of the avian pectoralis muscle acts with a huge mechanical disadvantage. Supporting a force of one

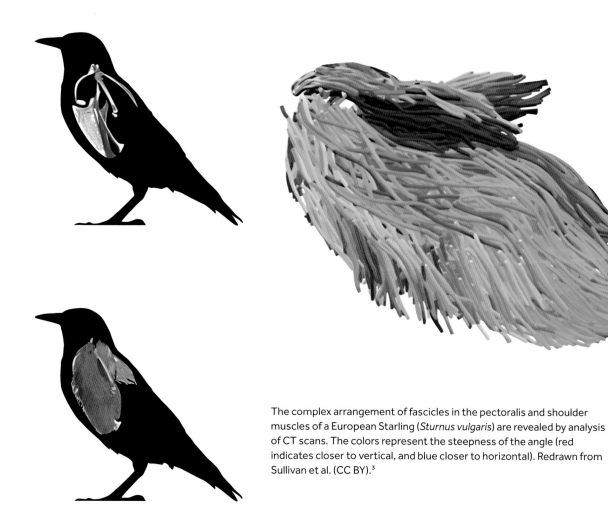

The complex arrangement of fascicles in the pectoralis and shoulder muscles of a European Starling (*Sturnus vulgaris*) are revealed by analysis of CT scans. The colors represent the steepness of the angle (red indicates closer to vertical, and blue closer to horizontal). Redrawn from Sullivan et al. (CC BY).[3]

pound in the hand would require a force of 10 pounds in the pectoralis muscle tendon. If we assume that one side of the pectoralis muscle needs to support half the bird's body weight, the implication is that the muscle force will be five times the bird's body weight. Because a bird wing moves through such a large arc, avian flight muscles have an unusual superpower: They can generate force over almost 40 percent of their length, a much greater operating range than human muscles. The individual units of muscle force are single-cell fibers about 40 mm (1½ inches) long and less than 4 microns ($^{15}/_{10,000}$ inch) in diameter. These fibers are bound together in bundles (called fascicles) that follow a curving path within the body of the muscle. Using advanced imaging and processing techniques on European Starlings (*Sturnus vulgaris*), Samuel Sullivan and his colleagues at the University of Missouri have revealed the complex internal architecture of the pectoralis muscle.[3]

Measuring Electrical Activity

To explore the dynamic actions of flight muscles, Andrew Biewener and his colleagues at Harvard University used a technique called electromyography (EMG)

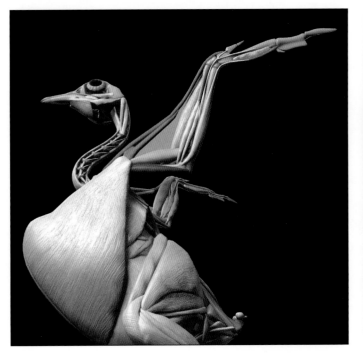

The major muscles that flex and extend the avian elbow: The flexors (gold) and extensors (purple) are analogous to those in our own upper arm. Muscles (in blue) that support the propatagium (in gray) span from the shoulder to the wrist.

Image courtesy of Biosphera

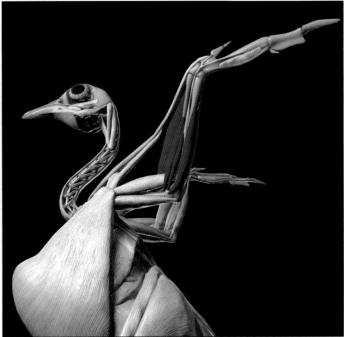

The avian forearm is packed with long, thin muscles that control the wrist and hand. In addition to flexors and extensors, these include the important rotators that pronate and supinate the wrist — analogous to "palm down" and "palm up" in humans — to perform crucial movements of the hand wing during flapping flight.

Image courtesy of Biosphera

to determine when the two major flight muscles turn on and off.[4] They placed fine wires in the muscle and measured the electrical signals that initiate muscle action. They found that when a pigeon wing was almost at the end of the upstroke, the powerful pectoralis muscles responsible for the downstroke were already activated and stayed on for the first half of the downstroke. Similarly, the supracoracoideus turned on before the end of the downstroke. This means the muscle fibers go through a "stretch-shortening" cycle, acting first to slow a movement down and then accelerating it in the opposite direction. This enhances the force that muscles can apply. The apparently uniform muscle bundles are actually a mix of fibers with different force-generating abilities and fatigue resistance (see pages 84–85).

The Avian Elbow and the Propatagium

The avian forearm skeleton is a conventional two-bone segment (ulna and radius bones, as in humans) from the elbow to the wrist that is controlled by short and long elbow flexors (the brachialis and biceps brachii muscles) and an elbow extensor (the short and long heads of the triceps brachii muscle). But as the upper-left illustration shows, there are also elongated muscles and ligaments that span from the shoulder directly to the wrist to support a membrane called the propatagium (meaning "front membrane" — sometimes called just the patagium). These structures form the leading edge of the inner part of the wing.

The propatagium, an elastic

composite membrane, was thought to have acted as a wing root faring in pterosaurs, and it provides the same function in birds. Several layers of elaborate contour feathers overlie the entire shoulder-to-elbow region to provide a clean aerodynamic profile, and some of these originate on the patagium.

The sketch of an owl wing below shows how the contours of the patagium can hide the humerus, making the wing seem as though it has only two major bony segments rather than three. But when you first see an albatross in flight, it looks as though it has an extra inboard segment to its wings compared with large broad-winged birds (see the comparison with a Bald Eagle on page 64). It does not, of course, but the upper arm segment (the humeral segment from shoulder to elbow) between the last secondary feather and the body is so long and so narrow in albatrosses that the elbow is not hidden as it is in the Bald Eagle. (A Snowy Albatross chick in the nest shows this pattern well on page 223.)

When museum specimens are prepared, wings from one side of the bird are usually preserved while the bones from the other wing are cleaned and isolated. In the images on page 64, I have taken advantage of this and overlaid actual wing skeletons on reversed images of the intact wings of a Black-browed Albatross and a Bald Eagle. It is as though we are seeing an X-ray of the wings revealing the major bones. This view emphasizes how the wings are supported by bony structures only in a narrow region along the front (anterior) margin.

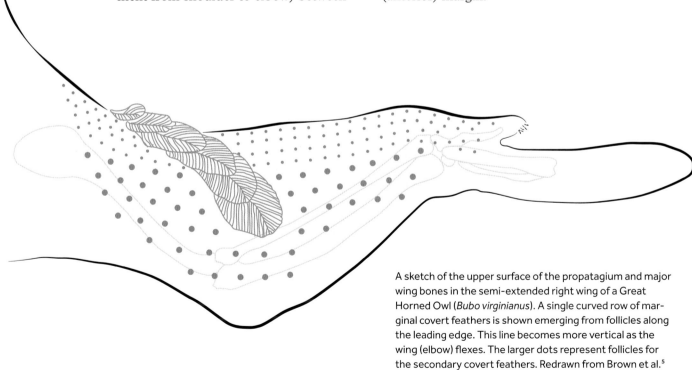

A sketch of the upper surface of the propatagium and major wing bones in the semi-extended right wing of a Great Horned Owl (*Bubo virginianus*). A single curved row of marginal covert feathers is shown emerging from follicles along the leading edge. This line becomes more vertical as the wing (elbow) flexes. The larger dots represent follicles for the secondary covert feathers. Redrawn from Brown et al.[5]

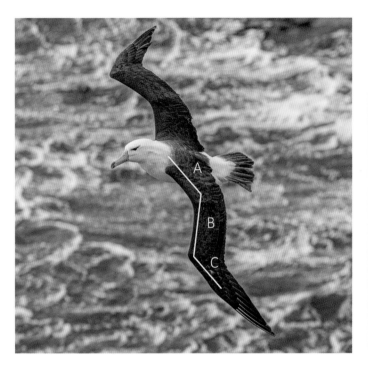

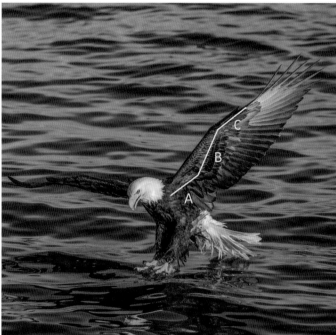

The three bony segments of the wing — shoulder to elbow (A), elbow to wrist (B), and wrist to fingertip (C) — are more obvious in a Black-browed Albatross (left) than in a Bald Eagle (right). The location of the elbow in the eagle is concealed by the patagium.

Black-browed Albatross (*Thalassarche melanophris*)
Saunders Island, Falkland Islands. January. IUCN category: Least Concern

Bald Eagle (*Haliaeetus leucocephalus*)
Sitka, Alaska, USA. March. IUCN category: Least Concern

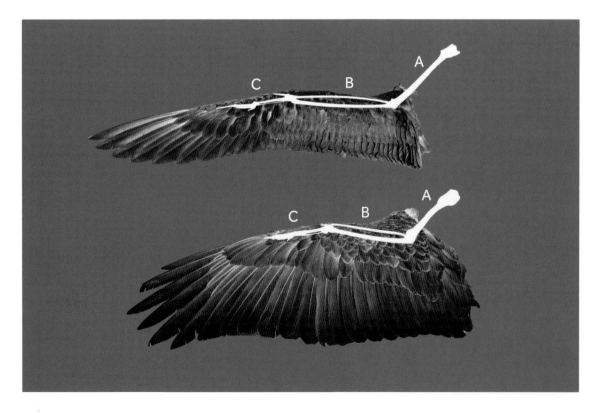

Wing bones super-imposed on the preserved wings of a Black-browed Albatross (above) and a Bald Eagle (below).
A: Upper arm
B: Forearm
C: Hand

Wings from the Burke Museum collection, University of Washington, Seattle

Multi-joint Muscles

There is much more mechanical complexity to the patagial structures than meets the eye. They cross at least three joints (the shoulder, elbow, and wrist) like a long spring, so they cause or resist motion at all these joints in a coordinated manner. Similarly, there are a number of wing muscles that span several joints, and these are particularly useful because, when they are activated, all the joints they cross may either be moved in a coupled, coordinated pattern or be simultaneously stabilized.

Moving the Wrist

The long muscles and tendons that control the wrist and hand (and therefore the hand wing) are packed tightly around the forearm. There are the wrist flexors and extensors and the rotators (pronators and supinators, analogous to palm-down and palm-up movements in humans), which perform crucial movements during flapping flight. The limb muscles are markedly smaller than the chest muscles, reflecting a general design principle in all animals: a rotating mass must be minimized. The mechanics underlying this is Newton's third law, formulated for rotation: the effort (the *moment* in mechanics) required to accelerate a mass in rotation is proportional to the square of its distance from the axis, meaning a mass placed 4 units away from the axis will require a 16 times greater moment than a mass only one unit away. This is why inboard control of the hand wing is required.

Hand Fusion

A bird's breastbone has smooth curves, reminiscent of a Henry Moore sculpture. In sharp contrast, the rough-hewn surfaces, the voids, and the odd spiky protuberances in the skeleton of the bird hand seem like features on a piece that modernist sculptor Alberto Giacometti left unfinished. It may come as a surprise that birds have hands, because they are well concealed under layers of feathers in the outer part of the wing's leading edge.

The evolution of a maniraptoran grasping hand into an avian flying wing remains to be fully charted, partly because of the large diversity of hand structures in fossil maniraptorans.[6] However, this much is agreed upon: The transformation from dinosaur hand to bird hand was driven by the need for a more robust element to which the primary feathers of the wing would be attached and the requirement that aerodynamic forces could be transferred to the arm with minimum muscular effort. This involved a reduction in the number of skeletal elements, and the loss of many of the degrees of freedom that enabled grasping in the maniraptoran hand. This was accomplished by fusing of the bones supporting the second and third digits (the

metacarpals, d1 and d2 in the illustration opposite) into a single bone called the carpometacarpus.

In short, the bird hand became dominated by a relatively large single finger (analogous to the second in the *Deinonychus* hand) while retaining a much-reduced thumb (digit 1), which would become the site of attachment of the alula feathers. The rotations at the wrist (pronation and supination) were preserved, as were small excursions between some of the hand bones. There are also bony "locks" so that some of the aerodynamic forces can be opposed by bone-on-bone forces rather than by muscular effort.[7]

Are Bird Bones Light and Thin?

The bones of flying birds are widely described as "lightweight," an adaption that minimizes the cost of flight. But as biologist Elizabeth Dumont has pointed out, this characterization raises the question "Light compared to what?"[9] Does it imply that bird bones are light compared to those of birds' ancestors? Light compared to similarly sized vertebrate animals? Light compared to flightless birds? Dumont compared passerines, bats, and rodents and found that the distinguishing feature of bird arm bones was their higher density. This apparently paradoxical finding can be explained by the fact that higher density could make the bird arm skeleton stronger and stiffer relative to its body weight.

Birds are also often said to have "thin" bones, implying fragility, which can be misleading. Wing bones need to resist bending, which thin bones of the right configuration can do much better than thick, solid bones. The critical measurement that predicts bending is the second moment of area, or moment of inertia (see opposite page, below). Hollow bones with non-circular cross sections can also provide added strength.

Pneumatic Bones

Some of the long bones and vertebrae in birds are hollow, containing air in their mid-shaft regions rather than the spongy

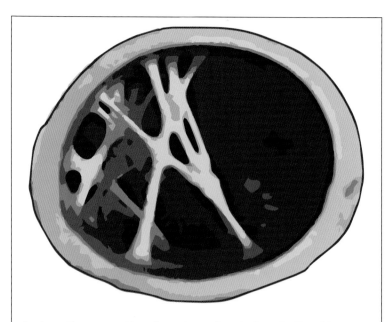

A schematic cross section of an outer region of a Cape Griffon's (*Gyps coprotheres*) upper arm bone. The bone struts are oriented in such a way to strengthen the bone along the lines of repetitive load during flapping flight. Redrawn from Sullivan et al.[15]

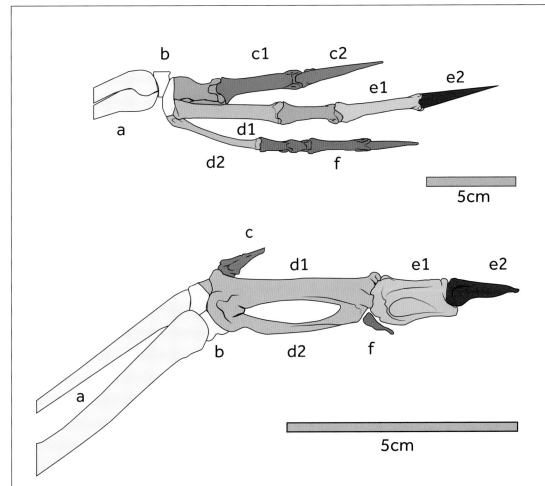

The fossil hand skeleton of the maniraptoran dinosaur *Deinonychus antirrhopus* (above) and the skeleton of a Rock Pigeon (*Columba livia*) (below). The transformation from dinosaur to bird hand involved a reduction of the first digit (c, in blue), a fusion of the second and third metacarpals (d1 and d2, in orange) and some wrist bones into the carpometacarpus, a relative enlargement of the second digit (e1 and e2, in green and magenta), and a reduction of the third digit (f, in purple). The forearm (a, in light gray) and wrist bones (b, in yellow) are similarly placed in both species. The bones shaded dark gray in the *Deinonychus* hand are not represented in the avian hand. Note the difference in scale: The hand of *Deinonychus* is approximately twice as large as a pigeon hand.[8]

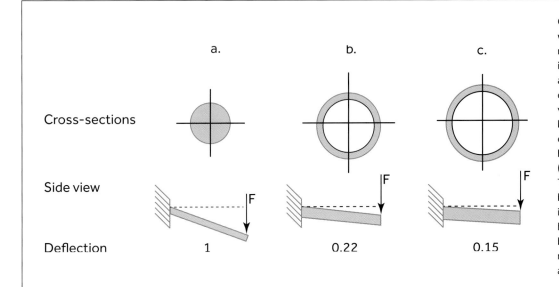

Cross sections of three bones with the same amount of bone mass (shown in gray). Bone (a) is solid, and bones (b) and (c) are hollow with thin walls of different diameters. In the side views, a load is applied to each long bone in a protocol called cantilever bending: one end is held firmly while a vertical load (F) is applied at the other end. The amount of deflection (or bending) in the hollow bones is only 22% and 15% of the bending in the solid bone. Bird bones exploit this property to maximize bending strength for a given bone mass.

marrow that is common in many mammalian bones, including our own. These "pneumatic" bones connect to air sacs in the body and, ultimately, to the lungs. This feature, which also has implications for flight, since it saves weight, appears to be unique to birds among living vertebrates. Small holes (called foramina) found in the fossil bones of pterosaurs suggest the convergent (or parallel) emergence of pneumaticity, reinforcing the commonsense notion that lighter bones are beneficial for flight.

But there is a spoiler: paleontologists from the University of Cambridge studied the fossilized bones of 131 species of non-avian therapod dinosaurs and found pneumatic vertebrae to be a common pattern, appearing independently at least 12 times in these non-flying animals.[10] Pneumaticity appears to save weight, but it was definitely not just an adaption for flight. There are also structural reinforcements in some hollow avian bones (see image on page 66).

Flight Feathers

For the last 50 years, a Peregrine Falcon (*Falco peregrinus*) flight feather has been gathering dust at the eastern edge of Mare Imbrium on the surface of the moon. I am a space enthusiast, and I recall astronaut David Scott's replication of Galileo's (possibly apocryphal) experiment of dropping two spheres of different masses from the Leaning Tower of Pisa. The spheres are reported to have landed on the ground at the same instant, as did the feather and the hammer that Scott dropped — because of the absence of an atmosphere on the moon.

"How about that! Mr. Galileo was correct in his findings," Colonel Scott recited in one of those slightly cringeworthy moments of scripted lunar commentary.[11] But I also know about the falcon feather from reading Thor Hansen's book *Feathers*,[12] in which the story of the lunar feather drop is artfully woven into the fabric of an engaging volume devoted to feathers.

Birds have three main groups of flight feathers in addition to the tail. The primaries, secondaries, and alulae are identified by the anatomical region to which they attach, but they also have distinct functional roles in flight.

The primary feathers (there are usually 10, but sometimes 12) all attach to the hand. I like to think of them as a fan that the bird holds, because these feathers are swept through the air to facilitate flapping flight. Primaries are the largest feathers in the wing and are usually quite asymmetrical, with the leading vane in front of the central shaft, the rachis, becoming narrower than the trailing edge vane toward the wing tip. If the bird straightens (or extends) its wrist, the primary "fan" of feathers arcs outward, tending to separate from the secondaries. The numbering of primaries starts with no. 1 at the primary-secondary junction and continues to primary no. 10 at the wing tip.

Although a pigeon only has 10 secondary feathers, some birds have

The three main groups of flight feathers:

1. The primaries (gray) attach to the hand wing.
2. The secondaries (purple) attach to the arm wing.
3. The alulae (blue) attach to the thumb.

The tertials, or tertiary feathers, which occupy space between the body and the secondaries, are not shown.

Images courtesy of Biosphera

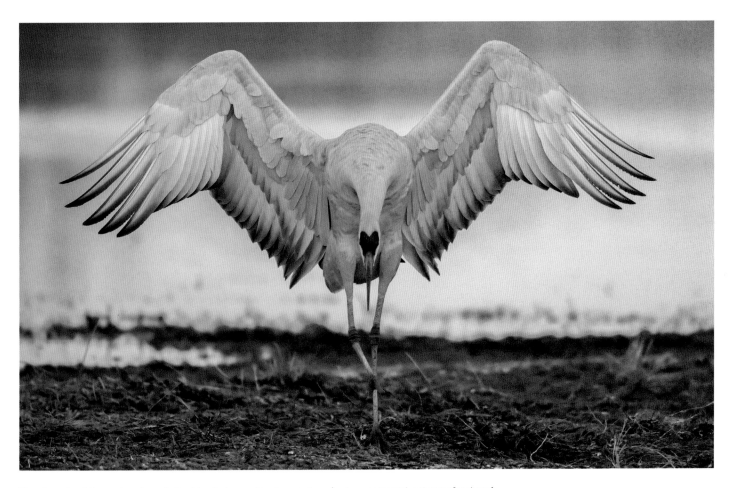

The flexed wrists mark a clear distinction between the hand wings (outer wings with primary feathers) and arm wings (inner wings with secondary and tertial feathers) in a Sandhill Crane (*Antigone canadensis*). The way in which the primary feathers can slide under the secondaries during wing folding is also visible.
Bosque del Apache National Wildlife Refuge, New Mexico, USA. December. IUCN category: Least Concern

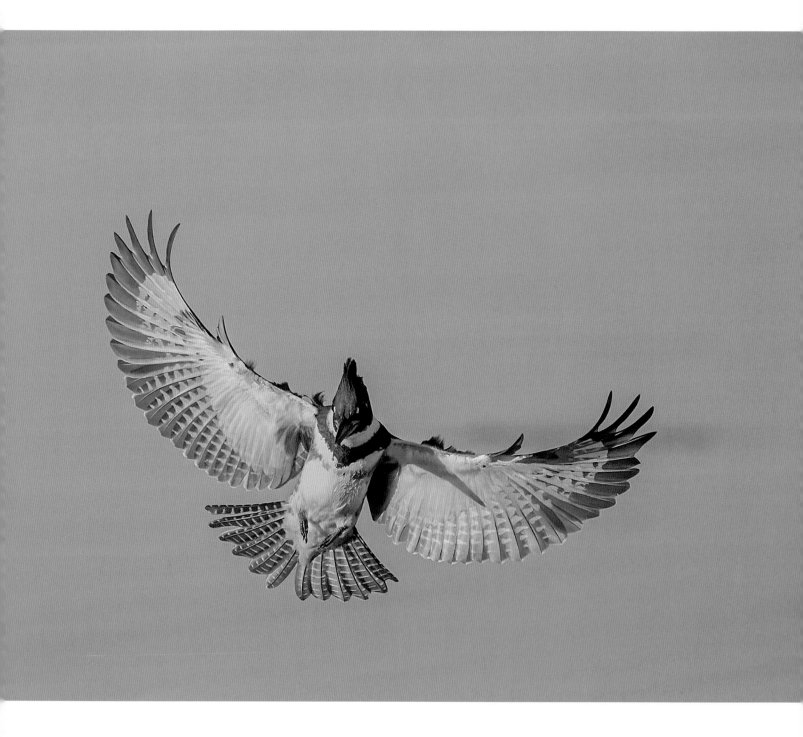

A female Belted Kingfisher showing off her distinctly marked tail and flight feathers. The 10 primaries have solid gray trailing edges, the 10 secondaries are barred with white, and the tertial coverts are flecked with rufous. The deployed alula feathers on both wings allow us to see exactly where the bird's wrist is located on the wing. The tail has 12 feathers.

Lopez Island, Washington, USA. July. IUCN Category: Least Concern

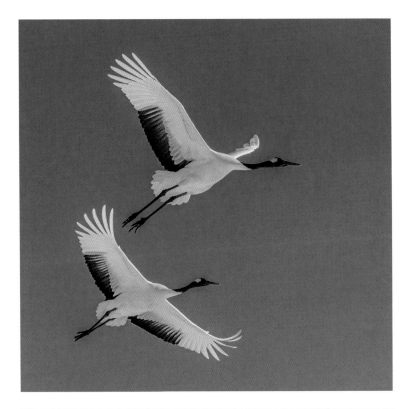

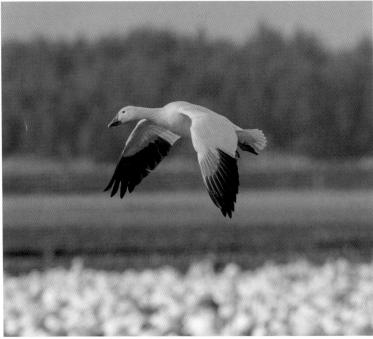

Black secondary feathers in Red-crowned Cranes (*Grus japonensis*), top, and black primaries in a Snow Goose (*Anser caerulescens*), above.

Red-crowned Cranes
Akan Crane Center, Hokkaido, Japan. February. IUCN category: Vulnerable

Snow Goose
Skagit County, Washington, USA. February. IUCN category: Least Concern

many more, because differences in wing length are mostly expressed in the forearm. The Snowy Albatross (*Diomedea exulans*) sports the requisite 10 primaries but has an astonishing 32 secondary feathers on each wing, laid out like a piano keyboard behind its long forearm (see photograph on page 13). The secondaries are numbered from 1 at the primary-secondary junction, increasing toward the body.

Alula feathers in a small cluster — three in the pigeon and usually between two and five in most birds — attach to the thumb and are deployed during slow, high angles of attack flight. The alulae were traditionally believed to act like the leading-edge slats in planes, which are deployed to increase the camber of the wing and increase lift during slow flight. More recently, it has been proposed that they act as leading edge vortex generators to create a novel form of lift.

In many birds, one or more groups of feathers have distinctive colors or patterning. The Belted Kingfisher (*Megaceryle alcyon*) on page 70, coming in to land, provides a good view of all three groups of differently patterned feathers and its 12 barred tail feathers. Red-crowned Cranes (*Grus japonensis*) are the only cranes with black secondaries, while Snow Geese (*Anser caerulescens*) sport black primary feathers. This makes it easy to distinguish between hand and arm feather groups on these birds in flight.

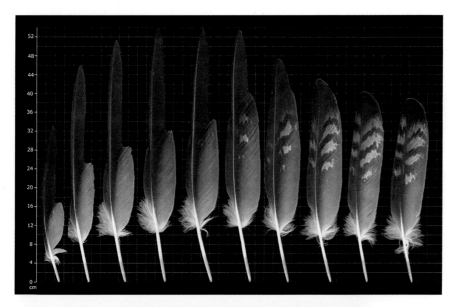

Left: The 10 primary feathers of a Golden Eagle hand wing are arranged from the junction between the primary and secondary feathers toward the tip. Note the notched shape of the 6 terminal primaries, known as the emarginated primaries.

Below left: Eight secondary feathers from a Golden Eagle numbered from the same primary/secondary junction but ascending toward the body.

Below right: When the primaries are aligned on the bird's wing, they result in "fingers" of apparently separated feathers at the wing tip because of the emargination.

Individual feather images are from the U.S. Fish and Wildlife Service Feather Atlas

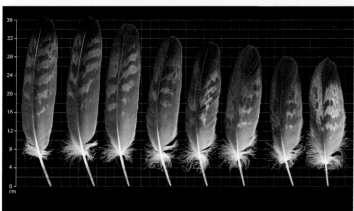

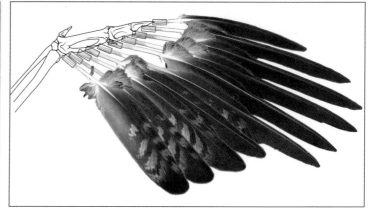

Feather Databases

There are three notable online resources dedicated to the identification and study of birds' flight feathers.[13] The site curated by the U.S. Fish and Wildlife Service (USFWS) features wing-feather photographs from 438 bird species found in North America, while Featherbase features an international cast of 1,717 species. Last, the Puget Sound Museum of Natural History's online collection contains 3,852 wing- and tail-feather images. These are the places to go if you have found a feather and want to determine the species of its former owner. These sites also explain some functional wing features. The 10 primaries and eight secondaries from a Golden Eagle (*Aquila chrysaetos*) shown above were downloaded from the USFWS site. In the diagram at middle right, the primaries are arranged in their approximate in vivo positions in relation to the hand skeleton. In this configuration, the broad parts of the asymmetrical feathers (called emarginated primaries) overlap to give the wing a smooth surface, but the "fingers" of the wing tip are separated. This pattern reduces the induced drag forces on the bird.

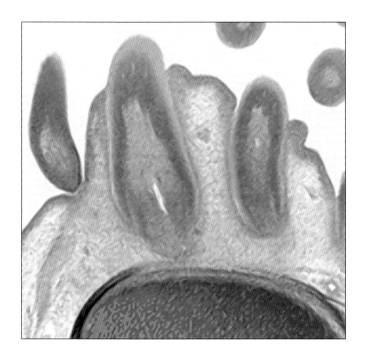

The ulna of a Turkey Vulture (*Cathartes aura*) forearm showing the bony prominences ("quill knobs") where the ligaments to the secondary feathers attach.

Ulna from the Burke Museum collection, University of Washington, Seattle.

A stained cross-section of the wing of a chick embryo showing developing flight feather buds extending through the skin (gray) toward the developing wing bone (blue and pink).[14]

Kondo et al. CC BY 4.0 DEED[14]

Feather Structure

Feathers are appendages that develop from buds on the skin's surface. These buds form connective tissue sheaths or collars that are reservoirs for the machinery needed to generate new feathers over a lifetime of molt cycles. The embryonic flight feather is already the second-generation feather from each bud, after an initial down feather has been formed and pushed out. The buds in the skin dip deeply toward the surface of the bone, and ligaments connect the feathers to their bony anchor sites. Bones remodel in response to frequently applied forces, as can be seen from the "knobs" on the upper surface of the Turkey Vulture ulna at the attachment sites of the secondary feather ligaments in the photograph above and right.

Feathers do not have a blood supply, except when they are growing during development or after a molt (when they are called "blood feathers"). Afterward, all parts of the feather are dead tissue, like people's nails and hair.

When a feather is plucked from a bird's wing, its shape looks very different from our traditional idea of a symmetrical plume. With the naked eye (A in the image on page 74), we can see three different asymmetries: (1) the leading edge (sometimes called the cutting leading edge) has only a narrow vane, while the trailing edge vane on the other side of the shaft (the rachis) is much broader; (2) the trailing edge vane is sculpted with a narrow outer half and a broader base, creating the emarginated feather; and (3) the barbs attached to the shaft lie closer to the rachis on the leading edge than those on the trailing edge (angles of 10 and 30 degrees, respectively).

To visualize the smaller structures, we need magnification. At about x50 (inset B), we see that the space between the barbs is filled with projections like

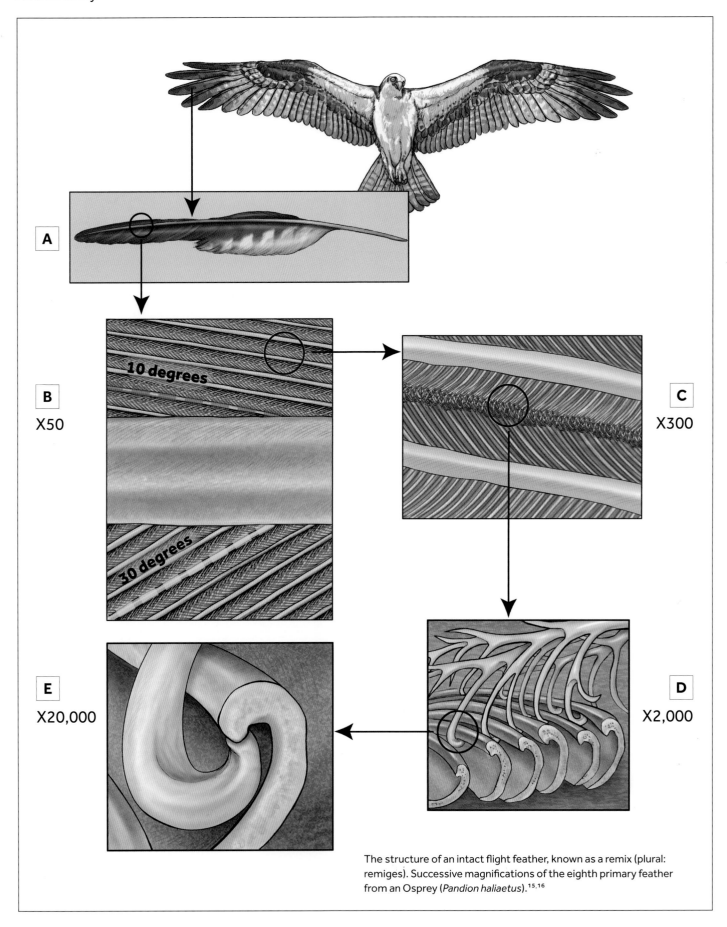

The structure of an intact flight feather, known as a remix (plural: remiges). Successive magnifications of the eighth primary feather from an Osprey (*Pandion haliaetus*).[15,16]

the teeth on a comb (the barbules), which are clearly visible at a magnification of x300 (inset C). The barbules closer to the leading edge of the feather have a more regular appearance, while those projecting from the barb below seem frayed. Bringing on some high-power magnification like a scanning electron microscope, at scales of x2,000 (inset D) and x20,000 (inset E), the barbicels are revealed as a hook on the lower barbule and a groove on the upper, locking together like Velcro to offer a connected sheet that steers the airflow across the feather.

When you pick up a discarded feather, there are often gaps in the middle of the vane, where the barbs have separated. If the feather is not damaged, the gaps can be eliminated by matching the separated edges and pulling along the length of the barbs, effectively zipping the adjacent barbs back together. This is what birds like the Scarlet Macaw (*Ara macao*) do when they preen. Tarah Sullivan and colleagues from the University of California San Diego have made the unexpected discovery that the spacing between barbs on a feather vane varies only modestly with the size of the bird.[15] For example, barb spacing in Andean Condors (*Vultur gryphus*) and Anna's Hummingbirds (*Calypte anna*) vary by only a factor of two even though the wingspans of these birds differ by a factor of 25. This suggests a near optimal design of the barbule interlocking mechanism that cannot be scaled.

A Scarlet Macaw (*Ara macao*) preening one of its long tail feathers. This process can lubricate the feathers, dislodge parasites, and close gaps in the vanes. Pilcopata, Peru. April. IUCN category: Least Concern

Pointed

Intermediate

Rounded

Relative length of the outer primary feathers is an important determinant of wing shape.

Wing Shape

Similarities of shape between different species generally reflect convergence toward a wing that functions well for the same environment and lifestyle. For example, birds with itinerant lifestyles characterized by long foraging flights, such as albatrosses, need long, narrow, and efficient wings with many secondary feathers. Wrens have rounded wings ideal for their lifestyle of flying in close cover. In between these extremes are the large quasi-rectangular wings of thermal-soaring birds like storks; the narrow, pointed wings of godwits, who are the world champion nonstop migrators; the elliptical wings of forest dwellers such as the Brown Tree Creeper; the scimitar-shaped wings of acrobatic birds such as swifts and swallows; and the high-speed wings of falcons. Wing size and shape are also related to the characteristics of a bird's ancestors (its phylogenetic signal). This complicates the search for a direct link between how a bird flies and the shape of its wings.

Some bird wing tips are "pointy" while others are rounded. British zoologist M.V. Hounsome described how pointed wings have long outer primary feathers, while the outermost primary is small or absent in some passerines with round wings.

Three features of wing geometry have received the most attention from ornithologists searching for a structure-function relationship between wings and flight: wing tip shape, surface area, and aspect ratio.

Surface area is important because of its role in wing loading, which is calculated by dividing the bird's weight by its wing area. Wing loading sets specific limits on the flight envelope — how well a bird can glide, soar, and turn.

Aspect ratio is a measure of slenderness — the ratio of wingspan to average wing width, or chord.[17] It is a good marker of wing efficiency because it affects the size of the drag forces that the bird must overcome to fly. It has also been shown to be a predictor of how far non-migratory birds will travel from their birthplace to the location where they breed (called the natal dispersal distance), as well as their foraging mobility. Long-distance flapping migrants have wings that are more pointed than in birds who do not migrate.

The wings of seven birds with different lifestyles (scaled to the same length to emphasize shape). The various feather groups are color coded as follows:

Primaries: Salmon
Secondaries: Butterscotch
Primary coverts: Sand yellow
Secondary coverts: Apple green
Marginal coverts: Cerulean
Scapulars: Blue gray
Alula (where visible): Aqua

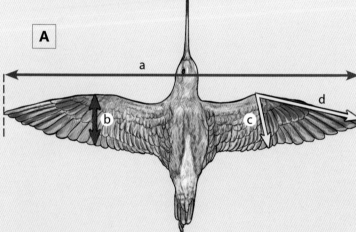

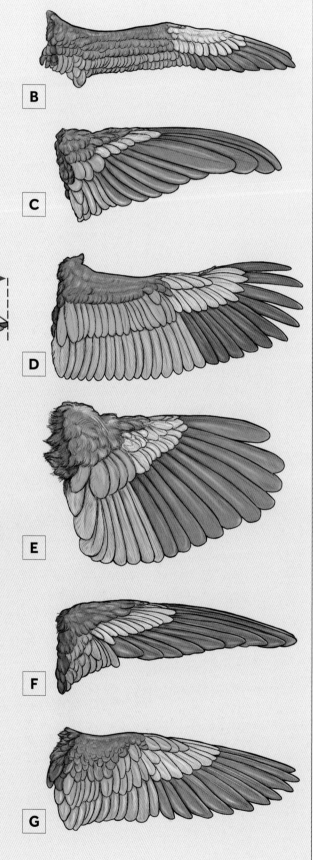

A. Bar-tailed Godwit (*Limosa lapponica*): long-distance flapping migrant (wingspan 75 cm)

B. Black-footed Albatross (*Phoebastria nigripes*): long-distance dynamic and slope-soaring forager (wingspan 213 cm)

C. Ruby-throated Hummingbird (*Archilochus colubris*): Nectarivorous hover feeder (wingspan 10 cm)

D. Wood Stork (*Mycteria americana*): soaring local migrant (wingspan 160 cm)

E. Brown Creeper (*Certhia americana*): short-distance flight, forest dweller (wingspan 18.5 cm)

F. White-collared Swift (*Streptoprocne zonaris*): perpetual flier, aerial insectivore (wingspan 50 cm)

G. Peregrine Falcon (*Falco peregrinus*): high-speed airborne predator (wingspan 100 cm)

The various measures of the wing and wing tip capture the shape and relative size of the hand wing. These distances shown are used by ornithologists to characterize wings numerically.[18]

Wing Folding

Aeronautical engineers have successfully designed wings to match the very basic aspects of avian flight performance, but they have not been able to replicate the intricate fan-like folding of bird wings. The folding process is so smooth and seamless that it can be quite confusing to identify the parts of the wings when looking at a perched bird with its wings tightly folded. Not only are the primary and secondary feathers retracted, but the tertials and coverts are stacked on top.

The sequence of images to the right shows an Osprey (*Pandion haliaetus*) folding its wings after landing. In a series of coordinated actions, the wrist is flexed (A), sweeping the primary feathers backward, folding them (B), and sliding them underneath the secondary feathers (C). The wrist is moved toward the head as the entire wing is lowered from the shoulder (D). The folded primary and secondary feathers are then drawn over the tail feathers.

The feathers that are most visible on the sides of a perching bird are the secondaries, and the rounded prominences near the head (that look like shoulders) are the flexed wrists. In hummingbirds, the situation is simpler because the primary feathers dominate the wings and, by flexing the wrist and lowering the shoulder, the folded primaries either hang down at the side of the bird or are crossed over the tail.

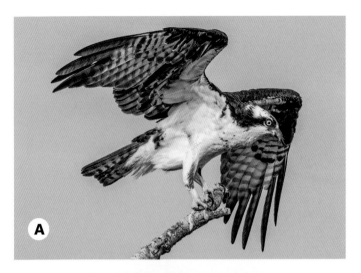

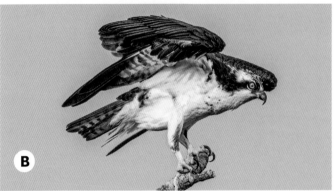

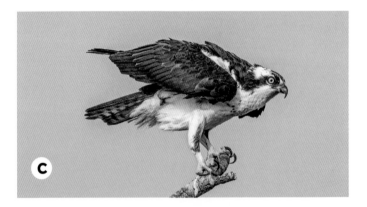

An Osprey (*Pandion haliaetus*) folding its wings after landing.
Lopez Island, Washington. April. IUCN category: Least Concern

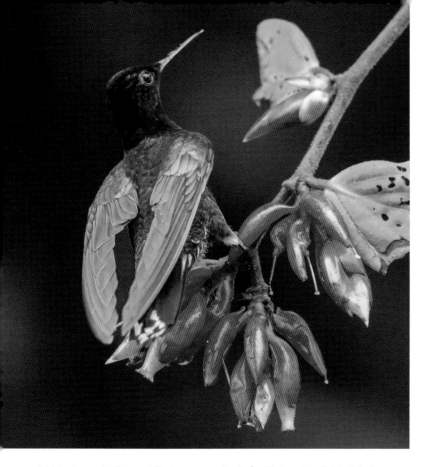

A Velvet-purple Coronet (*Boissonneaua jardini*) with its wings folded during a brief stopover on a flower. Its primary feathers are folded over its tail, but its secondaries are so small they hardly cover any of the primaries.
Las Tangaras, Colombia. January. IUCN category: Least Concern

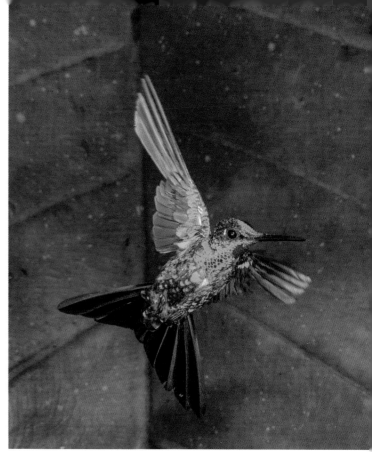

Green-crowned Brilliant (*Heliodoxa jacula*) with only four primary feathers because of molt.
Milpe, Ecuador. November. IUCN category: Least Concern

Flight Feather Molt

Most adult birds replace all their feathers, including flight feathers, every year. Molt is an energy-consuming process requiring an increase of 20 to 40 percent in basal energy expenditure. The timing of molt, which may take several months for complete flight feather replacement, has to be slotted in between energetically demanding flight tasks, such as delivering food to chicks and migration. To avoid a substantial loss of flight ability, flight feathers are usually replaced just a few at a time in an orderly sequence. Feathers are typically shed first at the junction between primary and secondary groups (P1 and S1). Molt usually progresses toward the wing tip in the primaries and toward the body in the secondaries.

However, this is not always the case. The photograph above-right shows a Green-crowned Brilliant (*Heliodoxa jacula*) that has shed six primary feathers on each wing but is still able to fly. Only four old primaries are still intact, while the remainder of the primaries and secondaries are growing. Its wings were moving so fast that I could not see this deficit when taking the image. The bird likely compensated for the loss of lift by decreasing its body mass during molt. Surprisingly, there are birds that shed all their flight feathers at once in a simultaneous molt. These are mostly waterbirds that have another mode of transportation — swimming — while the new feathers regrow.

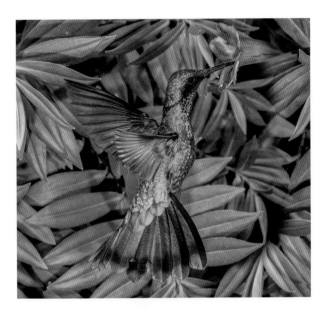

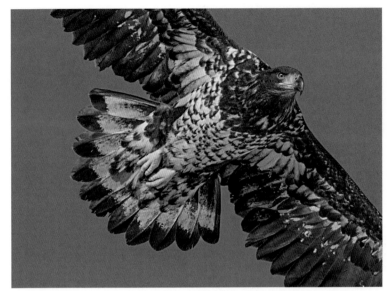

The rectrices of this Mexican Violetear (*Colibri thalassinus*) are overlaid with beautifully tiled tail covert feathers.
Quito, Ecuador. October. IUCN category: Least Concern

The fully spread tail of a subadult White-tailed Eagle (*Haliaeetus albicilla*). Note the asymmetry of the outer rectrices.
Akan Crane Center, Hokkaido, Japan. January. IUCN category: Least Concern

The Tail

The pygostyle, the shortening of the tail and fusion of terminal tail vertebrae, was heralded as a hallmark of early avians, a symbol of their independence from long dinosaurian tails. The tail feathers of *Archaeopteryx* were inserted side-by-side on each of the tail vertebrae, but today's birds typically have 12 tail feathers, known as rectrices, which all insert into the pygostyle. The pygostyle appears slowly during development as a fusion of terminal vertebrae and is not fully complete until the bird has a nearly mature skeleton.

Just like the bones of the avian hand, you can think of the pygostyle and its associated muscles as a hand that holds a fan. The fan of feathers can be spread or closed, elevated or depressed, and rotated left or right. Since the pygostyle is itself a single mass of fused bone, the mobility of the bird's tail comes from movement in the free vertebrae that have not been incorporated into the fused synasacrum or the pygostyle.

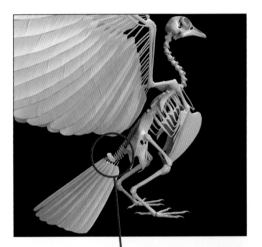

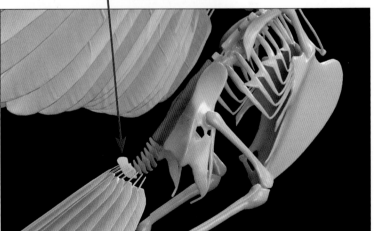

The tail feathers are inserted into the pygostyle (gold). Their mobility comes from the freely moving tail vertebrae (blue), which are sandwiched between the pygostyle and the fused syna- sacrum (purple). The individual feather bulbs are not shown here.

Images courtesy of Biosphera

Both male and female Red-billed Tropicbirds (*Phaethon aethereus*) show elongation of the two central rectrices. Those of the male tend to be slightly longer. Tower Island, Galápagos Islands, Ecuador. October. IUCN category: Least Concern

The two outer rectrices of this Fork-tailed Flycatcher (*Tyrannus savana*) are elongated and edged in white. Belize. December. IUCN category: Least Concern

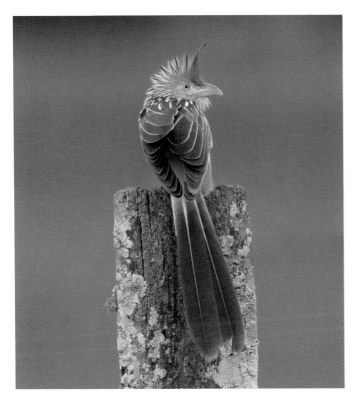

The long central tail feathers of a Guira Cuckoo (*Guira guira*) extend about a body length in both males and females. Pantanal, Brazil. July. IUCN category: Least Concern

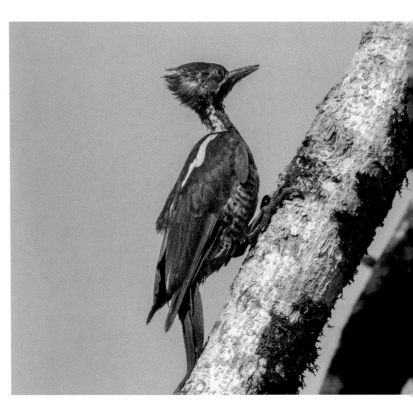

A young Crimson-crested Woodpecker (*Campephilus melanoleucos*) uses its tail feathers as a "third limb" to push its body away from a tree. Oso Peninsula, Costa Rica. May. IUCN category: Least Concern

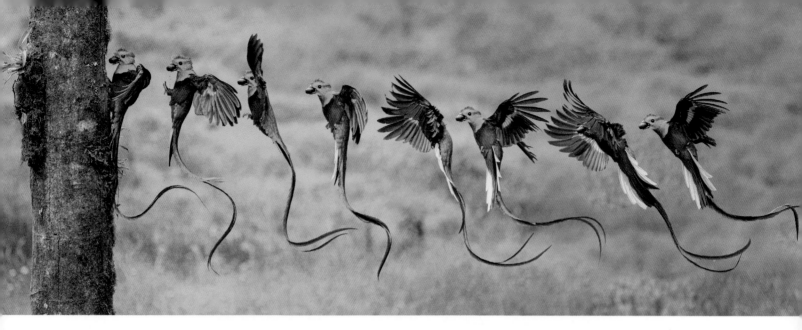

A multiple exposure composite of a male Resplendent Quetzal (*Pharomachrus mocinno*) provisioning his nest with a small avocado. The long tail streamers are actually tail covert feathers. The true rectrices are the black and white tail feathers that can be seen in the three images on the right. This feature is not present in the female. San Gerardo de Dota, Costa Rica. May. IUCN category: Near Threatened

Tails as Signals

Some male birds use their tails to send signals to prospective mates about their potential reproductive fitness. There are few species where this is as pronounced and magnificent as the Resplendent Quetzal (*Pharomachrus mocinno*). The male quetzal's tail streamers can extend more than 2 m (6½ feet) beyond its body. These streamers are not true tail feathers (rectrices) but are actually tail coverts.

Putting the Parts Together

The permutations of design among the 11,000 species of living birds are truly dazzling. A few of the designs make obvious sense: Swallows and swifts spend most of their lives hawking insects in the air, so their wings are designed for maneuverability; their legs are rudimentary. Ostriches and rheas have lost the ability to fly, but their lower limbs can transport them at breakneck speeds across open plains.

Stephen Gatesy and Kenneth Dial have suggested that the evolution of the locomotor structures in different birds can be considered as the variable expression of the main locomotor modules: the wings, tail, and legs.[19]

Imagine that the design of a particular bird's locomotor system could be controlled by a set of three sliders, one each for the wings, tail, and legs. In the ostrich, the leg slider would need to be 100 percent on and the wing slider 100 percent off. The Black-browed Albatross design would require its wing slider at 75 percent, whereas the tail slider would be set below 20 percent since it is not used during soaring. The wing slider in a Barn Swallow would be closer to 95 percent. The majestic Martial Eagle uses its tail to help lift its heavy body, so its tail slider might be set at 50 percent. For birds with less specialized lifestyles and habitats, the three sliders may all be somewhere in the mid-range. While this is obviously not the way evolution works, it is a useful and insightful framework.

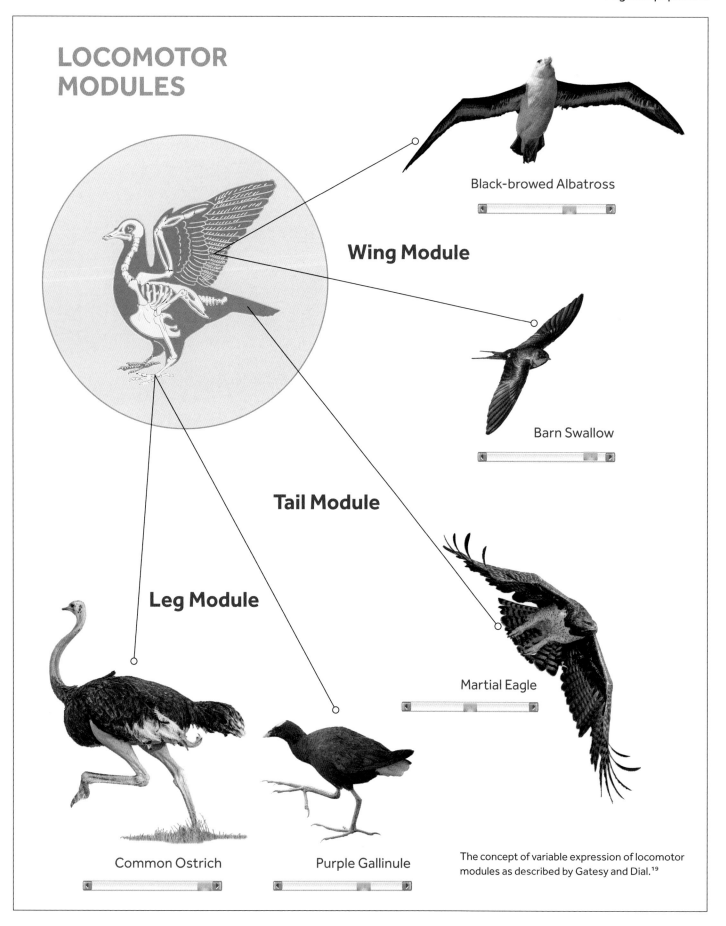

LOCOMOTOR MODULES

Wing Module

Tail Module

Leg Module

Black-browed Albatross

Barn Swallow

Martial Eagle

Common Ostrich

Purple Gallinule

The concept of variable expression of locomotor modules as described by Gatesy and Dial.[19]

Avian Flight Physiology

Most human athletes have the luxury of specializing in their events: a 100 m dash champion would fail dismally in a marathon (and vice versa). Likewise, there are specialist birds: Tinamous make short-burst flights only in emergencies, while hummingbirds spend their lives hovering in front of food sources. But many birds must do it all: They need rapid flight to escape predators, long-distance flight for migration, and a burst of power for takeoff.

These lifestyle differences are facilitated by differences in the cells of flight muscles, primarily variations in the speed of contraction and resistance to fatigue. Physiologists can identify a spectrum of muscle cells based on histological and molecular techniques, and these different fibers are arranged in a mosaic in the muscle. There are several naming systems in use, but the one that I like emphasizes just three types (outlined in the upper image opposite) and provides information about the speed of contraction and the primary energy source.

The speed label is like the zero-to-60 criterion for a car: The speed at which the muscle can develop peak force once electrical activation arrives. The energy source is important because it not only identifies the metabolic pathway, it also indicates how quickly fatigue will set in. Oxidative muscle requires a supply of oxygen to maintain force development, and if that supply continues, it will resist fatigue. Glycolytic muscle relies on internal energy sources that can be rapidly exhausted, so fatigue is always imminent. This is the difference between aerobic and anerobic metabolism. Most avian muscles are a mix of different fiber types, but there are exceptions.

Different Muscles for Flapping and Soaring

It will come as no surprise that hummingbird flight muscles are almost 100 percent fast oxidative. In hummingbirds, special systems have evolved to speed up oxygen delivery to the muscle tissues. In contrast, American White Pelicans (*Pelecanus erythrorhynchos*), which both flap and soar, have two components to their pectoralis muscle, one with slow oxidative muscle and the other with fast oxidative muscle.[20] They likely recruit the fast muscle fibers for flapping and the slow muscle fibers for soaring. The white breast meat in chickens (and tinamous) is composed of fast glycolytic muscle to power rapid takeoffs (since these birds do not practice sustained flight).

Breathing Without Lung Inflation

The need to supply large amounts of oxygen to fuel a bird's oxidative flight muscles has led to the evolution of a system for breathing that has been described as "the most complex and functionally the most efficient gas exchanger" in the entire animal kingdom. It is a completely different system from that found in mammals, and it operates without the "inflatable" lungs

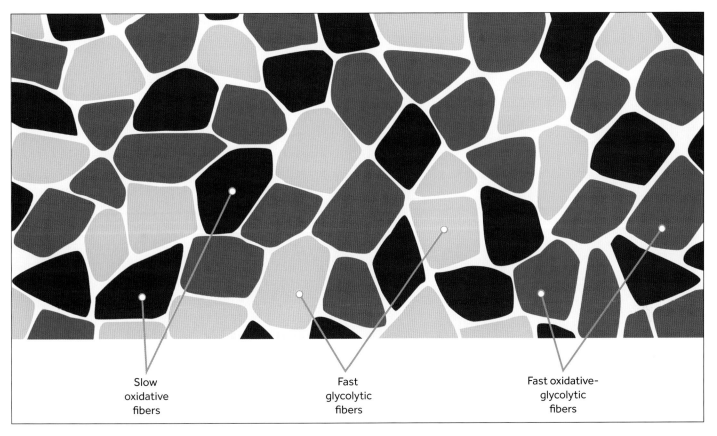

Slow
oxidative
fibers

Fast
glycolytic
fibers

Fast oxidative-
glycolytic
fibers

A cross section of a muscle
showing three different
types of muscle fibers.

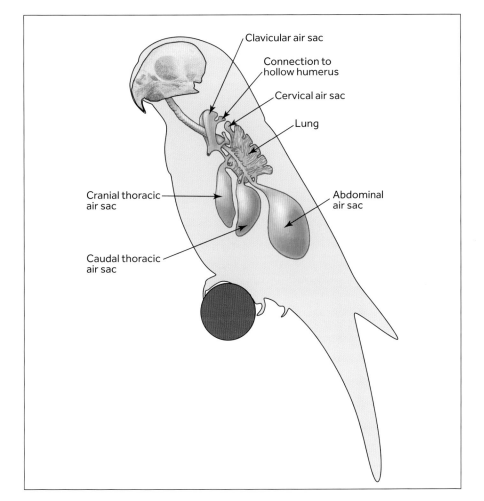

Clavicular air sac

Connection to
hollow humerus

Cervical air sac

Lung

Cranial thoracic
air sac

Abdominal
air sac

Caudal thoracic
air sac

The respiratory system of a Budgerigar
(*Melopsittacus undulatus*), showing the air
sacs and their connection to the lungs and
bones on the left side of the bird. Redrawn
from Evans.[21]

that we associate with breathing. One of its most remarkable components is a network of nine air sacs that control airflow and "pneumatic" bones.

English surgeon John Hunter conducted a gruesome but revelatory experiment on a chicken in 1774. In his own telling, "I cut the wing through the os humeri [...] and tying up the trachea [...] found that the air passed to and from the lungs by the canal in this bone."

By preventing the flow of air through the mouth and opening a portal in the upper arm bone, Hunter proved the long-suspected existence of a pathway for air from the bones and other structures to the lungs. These air cavities are not involved in the transfer of oxygen into, or carbon dioxide from, the blood, but air is forced through them during inspiration and expiration, since birds have no diaphragm. The rhythmic contraction of flight muscles during flapping, which compresses the chest, also plays a role in airflow. The unique hallmark of avian respiration is that fresh oxygenated air is delivered to the lungs during both inhalation and exhalation, thanks to the storage capacity and pneumatic action of the air sacs.

FROM THE LAB

How are flight feathers controlled?

THE QUESTION	What is the anatomical basis of wing shape coordination in Rock Pigeons?
THE AUTHORS	Tobin L. Hieronymus
THE SOURCE	"Flight Feather Attachment in Rock Pigeons (*Columba livia*): Covert Feathers and Smooth Muscle Coordinate a Morphing Wing," *Journal of Anatomy* 229 (2016): 631–656, PMID: 27320170, DOI: 10.1111/joa.12511.
THE HYPOTHESIS	There are interconnections between musculoskeletal elements and flight feathers.
THE EXPERIMENT	Pigeon specimens were examined using three techniques: a standard anatomical dissection, microcomputed tomography (microCT), and 1-mm sectioning and staining of tissues using standard techniques of histochemistry.
THE RESULTS	**Below left:** The web of connections between the shaft of the third secondary feather (orange), the major dorsal covert feather (yellow), and the adjacent small dorsal covert feathers (marginal in blue, upper in green). Skeletal (voluntary) muscle is indicated in red, smooth (involuntary) muscles are pink, and connective tissue is purple-gray. **Below right:** Detail of the attachment of the third secondary feather and its associated structures to the bone. Anatomical context for the feather is shown inset.

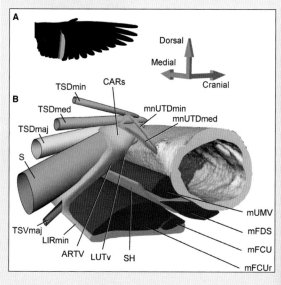

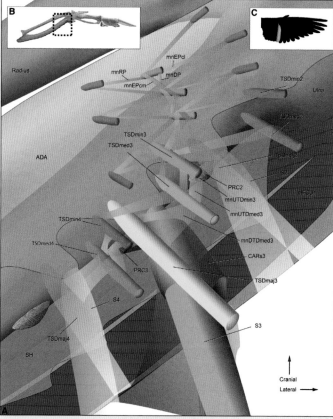

Figures used with permission

THE CONCLUSIONS	This study revealed a network of smooth (involuntary) muscle that provides background (tonic) stiffness to the feather shafts, which affects wing shape. The timing and duration of activity in these muscles remain to be determined.

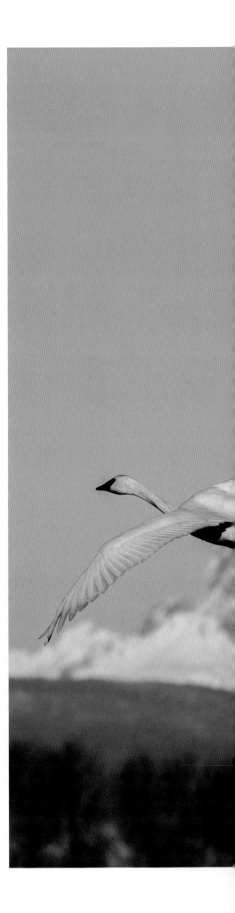

CHAPTER **FOUR**

> "Aerodynamics is not some black art revealed only to a chosen few by some great god of flight. It can be understood by almost anyone, if properly explained.
>
> — H.C. SKIP SMITH (1991)

The Aerodynamics of Bird Flight

Taking Air for Granted

T'S VERY EASY TO TAKE AIR FOR GRANTED, SINCE IT DOESN'T register with our most important sensory modalities. We can't see it, we can't smell it, and unless we are leaning into a strong wind, we can't feel it. The notion that we could use air for support when falling seems at first ludicrous, but that is exactly what birds and airplanes do: They use the forces generated by moving air to provide support against gravity, which is relentlessly pulling them to the ground. My own sense of wonder at the forcing function of air is rekindled every time I see a 10-kg (22-pound) Trumpeter Swan (*Cygnus buccinator*) in cruise flight and, even more so, at "wheels up," when a 181,440-kg (400,000-pound) fully loaded Boeing 767 takes off.

It is worth stating some differences between bird and airplane wings. Birds use their wings to generate both lift to resist the pull of gravity and thrust for forward propulsion. The wings of fixed-wing aircraft only generate lift. An engine (driving a propeller or jet) is needed to produce thrust. Because of their differences in size and speed, birds and aircraft also fly under different regimes (known as low and high Reynolds numbers,

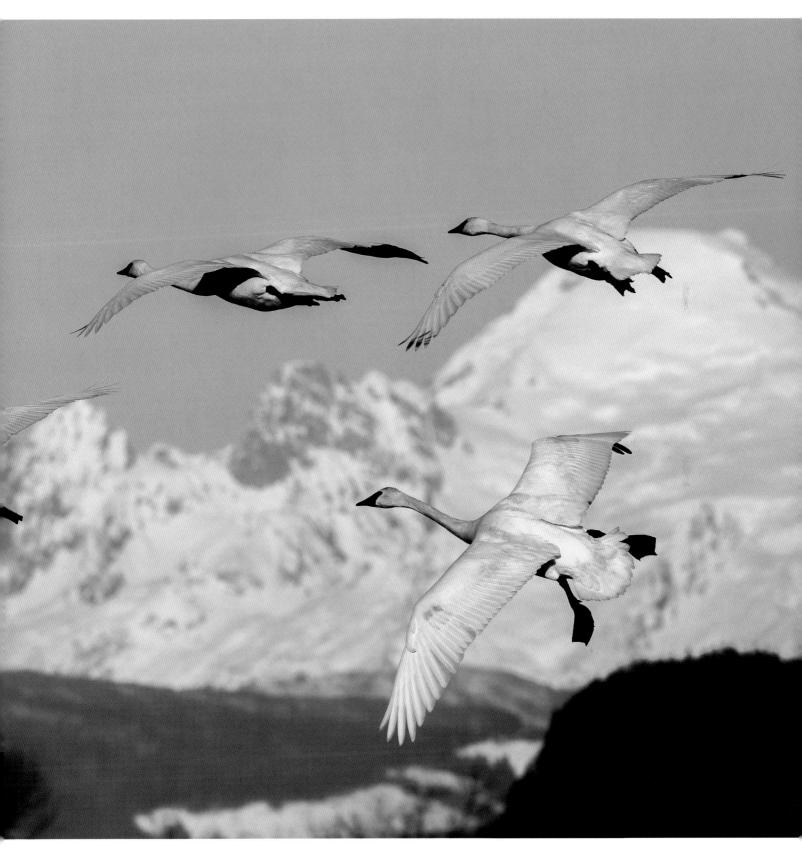

Invisible lift forces of about 10 kg (22 pounds) generated by their wings sustain the approach-to-landing glide of these Trumpeter Swans (*Cygnus buccinator*) pictured against Mount Baker, Washington, USA. February. IUCN category: Least Concern

An invisible lift force generated by moving airflow across the wings of this fully loaded Boeing 767 raises it gently into the air.

Shutterstock / KITTIKUN YOKSAP

A retouched version of a broken glass negative captioned by the Library of Congress: "[1901] Side view of Wilbur Wright piloting a glider in level flight almost overhead, moving to left, showing bottom wing and elevator."

respectively[1]), and so what works for a bird does not necessarily work for an airplane. This is one reason why the airfoils of modern-day aircraft do not look like those of bird wings.

Learning about Lift Forces from the Wright Brothers

Aerodynamics is a science that explores forces created by moving air. It came of age only at the turn of the 20th century, and it now has a broad reach, extending from supersonic flight to the speed enhancements of Formula 1 racing cars.[2] Orville and Wilbur Wright were on the cusp of this rising science, and their laboratory experiments, driven by failure in flight tests, were critical to their eventual success. Their 1901 summer season with a second-generation glider at Kitty Hawk, North Carolina, was disappointing. The craft was a 6.7-m (22-foot) wingspan biplane glider with

an elevator in front, known as a canard design, that could be either flown as a kite or piloted. The maximum gliding distance flown that season was about 90 m (300 feet), much less than they had hoped for or predicted. The problem seemed to be that the glider's wings were generating only one-third of the lift force they expected, based on calculations regarding wing performance that they had inherited from their European predecessors.

The Wright brothers then decided to throw out the book of then-current aerodynamic knowledge and start from scratch based on their own experiments. In the fall of 1901, they designed and constructed several pieces of equipment to measure the effect of an airflow across small models of a wing. Their crowning achievement of this intense period of creativity was a wind tunnel that generated controlled airflows of up to 13.4 m/s (30 miles per hour) and balances to directly measure the forces generated by wing sections

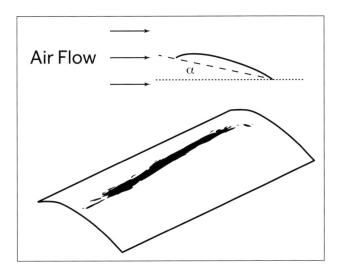

Left: The Wrights' no. 12 airfoil as it was tested in their wind tunnel. The angle of the airfoil's wing chord (dashed line) in relation to the direction of the airflow (dotted line) is known as the angle of attack (α). The Wrights systematically varied the airfoils, and they measured the lifting force of the wing and resulting drag at each angle.

Below: Actual data points for the lift coefficient of no. 12 airfoil in the wind tunnel, taken from the Wright brothers' notebooks. Each blue dot shows the results of a single experiment. The horizontal axis shows the angle of the wing with respect to oncoming air (the angle of attack), and the vertical axis is the lift (expressed as a coefficient that allows for comparison with other shapes). Lift increased with angle of attack until about 15 degrees, where stall began (indicated by the red arrow).

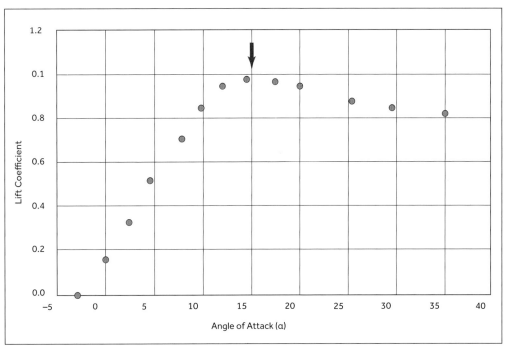

held at different orientations in the airflow.[3]

Wind tunnels take advantage of relative speed of airflow when measuring wing forces. The results are the same if the wing is moving in still air or if air of a similar speed is flowing across a stationary wing.[4] In a frenzy of experimentation, the Wrights tested more than 200 potential wing shapes, which they fabricated by hand from sheet metal.[5]

The Wrights' no. 12 airfoil is probably the most consequential strip of metal that the aeronautical world has ever known. It was approximately 2.5 cm (1 inch) wide, 15.2 cm (6 inches) long, and hammered into a cambered shape in which the front edge (the leading edge) rose more rapidly than the back, giving it a snub nose. The angle of attack is the angle between the line joining the leading and trailing edges and the airflow.

You will note from the graph on page 91 that when this shape was held pointing slightly downward (at a minus-3-degree angle of attack), it generated no lift at all. As it was steadily inclined with respect to the flow, the amount of lift generated rose smoothly to a maximum at an angle of attack of approximately 15 degrees. This is known as the "critical angle of attack" because, as the graph shows, further increases in the angle result in reduced lift and a possible stall. It was the combination of high lift and low drag that made no. 12 airfoil the best.

At the end of 1901, the Wright brothers could see a golden door opening in front of them that would lead, only two years later, to successful powered flight. Their experiments had allowed them to look critically at the data that had been passed down and discover that some key aspects of that data were incorrect. Most of all, they could now actually quantify that elusive quantity — lift — that birds had learned to exploit more than 140 million years earlier.

Bird-Shaped Wings

Like most of the other shapes that the Wright brothers considered, no. 12 airfoil looks very different from the wings of a modern-day airplane. It does, however, look remarkably like the cross sections of some bird wings, and this is not a coincidence. The assumption, here in Wilbur Wright's own words, was that they "could not understand that

The Wright brothers' no. 12 airfoil was just a thin strip of metal with a slight "snub nose," known as camber.

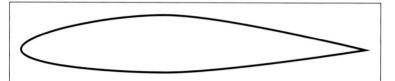

A Piker Cherokee wing that has kept me in the air for many hundreds of hours. It is officially known as a NACA 65(2)-415 airfoil.

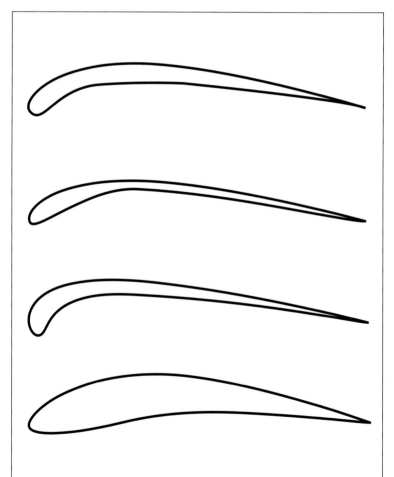

A selection of bird airfoils (top to bottom): eagle, stork, hawk, and albatross. Redrawn from White.[6]

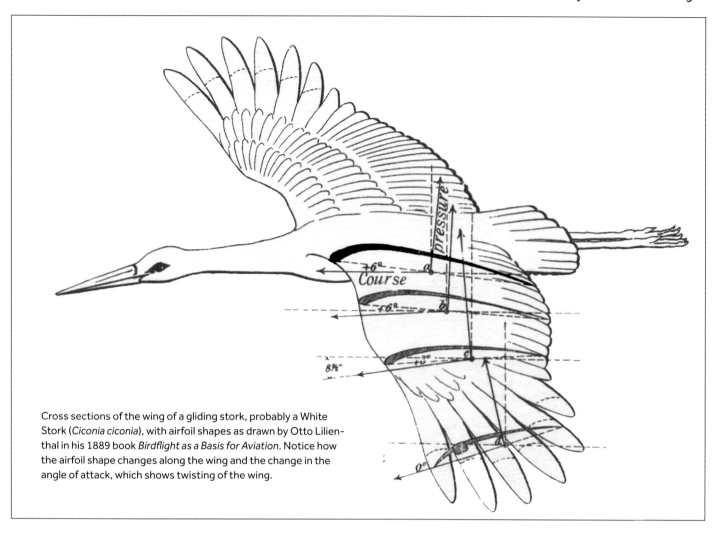

Cross sections of the wing of a gliding stork, probably a White Stork (*Ciconia ciconia*), with airfoil shapes as drawn by Otto Lilienthal in his 1889 book *Birdflight as a Basis for Aviation*. Notice how the airfoil shape changes along the wing and the change in the angle of attack, which shows twisting of the wing.

there was anything about a bird that would enable it to fly that could not be built on a larger scale and used by man. At this time our thought pertained more to gliding flight and soaring. If the bird's wings would sustain it in the air without the use of any muscular effort, we did not see why man could not be sustained by the same means."

We now know that to conduct an accurate simulation in a wind tunnel, the speed of the air flowing in it must be adjusted to account for the differing conditions and size of the model versus the actual flight test. The Wrights were unaware of this but were still able to derive meaningful results, despite not

correctly matching their flight and wind tunnel conditions.[7] However, it was not long after the first powered flight that wing shape became less "bird-like" in the (successful) search for improvements in "efficiency" of the wing in faster airplanes.

How Do Wings Generate Lift?

Aerodynamicists love to run computer simulations. Some of the core equations in the field cannot be solved with a pencil and paper (analytically), but with suitable assumptions, numerical approximation, and iterative

approaches, large-scale flow prob-
lems that are the bread and butter of
modern wing design can be solved with
adequate computing power. This field
is called computational fluid dynamics
(CFD), and we are about to benefit
from the results of one such simulation.

Former Boeing Technical Fellow
Doug McLean sought to dispel some
of the many myths behind the genera-
tion of lift.[8] He ran a two-dimensional
CFD simulation of flow past a station-
ary wing section used in sport planes
(known as a NACA 4412). The wing
was fixed at a 5-degree angle of attack
to the simulated airflow. Using a cross
section and considering the flow to be
two dimensional is a common approach
when analyzing wings. This method
carries with it the implied assumptions
that the wing is infinitely long and that
the airflow is the same everywhere
along the wing. Once drag is consid-
ered, however, these assumptions must
be abandoned because of the important
flow conditions at the wing tips.

What is so magic about CFD is that
it allows us to visualize the invisible.
Take, for example, the flow diagram
above right, showing what are called
streamlines.

Based on this flow pattern, the
pressure at each point on the field can
be estimated in the simulation on page
95. The beautiful simplicity of the
streamlines belies a much more complex
pressure pattern. The pressure is shown
relative to a distant reference point that
is not disturbed by the wing — a zero
value means that pressure is the same as
at the reference point. In general, there is

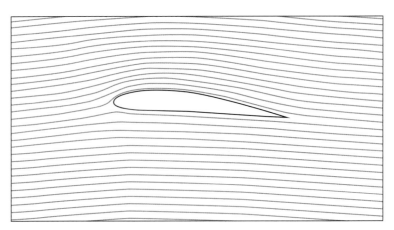

Streamlines around a wing showing smooth laminar flow. You can think of each streamline as the path taken by "packets" of air as they move across the wing. The streamlines get closer together as they speed up, but a packet from one streamline does not cross into a neighboring line. In this example, the flow is smooth everywhere (called laminar flow). The bending of the streamlines indicates that the air is slightly disturbed even at large distances from the wing. Redrawn from McLean.[8]

higher pressure under the wing and lower
pressure above it. High pressure wins the
battle, and this results in an upward force
on the wing, which we know as lift.

Force from Pressure: The Lift Vector

The pattern of pressure distribution
shown on page 95 does not easily lend
itself to the simplified analysis that
biologists and engineers like to use
when analyzing the dynamics of flight
and how birds can redirect their wing
forces in novel ways. Pressure applied
to an area results in a force (formally,
force = pressure × area, or its calcu-
lus equivalent, the integral of pressure
over area). The combined effect of all
pressures acting on the entire wing
is often represented as a single force
acting on the wing in a known direction
at a theoretical point called the center
of pressure. A line of the correct length
and orientation drawn from the center
of pressure is called the lift vector. The

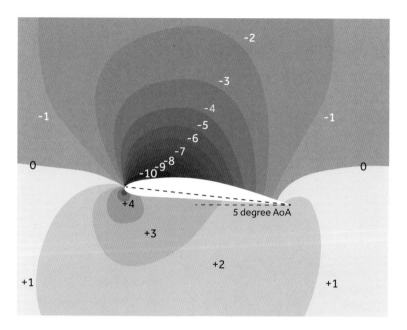

A simulation of the pressure distribution as a result of the airflow over a wing section. The units are arbitrary but the same for high and low pressures. Pressure values are compared to a distant reference point. Elevated pressure is in light teal and decreased pressure in dark blue. Despite the complexity of the pattern, the tendency for the wing to be lifted by the imbalance of pressure is easy to appreciate visually. The pattern will vary spanwise, from the wing root to the wing tip. Redrawn from McLean.[8]

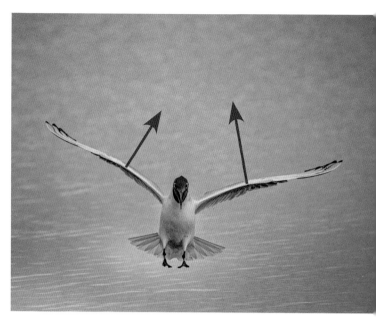

Hypothetical lift vectors from each wing of a Black-headed Gull (*Chroicocephalus ridibundus*) coming in to land. Note that the lift vectors act perpendicularly, not vertically, to the airflow over the wing. Different amounts and directions of lift from the right and left wings facilitate turning.

Brownsea Island, UK. March. IUCN category: Least Concern

direction of the line is always at right angles to the direction of airflow across the wing. Look back at Otto Lilienthal's image of a stork in flight, and you will see a series of arrows representing the lift forces on each two-dimensional cross section. The arrows point in slightly different directions because the wing twists toward the tip.

Why Do Wings Generate Lift?

Understanding the cause of the pressure imbalance that occurs with lift on a wing in an airflow is not an intuitive process.

The narrowing of distance between the upper streamlines as air flows over the nose of the airfoil is an indication that the flow in this region is speeding up. This contrasts with the slight widening of the distance between streamlines under the wing, where the flow is slowing down. Along any one streamline, we can apply the principle of Bernoulli, which states that the product of pressure and velocity is a constant. When velocity goes up, pressure goes down and vice versa. This is one of the reasons for the decreased pressure (dark blue in the diagram above) above the wing and increased pressure (light teal) below the wing.

There is another clue to the mystery of how airflow generates lift in the streamlines. The streamlines in the back two-thirds of the wing are directed downward, creating what is known as a downwash. Those theoretical packets of air have mass, and Newton's laws teach us that (1) a force is required

to accelerate a mass, and (2) there is always an equal and opposite reaction to a force. As the air is forced downward, the wing is forced upward.

How Much Lift Comes from Airflow?

If you think of moving your cupped hand quickly through water, you know that the faster you move, the more pressure you feel on your hand. One of the many forms of the famous Bernoulli equation leads to the definition of a quantity called "dynamic pressure," conceptually the pressure that moving fluid or air exerts on a surface. Dynamic pressure (defined as one-half times the density of the air multiplied by the square of the flow velocity) is an extremely useful concept in aerodynamics because the force that moving air exerts on a wing is directly proportional to dynamic pressure. The larger the area, the greater the force. The lift and profile drag forces on a wing are defined in a similar way using these lift and drag equations:

Lift force = Lift coefficient × dynamic pressure × area of the wing

Profile drag force = Drag coefficient × dynamic pressure × frontal area of the bird

Lift will depend on the wing's inclination, size, and shape, and that is where the "lift coefficient" is helpful. For each condition there will be a coefficient, usually determined by experiments, that allows us to compare the wing's performance under different conditions

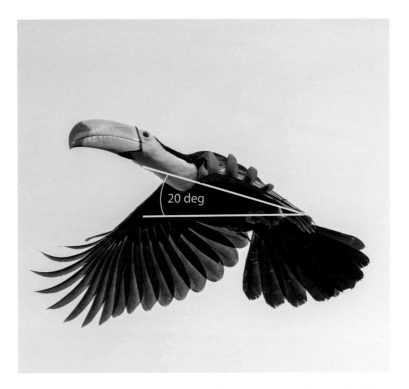

A Keel-billed Toucan (*Ramphastos sulfuratus*) climbs out with a high angle of attack (20 degrees). This will increase its wing-lift coefficient compared to a level wing, provided it is below the critical angle of attack.
Belize. December. IUCN category: Near Threatened

and to compare wings. If you look back at the graph from the Wrights' wind tunnel experiment, you will see that they measured the lift coefficient, and it varied from zero to one over a range of angles of attack.

How Does Lift Change with Speed?

One important detail in the expression for lift force is a velocity-squared term that is buried in the definition of dynamic pressure. This means that lift is related to the square of the speed. Doubling speed will result in an increase in lift by a factor of four. Double it again and the benefit increases to 16 times the lift at the

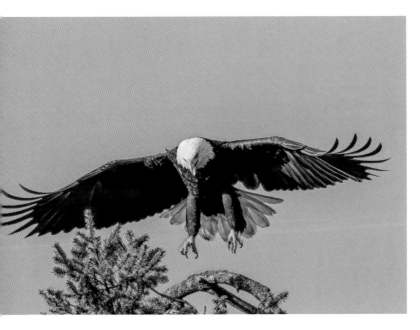

A Bald Eagle (*Haliaeetus leucocephalus*) ready to land on a perch. The speed of the headwind will affect control of the landing.

Lopez Island, Washington, USA. January. IUCN category: Least Concern

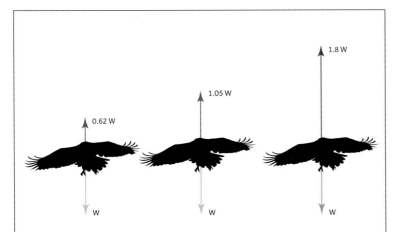

Schematic views of a Bald Eagle approaching a landing perch with a ground speed of 10 m/s (22½ mph). The blue arrows indicate body weight (W) acting downward, and the red arrows show the lift from the wings in units of body weight. The conditions shown are in still air (left) and into headwinds of 3 m/s (6¾ mph; center) and 7 m/s (15¾ mph; right). In still air, the lift from the wings is 2.8 kg (6.2 lbs.), which is only 62% of the bird's 4.5-kg (10-lb.) body weight, so conditions are good for the landing. The wing lift is approximately equal to body weight in 3 m/s headwind conditions, so the bird would stop descending. The strongest wind would increase lift force to 185% of body weight, so the bird would need to make some rapid configuration changes, decreasing the angle of attack and/or morphing its wings, to decrease lift and land. (The effect of the squared term is partly masked in these calculations because of the steady ground speed.)

original speed. This a potent gift that planes and birds exploit on a daily basis when taking off and landing.

A passenger sitting in a window seat on a fully loaded airplane during a takeoff roll knows that the speed across the ground at wheels-off is terrifyingly fast, somewhere in the region of 240 km/h (150 miles per hour). The lift generated is only just over 10 percent required for takeoff at 80 km/h (50 miles per hour), rising to 44 percent at 160 km/h (100 miles per hour), and then very rapidly to 100 percent — a full 181,436 kg (400,000 pounds) of lift — when the pilot rotates and lifts the nose of the plane (to increase the angle of attack) at 240 km/h (150 miles per hour). This at first slow and then very rapid increase in lift with speed is the work of the velocity-squared term in the lift equation. Some heavy birds, such as swans, geese, and cranes, also have long takeoff runs before they get airborne. The birds intuitively sense that they can gain disproportionate benefits in lift from higher air speeds across their wings.

Birds have to manage the effects of changing wind speeds, and the associated varying amounts of lift, when they are landing. The illustration on the left shows a Bald Eagle (*Haliaeetus leucocephalus*) traveling at a ground speed of 10 m/s (22½ miles per hour) and concentrating hard on a precision landing. With some reasonable assumptions, we can calculate the wing lift under different wind conditions using the lift equation.[9]

Vector Addition Using Parallelograms

In the illustrations below of the elegant White-tailed Kite (*Elanus leucurus*), let's assume that the bird is experiencing only two forces: the ever-present force of gravity pulling it down, and a force from a sudden strong gust of wind acting upward and to the right. In which direction will the bird tend to move? Will it be upward? Or in the direction of the wind? Or some other direction? We need to find the "resultant" of these two vectors, which could be done with algebra, but for our purposes, it is much better accomplished graphically.

An adult White-tailed Kite weighs about 330 grams (¾ pound), and the red arrow labelled "Body Weight" is a vector, representing the size and direction of this force acting at the bird's center of gravity. The force from the wind has a direction of 30 degrees upward and is about 420 g (just under 1 pound). It is drawn as a vector, with the right size and direction (shown as "Wind" in the illustration). To determine the resultant, we simply draw a parallelogram based on the two component forces, as shown by the dashed lines, and we then draw the resultant (orange arrow) from the point where the two forces act to the opposite vertex of the parallelogram. From this construction we learn that even though the wind is stronger than the bird's weight, because of the interaction with gravity, the bird will tend to move to the right and slightly downward. We can measure details of the resultant right from the illustration: 381 g (about ¾ pound), or 121 percent of body weight, acting at about 19 degrees down from the horizontal.

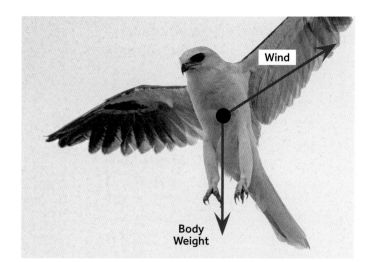 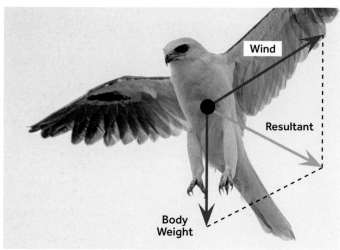

Ignoring lift, the forces acting on the bird are weight and a drag force from the wind of 1.21 × body weight acting upward at 30 degrees (left). The resultant of these forces (right) is the diagonal of a parallelogram (dashed lines) that includes the two forces. We can measure the size and direction of the resultant directly from the drawing (it is a force of 1.16 × body weight acting 19 degrees down from the horizontal.

White-tailed Kite (*Elanus leucurus*)
Belize. December. IUCN category: Least Concern

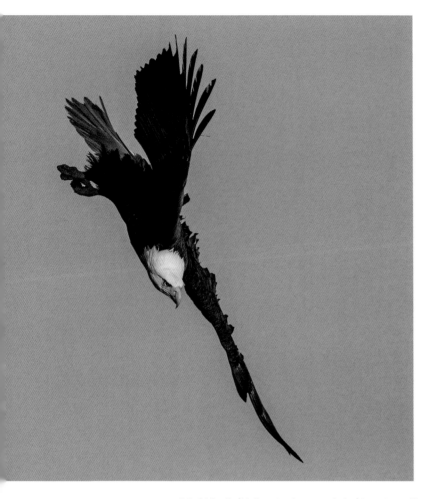

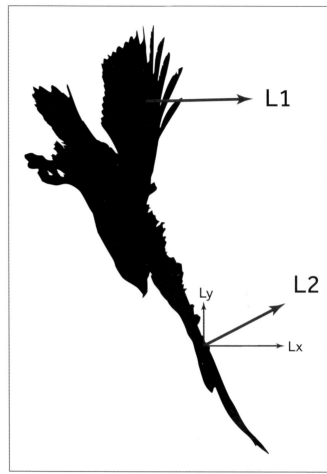

A Bald Eagle (*Haliaeetus leucocephalus*) in a steep dive.
Sitka, Alaska, USA. March. IUCN category: Least Concern

Redirecting the Lift Vector

We have considered lift as a force that acts against gravity to keep a bird in the air, but birds are much more versatile than this. They can redirect the lift forces from their wings to generate forces in other directions. The most important of these are propulsive forces used to overcome drag during flapping flight.

As an example of redirecting lift, look at the diving Bald Eagle in the image above. The approximate orientations of the lift vectors from each wing are shown in the accompanying silhouette, and you can see that the lift force from the right wing (L1) is now directed almost horizontally and plays no role in supporting the bird's body weight against gravity. The force from the left wing has been split into horizontal and vertical components — a useful device that uses the parallelogram rule discussed earlier. This force still has a component of weight support (Ly), but the component accelerating the bird to its left (Lx) is about twice as large. Drag can also be redirected to be helpful in many situations, such as when landing.

Using forces from the wing to balance or to pull at food are also common occurrences. The Great Blue Heron

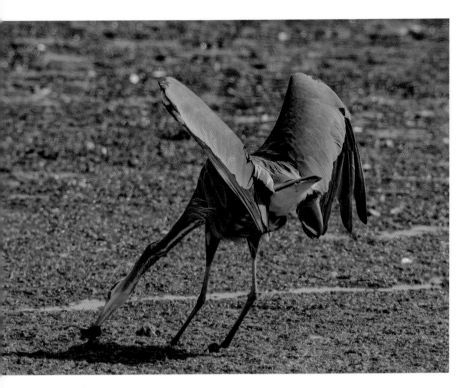

A Great Blue Heron (*Ardea herodias*) uses lift from its wings to extract some vegetation in tidelands.
The red arrows show hypothetical lift vectors generated by accelerating the arm wings.
Lopez Island, Washington. April. IUCN category: Least Concern

(*Ardea herodias*) shown above was foraging in tidelands using its wings in this way. The job at hand was to dislodge a piece of sea cabbage under which some nutritious prey may have been lurking. After first leaning back to add some weight to the force of its leg extension, the bird adds wing forces by a sweep of the arm wing. This causes airflow across the wing, which generates the wing forces shown schematically by the red arrows, which help to dislodge the vegetation.

Wing Loading

The total lift force that a bird experiences in level gliding flight is a known quantity. It is exactly the same as the bird's body weight:

There has to be a balance of forces, otherwise the bird would be climbing or descending. If the total area of the bird's wings is also known, we can calculate a quantity called wing loading.

Let's consider two well-known seabirds: the Laughing Gull (*Leucophaeus atricilla*) and the Atlantic Puffin (*Fratercula arctica*). The puffin is about 50 percent heavier than the gull but has only 26 percent of the gull's wing area. The calculation of mass divided by wing area for both birds reveals that the puffin has four times the wing loading compared to the gull.[10]

High wing loading has huge implications for a bird's structure and flight dynamics. We think of gulls as "dancing" lightly in the wind, while puffins tend to fly in purposeful straight lines without dramatic turns. You can

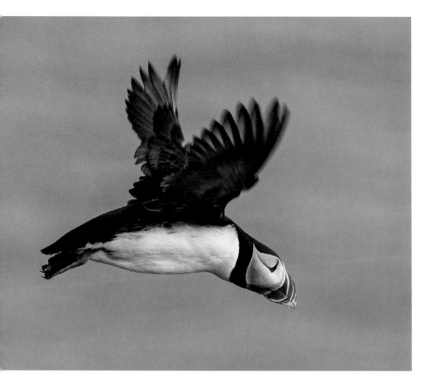

The wing loading of an Atlantic Puffin (*Fratercula arctica*) is 12 kg/m² (2½ lb./sq. ft.).
Látrabjarg, Iceland. May. IUCN category: Vulnerable

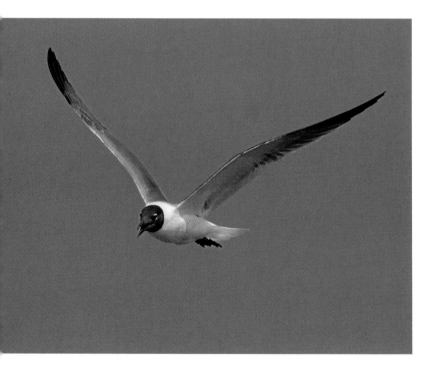

The Laughing Gull (*Leucophaeus atricilla*) has a wing loading of 2.9 kg/m² (½ lb./sq. ft.).
Green Island, Texas, USA. June. IUCN category: Least Concern

An Atlantic Puffin has about four times the wing loading of a Laughing Gull and requires twice the airspeed to take off.

appreciate how your own mobility and maneuverability might be impaired when wearing a backpack weighing 45 kg (100 pounds) compared to one weighing 10 kg (about 25 pounds). Taking off is also easier for birds with low wing loading because they can get airborne and start climbing at slower speeds. The gull and the puffin are great examples of this: Under similar conditions, the puffin will need twice the airspeed across its wings to takeoff.[11] The puffin solves this problem by choosing to nest in burrows at the top of cliffs. Takeoff for puffins involves thrusting themselves off the edge of the cliff and falling, sometimes gliding and sometimes in a flapping dive, until the lift developed by their wings is greater than their body weight. Birds with high wing loading cannot turn as tightly as species with low wing loading.

Novel Forms of Lift

Some birds and insects have developed novel ways to generate lift that depart from the more conventional models. For example, a leading-edge vortex (LEV) involves a continuous spiral of air that spins from the wing root (or the alula feathers) toward the wing tip, generating an upward force as it spins. Airplanes with swept wings (like the Concorde or a jet fighter) benefit from this effect, while hummingbirds and swifts are also known to exhibit LEVs. Recent research has pointed to the role of the small group of alular feathers as a controller of the leading-edge vortex in the hand wing.[12]

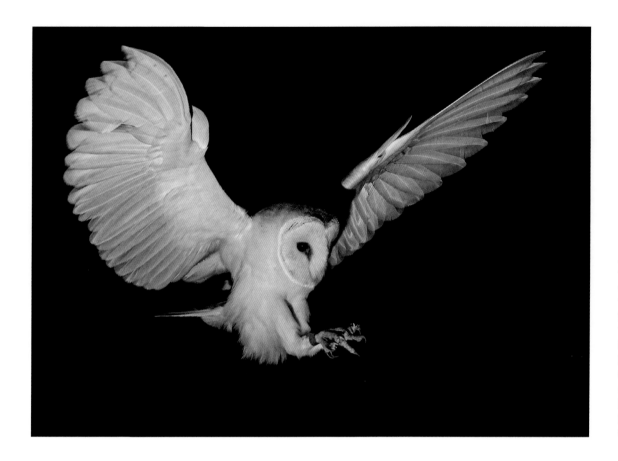

A Barn Owl (*Tyto alba*) with its alula feathers deployed is gliding in to pick up food with a high angle of attack. These feathers are likely generating a leading-edge vortex to generate lift during slow flight.
Norfolk, UK. April.
IUCN category: Least Concern

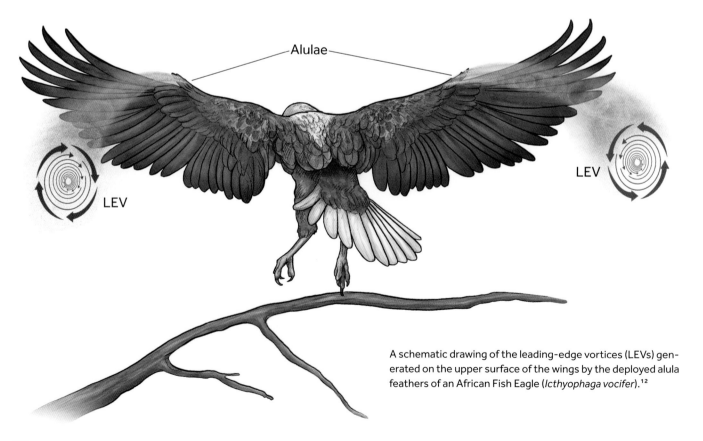

Alulae

LEV

LEV

A schematic drawing of the leading-edge vortices (LEVs) generated on the upper surface of the wings by the deployed alula feathers of an African Fish Eagle (*Icthyophaga vocifer*).[12]

Thomas Linehan and Kamran Mohseni, from the University of Florida, conducted experiments on model wings with position-adjustable alula feathers in a wind tunnel. By measuring the lift with various alula locations, these researchers discovered that the biological location of the alulae coincided approximately with the predicted position of maximum lift generation. The gain in lift was approximately 13 percent compared to a wing with no alulae. They also noted that LEV-generated lift was sensitive to angle of attack: The vortex became destabilized when outside a fairly narrow range of angles in the region of stall and post-stall.

At the moment, we only know of LEVs through model-based research and in the few species that have been directly studied. However, it seems likely that this may be a universal form of lift generation in bird wings during slow speed, high angle of attack activities such as landing.

Ground Effect

Every pilot has felt the yin and yang of ground effect. Shortly after wheels-off on a climb out from takeoff, there is a sudden sensation of loss of lift. It feels like a mysterious force gently pulling the plane down, and the pilot needs to be vigilant not to pull the nose up and climb too steeply without gaining more airspeed. The worst outcome could be a takeoff stall. At the other end of the trip, ground effect plays a different role: Typically, a plane is trimmed on approach for a steady descent to the runway, but just before landing, as the pilot flares and pulls the nose gently up, the gauges may show that the descent has stopped and the plane is "floating" down the runway at a constant distance off the ground. On a short runway, this can bring the end of the safe landing area into view remarkably quickly. Birds also experience and exploit this phenomenon.

It is sometimes said that ground effect is caused by a "cushion" of air or a hovercraft effect between the wing and the ground that dissipates on takeoff and reappears on landing. But this interpretation, although quite descriptive of the feeling, is not entirely correct. Ground effect occurs because proximity to a fixed surface — solid ground or water — alters airflow around the wing, changing the effective angle of attack and increasing lift. The wing-tip vortices, which are a significant source of drag during slow flight, are also attenuated. The wing thereby experiences more lift and less drag, hence the floating on landing and the sudden loss of lift at takeoff. Ground effect exists when the wing is at or less than one wingspan above the surface. For a small single-engine plane this might be about 9 m (30 feet), and for a medium-sized bird it is closer to 1 to 1.2 m (3–4 feet).

The island on which I live is the domain of cormorants — Double-crested (*Nannopterum auritum*) and Pelagic (*Urile pelagicus*) — and I frequently see both species exploiting ground effect on their

A Double-crested Cormorant (*Nannopterum auritum*) using flapping flight to cruise in ground effect.
J.N. "Ding" Darling National Wildlife Refuge, Sanibel Island, Florida, USA. January. IUCN category: Least Concern

A Brown Pelican (*Pelecanus occidentalis*) gliding in ground effect.
Belize. December. IUCN category: Least Concern

surface-skimming flapping flights between their nest and foraging grounds. Although they are quite capable of gaining height, they mostly stay close to the water. They have very good reasons for flying this way: It has been estimated that flying in ground effect results in an energy saving of 15–25 percent.[13] It is also likely that there is sometimes an additional energy saving in low-altitude flight into a headwind, since surface friction between air and water reduces wind speed close to the surface.

Drag Forces

On July 23, 1983, Bob Pearson, the captain of a Boeing 767 flying as Air Canada Flight 143 from Montreal via Ottawa to Edmonton, was startled by a series of fuel status alarms, soon followed by a complete shutdown of both engines. This was a flight condition considered so unlikely that it had not been covered during his pilot training. Neither was guidance provided in the emergency checklist that pilots typically consult in such situations. Through a series of malfunctions and misunderstandings (including a metric vs. imperial unit mix-up), the plane had left Ottawa with only half the fuel needed to get to its destination. Despite the failure of multiple electrical and hydraulic systems, Pearson (who, fortuitously, was an experienced glider pilot) landed the plane safely at a closed air force base in Gimli, Manitoba, after executing a technique called "side slip"

to lose altitude on final approach that, as far as is known, had never been attempted on a commercial airplane. At touchdown, the aircraft, since nicknamed the Gimli Glider, had been in a gliding descent for approximately 70 km (45 miles).

The fact that Flight 143 could not maintain airspeed and altitude after engine failure indicates that there were forces acting to slow forward airspeed, which we know decreases lift from the wings. These retarding forces have several components collectively called drag, which is normally overcome in planes by propellers or jet engines and in birds by flapping flight. The streamlined body shapes of many birds are designed to minimize one form of drag, known as profile drag, but there are also times when they try to maximize it.

Profile Drag

As the Wright brothers knew from their wind tunnel tests, a flat plate at an appropriate angle of attack can produce a decent amount of lift. But the magic of an airfoil's shape is that not only does it produce lift, it dramatically reduces drag compared to a flat plate. Even if the two objects generate the same lift, the airfoil is more efficient because it has a higher ratio of lift to drag.

As a thought experiment (or, as scientists like to say, a first approximation), we can consider a bird or plane gliding into a headwind as an example of the classic aerodynamic paradigm of a cylinder in a stream of moving

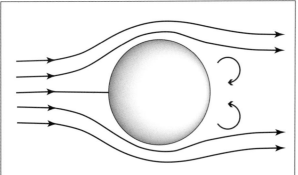

A schematic visualization of the streamlines of air flowing around a cross section of a cylinder under conditions that generate a turbulent flow.

Compare the outline of a trout from the notebooks of Sir George Cayley (1773–1854) with a symmetrical low-drag airfoil (from von Kármán, 1954). The circles on the airfoil are points on the outline of the trout. Symmetrical airfoils only provide lift when they have a non-zero angle of attack.[14]

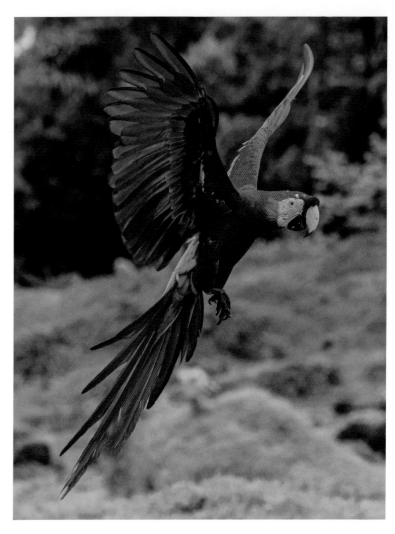

This Scarlet Macaw (*Ara macao*) is maximizing its frontal area during an approach to land, increasing profile drag. Birds often use this technique to slow down. Costa Rica. April. IUCN category: Least Concern

air. The airflow separates around the cylinder and can leave a signature in the wake that varies based on the size of the object and the physical conditions of the test, particularly the airspeed and air properties. The important factors that determine the form of the wake are all contained in the Reynolds number.[1] As airspeed increases, the flow becomes separated (or detached) from the wall of the sphere and leaves a chaotic — or turbulent — wake in contrast to the smooth laminar flow of air around the wing. Pressure is higher on the front of the cylinder compared to the back, in much the same way as flow over an airfoil creates lower pressure above and higher pressure below. In the profile drag equation, there is a term for area that is a multiplier for the drag force. For the same shape, the larger the frontal area, the greater the profile drag, which is why the Scarlet Macaw above was so stretched out.

The cylinder approximation is a poor one: The bodies of birds and airplanes are streamlined, and this dramatically reduces profile drag. The

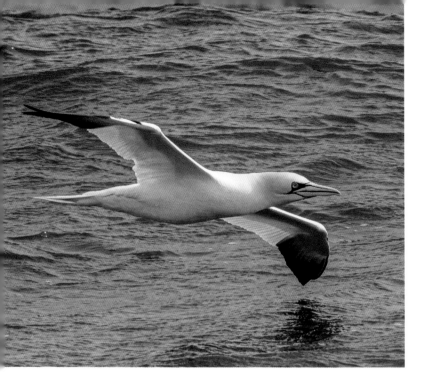

The well-streamlined bodies of two birds from the Sulidae family that plunge-dive to feed. Note how they retract their legs close to their body, like landing gear on an airplane, to reduce profile drag.

Left: Northern Gannet (*Morus bassanus*) Isle of Man. April. IUCN category: Least Concern

Right: Brown Booby (*Sula leucogaster*) Fernando de Noronha, Brazil. August. IUCN category: Least Concern

famous 19th-century English flight pioneer Sir George Cayley identified the shape of a trout as ideally streamlined. Theodore von Kármán later pointed out that a trout also has a remarkably similar cross section to a symmetrical low-drag airfoil from the mid-20th century. In 1810, Cayley understood from his keen observations of biology that to reduce profile drag, shaping the back part of a structure moving in a fluid was as important as shaping the part directly facing the air or fluid. Selection pressure led to the streamlining of birds' bodies, particularly members of the Sulidae family, such as the Brown Booby (*Sula leucogaster*) and Northern Gannet (*Morus bassanus*), which plunge-dive at high speeds into water.

We can get a quantitative feel for the effect of shape on profile drag by looking at the drag coefficients for various profiles. Under similar flow conditions, a flat plate might have a drag coefficient of 1.28, a bullet 0.295, and an airfoil 0.045.[15] This is almost a 30-fold range of profile drag. It is, therefore, not surprising that both evolution and aircraft design have prioritized reduction in profile drag. The Wright Flier was aerodynamically "dirty," since no attention was paid to the reduction of profile drag. This all changed within 20 years, after a French engineer and aviator, Louis-Charles Breguet, led a campaign for streamlining that included the retraction of landing gear.[16] Breguet also "walked the walk" by garnering endurance records in his streamlined aircraft.

Viscous Drag

A pancake breakfast can be a really good time to learn a little physics. Take a drop of orange juice and set it free on the outside wall of your glass. The drop will hit the table in a second. Now do

the same with a drop of maple syrup. It might take 30 seconds for the drop to creep slowly toward the table, or it might remain stuck to the glass halfway down. You have just made a viscometer, which is a tool for measuring the stickiness (or viscosity) of liquids. Viscosity is an expression of the internal friction between molecules of a substance, including the various gases in air.

As air flows across a bird's body, there is a thin boundary layer where air molecules exist in a no-slip condition, meaning they are not actually moving with the rest of the flow. Depending on viscosity, they will exert a pull on other molecules just above the boundary layer, and so on until the effect is so small that it is no longer slowing down the free-stream airflow. This situation is called a velocity gradient, and it describes where the velocity of the air varies between zero at the boundary layer and normal relative to headwind speed at some point above the bird's body. A force, called viscous drag, acts opposite to the direction of motion to slow the bird down and requires metabolic energy to overcome. (You may hear viscous drag referred to as friction drag or skin-friction drag. Another commonly used term is parasitic drag, which usually refers to the combined effect of profile drag and viscous drag.)

Viscous drag depends on the roughness of the surface over which the air or water flows; as every sailor knows, a boat hull encrusted with barnacles will not perform well. This effect has been explored in a wide range of birds with different feeding niches by Roelof

The smooth, tiled surface of the contour feathers on the back of this Barn Swallow (*Hirundo rustica*) minimize viscous drag.
Lopez Island, Washington, USA. July. IUCN category: Least Concern

Coertze from North-West University in South Africa and Arie Rijke from the University of Virginia.[17] Their research indicates that contour feathers can repel water, prevent water penetration, and provide smoothness to the body surface to reduce viscous drag. As expected, the researchers found that birds who feed underwater have plumages that scored better than land birds.

Wing-tip vortices shed by a military aircraft are rendered visible by clouds disturbed by its passage. The vortices roll behind the plane, making conditions potentially dangerous for following aircraft. The vortices rotate in opposite directions — counterclockwise from the plane's left wing, clockwise from the plane's right wing (when viewed from in front of the plane).

US Air Force Photo / Alamy Stock Photo

Induced Drag: Wing-Tip Vortices

Small aircraft are not popular at large commercial airports. They slow traffic on approach, increase the gap between departing aircraft, and clutter the lower-altitude airspace surrounding the field. On a summer afternoon at Boston's Logan Airport, my four-seater Piper Cherokee and I were about to make ourselves even more unpopular than usual.

As a Boeing 757 roared down the runway for takeoff ahead of me, my radio crackled into life as ground control issued the expected command, "Three eight Quebec position and hold," instructing me to advance and line up with the runway centerline in preparation for departure. Moments later, just as the wheels of the jet lifted

in front of me, I heard the command "Three eight Quebec cleared for departure." I keyed the microphone and, with an anxiety-laden voice, said, "Ground control, this is three eight Quebec requesting an amended clearance with 30-second delay." Why did I do this? Just days before this flight, I had been reading accounts of small aircraft being flipped by flying into the wing-tip vortex of a 757. It turned out the controller had my best interests at heart, and after the agreed-upon delay, he gave me an immediate right turn on takeoff to keep me well away from the potentially dangerous wake.

It is impossible to generate lift on a finite wing without creating induced drag. Drag is the cost of lift. The two-dimensional distribution of pressure around a section of a lifting wing that we have considered so far is an idealized representation of the truth. With a real wing, air at the trailing edge gets progressively more turbulent toward the wing tip, where a swirling current of air

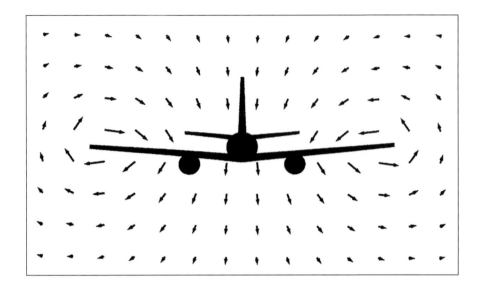

Velocity vectors (showing magnitude and direction) of the airflow around a lifting wing. Note the upwash at the wing tips and the downwash underneath the wing. Redrawn from McLean.[18]

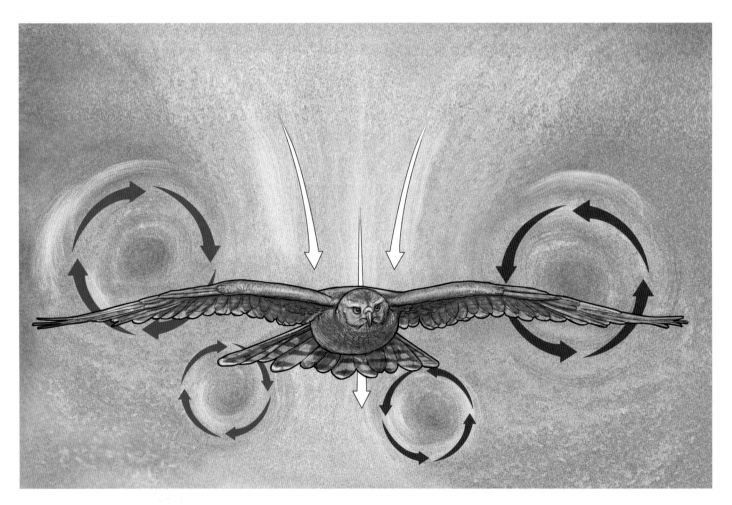

An illustration depicting the movement in a slice of illuminated helium-filled bubbles from which a gliding Northern Goshawk (*Accipiter gentilis*) recently exited. The main wing-tip vortices are emphasized with large rotating arrows. Clockwise rotation is shown with blue arrows, and counterclockwise rotation is in red. The smaller rotating arrows show the vortices shed from the body and tail. The white arrows represent the downwash caused by vortex rotations. There is also upwash on the outside of vortex. A movie of the swirling vortices can be viewed here: thekidshouldseethis.com/post /birds-gliding-through-helium-bubbles-reveal-an-aerodynamic-trick

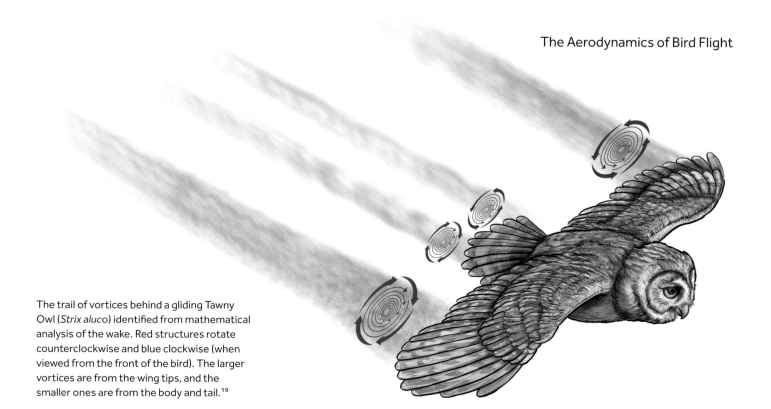

The trail of vortices behind a gliding Tawny Owl (*Strix aluco*) identified from mathematical analysis of the wake. Red structures rotate counterclockwise and blue clockwise (when viewed from the front of the bird). The larger vortices are from the wing tips, and the smaller ones are from the body and tail.[19]

moves upward, toward the low-pressure area above the wing, and continues to rotate. When viewed from the front of a bird or airplane, this vortex circulates in a clockwise direction from the right wing and a counterclockwise direction from the left wing.

The disturbance of the air extends for a considerable distance around the wing. The hypothetical airflow behind a flying plane, illustrated opposite (top), shows the upwash at the wing tips and the downwash underneath the wing. The pattern is likely very similar in birds. Exploiting the upwash and avoiding the downwash is a skill that migrating birds have learned.

The vortices shed by bird wings are qualitatively similar to those behind aircraft, and they are usually invisible. However, James Usherwood and his colleagues at the Royal Veterinary College in London trained birds in a laboratory to glide through a cloud of small, neutrally buoyant, helium-filled soap bubbles.[19] A thin slice of the cloud was strobed by LED light as the birds glided through. This revealed the movement of air, just like the actual clouds in the image of the military aircraft. (See photograph on page 109.) Individual bubbles could also be identified by tracking software and their trajectories extracted for the calculation of vorticity, which is a mathematical quantity characterizing the intensity and direction of vortex rotation.

Downwash reduces lift by changing the apparent direction of the oncoming airflow. You will recall that lift acts at right angles to the direction of airflow, so this change tilts the lift force vector backward, giving it a component of force that opposes forward motion. The bird must overcome this reduction of lift with metabolic energy to continue quasi-level gliding. This is why gliding birds add periods of flapping to maintain or restore their altitude. Henk Tennekes has described this effect as the bird having to fly "uphill."[20]

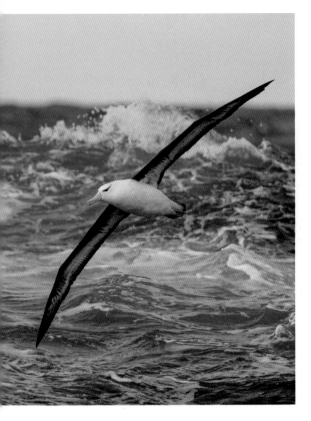

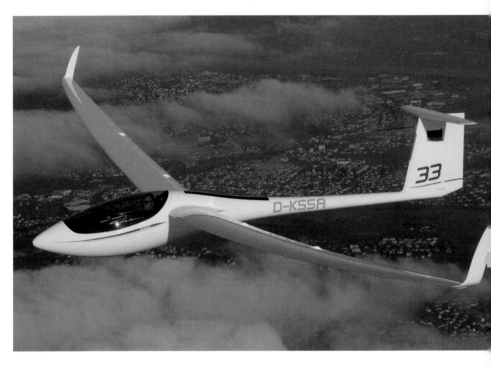

A Black-browed Albatross (*Thalassarche melanophris*), with an aspect ratio of 15:1. Southern Ocean. October. IUCN category: Least Concern

A high-performance sailplane with an aspect ratio of 32.4:1. This aircraft also has small winglets.

Photo courtesy of Alexander Schleicher Segelflugzeugbau

Reducing Induced Drag

Natural selection has worked to decrease induced drag, and aeronautical engineers, inspired by avian design, have done the same. Long, narrow wings generate much less induced drag than short, stubby wings. The basic geometry of wings is often characterized by aspect ratio (approximated by dividing the wingspan by average wing width). Snowy Albatrosses, which often travel on multi-day foraging flights of more than 10,000 km (6,200 miles), have an aspect ratio of 15:1, whereas Common Crows, known for short flights within a relatively small home range, have an aspect ratio of 4:1.

Sailplane designers have taken this concept to extremes, using wings that have aspect ratios of greater than 30:1.

Aerodynamicists like to consider wings that are infinitely long, which would not be subject to wing-tip effects and would therefore have no induced drag. In reality, wings must have a finite length, so increasing the length of a wing but keeping the same breadth increases its efficiency.

The sailplane shown above and almost every long-distance jet aircraft flying today have extensions called winglets at the wing tips.[21] These upturned wing tips are also seen in many birds, as their flexible terminal primary feathers bend during

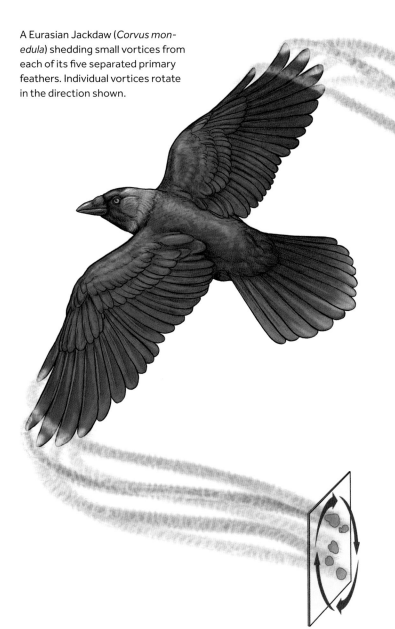

A Eurasian Jackdaw (*Corvus monedula*) shedding small vortices from each of its five separated primary feathers. Individual vortices rotate in the direction shown.

the downstroke. Winglets can reduce aircraft fuel costs by about 5 percent, and it is assumed that they also reduce the metabolic cost of bird flight. Winglets disrupt wing tip vortices, resulting in less induced drag, and they also help wings develop more lift.

Slotted Wing Tips

A visible feature of the tips of many bird wings is the separation of the

terminal primaries, resulting in what is called a slotted wing tip. The primary feathers in many birds are designed for this function, with their broad base and narrower tip (known as emarginated primaries). Marco Klein Heerenbrink and his colleagues at the University of Lund in Sweden trained a Eurasian Jackdaw (*Corvus monedula*) to fly in a wind tunnel through a cloud of illuminated particles (somewhat similar to the goshawk experiments described on page 111), so they could see the movement of air in the bird's wake.[22] Their results showed that each of the five slotted primaries generated its own mini-vortex (see diagram above). This process — called vortex spreading — is believed to lower the total induced drag compared to a wing without slots.

Slotted primaries have often been thought to be an adaptation that only enhances a bird's ability to soar, but it is now clear that there are benefits for both soaring and flapping. The jackdaw is not a soaring bird, and neither are many of the other species that have slotted wing tips. The scientists who conducted the Swedish wind tunnel study believe that the greatest benefit of vortex spreading may be for flapping flight.

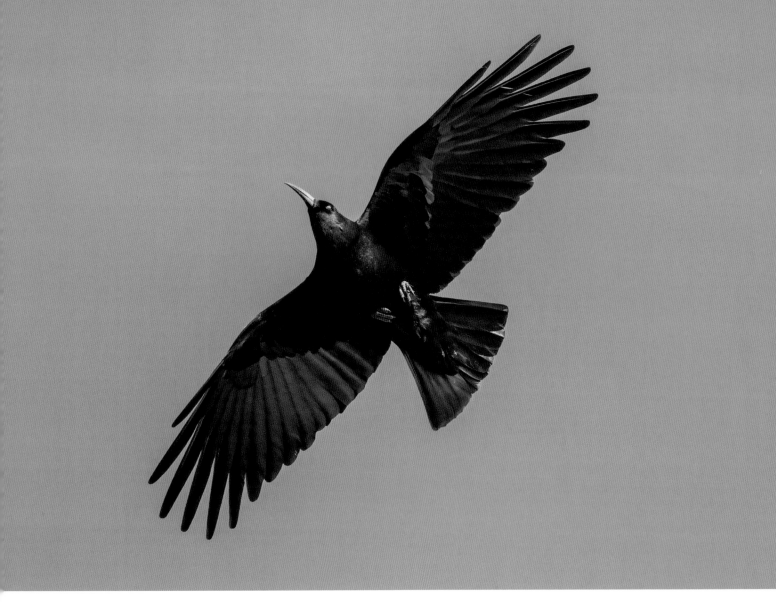

The slotted primaries of another corvid, a Red-billed Chough (*Pyrrhocorax pyrrhocorax*).
Isle of Man. April. IUCN category: Least Concern

Wing Efficiency: Combining Lift and Drag

While it is useful conceptually to compartmentalize lift and drag, it is much more insightful to consider them together. From the bird's viewpoint, all of the forces acting at any instant have a single outcome: Their combined actions tend to accelerate the bird's body in the direction of the "resultant" force (see page 164 for a diagram showing the resultant of lift and drag).

The most often used combination of lift and drag is the ratio that expresses their combined effect: the lift-to-drag ratio (which, incidentally, is what led the Wright brothers to choose the no. 12 airfoil). The lift-to-drag ratios of various bird wings were measured in a classic 1981 report by Philip Withers from Portland State University in Oregon. He found that the maximum lift-to-drag ratios for the wings of a Chimney Swift (*Chaetura pelagica*) and a Wood Duck (*Aix sponsa*) were 17 and 3.8, respectively, and that these

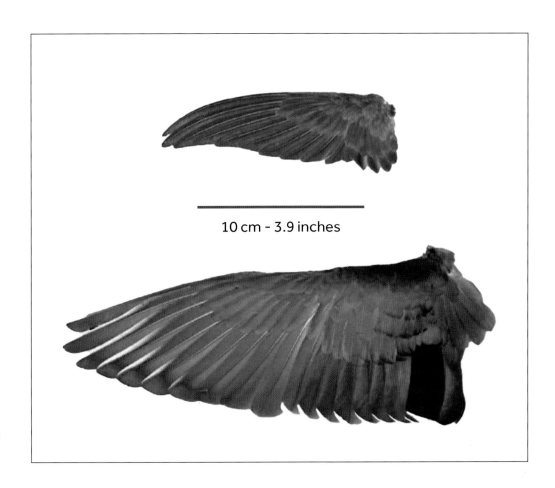

10 cm - 3.9 inches

The wings of a Chimney Swift (*Chaetura pelagica*), above, and a Wood Duck (*Aix sponsa*), below.

Images from the Wing and Tail Collection, Puget Sound Museum of Natural History, Tacoma, Washington

occurred at low angles of attack. The interpretation of these ratios is that for one unit of drag, the wings of the swift and the duck generated 17 and 3.8 units of lift, respectively, a rather startling difference that reflects the airborne and aquatic lifestyles of these two birds. The four-times-greater efficiency of the swift's wing is due to its higher aspect ratio and other structural factors. This ratio is often referred to as the "efficiency" of a wing.

How Does Drag Change with Speed?

The way in which lift changes with speed is fairly straightforward and very favorable for a bird taking off into the wind, since it increases as the square of airspeed. The speed trend with drag is more complex because two major drag components behave in opposite ways. Parasitic drag (the sum of profile and viscous drag) increases as the square of speed, which is bad news for high-speed birds. Induced drag, meanwhile, decreases as speed increases. The total drag on the bird at any speed can be found by adding the effects of all the components. This reveals a surprising fact: there is a speed at which all forms of drag are minimized. This speed is the most energy-efficient speed of flying for the bird.

The flight speed that a bird chooses at any moment will depend on its

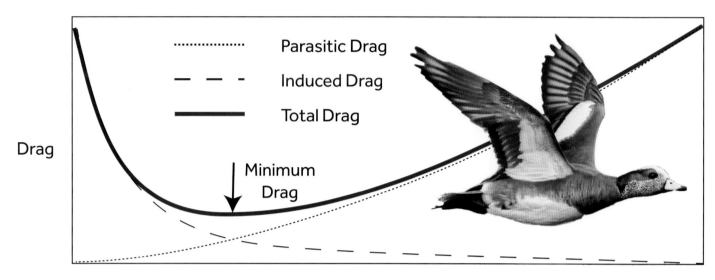

A hypothetical relationship between drag and flight speed: total drag on the bird (red line) is the sum of parasitic drag, which is profile drag plus viscous drag (dotted line), which increases with speed, and induced drag (dashed line), which decreases with speed. The addition of these two results is the total drag curve, which shows the speed at which drag is minimized (black arrow).

circumstances and purpose. Economy is a minor consideration during an escape response but can become the dominant factor during migration.

The Aerodynamics of the Tail

A bird's tail is perhaps the most ignored body part in ornithology. There are thousands of insightful studies on the structure and function of bird wings but just a handful of papers exploring tail function. As a result, there continues to be debate and disagreement about the tail's aerodynamic function. Bird-watchers know that the tail must be important: A fully spread tail is often deployed during landing and takeoff and in many flight maneuvers — times when lift needs to be maximized. Bird photographers always have a large trove of tail photographs from "going away" shots taken reflexively when the bird flew from a perch in the "wrong"

direction — away from the camera.

The most general statement of tail function in planes and birds is that it generates aerodynamic forces that affect flight stability. Because tail structures are usually smaller than wings, the absolute forces they produce are also smaller. However, these forces are applied at a relatively large distance from the center of gravity, so they have an outsize effect (the resulting moment is the product of force and distance).

While the aircraft wing analogy served us well for understanding the basic aspects of wing lift and drag, it breaks down when it comes to the vertical components of the tail. Most aircraft have a fixed vertical stabilizer to which a movable rudder is attached, but there is no such feature in birds (although some birds can rotate their tail through a large angle with respect to their body). The vertical stabilizer's role in an airplane is to prevent side-to-side movement (yaw), and the

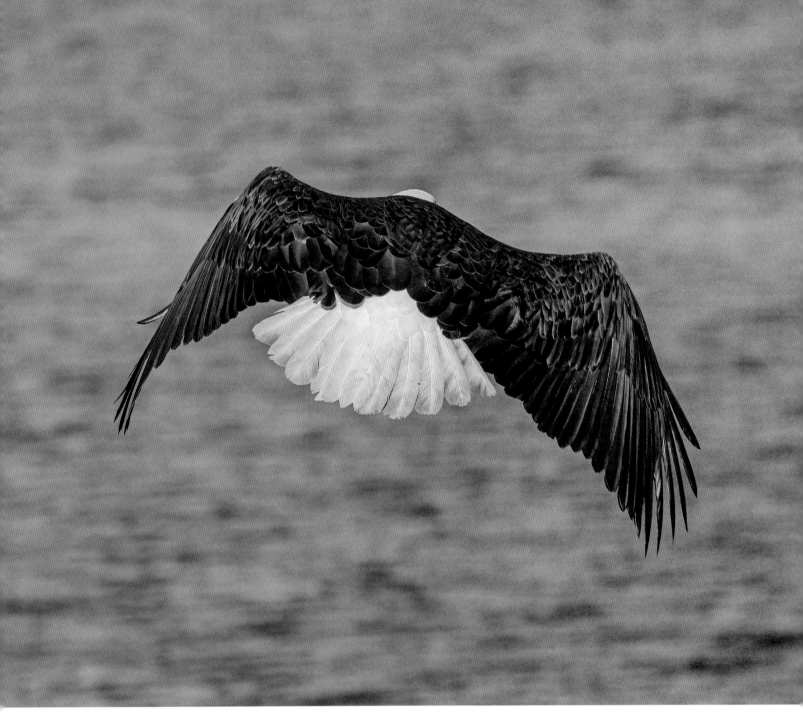

The fully deployed tail of a Bald Eagle (*Haliaeetus leucocephalus*) maneuvering close to the water at a slow speed. The tail's large surface indicates its role in generating lift.
Sitka, Alaska, USA. March. IUCN category: Least Concern

attached rudder is used to control the direction in which the plane is pointing in relation to the airstream. For pilots, one of the rudder's key uses is to pull the nose of the airplane back to line up with the runway centerline during a crosswind landing, after a "crabbed" approach in which the nose is pointing somewhere between the runway and the crosswind. In the absence of these structures, a bird must perform the same yaw-control functions by morphing its wings and tail.

However, the plane's horizontal stabilizer and elevator (and even more so the stabilator, which combines the two) are

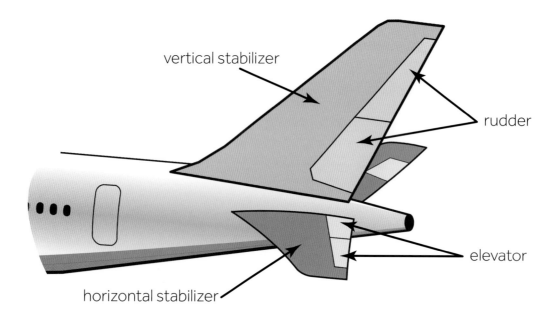

vertical stabilizer

rudder

elevator

horizontal stabilizer

The tail empennage of a conventional aircraft. The term is derived from the feathers on an arrow, hinting at its function: to stabilize flight.

quite similar to a bird's tail, since a bird can move and morph its tail into a wide variety of configurations. The lift vector from cambered airplane wings generally acts behind the center of gravity, and it therefore has a pitching moment that tends to tip the nose down. In planes, the horizontal stabilizer has a lift vector pointing downward to provide a stabilizing moment in the opposite direction to the wing-lift moment. The movable elevator can change the aerodynamic profile of the tail, tilting the nose down or up as required. This balancing of the lift moment from the wings is one of the theories for the function of tails in flying birds, but some believe the lift force acts in completely the opposite direction.

Look back to the image of the gliding goshawk wake on page 110. You will notice that there are two smaller vortices shed from each side of the tail, which are rotating in the same direction as their respective side wing-tip vortices. This implies that the tail is generating conventional lift: The lift vector is acting upward in the same direction as the vector from the wing. Usherwood's study (see page 111) also suggested that because lift generation is constant across the width of the tail, viscous drag is reduced. The main conclusion is that the tail does indeed contribute to lift during gliding.

These views of tail function in birds should probably be considered as the end of Season One of a to-be-continued series. The data comes from just a few species of birds flying in wind tunnels under quite limited conditions. The geometry of a flying bird is a movable feast: The wingspan can be changed and the tail itself can be unfurled, radically altering its aerodynamic properties. But these results do show the promise of laboratory study to unravel what has been a long-standing mystery, and they have revealed a major departure from the function of similar structures in airplanes.

Can aerodynamic forces be measured?

THE QUESTION	Can the aerodynamic forces generated by birds be directly measured?
THE AUTHORS	Diana D. Chin and David Lentink
THE SOURCE	"Birds Repurpose the Role of Drag and Lift to Take Off and Land," *Nature Communications* 10, no. 5354 (2019), DOI: 10.1038/s41467-019-13347-3.
THE HYPOTHESIS	An ultrasensitive balance on which an enclosed flight space is mounted can measure the aerodynamic forces during flight.

THE EXPERIMENT

Pacific Parrotlets (*Forpus coelestis*) are about 13 cm (5 in.) long and weigh 25 g (about 1 oz.). They were taught to fly from perch to perch inside a chamber. Any aerodynamic forces generated by the bird inside a sealed volume of air were opposed by a force against the walls of the container. The entire measurement volume sat on three extremely sensitive force sensors (only two are shown) to measure the horizontal and vertical components of the wall forces (F_x and F_z, respectively), which are used to calculate the resultant wing force F_{wing}. The device was based on Newton's third law of motion (action and reaction are equal and opposite). The forces applied to the perches (P1 and P2) were also directly measured. Synchronized high-speed video allowed the posture of the bird to be associated with force measurements.

Figure redrawn from Chin and Lentink

THE RESULTS

The blue arrows show the direction and magnitude of the net aerodynamic wing forces during flight. Black arrows (at the start and end of the sequence, $F_{Takeoff}$ and $F_{Landing}$) are force vectors from the perch. Black lines show postures of the bird corresponding with the force vectors.

Figure redrawn from Chin and Lentink

THE CONCLUSIONS

This system can measure aerodynamic forces and provides great insight into how birds use wing forces to maneuver during flight.

<div style="text-align:center">

CHAPTER **FIVE**

</div>

> When a bird with a wide wingspan and a short tail wants to take off, it will lift its wings with force and turn them to receive the wind beneath them. The wind, forming a wedge, will quickly propel it up high like the Greek partridge I saw on my way to Fiesole.
>
> — LEONARDO DA VINCI (CA. 1505)

Takeoff and Landing

BIRDS EXCEL WHEN THEY ARE IN THEIR ELEMENT — in the air — but their movements during takeoff and landing are sometimes far from elegant. Consider the image on the right of a Secretary-bird (*Sagittarius serpentarius*) making a concerted effort to get airborne in order to avoid the perceived danger from my inadvertent arrival. It looks more like a cartoon character in black dress pants than a distinguished raptor with a unique and ancient pedigree.

There are no standard methods for takeoff and landing used by all birds, because different body plans and different imperatives require different strategies. There is, however, a guiding principle that both airplanes and birds follow in order to maximize their success: Whenever possible, takeoff and land into the wind. There is a very sound aerodynamic reason for facing the wind: Lift is proportional to the square of the velocity of airflow across the wing, bringing exponentially greater lift as the airflow speeds up. The takeoff can be enhanced by any one of three things: if the bird is moving with outstretched wings (like the Secretarybird), that movement will cause airflow across the wings and result in lift; flapping wings can create additional airflow, thrust, and lift; and a headwind results in airflow over the wings (even over a stationary wing) and can generate lift. The optimal

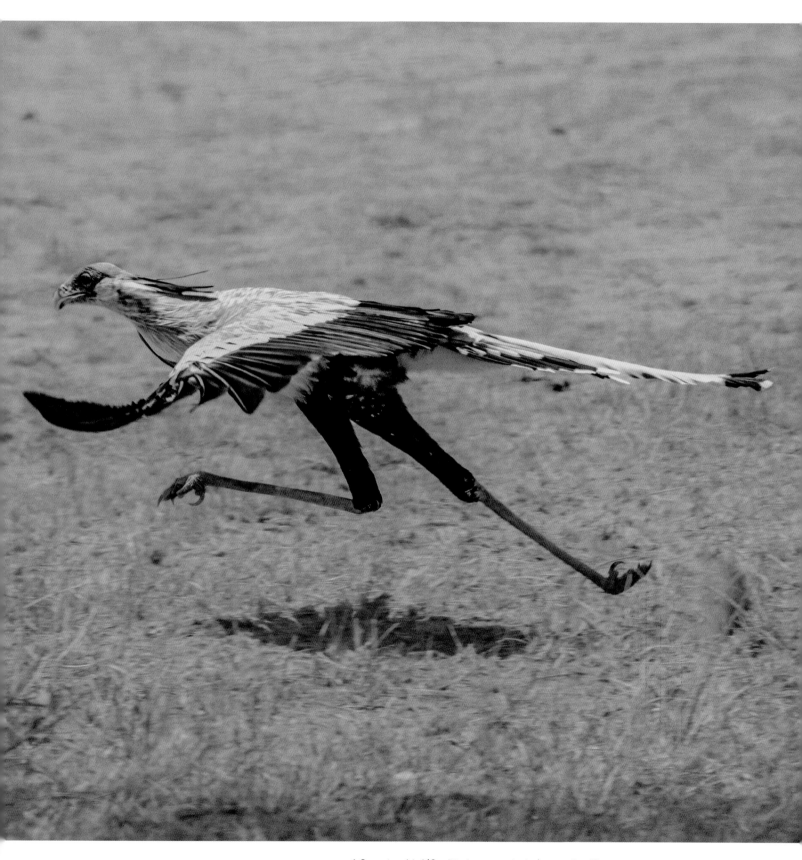

A Secretarybird (*Sagittarius serpentarius*) on a takeoff run.
Amboseli National Park, Kenya. October. IUCN category: Vulnerable

situation is when all three of these mechanisms are in operation (as in a flapping takeoff run into a strong headwind).

Lift generation is an obvious goal during takeoff, but why lift is useful in landing is not so apparent. The answer is control. Modulating lift helps a bird target its landing site more accurately and also allows it to postpone or redirect its landing to an alternative location if needed. But we also know that lift and drag are co-conspirators as air flows over a wing and that the combination of these forces (the net force) tends to accelerate the bird in a given direction. I like to think of the wings as multidirectional force actuators.

The Mechanics of Takeoff

Taking Off from a Perch

Since more than half of the world's birds are passerines (perching birds), let's start with takeoff from a perch. Most modern cameras, even those in cell phones, have "burst" modes that can capture rapid-fire exposures or take high-speed videos. My current camera can take up to 30 full-frame still images per second. This is fast enough to give some basic insights into the takeoff process but not the subtlety available to researchers, who sometimes shoot movies at up to 1,000 frames per second.

I call the typical passerine takeoff a "legs before wings" pattern, illustrated opposite by a small East African shrike, the Long-tailed Fiscal (*Lanius cabanisi*), departing from a tree stump in Amboseli National Park in Kenya.

The bird begins at rest (panel 1) and then goes into a deep "squat" (panels 2 and 3), keeping its wings tightly folded against its body. This is known as a countermovement. As the bird sinks, the extensor muscles in its legs are active but are being stretched out. By the return of stored elastic energy, this movement enhances the force generated as the bird rapidly reverses the direction of the "squat" and thrusts off explosively.

In panel 4, the bird has moved its body forward and upward, primarily through the powerful extension of its legs. This is the "legs before wings" part of the takeoff. As its claws leave the perch, the bird deploys its wings as high as possible above its body. (It is possible that raising the wings also results in some lift or forward thrust.) The wings are poised to act but have had no major propulsive role in the takeoff so far.

Between panels 4 and 5, the bird performs a single powerful downbeat of its wings, producing some lift to resist the downward pull of gravity. But in this particular takeoff, production of forward thrust dominates, since the bird's flight plan calls for a quasi-horizontal path just above the level of the perch.

In panel 6, the first upstroke wing recovery of the flight is in progress, with slight asymmetry of the left and right sides, indicating that the bird is planning a change of direction. It is moving its legs forward, to stow them under its breast feathers, improving its drag profile.

K.D. Earls from Brown University

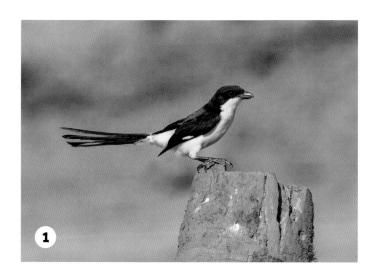

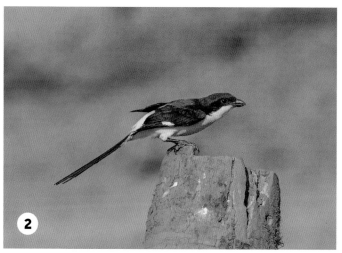

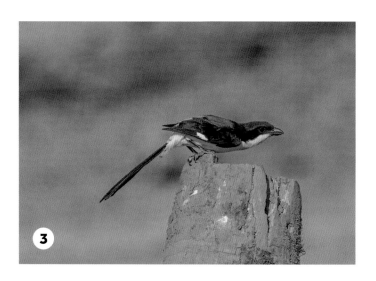

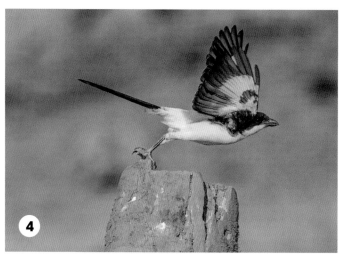

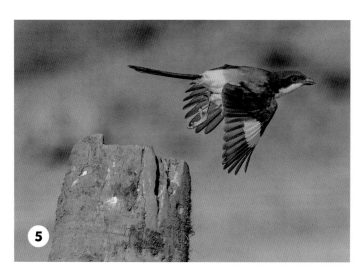

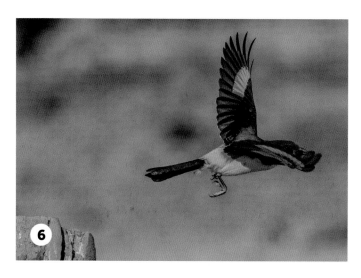

A typical passerine takeoff from a perch by a Long-tailed Fiscal (*Lanius cabanisi*).
Amboseli National Park, Kenya. October. IUCN category: Least Concern

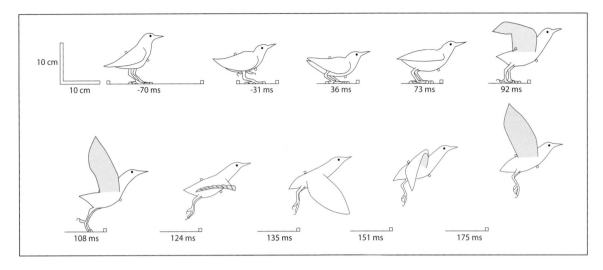

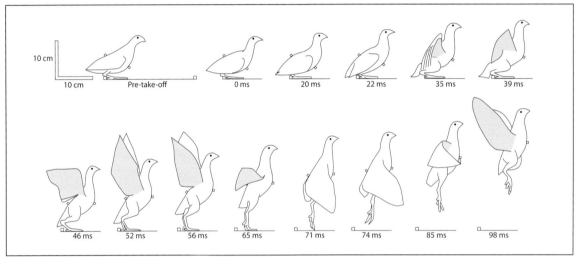

Tracings from the ground takeoff of a lab-trained European Starling (*Sturnus vulgaris*), top, and a Common Quail (*Coturnix coturnix*), below, with markers attached to track motion. The time is in milliseconds (¹⁄₁,₀₀₀ of a second) with time zero when foot forces just exceed body weight. The quail deploys its wings earlier and has a much more vertical takeoff trajectory. Redrawn from Earls.[1]

trained European Starlings (*Sturnus vulgaris*) to take off from the ground for a lab study and found a very similar movement pattern to that of the shrike pictured on page 123.[1] Pigeons also start their first wing downstroke as their feet leave the perch,[2] although, as Angela Berg and Andrew Biewener from Harvard University discovered, a pigeon's legs are responsible for only about one-quarter of its takeoff thrust. Earls also studied the Common Quail (*Coturnix coturnix*), which has a much

more vertical trajectory and earlier involvement of the wings, possibly because quails typically forage in deeper vegetation than starlings and need more vertical velocity to clear the terrain.

A powerful technique for separating the contributions of the feet from those of the wings in relation to velocity at takeoff is the aerodynamic force platform (see page 119). The diagram at the top of page 125 shows the takeoff forces from the legs and wings separately for a Pacific Parrotlet (*Forpus*

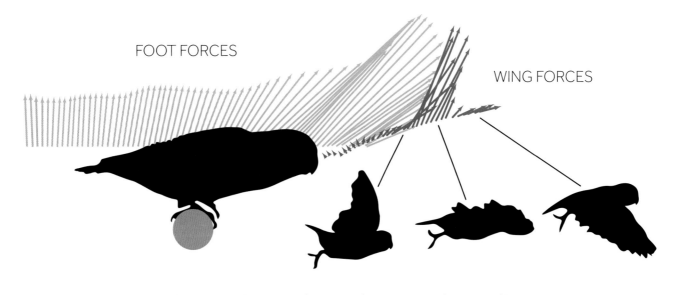

FOOT FORCES

WING FORCES

Sequential force vectors for leg forces (gray arrows) and wing forces (blue arrows) from a Pacific Parrotlet (*Forpus coelestis*) taking off inside an aerodynamic force platform. Note that the foot forces dominate early on, followed by wing forces during the first down wingbeat. Vectors show the size and direction of the forces. The black lines from the three posture sketches point to the corresponding wing forces. The vectors are arranged on a line representing the trajectory of the eye. Redrawn from Chin and Lentink.[3]

coelestis) taking off inside the platform volume. The results emphasize the legs-before-wings strategy for takeoff. One difference in the wild is that the perch may not be as rigid as in the lab, so some of the bird's energy at takeoff will be spent on deforming the branch rather than propelling its body.

Earls also measured the starlings' and quails' leg forces, and they peaked at a remarkable 4.3 and 7.3 times the birds' body weight, respectively. Some perching birds cannot generate such powerful leg thrust, and they must rely more on their wings for takeoff forces. The Latin name for the order to which hummingbirds belong — Apodiformes — is roughly translated as "footless ones." As one would expect, a hummingbird's takeoff relies more on its wings than its feet.

Bret Tobalske and his colleagues studied the takeoff of Rufous Hummingbirds (*Selasphorus rufus*) in the

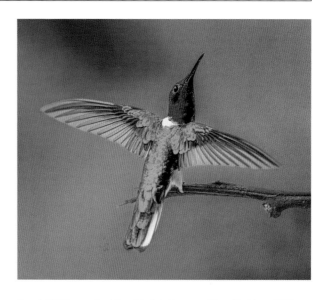

A male White-necked Jacobin (*Florisuga mellivora*) taking off. The reduced contributions from the feet and legs are apparent, since the bird is using wing lift while its feet are still firmly grasping the branch. Costa Rica. April. IUCN category: Least Concern

lab using a force-measuring perch.[4] Surprisingly, the bird's small legs and feet still played a role. The birds showed a countermovement "crouch," flapped their wings several times before

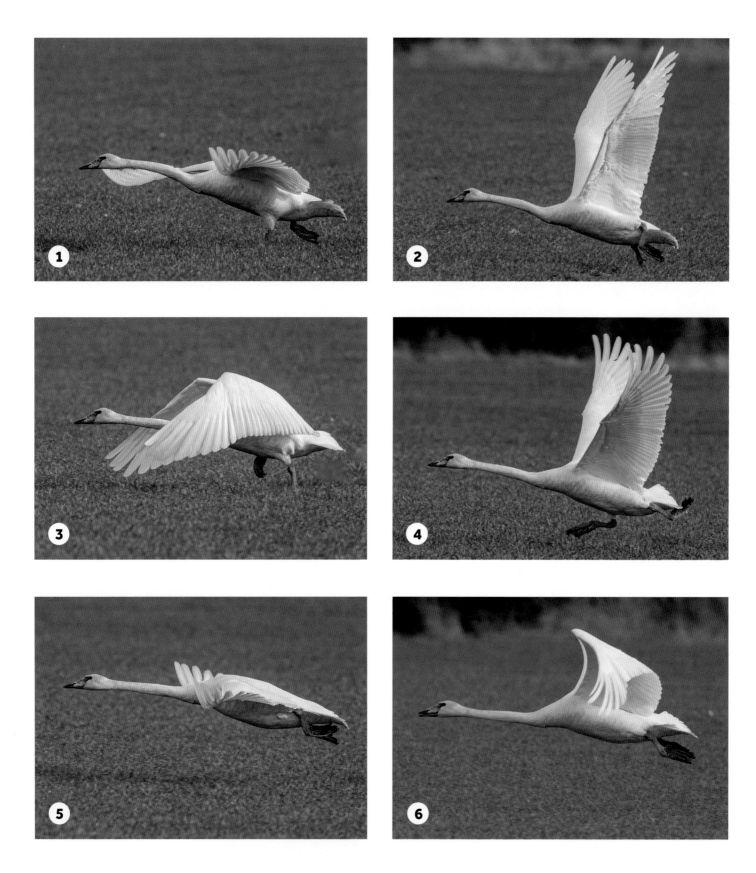

The dash to get airborne of a Trumpeter Swan (*Cygnus buccinator*).
Skagit County, Washington, USA. January. IUCN category: Least Concern

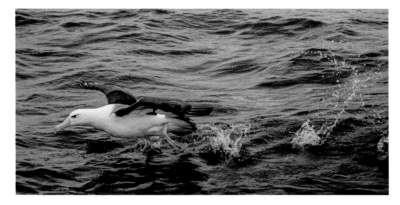

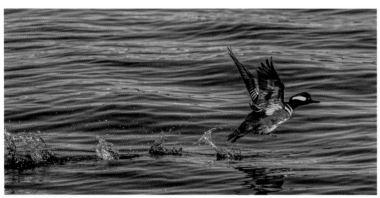

Splashes in the water show footfalls as an albatross (top) and a merganser (above) struggle to get airborne. Note that the albatross's tail is also deployed to add lift.

Black-browed Albatross (*Thalassarche melanophris*)
Westpoint Island, Falkland Islands. January. IUCN category: Least Concern

Hooded Merganser (*Lophodytes cucullatus*)
San Juan Islands, Washington, USA. April. IUCN category: Least Concern

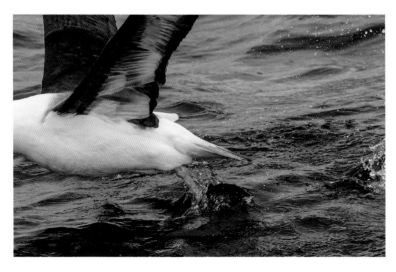

The Black-browed Albatross's foot is submerged as it runs in the water to take off.

leaving the perch, and shared the contribution to takeoff speed about equally between their legs and wings. When taking off was urgent, for example, in response to a startle, the wings played an even greater role.

Running and Flapping

The sequence of images on page 126 shows one of the heaviest waterfowl in North America, the Trumpeter Swan (*Cygnus buccinator*), working really hard to get added thrust and more than 11.3 kg (25 pounds) of lift from its furiously flapping wings, which incidentally have up to 26 secondary feathers.

A running takeoff is obviously extremely costly for the bird from an energy standpoint. The trade-off between the energy cost of takeoff and the expected benefit of food at a new foraging site is likely always part of the calculation as a Trumpeter decides whether to stay or to fly. Anecdotally, I often see Trumpeter Swans in winter foraging in the same place for long periods of time, preferring energy input over energy expenditure.

Running in Water

Birds that roost or feed on water do not always have the luxury of solid ground for takeoff. When these birds either want or need to get airborne from the water, they vigorously flap their wings and slap their feet against the water to gain the speed required for liftoff. It is often a lengthy and laborious process — as the many splashes behind the Black-browed Albatross (*Thalassarche melanophris*) and Hooded Merganser (*Lophodytes*

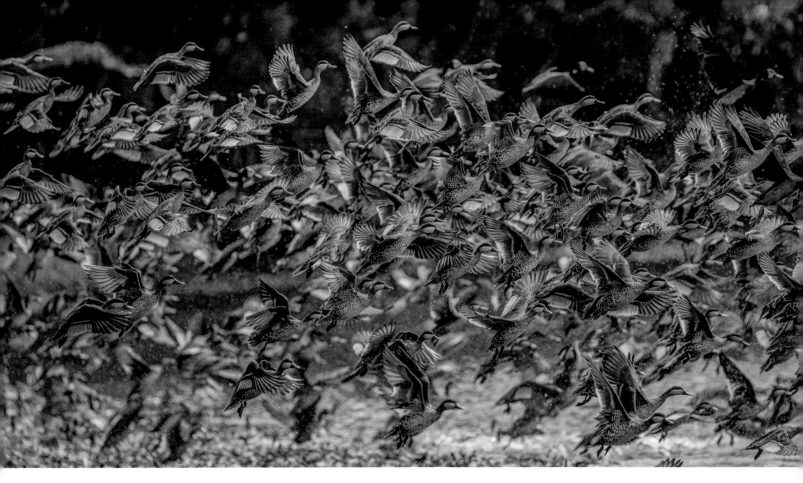

A flock of Red-billed Ducks (*Anas erythrorhyncha*) rise from shallow water on a lakeshore.
Antananarivo, Madagascar. September. IUCN category: Least Concern

cucullatus) on page 127 show. A recent study has shown that Snowy Albatrosses "run" for an average of about five seconds over water before getting airborne. In calm conditions, it may take a run of more than ten seconds for the bird to develop sufficient lift. Zooming in reveals that the albatross's large webbed foot is completely submerged during at least some of its footfalls. This is also what happens in the most celebrated example of water running — the Plumed Basilisk Lizard (*Basiliscus plumifrons*), sometimes called the Jesus Christ Lizard — and the water-running mating behavior of some grebes.

These animals actually run "in" the water rather than "on" it. A study using complex hydrodynamic modeling has shown that the initial slap of the foot on water creates both a large vertical force

and an air bubble that helps support the foot as it sinks in the water.[5]

Near-vertical Takeoff in Ducks

When they need to, many birds, including some ducks, quails, and tinamous, can very quickly launch themselves from land or water by taking off almost vertically. This means of rapid escape is possibly an evolutionary adaptation that helped them survive birds of prey when foraging on water or open land in plain sight of predators. Watching a flock of ducks rise from the water is an astonishing multisensory experience. There must be collisions, or at least wing contacts, but they are not apparent to the casual observer.

The takeoff of the ubiquitous Mallard (*Anas platyrhynchos*) has been studied in the laboratory by Kari

A composite illustration of an Atlantic Puffin (*Fratercula arctica*) taking off from a cliff top. After a vigorous leg thrust to push off without a wing downstroke, the bird starts a downward plunge with outstretched wings, picking up speed and lift. (The horizontal scale has been increased to separate the images.)
Látrabjarg, Iceland. May. IUCN category: Vulnerable

Taylor-Burt and Andrew Biewener at Harvard, and they have made videos of ground and water takeoffs.[6] These videos make for fascinating viewing: From solid ground, a countermovement is followed at liftoff by a horizontal sweep of the wings — a great demonstration of the development of lift without any thrust. The feet are also involved in an aquatic takeoff: From a forward starting position with its feet up against its belly, the bird sweeps its feet backward while driving its tail forcefully down into the water and driving its submerged wings forward. It is an altogether superb water ballet!

Jumping Off a Cliff
I have been an avid puffin watcher for many years, taking trips to Cape Flattery in Washington, the Látrabjarg Bird Cliff on the westernmost tip of Iceland, the Outer Hebrides, and the coast of Wales to photograph these magnetically attractive birds. They are generally unconcerned by the presence of a human intruder in their domain, which in the spring and summer months is usually grassy slopes on the edge of steep cliffs.

Like a good general who always plans for a retreat, puffins make their homes where there is a significant vertical drop nearby, because their method of taking off is basically to throw themselves off a cliff, as shown in the composite illustration above. The typical takeoff protocol goes like this: The bird waddles to the very edge of a cliff and may do a few practice wing flaps,

and then, with a powerful leg extension and raised wings, it pushes off outward and upward into the void. Gravity soon starts pulling the bird down because there is not much lift being generated, and the bird is often not flapping at this point. The bird holds its body in a characteristically arched posture with its head down. The main strategy is to outstretch the wings into a gliding position. As the bird gains speed in its plunge, the lift rapidly builds and provides aerodynamic weight support, and the flight trajectory flattens out over the water. The bird also sometimes flaps its wings all the way down to the water.

Because alcids, like the Atlantic Puffin, use their wings for swimming in water as well as flying in air, their surface area is relatively small compared to the size and weight of their bodies. This means that wing loading in flight and airspeed across the wings need to be high to provide adequate lift. During steady flapping flight, the puffin flaps at a tremendously high rate compared to most other birds, increasing the speed of wing flow, and therefore lift, across its wings.

The Mechanics of Landing

What Is a Good Landing?

There is a hackneyed saying among airplane pilots (sometimes attributed to Chuck Yeager) that a good landing in an airplane is one that you walk away from, while an excellent landing is one where the aircraft can be used the next day. Birds so rarely make landing errors

that we can propose a more biomechanically rooted definition of a good landing for birds: A good bird landing is one where a bird's feet reach the water, ground, or perch with minimum forward and vertical speed.

Since a bird's only brakes before touchdown are aerodynamic forces, it uses its wings, tail, body, and direction of flight in creative ways. Bird landings have been described as a process of collision avoidance, and a number of mathematical models have been proposed to account for their approach trajectories. One important control construct, called tau theory, is based on optic flow — the size on the retina of objects in the landing field of view. The control of landing in different birds can be modeled using this approach.[7] On a practical level, information from research studies and the keen observations of bird-watchers have led me to formulate a few rules for landing that birds seem to follow.

The Rules for Landing

If there were a flight school for birds, my guess is that the following five rules would be top of the curriculum in the Landing 101 class.

Rule No. 1: Land into the Wind

If you get the chance to watch a small flock of geese that has found a rich food source on a windy day, look at the approach of their conspecifics flying in from an upwind location. They will fly fast toward the group, go past it, and then execute a 180-degree turn, joining the group by landing in a direction

Ruffled covert feathers along the edges of the right wing of this Bald Eagle (*Haliaeetus leucocephalus*) indicate the turbulent flow around the wing as the bird stalls for landing.
Haines, Alaska, USA. November. IUCN category: Least Concern

that faces the oncoming wind. This is because the headwind reduces their ground speed, bringing the landing speed closer to the minimum forward speed criterion. In the limit, a head-wind of 32 km/h (20 miles per hour) and an airspeed into the wind of 32 km/h (20 miles per hour) will reduce ground speed to zero. A fascinating study has shown that birds prefer to land in either direction along an approximately north-south magnetic axis in calm conditions (see page 139).

Rule No. 2: Modulate Wing Lift
Birds will attempt to modulate their wing lift until it is almost equal to their body weight at touchdown so that there is no downward acceleration, which could cause a hard landing. They achieve this either by hovering or, more typically, by increasing their angle of attack until their wings are in a near-stall condition. Stall occurs when the smooth laminar flow over the wings is disrupted and eddies of turbulent air arise. You might be surprised to know that aircraft are close to a near-stall condition on landing, and it is not uncommon to hear the stall warning horn blaring just before the wheels of a light plane touch down on the runway. In a near-stall condition, flight control is reduced, and so this part of the flight envelope needs to be approached with caution.

Positioning the Feet for a Landing

An Atlantic Puffin (*Fratercula arctica*) makes sure its feet are
front and center in anticipation of a cliff-top landing.
Isle of Staffa, Scotland, UK. July. IUCN category: Vulnerable

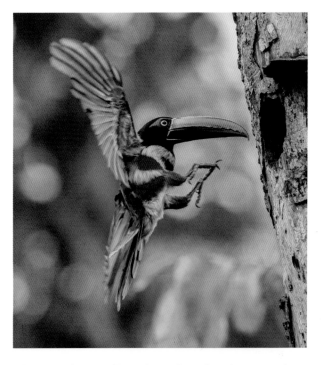

A Fiery-billed Aracari (*Pteroglossus frantzii*) ready to grasp the
edge of its nest cavity.
Osa Peninsula, Costa Rica. May. IUCN category: Vulnerable

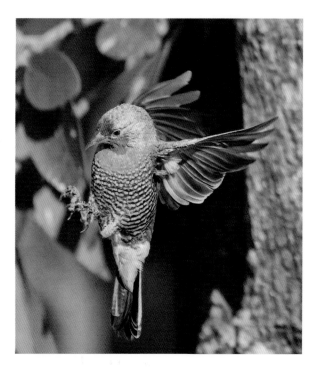

A Green-winged Pytilia (*Pytilia melba*) flies in to perch
at a feeder.
Erongo, Namibia. September. IUCN category: Least Concern

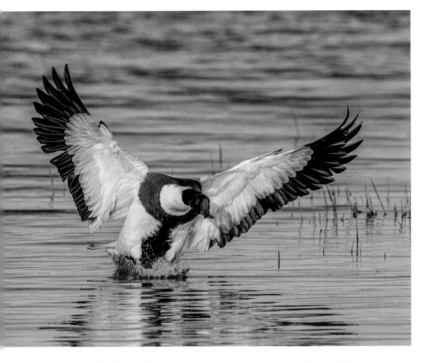

A Common Shelduck (*Tadorna tadorna*) water-skis on landing with its alula feathers deployed. Norfolk, UK. April. IUCN category: Least Concern

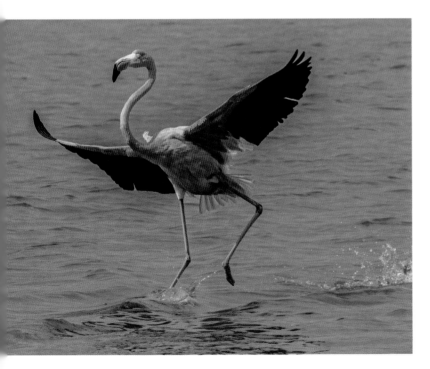

Waders, such as this American Flamingo (*Phoenicopterus ruber*), prefer to land in water that they know to be suitably shallow and then "walk out" of the landing, braking with their wings and legs to lose momentum.
Floreana Island, Galápagos Islands, Ecuador. October.
IUCN category: Least Concern

Rule No. 3: Get the Landing Gear Down

This rule is also important for pilots of retractable-gear aircraft: Get the landing gear down and locked. For birds, the goal is to position their anatomically different feet so they're ready for interaction with the landing substrate.

Water landings deserve additional points for difficulty because incorrect placement of the feet could generate large hydrodynamic forces and destabilizing moments. Ducks, geese, and swans water-ski on landing, surfing on their webbed feet until they gradually sink into a swimming position. Waders, which usually have separated long, narrow toes, will generally land in water that they know to be sufficiently shallow and will walk forward out of the landing to brake and lose momentum. Although flamingos have webbed feet, they land in water with their feet folded, using a typical wader landing, because their long legs allow them to touch the bottom in quite deep water.

Rule No. 4: Swoop Up to the Perch

A very good way to bleed off speed before landing is to glide up toward a perch. I often have the opportunity to watch Pelagic Cormorants (*Urile pelagicus*), which are masters at this kind of landing. These birds nest and perch on top of the pilings along the ferry dock in Anacortes, Washington, about 6 m (20 feet) above the water. Their approach to landing is to fly just above the water and then abruptly swoop up to the perch with the goal of landing at zero vertical speed.

This bird takes the kinetic energy

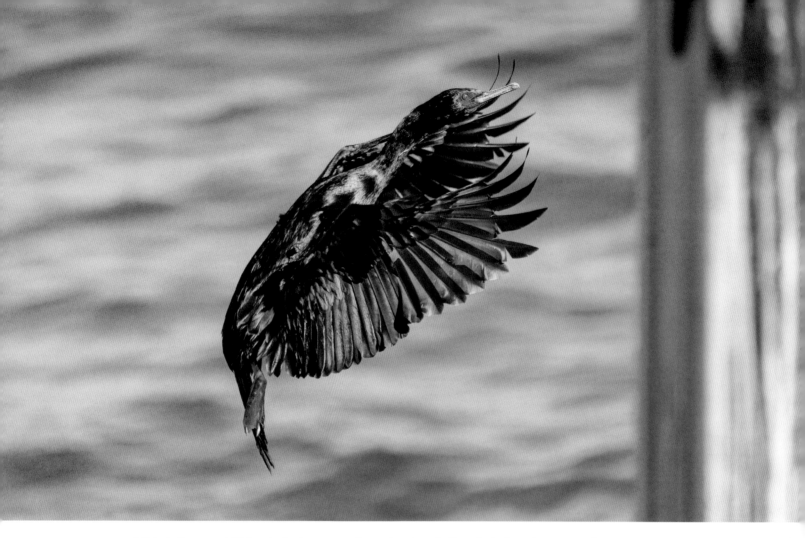

A Pelagic Cormorant (*Urile pelagicus*) swoops up to perch on top of a ferry dock after a long approach at water level. It has transferred the kinetic energy of its approach at speed to potential energy.
Anacortes, Washington, USA. June. IUCN category: Least Concern

from its fast approach and converts it into potential energy, stalling out just before landing. With some simple assumptions we can calculate that to reach the 6-m (20-foot) high perch, the bird needs to approach at a speed of 10.9 m/s (about 24 miles per hour), which is well within its capabilities.[8] A similar calculation predicts that if the bird flew the approach at its maximum speed of 15 m/s (about 33 miles per hour), it could reach a perch 11.3 m (37 feet) off the water.

This form of landing has been studied by Marco Klein Heerenbrink and his colleagues at the University of Oxford, UK, in Harris's Hawks (*Parabuteo unicinctus*) that were trained to fly between two perches.[9] They found that the control strategy in a swoop-up landing involves minimizing the time between stalling and landing. This is understandable, since control during slow flight after a stall is difficult. I have noticed that when a cormorant's target perch is occupied and it peels off its approach at the last moment, it sometimes scrambles, flapping energetically and diving, to gain control and generate lift.

Rule No. 5: Apply the Brakes
The final landing rule is key to reducing landing speed, preventing overshoot on

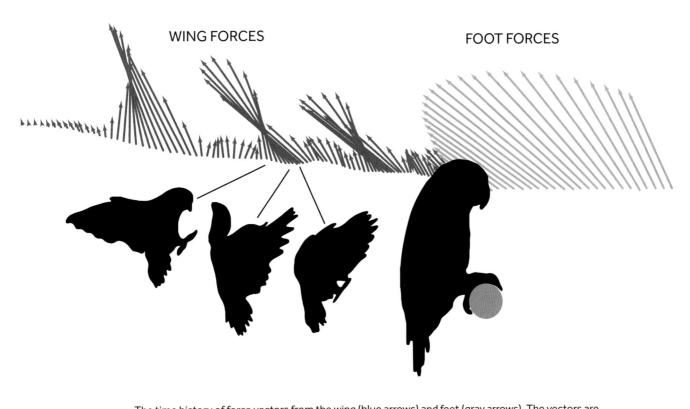

The time history of force vectors from the wing (blue arrows) and feet (gray arrows). The vectors are arranged along the trajectory of the bird's flight (taken as the instantaneous position of the eye). The three tracings of the bird's posture represent the middle cycle of three braking wingbeats before contact with the perch. The black lines point to the corresponding wing forces. As the wings start their forward sweep (left), the wing force vector begins to point backward, showing that it is a braking force. This force increases in size and backward slope until wing recovery starts for another braking stroke (right). Notice also that the tail is deployed. Redrawn from Chin and Lentink.[3]

a ground or water landing, and minimizing rotation when landing on a perch. We can visualize how this works by looking again at results from the aerodynamic force platform (see page 119).[3]

Diana Chin and David Lentink, who conducted the experiment, describe what is happening as "repurposing" lift. These forces cause the bird to bleed speed from the approach. On hitting the perch, the foot force increases rapidly, not only supporting the body weight but also continuing the braking action, as shown by the backward orientation of the force vectors. In this landing the contribution of the wings and feet to the braking action was determined to be 25 percent and 75 percent, respectively.

You will notice that the parrotlet in the sketches above has a much more upright posture in the approach-to-landing phase than during flight. Most birds do this: It gets their feet out front, increases profile drag, which contributes to braking, and prepares them for a balanced posture once safely on the perch.

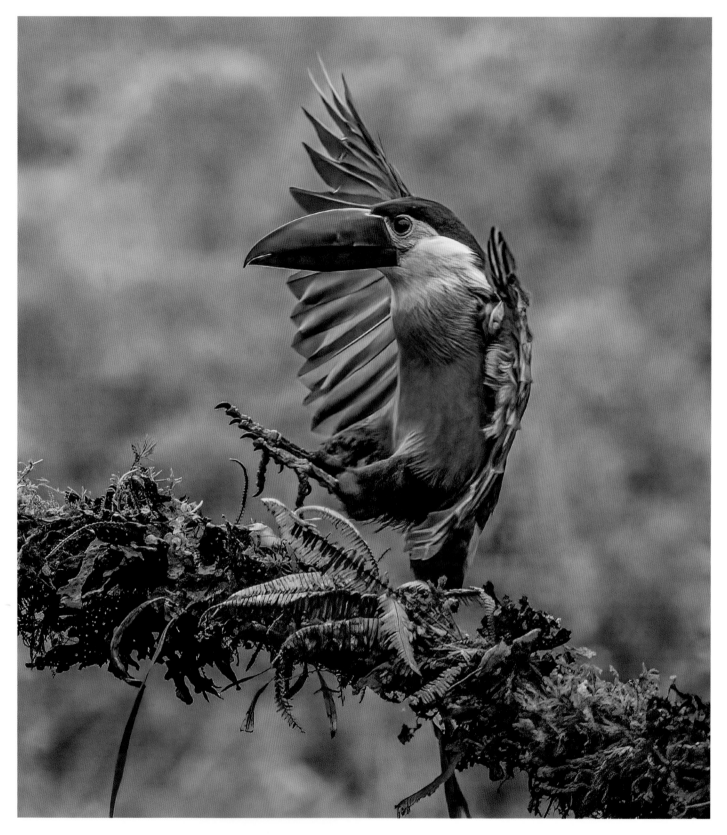

A Black-billed Mountain Toucan (*Andigena nigrirostris*) with the brakes fully on, having just completed a braking wingbeat and maneuvered its body into an upright posture.
Villamaria, Colombia. January. IUCN category: Least Concern

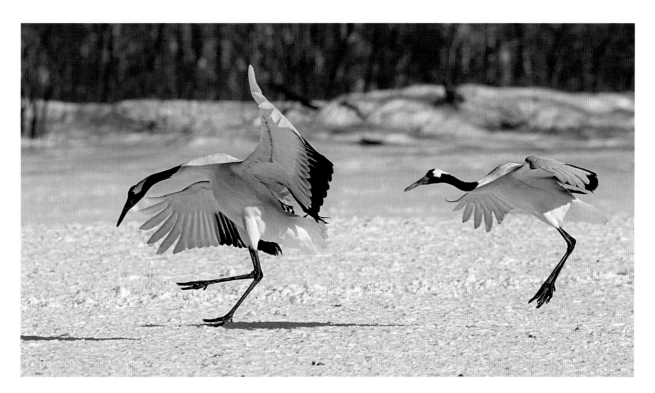

A pair of Red-crowned Cranes (*Grus japonensis*) in different stages of landing, showing the transition in wing use as touchdown approaches. The trailing bird, on the right, is still reducing its vertical speed with lift from its wings, and so its body is more horizontal. The bird on the left has made ground contact and urgently wants to reduce its forward speed, so its body is upright to increase the frontal area (and profile drag), and its wings are swept forward, with a high angle of attack, to apply braking forces.
Tsurui Crane Center, Hokkaido, Japan. January. IUCN category: Vulnerable

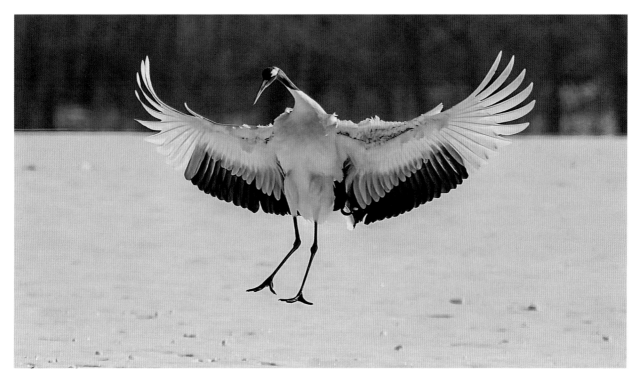

A front view of the end of a Red-crowned Crane's (*Grus japonensis*) braking wingbeat just before touchdown.
Tsurui Crane Center, Hokkaido, Japan. January. IUCN category: Vulnerable

Grasping the Perch

Landing on a perch has been one of the most challenging tasks for bird-inspired robots to achieve, although a robot that can do this has recently been built (see pages 266–69). This speaks to the complexity of a task that requires the integration of visual, sensory, motor, navigational, and predictive capacities. Wind conditions can also have a major impact on the approach to landing. Birds depend on their claws to correct for any undershoot or overshoot of the perch and to cope with the frictional conditions that they find on landing. These post-landing adjustments have been studied in the lab by William Roderick and his colleagues at Stanford University.[10] A fascinating part of the adjustment is that, if friction is inadequate, the birds will rotate their grip until they come to a stop on surface asperities.

Slow but Steady: Using the Thumb Wing

The alulae, or "thumb wings," are not the most frequently used component of a bird's flight equipment: I have taken more than 800,000 images of birds in flight, and the alulae are deployed in just a tiny fraction of them. We now know from advanced aerodynamics experiments that the deployed alula feathers induce a swirling vortex of air called a leading-edge vortex (LEV).[11] The vortex trails across the upper surface of the wing (see page 101), keeping the flow attached, increasing the lift force, and enhancing control at high angles of attack.

This Tropical Kingbird (*Tyrannus melancholicus*) is holding its wings with a high angle of attack, with its claws ready and its alulae partially deployed as it prepares for an imminent touchdown.
Sittee River, Belize. December. IUCN category: Least Concern

A Bald Eagle (*Haliaeetus leucocephalus*) with its claws at the ready just before touchdown on a "helicopter" landing into a stiff headwind.
Lopez Island, Washington, USA. November. IUCN category: Least Concern

Do birds land by compass?

THE QUESTION	In calm conditions, do flocks of waterbirds have a preferred landing direction?
THE AUTHORS	Vlastimil Hart, Erich Pascal Malkemper, Tomáš Kušta, Sabine Begall, Petra Nováková, Vladimír Hanzal, Lukáš Pleskač, Miloš Ježek, Richard Policht, Václav Husinec, Jaroslav Červený, and Hynek Burda from the Czech University of Life Sciences, Czech Republic.
THE SOURCE	"Directional Compass Preference for Landing in Water Birds," *Frontiers in Zoology* 10, no. 3 (2013), PMID: 23835450, DOI: 10.1186/1742-9994-10-38.
THE HYPOTHESIS	The direction of magnetic field lines may serve as a landing direction indicator.
THE EXPERIMENT	The investigators recorded and analyzed landing directions of 3,338 flocks in 14 species of waterbirds in eight different countries. 70% of the birds studied were Mallards (*Anas platyrhynchos*). Observations were made primarily on standing bodies of water and only in relatively calm conditions (maximum light breeze), so that wind direction was eliminated as a factor. Flight directions were estimated to the nearest 5 degrees by means of handheld compasses.
THE RESULTS	The preferred landing directions averaged 3 and 183 degrees.

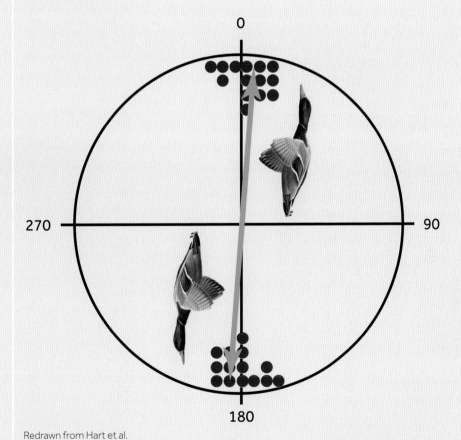

Redrawn from Hart et al.

- Thirteen of the 14 species studied showed bimodally distributed landing directions.
- The mean landing direction vector of all species fell with the geomagnetic north-south axis, with preferred landing direction of either 3 or 183 degrees.
- The direction of landing did not change in relation to the position of the sun.
- Magnetic north is a better predictor of landing direction than true north.

THE CONCLUSIONS	"Water birds landing on the water surface under windless conditions prefer to land roughly along the geomagnetic north-south axis, irrespective of the direction of arrival. A common [landing] direction may facilitate flock formation in an escape context and may be of significance to prevent collisions."

> When the bird rises in circles above the wind, without beating its wings, using the ascending currents, it will be carried far from the area to which it wishes to return.
>
> — LEONARDO DA VINCI (CA. 1545)

Gliding and Soaring

COLIN (C.J.) PENNYCUICK WAS A BRITISH BIOLO-gist with a passion for bird flight. He worked in Kenya and at the Serengeti Research Station in Tanzania between 1968 and 1972. The Serengeti was a bird scientist's utopia, with storks, vultures, eagles, pelicans, flamingos, and many other birds living in, or migrating to, the famous Ngorongoro Crater, rising high above its luminous African skies.

Pennycuick wanted to know how these birds soared, how often they flapped their wings, how much energy they saved, how they communicated with each other, and how they glided between neighboring columns of rising air. At the time, there were no miniature data-loggers to track the location and elevation of birds, so Pennycuick leveraged his experience as a pilot in the Royal Air Force and got up among the birds, eye to eye, in a motorized glider (a Schleicher ASK-14). His observations were groundbreaking at the time and are still relevant today, in the age of miniaturized mobile electronics.[1]

Gliding

Gliding Is All Downhill

As we learned from the Gimli Glider, a gliding plane cannot go on forever, and the same is true for a gliding bird. Although birds

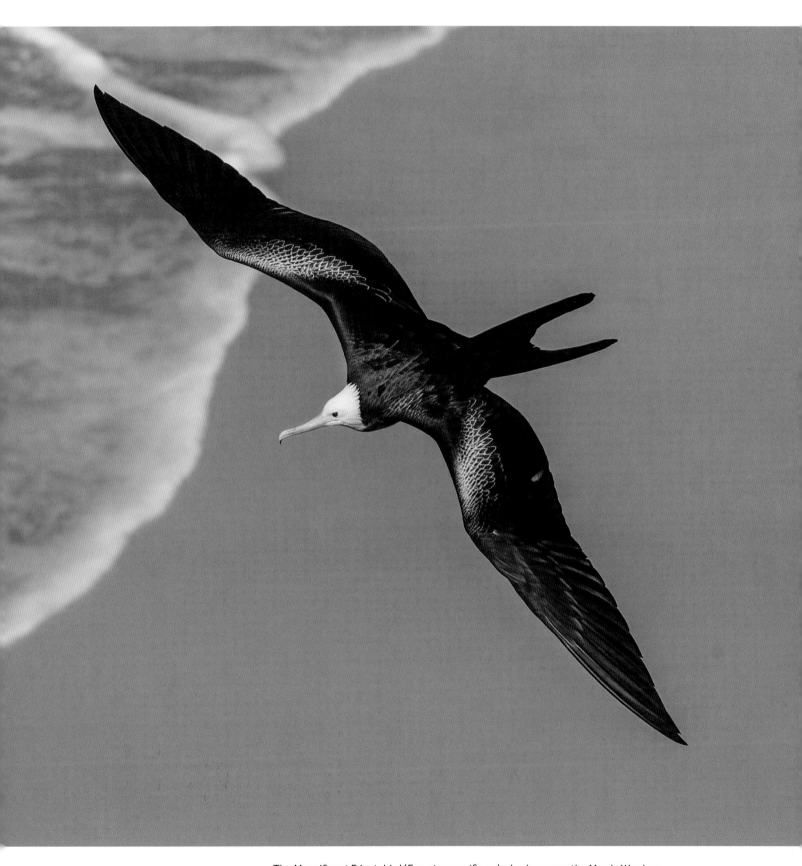

The Magnificent Frigatebird (*Fregata magnificens*), also known as the Man 'o War, has
low wing loading and a high aspect ratio wing, making it a master glider and soarer.
Fernando de Noronha, Brazil. November. IUCN category: Least Concern

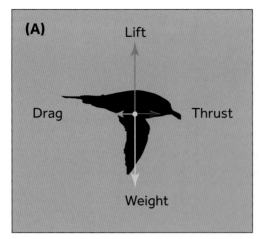 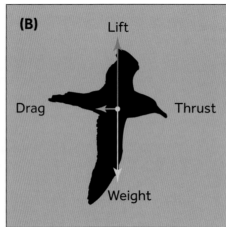 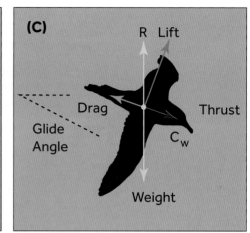

Forces on a Light-mantled Albatross (*Phoebetria palpebrata*) during the transition from flapping to gliding. Panel A depicts steady-speed, level flapping flight; B shows the instant the bird stops flapping and transitions to gliding; C shows a gravity-powered descending glide. (See text for details.)
Elsehul Bay, South Georgia. November. IUCN category: Near Threatened

glide often, most glide for only brief periods, with notable exceptions such as some petrels, frigatebirds, and albatrosses, who make a good living from gliding, flap-gliding, and dynamic soaring. Soaring birds also make long glides between thermals when soaring along a thermal "street." Pennycuick defined gliding as "a state in which no propulsive power is supplied by the bird's muscles." To understand why gliding in still air inevitably involves a decrease in altitude or a loss of speed, let's consider the forces on the near-threatened Light-mantled Albatross (*Phoebetria palpebrata*) that I encountered on Elsehul Bay in South Georgia. (See the diagram above.)

In panel A, the albatross is momentarily in equilibrium during steady-speed, level flapping flight. There is no net force acting on it because gravity is balanced by lift and drag is balanced by wing-generated thrust.

Panel B illustrates the instant when the bird stops flapping for a transition to gliding. The lift is still equal to the bird's weight, the drag is approximately the same as it was during flapping, but

the thrust is no longer present, since the bird has stopped flapping its wings. The "engine" has been turned off, and the net force acting on the bird is now the force of drag. The albatross will therefore start to slow down, which will decrease lift, causing a loss in altitude.

The bird now has two options available. Option one is to increase its angle of attack to generate enough lift to maintain altitude. More lift is accompanied by more drag, so the bird will lose even more forward speed and eventually stall. Option two is to pitch down and begin a steady downward glide, as shown in panel C. There are two arrows on this panel that need explaining. The first, labeled R, is the resultant of lift and drag acting upward to support the bird's body weight. The second is a component of weight along the glide angle, labeled C_w, and it is this force component that is driving the descent, providing opposition to the drag force. A good analogy is a ball rolling down a slope. Even though gravity always acts vertically, it has a component along the slope that is the "engine" of the glide.

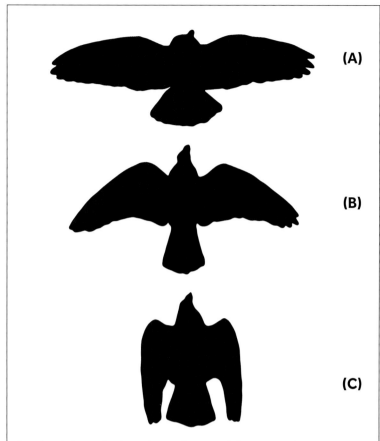

Overhead views of a pigeon in steady-state gliding in a wind tunnel at increasing speeds. This wing morphing decreases lift, resulting in a steeper glide. **(A)** 8.6 m/s (19 mph). **(B)** 13 m/s (29 mph). **(C)** 22 m/s (49 mph). Redrawn from Pennycuick.[3]

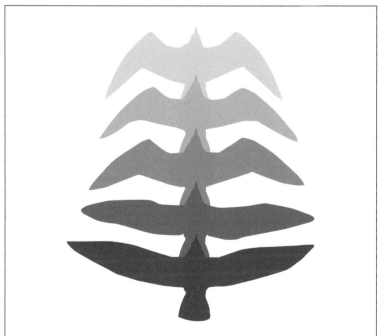

Outlines of gulls gliding at different speeds, showing how they can flex their hand wing to change their wings' characteristics. The fastest speed is at the top. Redrawn from Harvey et al.[2]

A steady gliding speed is reached when the drag force, which increases as the bird gains speed, becomes equal to (and opposite) the force C_w, as it is in the illustration.

The glide ratio at a given speed under steady conditions always equals the lift-to-drag ratio. This number is well defined for airplanes because, unless the pilot deploys the flaps or adjusts the trim, both of these quantities are known. The Wright brothers plotted the lift-to-drag ratio at various angles of attack over a range of speeds for many wing sections. A bird, however, can change lift and drag, and consequently their ratio, at will by morphing its wings or deploying its tail. Data are available for a standard configuration of wings fully extended and tail stowed, and maximum ratios between 10 and 20 are typical for birds. This implies glide angles between 4.8 and 5.7 degrees, respectively. The best interpretation of a glide ratio of 20 is that for every 20 units of movement across the ground, the bird will lose one unit in height.

Glide Angle and Glide Speed

A bird can choose whatever glide angle it needs to perform a given task, even pitching down to the steep stoops performed by Peregrine Falcons, which have been estimated to reach speeds of more than 240 km/h (150 miles per hour). Birds can achieve a steeper glide angle by morphing their wings to decrease both lift and drag (see top left illustration). C.J. Pennycuick also built a wind tunnel, which was the source for the illustration at the top left of a pigeon

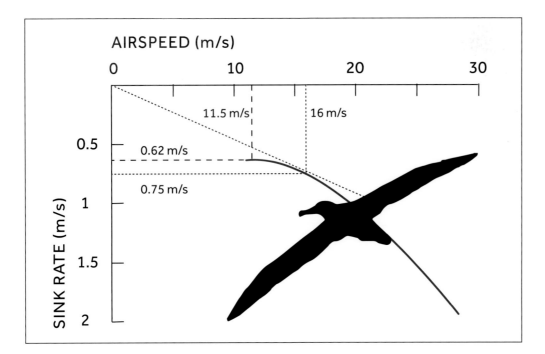

This glide polar for a Snowy Albatross shows the sink rate for different speeds of gliding. The minimum sink rate is 0.62 m/s (about 1½ mph) at an airspeed of 11.5 m/s (about 26 mph). The bird will spend the longest time in the air when gliding at this speed with a glide ratio of 18.6:1. At a speed of 16 m/s (about 36 mph), the albatross can travel the greatest distance over the ground. Data from Pennycuick.[4]

gliding at different speeds. As the glide angle gets steeper, the speed along the path and sink rate both increase. This raises an important question relevant to both birds and airplanes: Why didn't the Gimli Glider pilot just increase the glide angle of the plane, increasing speed so he could get to a landing site quicker? The answer is that there is a best glide speed, which will take a gliding flier as far as possible (this is the speed the Gimli Glider pilot used), and a related speed that will keep it in the air as long as possible.

What Is the Best Glide Speed?

I have never had to glide into an emergency landing because of engine failure, but on several occasions during flight training, my instructor leaned over, turned the engine off, and calmly announced: "Now land the plane." After a few seconds of getting used to the eerie absence of engine noise and listening to the whoosh of the wind,

my trained response started to kick in: Identify a landing site, "clean up" the plane (flaps and landing gear up), and start flying the plane at the best glide speed. Then came a moment of doubt: What is the best glide speed for this airplane? Do I need to grab the emergency checklist to make sure?

In an airplane, glide speed is controlled by the elevator: pushing the nose down speeds the plane up, and pulling the nose up reduces speed. A bird can also change its glide speed by modulating the lift on its wings and pitching forward or backward. This matters because the distance a plane or bird can glide and the amount of time it can stay in the air depend greatly on speed.

To find out the best glide speed, we use the graph above, called (for odd historical reasons) a "glide polar." The curve shown here, for a Snowy Albatross, can be determined experimentally or theoretically. It plots the sink rate (i.e., the speed with which the

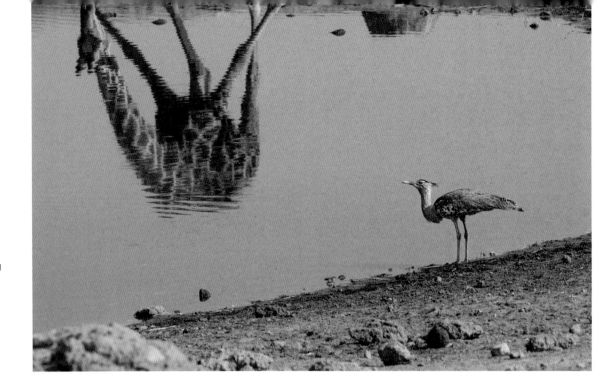

The world's largest living flying bird, a 19-kg (42-lb.) male Kori Bustard (*Ardeotis kori*), observing the reflection of a drinking giraffe. The Kori Bustard prefers walking to flying.
Etosha National Park, Namibia. September.
IUCN category: Near Threatened

bird will fall toward the ground) during gliding as a function of airspeed. The most obvious thing about the curve is that it has a hump, showing that there is a particular airspeed — 11.5 m/s (about 26 miles per hour) — at which the loss of altitude (the sink rate) is as slow as possible (called the minimum sink rate). This speed is the magic number I was looking for during the simulated engine-out if my goal was to stay airborne for the longest time (for example, if trying to solve an on-board failure) in the absence of helpful rising air. There is a faster speed for the albatross — 16 m/s (about 36 miles per hour) — that will provide the longest distance for a glide, with a glide ratio of about 21:1.[5] Heavier birds will need a higher speed to generate lift to support their weight, but this will not change the glide ratio for similar wings.

What Makes a Bird a Good Glider?

Lift divided by drag can be considered the efficiency of the wing.

High-efficiency wings have a high aspect ratio. Birds that are good gliders, like albatrosses, tend to have high-efficiency wings. High aspect ratio wings have lower induced drag than low aspect ratio wings with a similar area. Aerodynamically, this is related to the flow of air that occurs around the end of the wing from the bottom surface to the top surface, which is driven by the pressure gradient from under the wing, which is higher than the pressure above the wing. This effect is what causes the shedding of wingtip vortices.

Was the Largest Flying Bird That Ever Lived a Glider?

Many people have speculated regarding the maximum size of a bird that could still fly and whether that flight might have been limited to gliding rather than flapping. Currently, the heaviest living bird that flies (albeit only occasionally) is the Kori Bustard (*Ardeotis kori*), shown above, which weighs in at 19 kg (42 pounds). I have seen this bird many

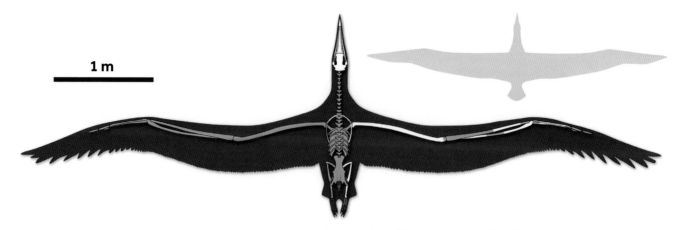

A restoration of *Pelagornis sandersi* from fossils found in Charleston, South Carolina. Preserved elements are shown in white. The outline of a Royal Albatross (*Diomedea epomophora*) with a 3-m (9¾-ft.) wingspan is shown for comparison. The scale bar is 1 m. Redrawn from Ksepka.[6]

times in southern Africa, but I have never seen it fly. It is said to be a strong flapping flier after a running takeoff.

The debate regarding flight modes in large birds was rekindled by a study of some well-preserved wing bones and a skull of a bird named *Pelagornis sandersi,* found near Charleston, South Carolina, in 1983.[6] It was estimated to have lived 25–28 million years ago and to have had a wingspan of 6.4 m (21 feet) and a body weight between 22 and 40 kg (48½ — 88 pounds).

Daniel Ksepka of the Bruce Museum in Greenwich, Connecticut, calculated glide polars for this bird using a software package written by C.J. Pennycuick and a range of reasonable estimates for body mass and wingspan. While not ruling out the possibility of powered flight by this massive bird, Ksepka found that the bird's gliding abilities matched the very best of today's gliding specialists. There is, therefore, a very high possibility that this enormous bird, however it managed to get airborne, behaved similar to albatrosses, gliding and soaring over the water to search for prey. However, authors of a competing study have asserted that *Pelagornis sandersi* was only capable of thermal soaring.

Soaring

In 2014, a group of biologists led by Olivier Duriez at the Université Montpellier in France made one of those remarkable discoveries that leaves people shaking their head and saying "That just can't be right!" They attached heart-rate logging devices to Old World vultures as they soared on thermals and found that soaring was no more costly for the birds than sitting on a perch.[7] It is no wonder that many birds use soaring while they are searching for food or migrating over long distances. It's a free ride!

Why Does Air Rise?

Rising air happens for a number of reasons, but the two most relevant to soaring birds are thermals and slope-related (orthographic) lifting. Thermals are generated from the heating of the Earth's boundary layer of air. Every hot surface heats this layer, but not all surfaces are heated to the same temperature. A plowed field with rich brown loam will be hotter than a nearby corn field, and a blacktop

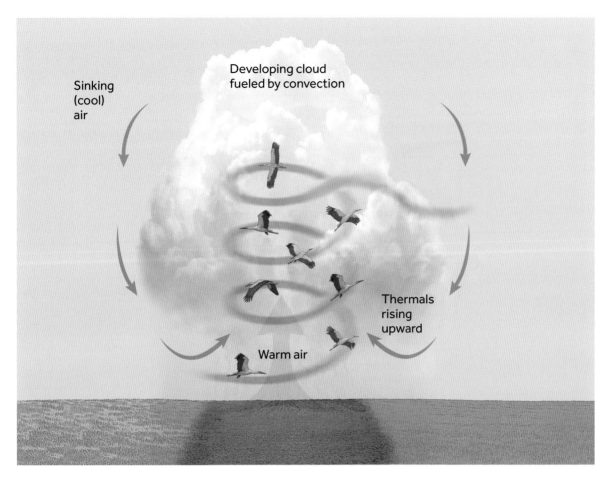

Sinking (cool) air

Developing cloud fueled by convection

Thermals rising upward

Warm air

White Storks (*Ciconia ciconia*) flying in a spiral pattern on rising air caused by uneven heating of the Earth.

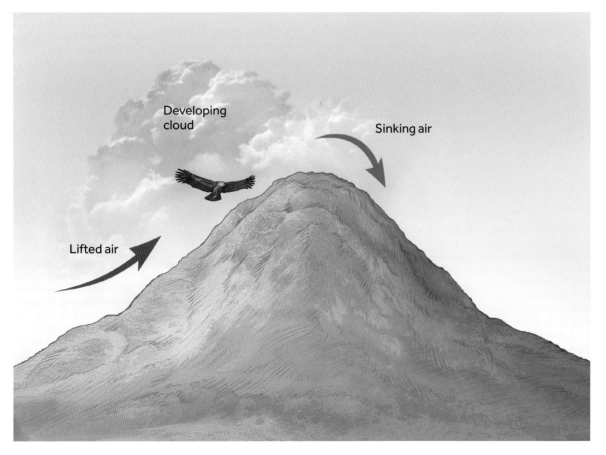

Developing cloud

Sinking air

Lifted air

An Andean Condor (*Vultur gryphus*) riding the rising air caused by air flowing over an obstruction (orthographic lifting).

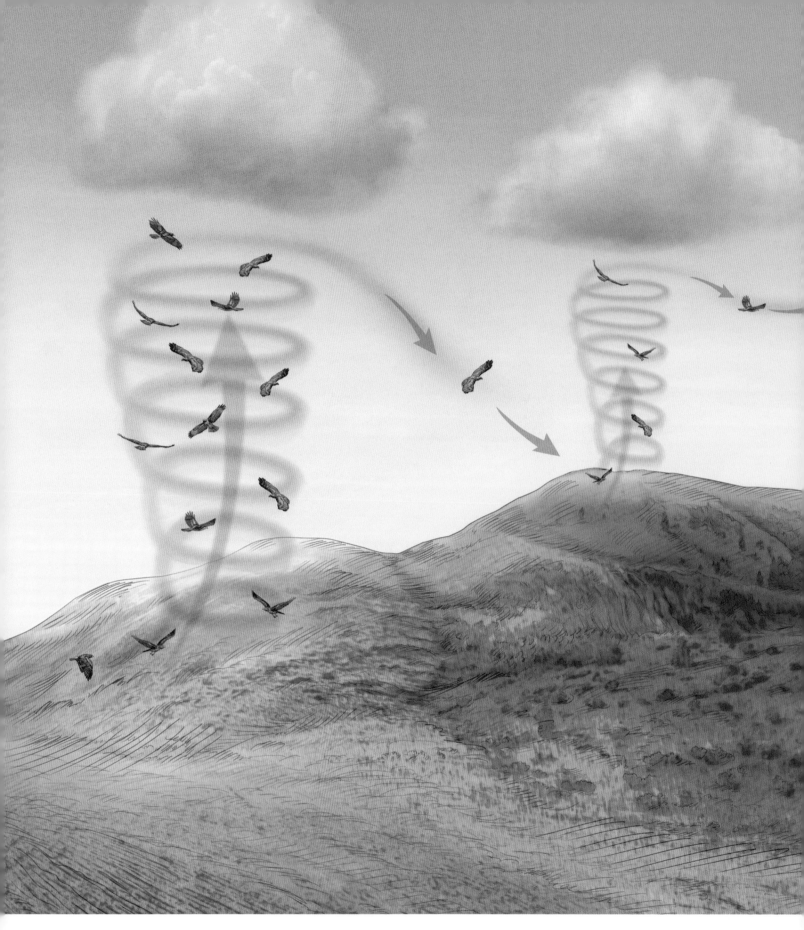

The climb-glide strategy used by migrating Red-tailed Hawks on a thermal street. After rising in a thermal by flying tight turns, the bird exits the thermal, briefly using flapping flight, and then glides to the next thermal. The bird then repeats this process as long as it can find thermals in its preferred direction of travel.

road will be hottest of all. Air above the hot spots will rise by convection, forming columns like elevators in the sky that can be ridden to gain altitude. Thermals get blown by the wind, and descending air may be present around the periphery, so they are not perfectly cylindrical columns.

Orthographic lifting occurs when a moving air mass is deflected by rising topography, such as a cliff or steep mountain. Air cools as it rises, and clouds may form above thermals or above orthographically lifted air from the condensation of water vapor, which increases as temperature decreases. Andean Condors (*Vultur gryphus*) typically nest in mountainous terrain and expertly exploit the lift provided by moving air.

Finding Thermals

Birds use several clues to find thermals. They may identify the clouds above lifting air, or they may visually assess the mosaic formed by the landscape and fly toward the darkest areas. Another method is to follow the crowd, which Pennycuick suggested was a much more efficient strategy. He identified "thermal-finding units" of White Storks (*Ciconia ciconia*) who led the way in the search for thermals.

Some confirming research on this theory was conducted by a team led by Hannah J. Williams from the University of Swansea in South Wales.[8] Five Old World vultures were tracked after being released in two waves; the first group was initially "uninformed" about the presence and location of thermals, while the second group was "informed" as

soon as they saw the other birds soaring. The newly informed birds flew faster in their glides between thermals than the initial explorers, relying on the information they presumably derived from their already soaring peers. The acquisition of information by the late-arriving birds has been called "social eavesdropping."

How Do Birds Use Thermals?

It takes a lot of skill, and the right flight equipment, to successfully exploit rising air, particularly if the column of air has a small diameter. A bird is not automatically lifted by the rising air, because gravity still acts with a downward pull. Air must be moving across the wings to generate lift. The solution that soaring birds have evolved is to fly tight circles within the rising air column, often accompanied by a small flock of conspecific or mixed species birds. The flight can be either clockwise or counterclockwise depending on conditions, and birds do change the direction of their circling while flying inside a thermal.

The tightness of a turn that a bird can fly is related to its wing loading (calculated by dividing body mass by wing area). Higher wing loading demands wider turns. Pennycuick estimated that Magnificent Frigatebirds could turn with a radius of about 12 m (39 feet), while the higher wing loading of Black Vultures and Brown Pelicans only allowed turns with a radius of about 18 m (59 feet). This may mean that the less-able birds stay on the fringes of the most rapidly rising air.

The bird will continue to fly in the thermal with outstretched wings until

it senses that the thermal is no longer assisting it. After an extended-radius circle, the bird exits the area with perhaps a wing flap or two and glides to another thermal in its preferred direction of travel (see illustration on page 148). The most favorable situation is what Pennycuick called a thermal street, in which a long line of thermals is available along a migration route. If these thermals are close enough together, then flight in a straight line along the tops of adjacent thermals is possible. This "climb-glide" soaring strategy is often seen in migrating birds.

Body Plans in Soaring Birds

Pennycuick was perplexed by the variation in the body plans of birds that depend on soaring. The silhouettes to the right show that two birds known for their extensive use of soaring and with about the same body mass are extremely different in most other respects.

Magnificent Frigatebirds (*Fregata magnificens*) have tapered, high aspect ratio wings with low wing loading, while Black Vultures (*Coragyps atratus*) have wings with emarginated primaries, lower aspect ratios, and high wing loading. Pennycuick suggested that these different body plans are compromises between the requirements for soaring and for the birds' other activities.[9] For example, frigatebirds can stay aloft for many days without landing, so the efficiency of their high aspect ratio wings and low wing loading is likely an adaptation to that lifestyle. The Black Vulture needs to land and take off from the ground as it moves between carrion sites, and its larger wings may facilitate this.

Different body plans among frequent soarers

Magnificent Frigatebird (*Fregata magnificens*)

Mass	1.52 kg (about 3½ lb.)
Wing loading	36.5 N/m² (0.08 oz./sq. in.)
Aspect ratio	12.8
Wing tip	Tapered

Black Vulture (*Coragyps atratus*)

Mass	1.82 kg (4 lb.)
Wing loading	54.7 N/m² (0.13 oz./sq. in.)
Aspect ratio	5.82
Wing tip	Emarginated

How Important Are Thermals to Migrating Birds?

The critical importance of soaring during migration was highlighted in a study of Golden Eagles (*Aquila chrysaetos*) that were migrating along the Appalachian Mountains in the eastern

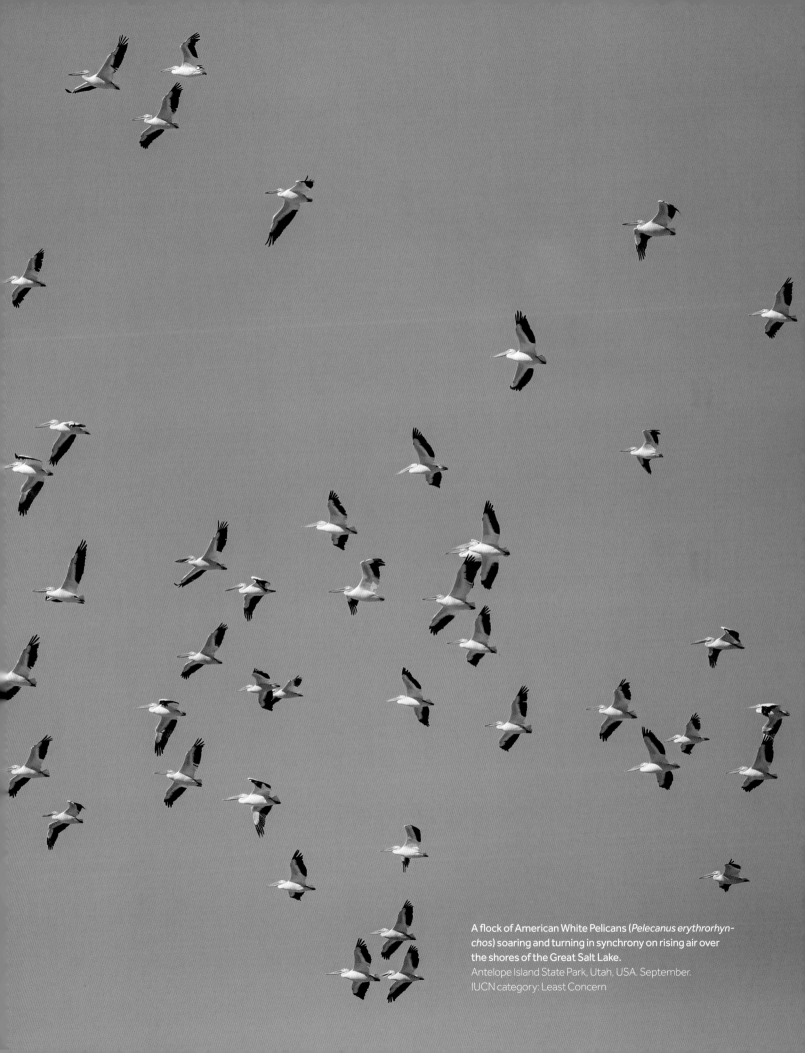

A flock of American White Pelicans (*Pelecanus erythrorhynchos*) soaring and turning in synchrony on rising air over the shores of the Great Salt Lake.
Antelope Island State Park, Utah, USA. September.
IUCN category: Least Concern

United States.[10] Using onboard GPS telemetry to classify flight behaviors, Todd Katzner and his coworkers from Swansea University in Wales and Université Paul-Valéry Montpellier in France found that the birds used a "subsidized flight" for a quite remarkable 87 percent of their journey. The breakdown is 42 percent thermal soaring, 45 percent gliding between thermals, and 13 percent flight aided by orthographic updrafts. It is not surprising that birds will choose their days, and time of day, for migratory flight, since favorable thermal and wind conditions result in massive energy savings. Thermal activity typically builds during the morning to a peak at midday before declining in the afternoon, which constrains the time of day at which many soaring birds move.

Soaring on Fast Muscles

It would seem logical that the flight muscles of all soaring birds would be dominated by slow, oxidative muscle fibers that can generate fatigue-resistant forces. This conventional wisdom was upended by a study from Ron Meyers and Joshua McFarland at Weber State University in Utah, USA.[11] These authors found that the major flight muscle (the pectoralis major) of Bald Eagles and Golden Eagles lacked a deep layer of slow-twitch fibers that is often found in soaring birds. Other shoulder muscles in these two species also had "few to no" slow-twitch fibers. This puzzle remains to be fully explained, but future research may reveal the presence of a passive wing

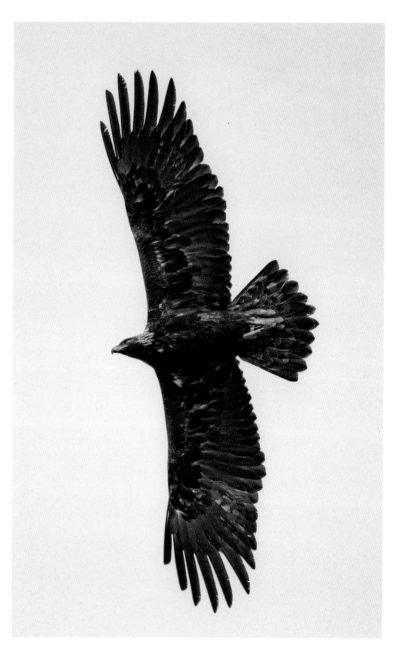

A Golden Eagle (*Aquila chrysaetos*) flying directly above the camera, showing the large wing area which it needs to soar because of its high body weight. Lopez Island, Washington, USA. April. IUCN category: Least Concern

"lock," such as that found in some albatrosses, which keeps the wings outstretched during soaring with reduced muscle force.

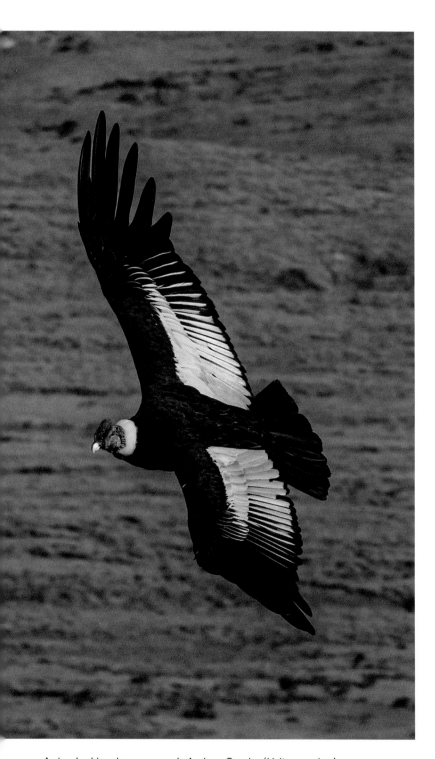

A view looking down on a male Andean Condor (*Vultur gryphus*), taken from a cliff top as the bird soared below.
Patagonia, Chile. February. IUCN category: Vulnerable

The Endless Soaring of Andean Condors

Andean Condors were revered by the Indigenous Peoples of South America and still command respect today, as evidenced by the five national flags on which they appear. Condors are also celebrated by ornithologists, mostly for their astonishing soaring skills. In a study led by Hannah Williams from Swansea University, Wales, five condors were tracked using portable data-loggers for 235 hours of flight time (see page 157). The birds flapped their wings for only 1.3 percent of the observation period. One bird, which is currently the world champion in soaring skills, remained airborne for more than five hours without a single wingbeat, covering more than 170 km (106 miles) in the process.

Condors seem to be unlikely candidates for soaring success. An adult male can tip the scales at 15 kg (33 pounds), which raises the question of how it gets into the air at all. The answer is with difficulty, not after a meal if possible, and not at high elevations. Takeoff is the most costly thing a condor does, because that is when it does most of its flapping. Flapping calls for an energy expenditure of 30 METs (multiple of the resting metabolic rate), while soaring requires only 2 METs. This difficulty in takeoff seems to make Andean Condors extremely wary of landing where departure may be difficult. They typically nest high on cliffsides, where they can exploit gravity for airspeed to generate lift on their wings after they launch. What Andean Condors do have working in their favor is an enormous wingspan

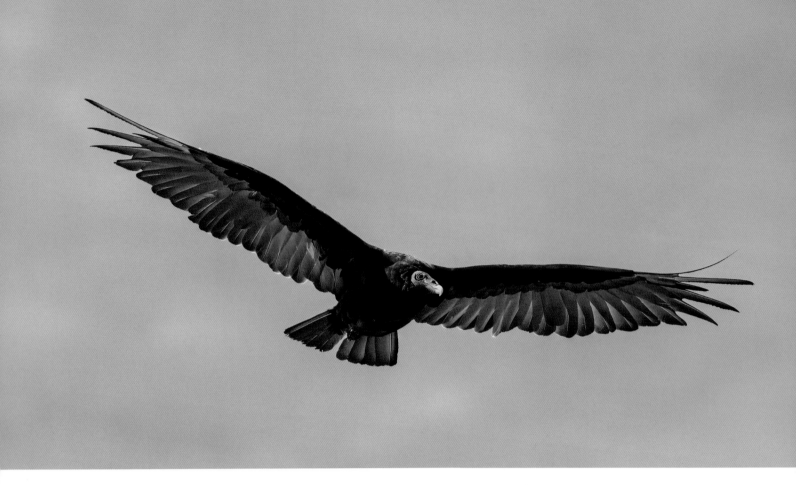

A Turkey Vulture (*Cathartes aura*) wheeling and turning on small currents of air but rarely flapping. This behavior has been called contorted soaring.

Carcass Island, Falkland Islands. January. IUCN category: Least Concern

— up to 320 cm (126 inches or 10½ feet) — and a huge wing surface area.

The Contorted Soaring of Turkey Vultures

I have watched Turkey Vultures (*Cathartes aura*) wheeling in the sky in the San Juan Islands of Washington State, in Tierra del Fuego, Argentina, and in many places in between — such is the enormous range of this successful scavenger. It is quite astonishing how Turkey Vultures seem to stay in the air near an object of interest, such as a dead or dying animal, with only the most infrequent of wingbeats along complex, erratic flight paths. They are often low in the sky, no more than 30 m (100 feet) off the ground, and their constant staccato wheeling, searching,

and rolling from side to side is a defining characteristic of their flight. You see it from a distance and instantly know what bird you are looking at. I have often thought that Turkey Vultures must be exploiting microthermals, tiny differences in the rates of rising air among various areas of their terrain. Sure enough, once I started looking into this, I found that Julie Mallon from the University of Maryland had studied the flight of Turkey Vultures and Black Vultures in 2015, using nothing more complicated than binoculars and observation techniques devised by Pennycuick.[12]

But I was not quite right about microthermals. Mallon identified a behavior she called "contorted soaring," so named because the flight paths

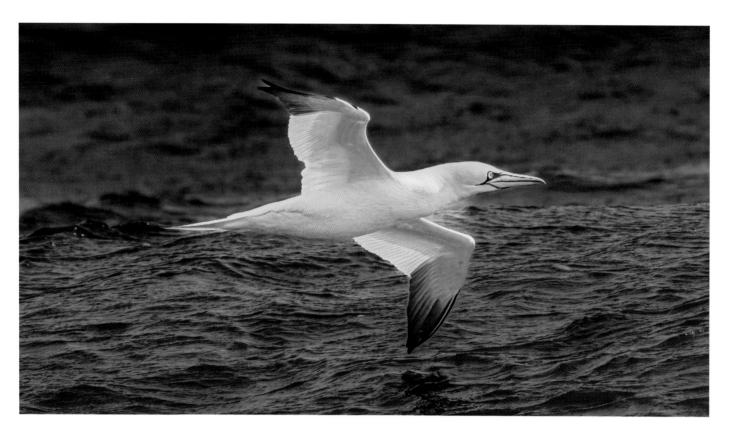

A Northern Gannet (*Morus bassanus*) skims the surface of the Irish Sea along a wave line.
Point of Ayre, Isle of Man. April. IUCN category: Least Concern

were so tortuous — sometimes up, sometimes down, sometimes sideways. The birds are riding "small scale, shear induced turbulence" and doing it very excellently, almost completely eliminating the need to flap. This ability to "use" the air for flight was something Wilbur Wright had noticed about Turkey Vultures (or buzzards, as he called them, see page 302).

Wave-Slope Soaring

Pelicans are masters of aerodynamic forces. When conditions are favorable, they "draft" in the wake of fellow travelers, fly just above the surface of still water to benefit from ground effect, soar in extended spirals on thermals, and exploit micro-lines of air that rise from waves rolling into shore.

This effect was explored by Ian Stokes and Andrew Lucas from the University of California San Diego.[13] Their curiosity was piqued as they watched Brown Pelicans (*Pelecanus occidentalis*) from their laboratory windows. The birds were flying over the Pacific Ocean at 90 degrees to the direction of an incoming wave, along the unbroken crest of swelling water beyond the surf line. This was more than just flying in ground effect, and it led to the identification of what is now known as wave-slope soaring. As large waves roll in, a small updraft in the air along the line of the wave is created. By flying along this line, pelicans are estimated to save as much as 60–70 percent beyond any ground effect savings. If they get really adventurous and fly even

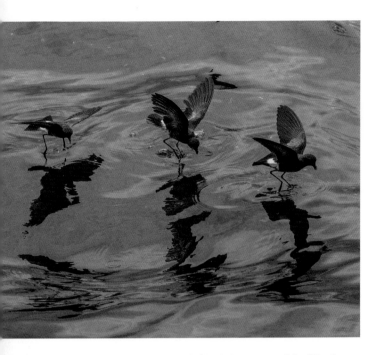

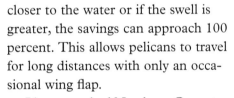

Band-rumped Storm Petrels (*Hydrobates castro*) "walking" on water in a behavior known as sea-anchor soaring. Galápagos Islands, Ecuador. October. IUCN category: Least Concern

Sea-anchor soaring: The headwind exerts forces on the wings (red vectors), moving the petrel upward and backward. These forces are opposed by weight (white vector) and the hydrodynamic forces (similar to drag) from the bird's feet in the water (yellow vector). This is similar to the way a kite is restrained in the wind by someone holding its string.

closer to the water or if the swell is greater, the savings can approach 100 percent. This allows pelicans to travel for long distances with only an occasional wing flap.

I have watched Northern Gannets (*Morus bassanus*) skimming close to the surface of the roiling Irish Sea. The wave lines are less predictable than Pacific Ocean rollers, and the gannets flap more frequently than the pelicans, but these birds appear to be seeking rising air in a form of itinerant wave-slope soaring, although this remains to be confirmed by serious study.

Sea-anchor Soaring in Storm Petrels

On a blisteringly hot afternoon afloat in the Galápagos, we left Urbina Bay on Isabela Island and set a course for Floreana Island, where Charles Darwin had visited in September 1835.

Shortly after lunch, a small group of storm petrels appeared behind the boat (see top left photograph). They seemed to be dancing on the water, moving haltingly forward while feeding on some residual food floating on the surface that had been discharged from the galley. In 1979, Philip Withers at the University of Cape Town, South Africa, studied this behavior.[14] He found that it could be compared to a kite on a string: a kite will only fly if the the owner is holding the string, acting as an anchor. Likewise, as a petrel faces into a headwind, it is swept backward by drag forces and upward by lift, and unless there is an opposing force, it will tumble backward with the wind. The opposing force comes from the hydrodynamic drag of the bird's feet in the water, which act as an anchor (see top right illustration).

Monitoring the soaring flights of Andean Condors

THE QUESTION	Are flight costs in the Andean Condor (*Vultur gryphus*) linked to the prevailing environmental conditions? How often do Andean Condors flap during daily foraging flights?
THE AUTHORS	H.J. Williams, E.L.C. Shepard, Mark D. Holton, P.A.E. Alarcón, R.P. Wilson, and S.A. Lambertucci
THE SOURCE	"Physical Limits of Flight Performance in the Heaviest Soaring Bird," *Proceedings of the National Academy of Sciences of the United States of America* 117, no. 30 (July 2020): 17884–17890, PMID: 32661147, DOI: 10.1073/pnas.1907360117.
THE HYPOTHESIS	The cost of flight decreases when thermals are available and increases when they are not.
THE EXPERIMENT	Eight immature condors, weighing 9.5–13.9 kg (21–30½ lbs.), were equipped with flight recorders weighing less than 1% of their body weight, which enabled position, wingbeats, circling behavior, and altitude to be monitored. Data for 235 hours of flight time was collected.
THE RESULTS	The birds flapped their wings for only 1.3% of all flight time, 0.8% of traveling flights, and 8.6% of short flights. The longest periods of uninterrupted, non-flapping flight ranged from 98 to 317 minutes per bird, with birds covering up to approximately 172 km (107 mi.) in this time. One bird remained airborne for more than five hours without using flapping flight, covering more than 170 km (105 mi.).

- A flight segment of an Andean Condor (upper map) tracked while traveling from A to B — a straight line distance of about 30 km (19 miles) — from the mountains to the steppe. However, the bird did not travel in a straight line.
- The expanded Area 1 (below left) shows that the bird was slope soaring (orange trace) when not gliding (blue trace).
- The expanded Area 2 (below right) shows the bird traveling down a "thermal" street (pink trace), riding nine successive thermals when not gliding (blue trace).
- Many other examples of these behaviors can be seen in the upper map.

Figure used with permission

THE CONCLUSIONS	"Condors flap very infrequently but do so more in winter than in summer. The maximum altitude reached is also higher in summer. Our data reveal the lowest levels of flapping flight recorded for any free-ranging bird, with condors remarkably spending 99% of all flight time in soaring/gliding flight."

> When flapping, wings have to act not only as lift generating surfaces, but also as propellers, a combination never successfully imitated by human technology.
>
> — HENK TENNEKES (2009)

Flapping Flight

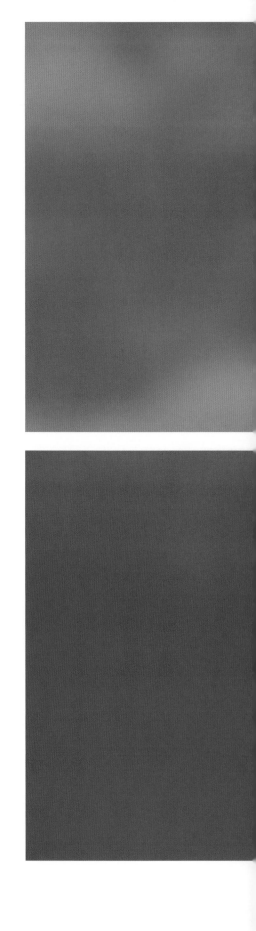

Moving Quickly

FLAPPING FLIGHT GETS A BIRD FROM POINT A TO point B in the quickest way possible. That trip might be just a short distance from the nest to a nearby food source, it might be a journey of thousands of miles from summer home to winter home, or it may be a steep climb from the ground to a vantage point. In each of these situations, a bird will likely choose a different style of flapping flight. Although it is the most versatile form of locomotion, flapping is also the most energetically expensive thing that birds do, so they exploit many subtleties of energetics and action to minimize the cost.

C.J. Pennycuick studied flapping frequency (the number of flapping cycles per second) in over 30 different bird species during steady flight. He found that the average flapping frequency was 4.5 cycles per second (Hz), with highs of 12.3 Hz in a South Georgia Diving-Petrel (*Pelecanoides georgicus*) and lows of 2.2 Hz in a Magnificent Frigatebird (*Fregata magnificens*). (Pennycuick did not include any hummingbirds, which flap much faster than other birds in his study.) This is high-speed movement! For comparison, Jamaican sprinter Usain Bolt had a stride cycle frequency of 2.1 Hz when he won the 100-m dash in record time at the world championships in 2009.

Pennycuick also developed a mathematical model to predict

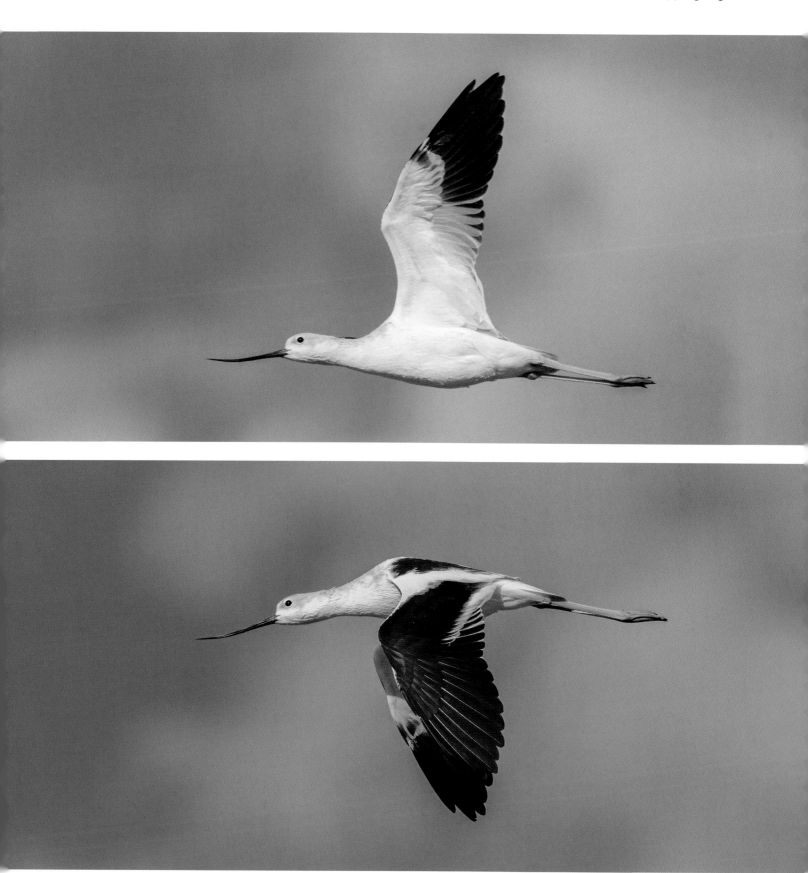

An American Avocet (*Recurvirostra americana*) at the top and bottom of a wingbeat in fast flight. Great Salt Lake, Utah, USA. September. IUCN category: Least Concern

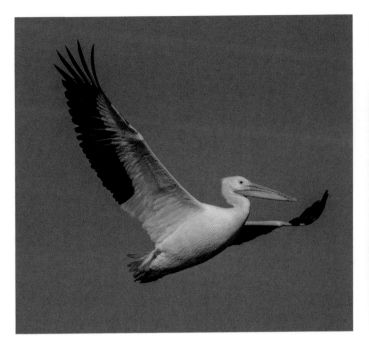
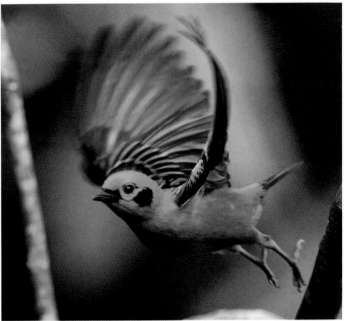

Flapping frequency will be slower in a large bird like a pelican than in the smaller tanager.

American White Pelican (*Pelecanus erythrorhynchos*) Sanibel Island, Florida, USA. January. IUCN category: Least Concern

Golden Tanager (*Tangara arthus*) La Florida, Colombia. January. IUCN category: Least Concern

flapping frequency based on a number of physical characteristics.[1] He found that heavier birds tended to flap more quickly, but all measures of wing size (area, wingspan, etc.) showed that birds with larger wings tended to flap more slowly. This makes sense: A lot of drag is generated when large surfaces move through the air.

Another important choice a bird makes during flapping is the height and depth of its stroke — a variable called stroke amplitude. This can change from strokes in which the wings almost clap together at the front and back of the wingbeat to very abbreviated, small-amplitude strokes, such as when a bird is flap-gliding or powered-gliding. A raft of studies have shown extremely variable and confusing relationships between speed, stroke amplitude, and flapping frequency. However, it does seem that large-amplitude wingbeats

are reserved for the more challenging tasks, such as takeoff, accelerating, climbing, and landing.[2]

Spending the Energy Budget

Every bird has a range of flight speeds in its repertoire, and the speed it chooses at any given time depends on the purpose of its trip. All speeds are not equally costly. Power output, a measure of how fast work is done, is a useful quantity for examining the consequences of different flight speeds, much like the cardiovascular exercise machines that provide feedback in a unit of power (watts).[3] The curve on page 161 shows the estimated power output plotted against the speed of flying for a European Kestrel (*Falco tinnunculus*). This curve has echoes of the total drag-versus-flight-speed

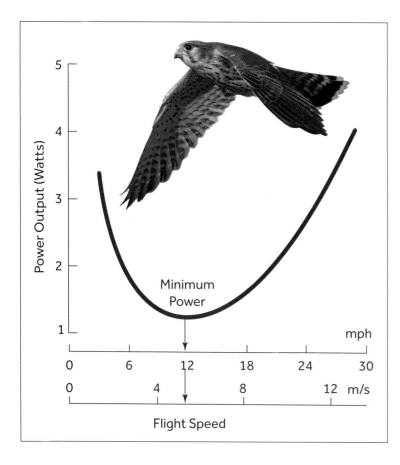

Estimated mechanical power as a function of flight speed in a European Kestrel (*Falco tinnunculus*). Power output will be minimized during flapping flight at 5 m/s (12 mph). Flight below the minimum-power speed is costly, as is flight at higher speeds. Data from Tobalske.[3]

The bird in the photo is a Rock Kestrel (*Falco rupicolus*), a close relative of the European Kestrel, at the end of an abbreviated downstroke during flapping flight. Notice the twisting in the left wing, in which the leading edge at the wing tip is lower than the trailing edge.

Windhoek, Namibia. September. IUCN category: Least Concern

for birds. A bird has to work hard during slow flight to generate support of its body weight. You will recall that lift from the wings increases with the square of speed. At slow flight speeds, that airflow comes less from forward speed and more from the speed of the beating wings, which costs muscle power. The component of drag due to lift generation (induced lift) is also highest at slow speeds. Flying fast, just like running fast in humans, is also costly, with the power output rising very steeply (non-linearly) from the minimum-power speed.

How Fast Do Birds Fly?

Since I am often out looking for birds, it is not uncommon for me to be driving along a road with a bird flying alongside me. A quick look at the speedometer is sometimes surprising! I may find that a relatively small bird is flying nearly 50 km/h (over 30 miles per hour). Thomas Alerstam and a team from the University of Lund in Sweden measured the airspeeds of 138 species during migration, recording speeds between 29 and 83 km/h (18 and 51 miles per hour).[4] Rock Pigeons (*Columba livia*) have flown in wind tunnels between 22 and 78 km/h (13 and 45 miles per hour), and Black-billed Magpies (*Pica hudsonia*) between 14 and 52 km/h

curve, and so it should, because the power output in flapping is, in addition to moving the wings, primarily from work done to overcome drag. The most important aspect of this curve is its clear minimum, known as the minimum-power speed. For the kestrel, this is the rather slow speed of about 5.4 m/s (12 miles per hour).

The steeply U-shaped relationship illustrates the trade-off that a bird must make when it chooses how to spend its energy budget. Fast flight to escape predation would definitely be worth the increased cost, as would slow flight while patrolling for food, as long as it increases the probability of capturing prey. Without these imperatives, a flight at the most economical minimum-power speed is most sensible.

It may come as a surprise to learn that flying slowly is energetically costly

(9 and 31 miles per hour). Their ranges in free flight are likely to be greater. Theoretical predictions suggest that flight speed will be greater in heavier birds with high wing loading, but experimental results show only moderate speed dependence on these features.

Generating Thrust

Flapping flight is a thing of great visual beauty, but it is also a deeply complex mathematical puzzle. While everyone can marvel at the elegant, coordinated movement of a heron's wings, only a small band of aerodynamicists have access to the advanced simulation tools that allow us to formulate and solve the equations that describe the lift and forward thrust that result from the subtle interactions between the bird's wings and the surrounding air. The people who understand flapping flight best are those striving to mimic it in their flying robots, and the results of their endeavors are thus far fairly rudimentary (see pages 266–69). There are, however, several mechanisms operating to maximize aerodynamic efficiency during flapping.

A Helicopter Analogy

A bird and an airplane have totally different methods of generating thrust: The airplane has a propeller or jet engine, and the bird flaps its wings. A much better analogy to a flapping bird's wings is the rotor blade of a helicopter, which is called a rotary-wing craft.[5] The lift vector from a helicopter's rotor can be redirected to generate both weight support and thrust.

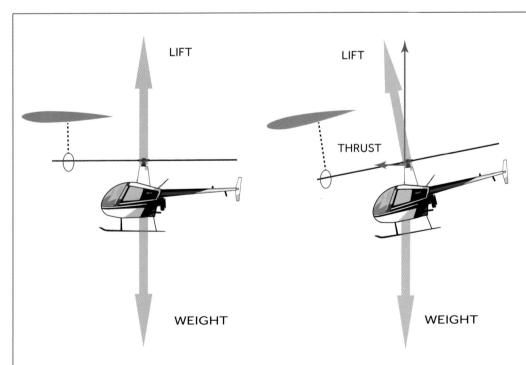

LIFT

LIFT

THRUST

WEIGHT

WEIGHT

Far left: A constant-altitude hover, in which the lift generated by the rotor is equal to the weight of the helicopter.

Left: Forward movement, where the lift vector from the rotor is "repurposed" by tilting the helicopter forward to provide not only weight support (long red arrow) but a component of thrust (the short red arrow) in the direction of travel. The orientation of a cross section of the rotor blade viewed end-on is shown in solid blue.

Eurasian Oystercatchers (*Haematopus ostralegus*), top, weigh about 15 times more than Red-necked Phalaropes (*Phalaropus lobatus*), bottom — 500 g (17½ oz.) vs. 33 g (1¼ oz.) — but both were measured flying at the same speed of around 13 m/s (29 mph) during migration in a study by Pennycuick.[6]

Eurasian Oystercatcher Isle of Man. April. IUCN category: Near Threatened

Red-necked Phalaropes Baranof Island, Alaska, USA. July. IUCN category: Least Concern

The blade has a typical airfoil shape (see diagram, page 162). In still air, it creates its own airflow, and therefore its own lift, by rotation of the main rotor assembly. As long at the blade's plane of rotation is horizontal, the helicopter can take off vertically as soon as the lift generated exceeds the weight of the craft.

Once airborne, if the rotor's plane of rotation is tilted forward, there will be a force component in the direction of intended travel. In the same way that the lift vector was "repurposed" by the landing parrotlet we met in chapter 4 (see page 119), the lift vector now has a thrust component and will accelerate the helicopter forward when it is greater than any drag that may be acting.

In other words, a helicopter has a rotor blade that can be tilted to repurpose the lift vector and generate thrust. A bird, meanwhile, has wings that it can move and rotate to repurpose the lift vector and create thrust as well as weight support. You can visualize a bird's wings as a movable, flexible force generator whose movement is constrained only by the bird's anatomy. This is particularly true of the hand wings, which contain the long primary feathers.

Twisting Wings

The conceptual model above right of three different modes of flying represents a bird's arm wing (A) from elbow to wrist, and the hand wing (B) from wrist to wing tip. The "rotor blade" is now divided into two parts that can be twisted in relation to each other. Air is flowing from left to right.

In mode 1, the hypothetical bird is

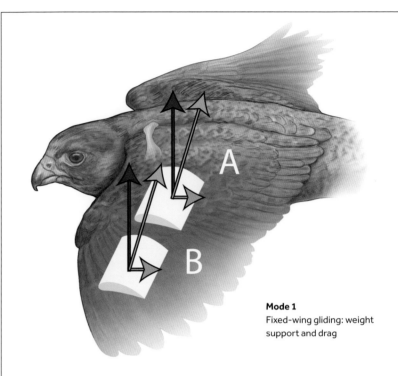

Mode 1
Fixed-wing gliding: weight support and drag

Repurposing the lift vectors (yellow arrows) from the arm, A, and hand, B, wings to produce thrust (blue arrows) and weight support (red arrows) in flapping flight. The blue arrow points backward during gliding when the lift vector has a net drag component.

gliding in still air at speed with its wings fixed and outstretched. None of its arm joints is moving. This is a familiar situation: Lift forces (yellow arrows) are generated on each wing segment perpendicular to the airflow, and this has components of weight support (red arrows) and drag (blue arrows). No thrust is developed; in fact the drag tends to slow the bird down.

In mode 2, the flapping wing is in the middle of a downbeat. The wing has been rotated forward and the hand wing is also twisted forward in relation to the arm wing. This looks like the orientation of the helicopter rotor on

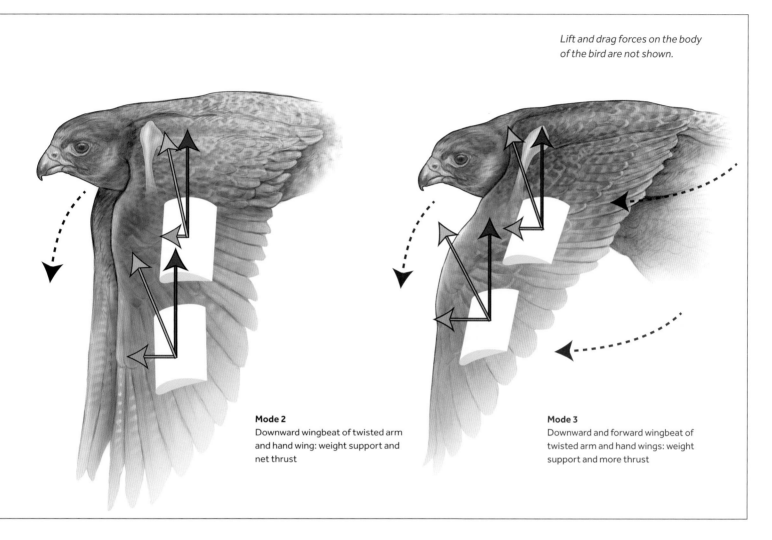

Lift and drag forces on the body of the bird are not shown.

Mode 2
Downward wingbeat of twisted arm and hand wing: weight support and net thrust

Mode 3
Downward and forward wingbeat of twisted arm and hand wings: weight support and more thrust

page 162, from the illustration showing forward movement. Air is now flowing along the rotated wing, resulting in forward-leaning lift vectors (yellow arrows), which have components of net thrust (blue arrows) in the direction of flight and weight support (red arrows). The term "net thrust" implies that the thrust is greater than the drag.

In mode 3, the wing is being swept down and forward, adding a velocity component to the airflow over the rotated wing. This forward sweep increases the linear speed toward the wing tip, and there is thereby a larger lift vector and a larger net thrust component

from the hand wing than in mode 2.

There are many simplifications in the above example, enough to make an aerodynamicist blush. The rotations have been exaggerated to illustrate the concept, but it does show the basic mechanisms that birds use to generate thrust during flapping flight: They repurpose the lift vector from rotated wings to provide forces in the direction of flight that overcome drag forces. The precise contributions of the hand and arm wings have not yet been well elucidated in different birds under different flying conditions, but this fundamental principle will always apply.

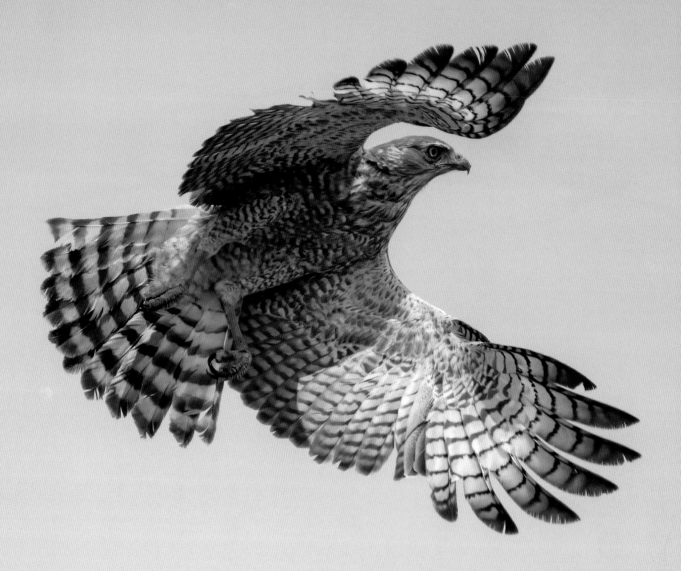

A young Pale Chanting-goshawk (*Melierax canorus*) climbs shortly after takeoff, showing the independence of its arm wing and hand wing and marked warping of its right wing. Etosha National Park, Namibia. September. IUCN category: Least Concern

Plunging and Pitching

In the terminology of aerodynamics, a bird that is flapping its wings is forcing an airfoil into a combination of plunge and pitch. Plunging is the sudden depression of the airfoil with respect to an oncoming airflow, while pitching is rotating it so that the air flows across the wing at a different relative angle. Repurposing the lift vector to produce thrust appeals to common sense, but the counterintuitive surprise is that simply plunging the wings can also generate thrust. The airflow around a plunging airfoil is altered in such a way that the wings' effective angle of attack generates a component of lift that is repurposed into thrust. The subtlety of these flows is beyond the scope of our discussion, but knowing they exist helps acknowledge that flapping flight is a deeply complex behavior that does not easily yield its secrets to the casual observer.

How Do Bird Wings Actually Move?

The wing twist and forces during flapping have been measured and modeled by Jialei Song and his colleagues in Calliope Hummingbirds (*Selasphorus calliope*).[7] The results show that the arm wing continues to develop lift and drag much as it does in gliding, but the rotated arm wing generates lift and thrust on both the downstroke and the upstroke.

Song and his team also created a heat map of pressure distributions on the wing of the Calliope Hummingbird using computational fluid dynamics. The results are reminiscent of the diagram we used to explain the lifting action of an airfoil (see page 91). These distributions — high pressure under the wing during downstroke and low pressure under the wing in the upstroke — explain why the red arrows representing net force in the diagram at left reverse direction during downstroke and upstroke.

Other, more extensive research has established that there is no single pattern of wing movement during flapping that applies to all birds under all

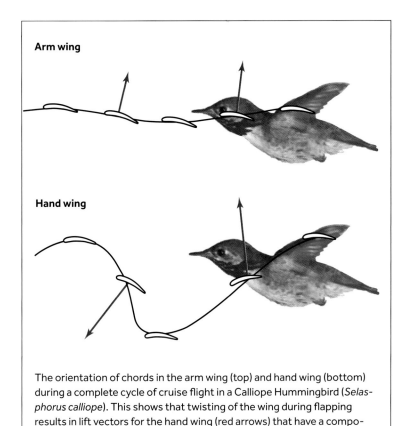

Arm wing

Hand wing

The orientation of chords in the arm wing (top) and hand wing (bottom) during a complete cycle of cruise flight in a Calliope Hummingbird (*Selasphorus calliope*). This shows that twisting of the wing during flapping results in lift vectors for the hand wing (red arrows) that have a component of thrust during both the downstroke and upstroke. Redrawn from Song et al. (CC BY 4.0 DEED).[7]

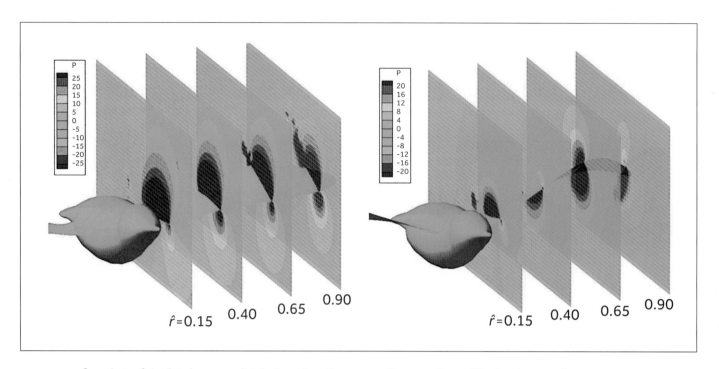

Snapshots of simulated pressure distributions along the upper and lower surfaces of the flapping arm wing of a Calliope Hummingbird at mid-downstroke (left) and mid-upstroke (right). Highest pressures are bright red, and lowest pressures are deep blue. The reversal of high- and low-pressure surfaces changes the direction of the resultant lift vectors.[7]

Song et al. CC BY 4.0 DEED[7]

circumstances. This should not come as a surprise. Humans, for example, change their patterns of limb movements as they increase speed from a slow walk to a fast sprint, and apes walk differently than humans. And so it is with birds: the patterns of wing movement change with speed, and different species move differently.

But there are a couple of general principles worth mentioning. While standing in front of an exhibit on bird flight that I guest-curated at the Seattle Museum of Flight, I asked a group of visiting kids (including one of my grandsons) to show me with their arms how birds flap their wings. They enthusiastically raised and lowered their arms, some quickly and others slowly, but to anyone watching them, they were moving their arms in the same vertical plane, at the same speed up and down, as if they were flapping while touching an invisible vertical wall. These were entirely reasonable simulations because it really does look like that when you see a bird flapping from a distance.

But there are two subtle deviations from this up-and-down pattern that make all the difference between thrust and no thrust, lift and reduced lift. First, the movement of the wing tip from its highest point to its lowest point is usually not just downward, it is downward and forward. The forward movement gives an extra boost, an increase in the size of the repurposed lift vector, because it increases airspeed over the twisted hand wing. Ornithologists call this increment the flapping velocity.

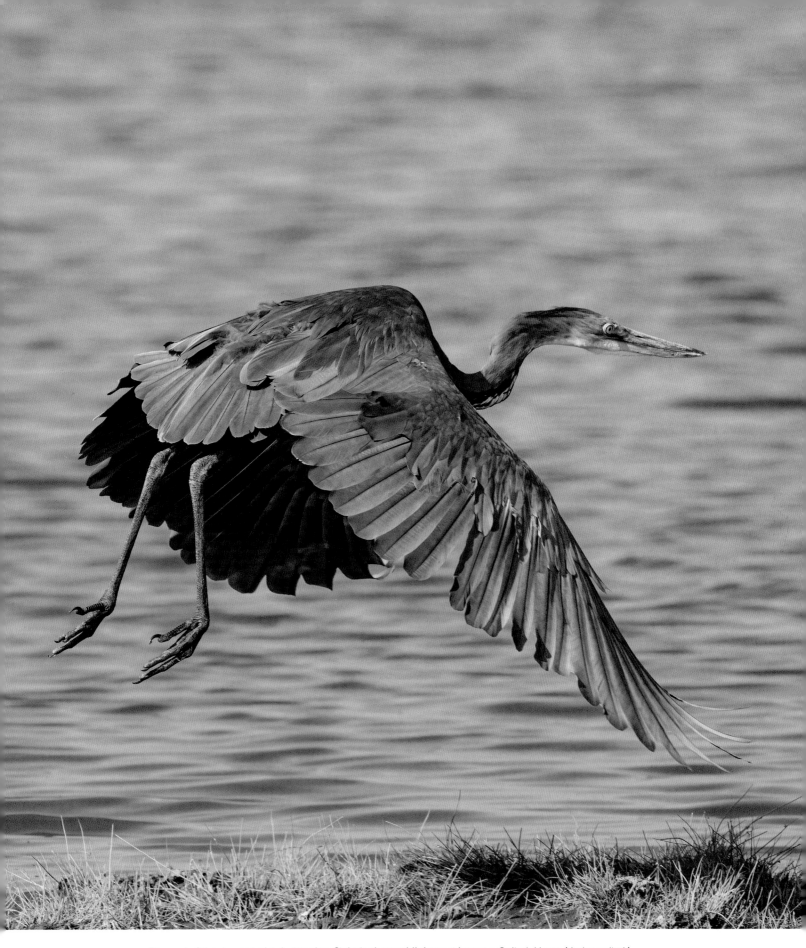

The end of the downstroke during slow flight in the world's largest heron, a Goliath Heron (*Ardea goliath*), shortly after takeoff. Note how far forward it moves the tips of its huge primary feathers.
Lake Amboseli, Kenya. September. IUCN category: Least Concern

Tracking Wing Motion

Clues about wing motion during flapping can be gleaned by tracking a point on the wing, the wrist or wing tip with motion analysis equipment. The results from a study by University of Montana biologists hint at the complexity of the flapping action and show conclusively that the wing tip follows a different path on the downstroke and upstroke. The timing is also different: The downstroke usually lasts longer than the upstroke at slower speeds.

The diagrams opposite show the wing-tip paths during wind tunnel flight of two species: a Black-billed Magpie (*Pica hudsonia*) and a Rock Pigeon (*Columba livia*). They reveal quite different patterns in the two species. The magpie has broad, elliptical wing sweeps when viewed both from the side and from overhead. The paths of the pigeon's wing tips are more complex and involuted, resembling squashed figure eights.

The changes in wing movement as flight speed increases in the pigeon are quite dramatic. At a slow speed, the wing tips come together at the apex of the recovery stroke and almost touch at the far reach of the downward forward stroke. When the pigeon flies faster, its wing tips move through a more compact trajectory. The changes with speed in the magpie are quite limited by comparison. The forward movement of the wing tips is very clear in both birds, particularly in the overhead view, as are the different paths of downbeat and recovery.

The Aerodynamics of the Upstroke

Early investigators of bird flight had an inkling that the upstroke during flapping flight was more than just a necessary action to move the wings back for the next powered downstroke. They suspected that it was not always aerodynamically "inert." In his 1889 book *Birdflight as the Basis for Aviation*, Otto Lilienthal said, "The upstroke may also take place under such inclination that there is no pressure (force) at all […] and finally it is possible that a peculiar kind of upstroke may produce a lifting effect, in which we have the remarkable condition for which all parts of the wing act in a lifting sense during the whole period of flight."

Lilienthal's prescient observation was confirmed when it became possible to visualize the wake left behind a flying bird and to measure the kinematics (movement) of the wings more accurately.

Two distinct upstroke patterns are generally recognized. In the first, called a flexed upstroke, the bird flexes at the wrist and tucks its hand wing close to its body. Near the top of the upstroke, the bird extends its wrist to prepare its hand wing for the downstroke.

In the second pattern, demonstrated by the Bald Eagle on page 172, the bird makes a much more complicated set of movements. The wrist is flexed (but nowhere near as much as the magpie's), and the forearm is supinated. To see the movement, hold out your right forearm, with your palm facing down, and imagine

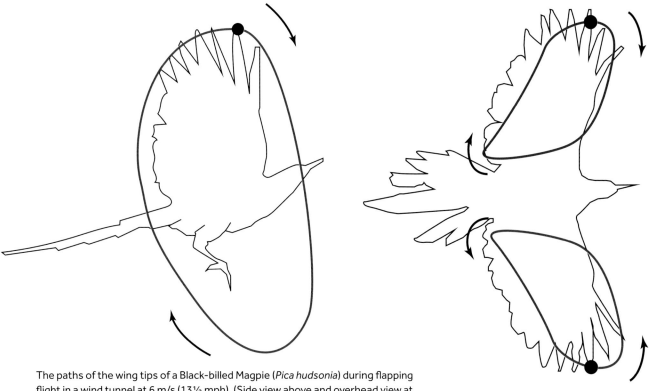

The paths of the wing tips of a Black-billed Magpie (*Pica hudsonia*) during flapping flight in a wind tunnel at 6 m/s (13½ mph). (Side view above and overhead view at right.) The red line is the right wing-tip path, while the blue trace is the left wing. The sketch of the bird from the side is at upstroke/downstroke transition. The body position on the right is at mid-downstroke. Redrawn from Tobalske and Dial.[8]

Contrasting wing-tip paths in overhead views of a Rock Pigeon (*Columba livia*) flying in a wind tunnel at 6 m/s (13½ mph), left, and 12 m/s (27 mph), right. The red line is the path of the right wing tip, and the blue trace is the left. Redrawn from Tobalske and Dial.[8]

Wing kinematics will depend on the goals and constraints of a particular flight. The deep wingbeat of a Bohemian Waxwing (*Bombycilla garrulus*) on a climb-out reflects an effort to maximize the rate of climb. Norfolk, UK. December. IUCN Category: Least Concern

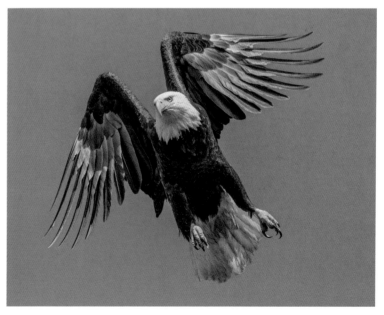

Two contrasting styles of recovery strokes during flapping flight: A Black-billed Magpie (*Pica hudsonia*), left, with its wings flexed and held close to its body during a climb-out, and a Bald Eagle (*Haliaeetus leucocephalus*), above, showing wing-tip reversal during the recovery phase of flapping while gaining height after leaving a high perch.

Black-billed Magpie Haines, Alaska, USA. November. IUCN category: Least Concern

Bald Eagle Lopez Island, Washington, USA. March. IUCN category: Least Concern

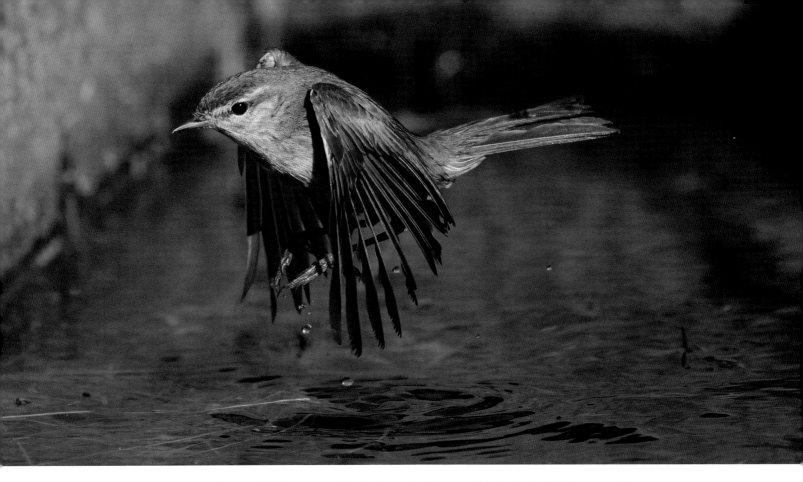

A Willow Warbler (*Phylloscopus trochilus*) using a wing-tip reversal upstroke. On a hot summer afternoon, this small bird flew repeatedly to the bottom of a deep cattle-watering trough to drink. To get back to the rim of the trough, the bird needed an almost vertical ascent.
Isle of Man. April. IUCN category: Least Concern

primary feathers flowing horizontally from the back of your hand. Next rotate your hand clockwise as if you were going to place a soup plate on it. You are now supinating your forearm and your imaginary feathers are turning toward the front of your body, rather than trailing behind you. This is wing-tip reversal. Take another look at the Bald Eagle opposite, and you will see that this bird was doing exactly that: It reversed the direction of the tips of its primary feathers, which point to the side and front.

This sequence of movements causes the primary feathers to separate like the slats of a Venetian blind. This observation led to the theory that a wing-tip reversal upstroke was designed to minimize drag, allowing air to flow through the gaps between the feathers rather than encountering the sail-like surface of a closed wing. We now know from work by Kristen Crandell and Bret Tobalske at the University of Montana that a wing-tip reversal upstroke can result in active aerodynamic forces that partially support the bird's body weight and, in some cases, generate thrust during the upstroke. This does not generally happen during a flexed upstroke. In a study by Ivo Ross and a team from Harvard University's Concord Field Station, pigeons turning slowly around a 90-degree corner were found to generate an upstroke impulse (force acting over time) that was 27 percent of the downstroke impulse.[9] Many had previously thought that these bi-directional force-generating skills were the exclusive province of hummingbirds.

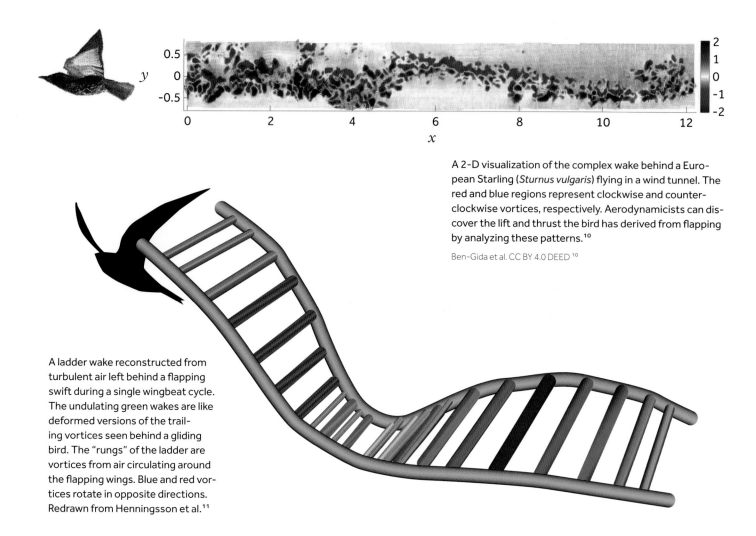

A 2-D visualization of the complex wake behind a European Starling (*Sturnus vulgaris*) flying in a wind tunnel. The red and blue regions represent clockwise and counterclockwise vortices, respectively. Aerodynamicists can discover the lift and thrust the bird has derived from flapping by analyzing these patterns.[10]

Ben-Gida et al. CC BY 4.0 DEED [10]

A ladder wake reconstructed from turbulent air left behind a flapping swift during a single wingbeat cycle. The undulating green wakes are like deformed versions of the trailing vortices seen behind a gliding bird. The "rungs" of the ladder are vortices from air circulating around the flapping wings. Blue and red vortices rotate in opposite directions. Redrawn from Henningsson et al.[11]

The Secrets of the Wake

There is another way to extract the details of the wingbeat, and that is to examine the wake of disturbed air left streaming behind a flapping bird. In chapter 5, we saw the relatively simple vortices, one from each wing tip and one from each side of the tail, that are shed by a gliding owl. The otherwise invisible vortices were visualized by a thin slice of buoyant, laser-illuminated bubbles through which the birds were taught to fly.

The illustration above (top) of air behind a flapping starling reveals the gulf between the relatively simple wake from gliding and the more complex wake of flapping birds. An aerodynamicist can read these tortured tracings like a fortune teller reading tea leaves and estimate the lift and thrust that the bird has extracted from the air. As complex as the wake may be, it still obeys the natural law of conservation of momentum, so the history of the time-varying development of forces that keep the bird in the air and propel it forward is

locked up in the moving air currents of the wake.

The topology of the wake varies with the bird's speed of flying and its flapping style. Early studies of small birds flying in slow wind tunnels revealed a simpler pattern of closed-ring vortices shed at the bottom of each downstroke, similar to deflected smoke rings. The orientation of these rings in space was related to the ratio of lift to drag experienced during the downbeat of the wing. Swifts are "stiff-wing fliers," meaning they do not flex their wings during the upstroke. A study in a wind tunnel at the University of Lund in Sweden by Per Henningsson and his colleagues revealed

A flock of Eurasian Linnets (*Linaria cannabina*) silhouetted as they fly across a sand dune. Almost all the birds are in the bounding phase of flap-bounding flight, with their wings closed against their bodies. Titchwell, Norfolk, UK. December. IUCN category: Least Concern

that a flapping Common Swift (*Apus apus*) left a much more structured pattern in the air, known as a ladder wake.[11] (See lower diagram on page 174.)

Hybrid Gaits

The flight behavior of many bird species can deviate from the steady gliding, soaring, and flapping gaits that we have examined so far. As a rule, whenever there is an opportunity to save metabolic energy, most birds will take it. The most extreme form of this behavior is to stop flapping completely mid-flight and tuck the wings tightly against the

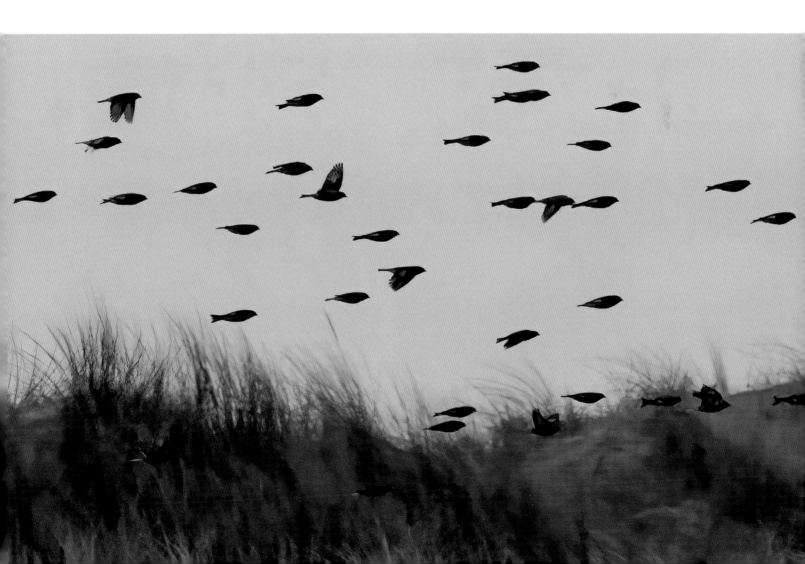

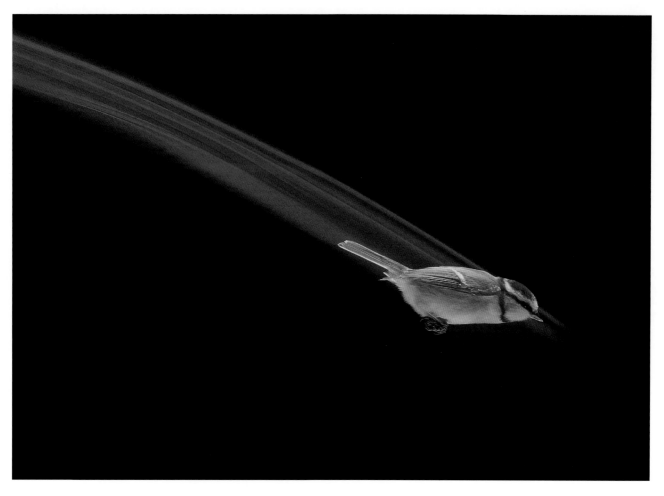

A slow exposure with a final flash reveals the path of a Eurasian Blue Tit
(*Cyanistes caeruleus*) in the bounding phase of a flap-bounding flight.
Lincolnshire, UK. December. IUCN category: Least Concern

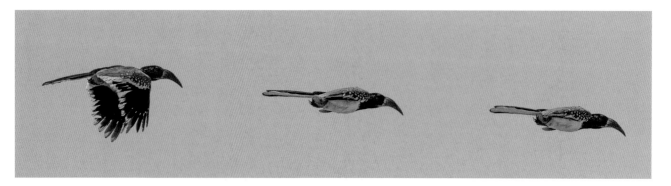

A Monteiro's Hornbill (*Tockus monteiri*) transitioning from flapping (left) to bounding (middle and right).
The images are separated in time by about 0.05 second. The horizontal spacing is arbitrary. This bird was
using flap-bounding to deliberately lose height and never returned to the same height after it restarted
flapping less than half a second later. I have seen Yellow-throated Toucans (*Ramphastos ambiguous*)
behave this way, leaving a treetop with a few wing flaps, then plunging with their wings tightly furled for
long distances before flapping again.
Namibia. September. IUCN category: Least Concern

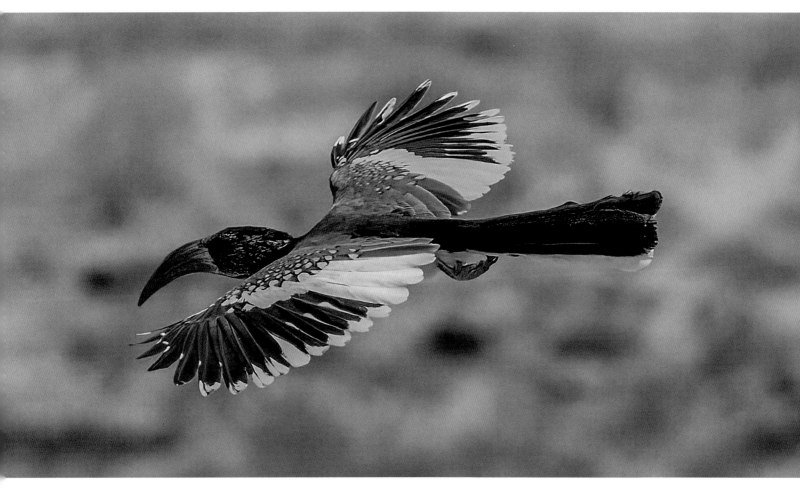

The same Monteiro's Hornbill (*Tockus monteiri*) intermittently flapping and gliding.
Namibia. September. IUCN category: Least Concern

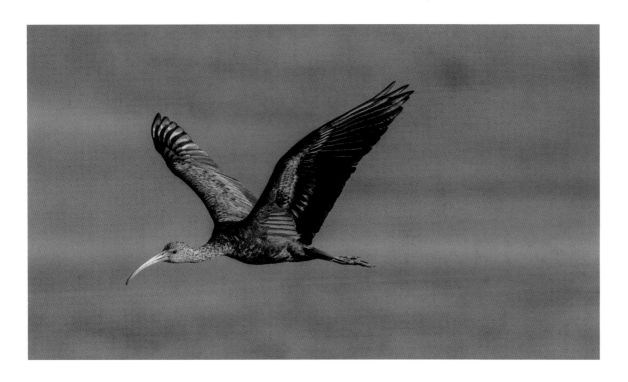

A Glossy Ibis (*Plegadis falcinellus*) in flapping flight.
Lake Amboseli National Park, Kenya. October. IUCN category: Least Concern

177

body. This results in loss of height because, although some lift is created by the body and tail, it is not sufficient to support the bird's body weight. After an appropriate energy-saving pause, the bird will insert another period of flapping, gain height, and repeat the cycle.

This process is known as flap-bounding because it results in a sinusoidal flight path when viewed from the side. The reasons behind this energy saving are not fully understood, but so many small birds use this technique, we must assume that they benefit from it.[12]

Flap-Gliding and Powered-Gliding

Large birds do not use flap-bounding, but many large and small species use a related technique called flap-gliding to turn off the expensive rhythmic contractions of the flight muscles. As the term suggests, when the bird stops flapping its wings, instead of folding them against its body, it holds them outstretched in a typical gliding posture to provide lift. The Monteiro's Hornbill pictured on page 176 was mixing flap-bounding and flap-gliding. The picture on page 177 was taken during the same encounter with this wonderfully textured bird as it intermittently glided between wing flaps.

An energy-saving behavior called powered-gliding has been identified in birds traveling long distances, such as a migratory flight. One of the adherents of this flight style is the legendary Bar-headed Goose (*Anser indicus*), a bird known for passage over the Himalayas at altitudes of 9,000–10,000 m (29,527–32,808 feet). While the physiological prowess of this species has received the most attention, its flight mechanics have also been studied. Bar-headed Geese fly roller-coaster trajectories on long descents.[13] The strategy of alternating descents and climbs seems to have evolved to take advantage of orthographic lifting and to minimize high-altitude flight. The descents are "powered" by attenuated flapping flight, which provides thrust as well as lift. Quite counterintuitively, a theoretical model of powered-gliding and climbing indicates that this style of flight results in lower energy cost than flight at constant altitude.

Are swifts designed for gliding or flapping?

THE QUESTION	Is the body plan of the swift designed best for gliding or flapping?
THE AUTHORS	Per Henningsson, Anders Hedenström, Richard J. Bomphrey, Department of Biology, Lund University, Sweden, and the Royal Veterinary College, University of London, UK
THE SOURCE	"Efficiency of Lift Production in Flapping and Gliding Flight of Swifts," *PLOS One*, 9, no. 2 (2014): e90170, PMID: 24587260, DOI: http://10.1371/journal.pone.0090170.
THE HYPOTHESIS	Preference in wing design of the Common Swift (*Apus apus*) will be toward flapping flight optimization since this is the most energetically demanding flight mode.
THE EXPERIMENT	Two juvenile swifts were trained to fly in a wind tunnel at speeds of 5.9–11 m/s (about 13–24 mph). The birds flew through a mist of laser-illuminated small particles, some of which were automatically tracked using particle image velocimetry (PIV). The motion of the wing tip and tail vortices was quantified. The efficiency of lift production (lift divided by drag) and span efficiency (efficiency of lift production along the wing) were calculated as measures of efficiency.
THE RESULTS	

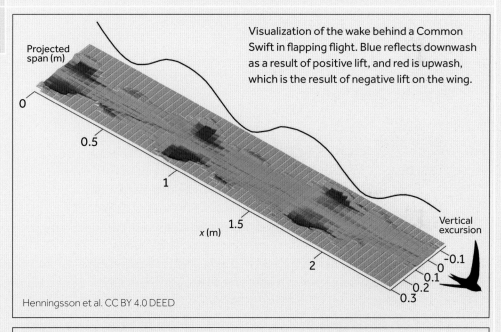

Visualization of the wake behind a Common Swift in flapping flight. Blue reflects downwash as a result of positive lift, and red is upwash, which is the result of negative lift on the wing.

Henningsson et al. CC BY 4.0 DEED

Swifts typically alternate between flapping and gliding flight, flapping for about 60% of the time in free flight.

Aerodynamic span efficiency during flapping flight was 58% greater than efficiency during gliding when averaged over all speeds. Red bars are +/− 1 SD.

The wake generated by the tail in gliding flight had a detrimental effect on the downwash distribution and, consequently, the span efficiency.

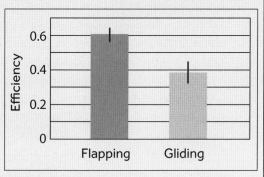

THE CONCLUSIONS	"Despite common swifts being renowned for their gliding behavior, they performed better in terms of efficiency of lift production in flapping flight than in gliding flight in wind tunnel experiments. Because of their unusual wing design with short arm section and long hand section, they cannot adapt their wings to fully suit both the requirement for gliding and flapping. Swift wings are primarily adapted to efficient flapping flight."

CHAPTER **EIGHT**

> Whereas stability is avoiding unintentional changes in direction, maneuverability is intentionally causing a change in direction.
> — DAVID E. ALEXANDER, *NATURE'S FLYERS*

In-flight Maneuvers

Breathtaking Moves

STANDING WITH MY CAMERA ON A RICKETY DECK overlooking Frederick Sound, part of Southeast Alaska's legendary Inside Passage, I imagined the travelers who had passed this way before me. More than 120 years earlier, this waterway had carried overstuffed wooden boats with some of the 100,000 prospectors who left Seattle and San Francisco for the Klondike, where they hoped to find gold. Most of them left empty-handed. But on that misty morning in Petersburg, I came away with a digital treasure: close-up images of Bald Eagles exquisitely executing extreme moves as they flew in to snatch salmon carcasses thrown by a waterside resident into the seaweed-decorated gray muddiness of the ebbing tide. They came in squadrons, adults and juveniles taking their place in a landing pattern that required a right-angled turn from approach to pickup point. I positioned myself close to the turning point, between what pilots call base and final legs, and struggled to hold focus on these fast-moving birds. (These were the days before cameras had AI detection and locking on the bird's eye.)

It was a breathtaking experience to feel and hear the vorticity of an eagle's wake moving across my face from a distance of a few feet. It felt a bit like standing on the floor right next to an Olympic gymnast performing a complex twisting somersault or

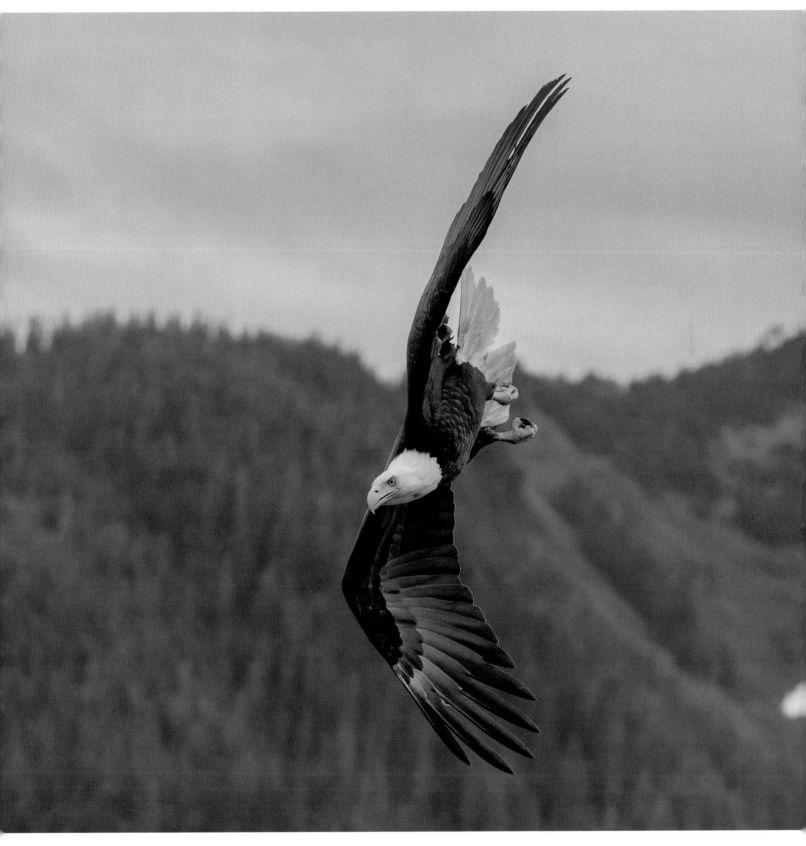

A Bald Eagle (*Haliaeetus leucocephalus*) pulls Gs in a 90-degree banked turn.
Petersburg, Alaska, USA. July. IUCN category: Least Concern

standing on the sidelines at Wimbledon as a champion hit the ball with seemingly unattainable velocity. Only at close quarters can one appreciate the sheer speed of the flight and the finesse with which these birds alter their trajectory in apparently endless ways by moving and deforming their control surfaces.

Making a Turn

Let's first establish some terms used to describe flight maneuvers. This is usually done by imagining a set of three mutually perpendicular axes fixed at the bird's center of gravity, called roll, pitch, and yaw axes in mechanics.

To create a pure change in pitch in still air (with no other rotation), lift must be increased or decreased symmetrically in both wings or in the tail. A pilot does this by pushing the yoke forward (pitching down) or pulling it back (pitching up), an action that changes the angle of attack of the elevators or a stabilator in the tail section of the plane (known as the empennage). (Elevators change the effective angle of attack of the aircraft's stabilizer, while a stabilator physically rotates to change the angle of attack.) The left and right elevators move in unison; if one goes up, so does the other. Birds can manipulate their tails to change lift and drag. Forces at the tail have magnified actions because of their distance from the bird's center of mass (meaning they have a higher moment). But there is more versatility in the wings of a bird, since the camber, area, flapping speed, and angle of attack can be dynamically altered.

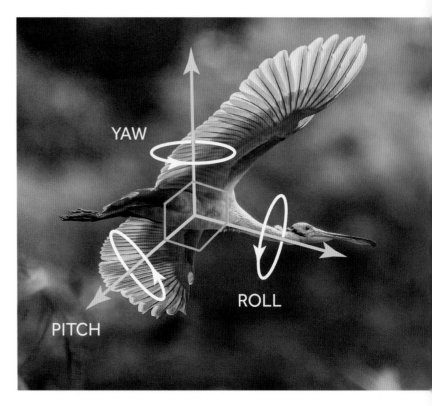

Three mutually perpendicular axes used to define rotations. Positive roll tips the right wing down, positive pitch tilts the head up, and positive yaw rotates the Roseate Spoonbill (*Platalea ajaja*) to the left.
Green Island, Texas, USA. April. IUCN category: Least Concern

A Laysan Albatross (*Phoebastria immutabilis*) pitches its entire body up. Note the angle of attack of its wings, which create increased lift.
Kilauea Point National Wildlife Refuge, Kauai, Hawaii, USA. February. IUCN category: Least Concern

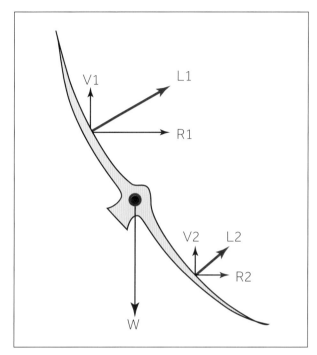

Left: A Common Redshank (*Tringa totanus*) in an ongoing right-banked turn. Norfolk, UK. April. IUCN category: Least Concern

Right: A two-dimensional schematic view from behind of a bird turning to the right. At this instant, the bird has morphed its wings, and perhaps increased the angle of attack, to generate more lift on the left wing than the right. The lift vectors L1 and L2 from both wings are repurposed to generate force components R1 and R2, which accelerate the bird to the right. Out-of-plane changes not visible in this view also facilitate the turn. W is the weight of the bird acting at the center of mass (the filled circle). The moments of the lift vectors around the bird's center of mass are unequal, so the turn and the banking will continue. Once these moments are equal and opposite, no further banking will occur, but turning will continue until the lift vectors are vertical.

To roll to the right, both an aircraft and a bird must create a non-symmetrical pattern of lift on the wings so that the left wing has greater lift than the right wing. A pilot has one primary way of achieving this goal: Moving the stick or turning the yoke to operate small flaps called ailerons on the outside trailing edge of the wing. In contrast to the synchronous movement of the two elevators, the ailerons automatically move in opposite directions; in this case the flap on the right wing is raised and the one on the left wing is lowered. This effectively changes the angle of attack of each wing in opposite ways, creating more drag and less lift on the right wing and more lift and some increased drag on the left wing.

The Common Redshank (*Tringa totanus*) above is banking steeply in a turn to the right by wing morphing that is not visually apparent. Banking causes the bird to turn because components of each wing's lift force are directed laterally — the lift is being repurposed to cause a turn. The bank can be stabilized by making the moments of the forces around the bird's center of mass the same, but the turn will continue as long as the lift forces are directed away from the vertical.[1]

You will also notice that the sum of the two vertical lift components

from the wings (V1 + V2) is less than the bird's weight (W), which means it will lose height in the turn. A bird will typically increase the angles of attack of its wings during a turn to generate more lift and prevent this from happening. The bird will also fully deploy its tail, adding more lift. The tightest turn that a bird can achieve will depend on its wing loading: Lower wing loading means tighter turns are possible.

Wing Morphing

Traditionally, rigidity and resistance to deformation have been required design criteria for aircraft. This is certainly changing, as a pilot of a Boeing 787 Dreamliner confirmed when he sent me images of the plane's carbon fiber–reinforced polymer wings flexing up and down (alarmingly, at least to the naive passenger) in flight. Current aircraft control surfaces include flaps, ailerons, flaperons, spoilers, and leading-edge retractable slats, and a new generation of "shape-shifting" aircraft may be on the horizon. However, these enhancements do not bring fixed-wing aircraft even close to the performance of the wings of a lowly sparrow.

Birds continuously morph the size and shape of their wings and tail from one moment to the next as they navigate varying atmospheric conditions and accommodate changing requirements during flight. Sometimes the observer can see what's happening, as in the Bald Eagle at the opening of this chapter, with obvious torsion between the left and right wings, and the dramatic changes in wing area of gliding pigeons and gulls. But often, as in the redshank's turn on page 183, the changes are subtle yet still aerodynamically important.

Changing Wing Area

Jorn Cheney and colleagues from the UK's Royal Veterinary College have found ways to measure these small changes in wing shape during gliding flight, including measuring the planform, or area when viewed from above, and measuring the camber (the curvature from the leading to trailing edge) of the airfoil along the wing. Data for a Barn Owl (*Tyto alba*) indicate that the main shape variation is in the tip of the leading edge, where the two terminal primaries are extended to increase wing area. As speed increases, the wing is flattened along the entire length, except at the tip, where it is elevated, probably because the movement of the terminal primaries is downward and forward. These are very subtle changes that show what fine-tuning a bird can apply to adjust to new flight conditions. The tests were, however, conducted using quite limited flight conditions compared to what a bird encounters during its daily life as a hunter.

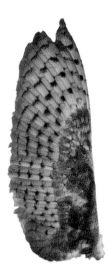

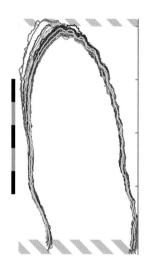

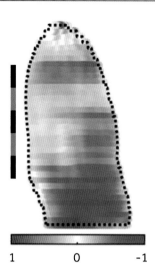

A

Overhead view of the left wing of a Barn Owl (*Tyto alba*).

Wing from the Burke Museum collection, University of Washington, Seattle

B

Perimeter scans of a live Barn Owl's wing during gliding in a laboratory at different speeds. The scale bar is 20 cm (8 inches).[2]

Cheney et al. CC BY 4.0 DEED[2]

C

Changes in the camber of the wing over the speed range. Red shows an increase in camber with speed, and blue a decrease. One unit is 1% of chord length. The scale bar is 20 cm (8 inches).[2]

Cheney et al. CC BY 4.0 DEED[2]

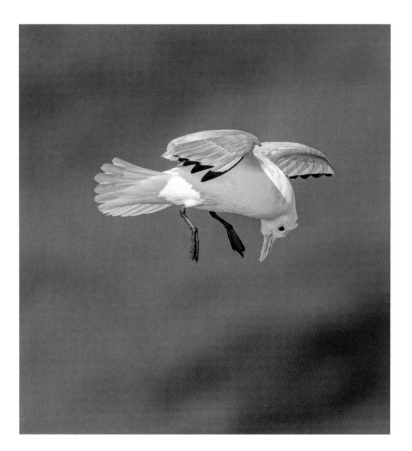

A gull of northern latitudes, the Black-legged Kittiwake (*Rissa tridactyla*), hangs on its drooping wings (wrists higher than the tips of primaries) as it glides over a potential food source.

Arnarstapi, Iceland. May. IUCN category: Vulnerable

Maintaining Stability

Birds fly despite being buffeted by wind, rain, and snow. They have a number of mechanisms to maintain stability and regain it after a disturbance. These include dihedral, wing droop in gulls, a suspension system, and large ranges of motion at important joints of the wings.

One way that birders distinguish a Turkey Vulture from other large birds at a distance is that the vulture's wings are usually held in a V configuration when it is not flapping. This is known as a dihedral, and it is a common design feature in many airplanes. When a bird is turning, there is a tendency to slip (move toward the inside of the turn) and to lose altitude. In a wing with dihedral, the lower wing (on the side of the tilt) generates more lift than the upper wing and tends to restore the

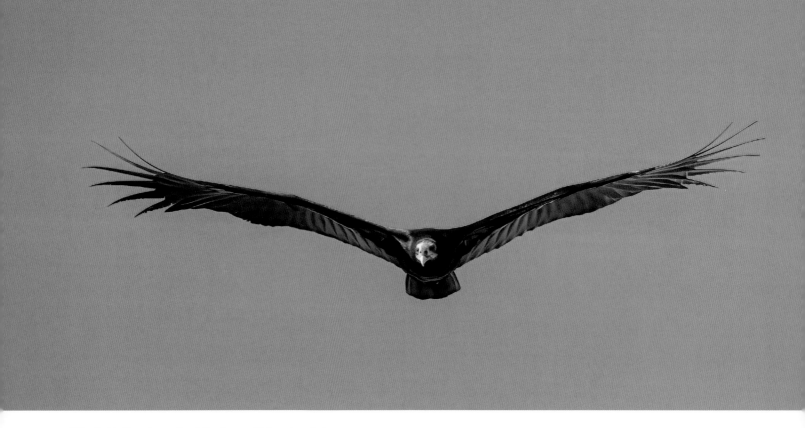

Dihedral in the wings of a gliding Lesser Yellow-headed Vulture (*Cathartes burrovianus*).
Crooked Tree Preserve, Belize. January.
IUCN category: Least Concern

equilibrium and get the bird out of the roll. This happens because the angle of attack on the low wing is temporarily higher than that on the high wing.

The "drooping" wings of gulls (where the wings are held in an arc with the tips lower than the wing roots, see image of the kittiwake on page 185) are often a feature of children's seaside drawings. A team from the Altshuler Lab at the University of British Columbia has shown that by altering the droop (technically known as spanwise camber), gulls can change the stability of their flight behavior, allowing them to recover from a small disturbance in pitch without active wing movement.[3] Similarly, Jorn Cheney and his researchers from the Royal Veterinary College in London, UK, demonstrated that bird wings can act as passive suspension systems to minimize body movements in gusty conditions.[4]

Asymmetrical Wing Movements

A major difference between birds and airplanes is that a bird can move its wings into an asymmetrical position to radically redirect the lift vectors on either side of its body. Birds can, for example, have asymmetrical dihedral, where one side of the V is higher than the other. This offers more possibilities for quickly reestablishing equilibrium. Hummingbirds also sometimes use their right and left wings independently to accomplish agile turns.

I photographed some very asymmetrical wing motions on a visit to one of several "feeding stations" for Red Kites (*Milvus milvus*) in Mid Wales. This species was almost extinct in the United Kingdom at the start of the 20th century, but reintroduction and feeding programs have moved Red Kites into the success column. I shot continuously for 20 minutes, between the arrival of

The kite approaches in level flight on the lookout for food.

Target spotted! It morphs and drops its left wing to decrease lift, resulting in a 90-degree roll to the left. It maintains its head in a horizontal orientation.

Note that the feathers on the upper surface of the wing are all dark brown but are lighter underneath, on the lower surface. This helps decode the orientation of the wings.

The kite continues its roll through about 220 degrees. We now start to see only the ventral (under) surface of the wing, which shows light brown coverts and gray barred flight feathers. It has turned its feet skyward and rotated its head to maintain visual contact with the food.

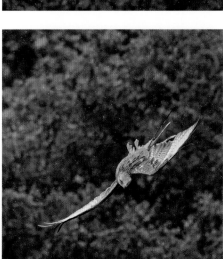

We are now looking at the underside of the bird, but its head is rotated 180 degrees with respect to its body. It is now flying upside down in a steep dive.

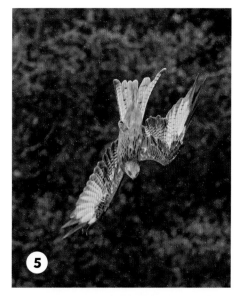

The bird has retracted its left wing (flexed at the wrist) and extended but lowered its right wing. With no vertical lift component, the bird falls rapidly toward the target. There are forces tending to roll its body toward its right wing.

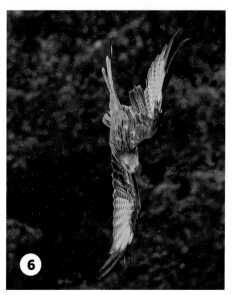

The bird begins to unwind through about 90 degrees as it sweeps its left wing under its body.

It maintains its head with its eyes fixed on the target. During this maneuver, the body has, in effect, rotated around the head.

Red Kite (*Milvus milvus*)
Wales, UK. August. IUCN category: Least Concern

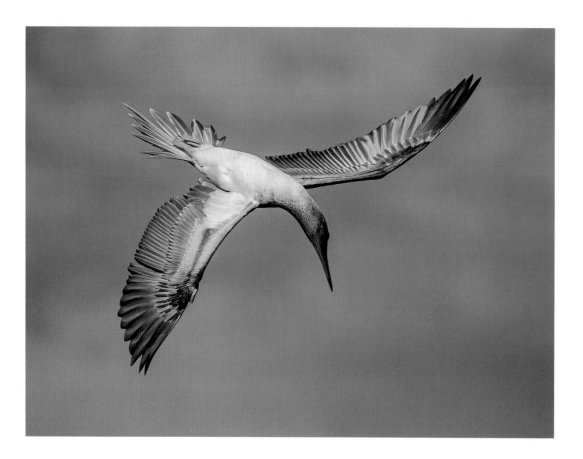

A Blue-footed Booby (*Sula nebouxii*) performs a 180-degree roll to the left by dropping its left wing and starts to lose height. It is momentarily flying upside down in preparation for a dive, with its eye fixed on its prey. It completed its dive with its wings and tail outstretched until just before it entered the water, when they were tightly furled. Santiago Island, Galápagos Islands, Ecuador. October. IUCN category: Least Concern

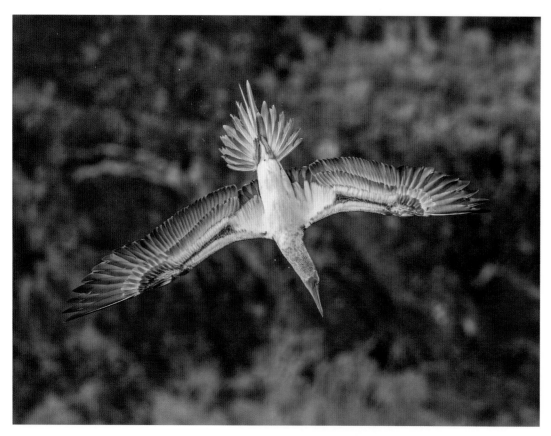

Another Blue-footed Booby (*Sula nebouxii*) in the descent phase of a dive. San Cristobel Island, Galápagos Islands, Ecuador. November. IUCN category: Least Concern

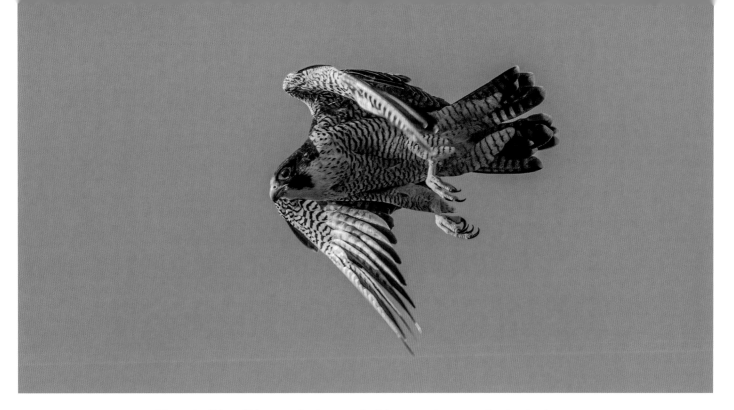

A Peregrine Falcon (*Falco peregrinus*) pursues its flying prey using proportional navigation, which resembles the target seeking of guided missiles.
Lopez Island, Washington, USA. September. IUCN category: Least Concern

the food and the departure of the last satiated kite.

Scrolling through the results at the end of the day, I discovered that I had captured the sequence of a Red Kite transitioning from level flight to a near vertical dive, or stoop (see page 187). From level flight, the bird performed a dramatic roll to the left by dropping its left wing and almost eliminating the lift it produces. Soon the bird was flying completely upside down, but with its head twisted to keep an eye on the food. This is an excellent example of asymmetrical wing motion being used to achieve aerobatic performance.

Chasing Moving Prey

The Peregrine Falcon (*Falco peregrinus*) has been called nature's perfect aerodynamic performer. Among this bird's credentials are pursuit speeds of more than 110 km/h (approaching 70 miles

per hour) and a speed in the stoop (closed-wing dive) that has been estimated to be between 240 and 320 km/h (150 and 200 miles per hour). The Peregrine Falcon steals food from Ospreys and hawks and takes small mammals off the ground, but it mostly snatches smaller birds from the air. As impressive as its performance numbers are, an even more extraordinary facet of this bird's intelligence is that it intercepts airborne prey using a method similar to the algorithm used for guided missiles, called proportional navigation.

The most basic way to run down prey is to follow its every move, a process known as pure pursuit or tail chasing. In birds, this method matches the angle of flight (the direction of the chasing bird's velocity vector) with the angle of site (the angle between the chasing bird's eye and its prey). It is a very inefficient way to capture a moving target, since the pursuer must duplicate every wrinkle in the prey's potentially erratic escape behavior.

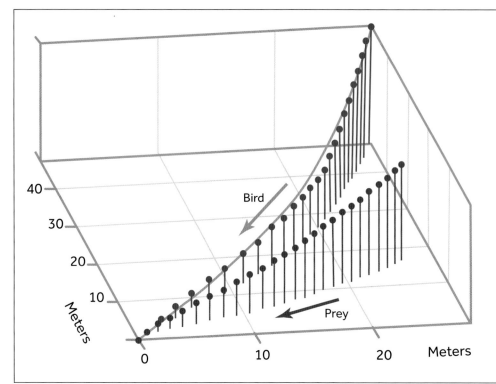

The trajectories in 3-D space of a Peregrine Falcon (blue dots) and simulated prey (purple dots) during the final attack phase of an aerial pursuit, expressed in a coordinate system with the origin at the location of the kill. "Stalks" from the kill plane indicate altitude. The solid blue line is a best-fit model of the bird's approach, using a guided missile algorithm called proportional navigation. Redrawn from Brighton et al.[5]

In a slightly more efficient method, called deviated pursuit, the bird anticipates the direction in which its prey is escaping and flies not toward the prey but toward where it expects it to be in a few seconds. In a study of eight captive Peregrine Falcons chasing lures towed by a light airplane, Caroline Brighton and her colleagues at Oxford University found that the birds exhibited an even better method: proportional navigation, which is sometimes called the missile guidance law.[5] GPS loggers and onboard video cameras tracked both the bird and its prey during the final stages of flight, called the "attack phase."

What is remarkable about the smooth trajectory flown by the Peregrine Falcon in the diagram above is that its path was never directed toward the prey until the final instant of intersection. The paths of the bird and its

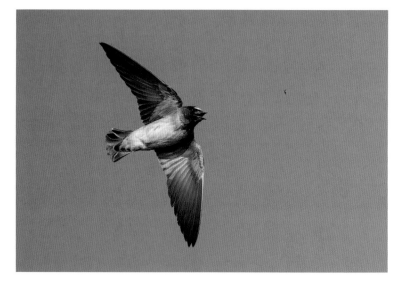

A Cliff Swallow (*Petrochelidon pyrrhonota*) has its bill open as it maneuvers to capture its next meal (a small insect, visible in the upper right). Lopez Island, Washington, USA. July. IUCN category: Least Concern

prey never cross until they intersect at the moment of attack. As you would expect, the actual algorithm involves some calculus, not for the bird but for us to understand it.[6] The rules state

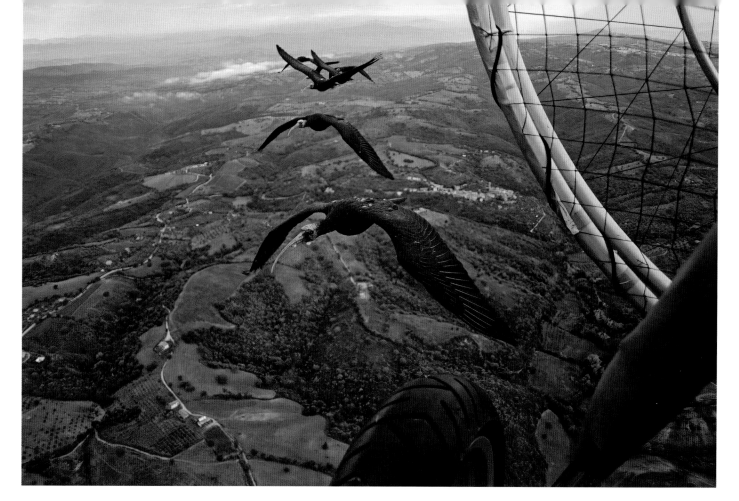

A small group of instrumented Northern Bald Ibises (*Geronticus eremita*) flies in formation behind a paraplane that they have been trained to follow, which is leading them on a migration flight.

Austria. September. IUCN category: Endangered

Photo by Markus Unsöld, the pilot of the paraplane, and used with permission

that the bird's trajectory must change in proportion to the change in the prey's line-of-site angle multiplied by a constant, which tunes the response. It is truly remarkable that birds have evolved strategies for hunting that mathematicians have independently discovered for missile guidance.

To my knowledge, the flight of swallows and swifts has not yet been modeled using the same techniques, but birds in these families also feed on the wing and need to fly intersecting trajectories with extremely small insects, reputedly catching as many 850 insects per day. It is very likely that their flight paths maximize the number of successful prey encounters.

Formation Flying

Swans do it, geese do it, pelicans and cormorants do it — and that is a very incomplete list. Members of these bird families are well-known for their formation flying. V-shaped skeins of birds often stretch over large sectors of the sky, particularly during migration, and it has always been assumed that they are "drafting" each other, like track cyclists in a pursuit race. But why are the cyclists tightly arranged into a single linear phalanx, while each bird is offset from its leader, flying slightly to the side? The mystery of why following the leader in this way is advantageous has been unraveled by Steven Portugal and his colleagues at the Royal Veterinary College in London, UK.[7]

The target bird in the study was the Northern Bald Ibis (*Geronticus eremita*),

a migratory species with a fragmented range that is teetering on the brink of extinction but buttressed by a number of conservation and reintroduction programs. As part of a conservation program, the ibises had been hand-reared at Zoo Vienna in Austria, imprinted onto a human caregiver, and taught to follow a paraplane in order to learn a migration route that would take them to warmer winter quarters (see image on page 191).

The birds were equipped with instrumentation that tracked their positions, trajectories, and body accelerations. This enabled researchers to know where the birds were in relation to each other and what phase of the flapping cycle they were in at a given time. The diagram to the right shows the position of every flap in every following bird in the flock in relation to its immediate leader. Individual birds moved around in the available space behind their leader, perhaps sampling conditions in the available space, but there was a "sweet spot" where most flaps occurred at about 45 degrees behind the leader and at a distance of approximately 1.2 m (4½ feet) behind it.

When researchers examined the sequencing of the birds' wing flaps, they again noted variability but also a strong tendency for a following bird to perform flap-phasing (timing its upstroke and downstroke in synchrony with the wake of its leading neighbor). This combination of position and timing allowed the follower to benefit from the upwash from the trailing vortex of the leading bird, which essentially gave the follower a free

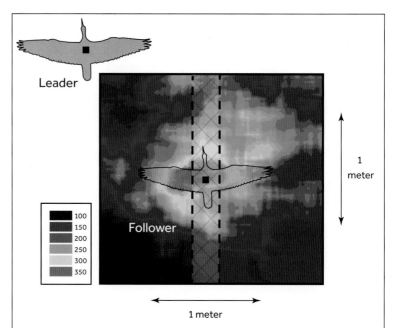

A heat map showing the position of all wing flaps in every following bird in a flock of Northern Bald Ibises in relation to its immediate leader during a guided migratory flight. The color scale shows the number of wing flaps. The zone of predicted maximum aerodynamic advantage behind the leader is shaded. Redrawn from Portugal et al.[7]

lift and presumably an energy saving, because of the reduced power needed for weight support against gravity. A corollary of engaging with the rising air is that the bird also avoided the descending air (the downdraft) that would have been encountered by following directly behind the leader. As the following bird got further behind its leader, its wingbeats drifted more out of phase, as would be expected from an allowance for movement of the turbulent wake over time.

Quite how birds sense the right spot to fly and flap in formation is unknown. Previous studies of pelicans have shown decreases in exercise heart rates when they fly in formation as followers, and this is certainly something that a bird can perceive. But there must be a signal with a shorter time constant, something the bird can sense and seek if it has an immediate

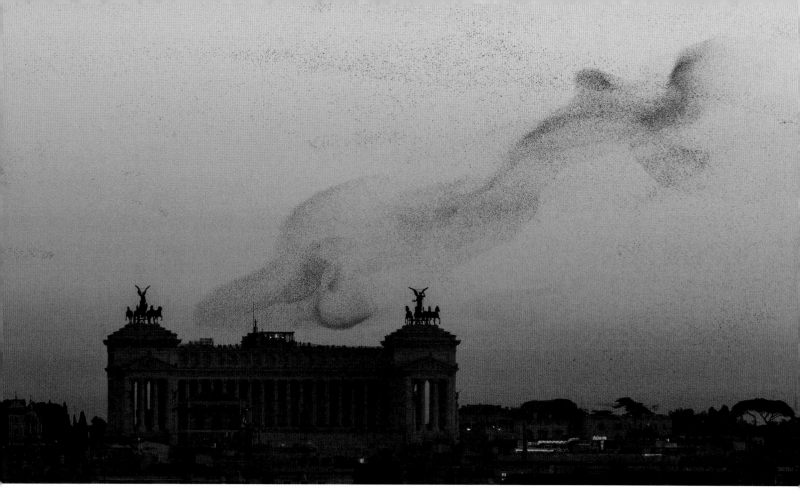

Thousands of European Starlings (*Sturnus vulgaris*) in murmuration, sketching ameboid designs in the skies above the Vittoriano in Rome, Italy.

Rome, Italy. December. IUCN category: Least Concern

need to reduce its energy expenditure to a minimum. So while this research revealed one secret, it identified another that is, as yet, closely guarded by the birds.

Flocking

While some birds are universally loved, such as puffins and quetzals, others have the misfortune of being widely despised. The lowly European Starling (*Sturnus vulgaris*) definitely fits into the latter category, an opinion shared by the general public and wildlife professionals alike. This bird's status as an avian pariah is primarily a consequence of its spectacular breeding success and survival skills. For example, it has

been estimated that the 100 starlings released into Central Park, in New York City, in 1890–91 have subsequently multiplied into an air force more than 200 million strong, occupying foraging and nesting space throughout North America that was previously used by native species.

European Starlings are equally successful in their native countries, where they bring mixed emotions of joy and despair, as this extract from an article in the *Washington Post* explains: "This time of year [January] in Rome, the evening sky is a marvel. Just before sunset, there among the cupolas, starlings mass by the hundreds of thousands, performing an aerial dance. They dip and soar, bunch together and spread out. Seen from the ground, their ephemeral parabolas look like calligraphic brushstrokes. But when

the sun sets, the magic ends. The birds descend — and wreak havoc."[8]

The havoc, of course, is the thick detritus in the streets and on top of cars from the excrement of thousands of birds on an oily olive diet. But the joy is the aerial choreography of hundreds of thousands of birds making ameboid shapes that expand, contract, morph, and multiply against the background of a golden sky.

These displays are called murmurations, an onomatopoeic term coined to capture the sound of an infinite number of flapping wings and an impossibly large choir of bird voices falling to Earth. Once the viewer recovers from the sheer beauty of the spectacle, the most frequently asked question is "How can they do this without colliding with each other?"

Andrea Cavagna, a mathematician living in Rome, was driven to explain the enigma of the birds traveling in the skies above his city in dense, choreographed flocks without constantly colliding with each other.[9] After a series of publications invoking such arcane mathematical esoterica as entropy, statistical mechanics, topology, and consensus dynamics, Cavagna and his colleagues distilled their findings into a simple rule that we can all understand: Each flocking starling appears to monitor the position of about half a dozen of its nearest neighbors and then flies a path to maximize the overall separation from them. This results in a slow, graceful flow of the ensemble by propagation of directional changes throughout the enormous flock.

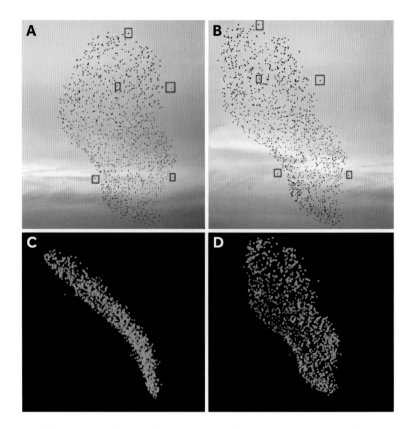

A and B are views of a flock of 1,246 starlings from two stereo cameras. Red rectangles identify the same birds in both photos. C and D show two planes of a 3-D digital graphical reconstruction of the 3-D location of every bird in the flock. Panel D reconstructs the view from camera B.[9]

The theoretical work that led to this conclusion is based on some remarkable three-dimensional tracking and image recognition. In the diagram above, a relatively small flock of 1,246 starlings has been photographed simultaneously by a pair of stereo cameras. Every bird was automatically identified in the two images, and the three-dimensional location of each bird was calculated. Once the data existed for every frame of the flight, the computational fun could begin.

The position of every bird in the flock relative to every other bird was defined using three coordinates: two angles (for azimuth and elevation) with respect to the reference bird's direction

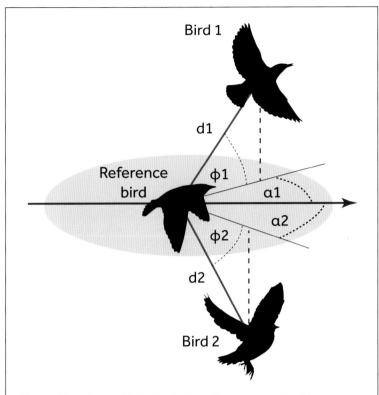

The position of every bird in the flock relative to every other bird was defined using angles for azimuth and elevation (α and Φ) with respect to the reference bird's direction (black arrow) and a distance (d). Only two birds are shown around the reference bird, but these coordinates were also obtained for all other starlings in the flock.

such as alignment, attraction, and repulsion — traditionally believed to be important in flocking — are implicitly included in this analysis.

The final simple guidance law that emerged, that each bird gathers information on six or seven neighbors, included a surprising finding. As shown in the illustration on page 196, the monitored birds are not necessarily the reference bird's nearest neighbors. There are preferred zones for scanning other birds, notably neighbors to the left and right, which receive more attention than those directly in front or directly behind. Side neighbors flying behind the reference bird are also candidates for surveillance, which is reasonable since birds depend on their monocular vision, with starlings having about a 150-degree angle of view on each side.

But what signals are being sensed? Is it just visual information or are sound, smell, and movement of the air also monitored? Zebra Finches (*Taeniopygia guttata*) have been found to use auditory signals to help coordinate small-group flights in a wind tunnel when visual signals were inadequate.[10] Starlings certainly seem to be talking to each other during flocking.

The way in which flight direction, flock shape, and speed can propagate through a flock is clear from these findings. Following birds monitor leading birds and adjust their flight parameters accordingly, but these following birds are leading birds for those behind them, and their flight parameters are also monitored. And so it goes, until the

and a distance (see diagram above). This required 1,245 calculations for each bird and over 1.5 million calculations for the entire flock for every frame of data (1,246 reference birds with respect to 1,245 other birds). This was definitely not a back-of-the envelope calculation!

These hard-won data points allowed the researchers to examine each bird's movement in relation to every other bird. For example, it is likely that neighboring birds moved in much closer synchrony than two birds at the opposite extremes of the flock, but even distant birds had some codependence because, overall, the flock moved in a particular average direction. Factors

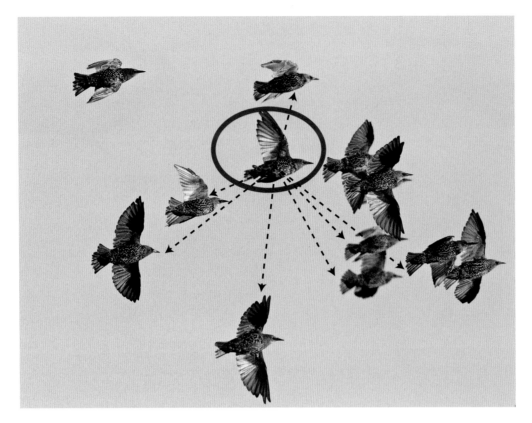

The key elements of flocking behavior. Every bird monitors approximately seven of its neighbors based on preferred zones of surveillance. These are not always the nearest neighbors.

European Starlings (*Sturnus vulgaris*) Lopez Island, Washington, USA. September. IUCN category: Least Concern

direction, altitude, and speed of the last bird in the flock depend to a certain degree on almost every bird in front of it. It is rather like a game of "whispers" in which slight differences in perception from one neighbor to the next determine the shape and movement of the murmuration. In other species, such as Rock Pigeons (*Columba livia*), there are natural leaders of a flock. These birds have faster maximum flight speeds and they may also have personalities that are prone to risk-taking.

Avoiding Obstacles in Flight

The Eurasian Sparrowhawk (*Accipiter nisus*) is a forest-dwelling bird hunter (see photograph on page 197). Like many woodland accipiters, such as its

fabled larger relative the Northern Goshawk (*Accipiter gentilis*), the sparrowhawk is a fighter pilot among cargo planes. To see it land silently in a forest clearing after skillfully rounding an obstacle course of tree branches and shrubbery is a wondrous thing. Vision in some raptors is doubly acute because there are two regions of the retina that have increased visual acuity, both pointing forward but at 15 and 45 degrees to the side (see diagram opposite). When perching, these birds can sometimes be seen looking sideways at a distant object because the 45-degree line has the best visual acuity.

Vision is obviously the key sense involved in avoiding obstacles, and there have been initial efforts to reconstruct the changes in visual input that hawks see during flight, known as the optic flow. Most of what we have

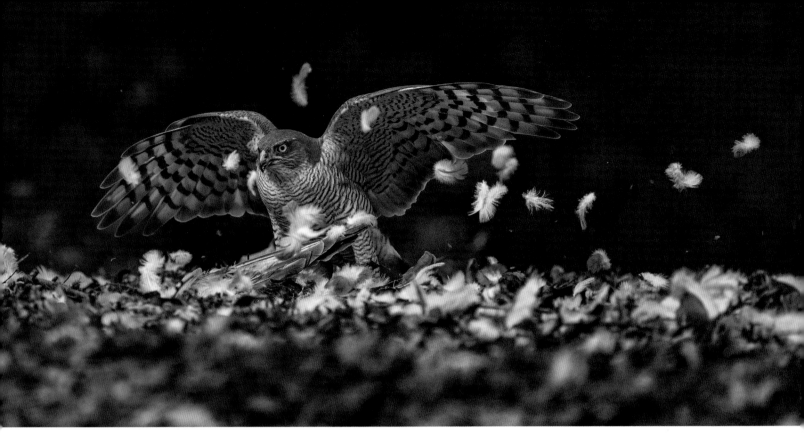

Feathers fly as a Eurasian Sparrowhawk (*Accipiter nisus*) attempts to lift a bird carcass. This bird's predilection for small birds as prey requires it to hunt in forests, where it must constantly avoid obstacles.
Norfolk, UK. April. IUCN category: Least Concern

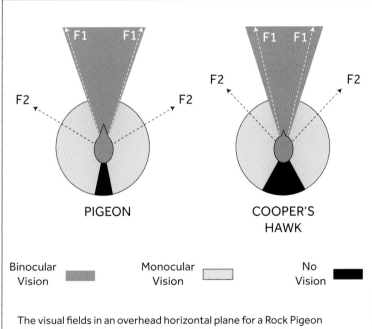

The visual fields in an overhead horizontal plane for a Rock Pigeon (*Columba livia*) and a Cooper's Hawk (*Accipiter cooperii*). Both birds have two areas in each eye where the retina has enhanced sensitivity (foveal areas) for forward vision (F1) and lateral vision (F2). Although the pigeon has a slightly wider field of view, the visual acuity of the hawk is much better.

learned about obstacle avoidance and visual flight control comes from studies of birds such as pigeons, small parrots, and lovebirds, which are easier to manage in a laboratory setting and can fly more slowly. Birds have limited ability to rotate their eyes in the orbit, the bony cavity that encloses the eye, so shifting their gaze often means moving their head. Lovebirds and pigeons in flight have been found to alternate between periods of gaze stabilization and rapid scans using head and neck movements, called head saccades.[11] This appears to be a way of generating additional optic flow (beyond that from the average forward movement itself) about key elements in the environment, such as obstacles and landing sites. Birds probably depend on their monocular vision for navigation, since the narrow area of binocular vision has been associated primarily with the ability to see food and feed chicks. There are two areas of the retina that

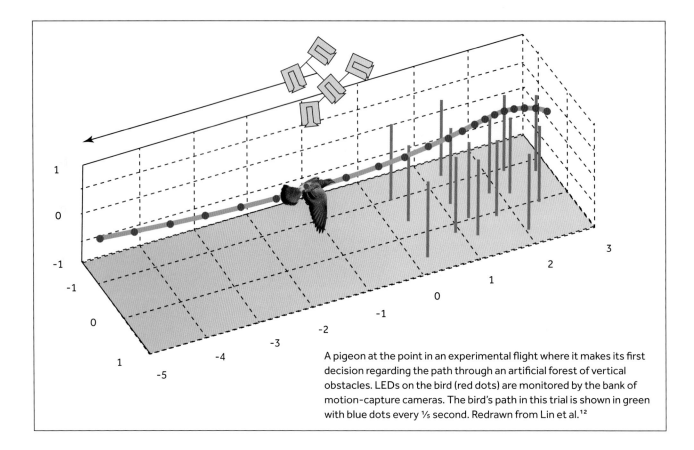

A pigeon at the point in an experimental flight where it makes its first decision regarding the path through an artificial forest of vertical obstacles. LEDs on the bird (red dots) are monitored by the bank of motion-capture cameras. The bird's path in this trial is shown in green with blue dots every 1/3 second. Redrawn from Lin et al.[12]

have enhanced sensitivity, one for forward vision and one for lateral vision. In general, birds are nearsighted in their binocular (forward) vision and farsighted in their monocular (lateral) vision, although raptors do not share the near-field limitation.

Once the obstacle has been identified, the bird now has a navigation problem to solve, just like the Peregrine Falcon in our earlier example, except the obstacle is not generally moving (although it might be, such as a tree branch blowing in the wind). Andrew Biewener and his colleagues at Harvard's Concord Field Station have studied pigeons challenged to fly through a 20-m (65½-foot) straight course obstructed after 10 m (about 33 feet) by arrays of vertical obstacles to represent an "artificial forest."[12] LED markers on

the birds' head and body were automatically tracked to measure position 500 times per second. The hanging obstacles were 25 cm (about 9 inches) apart (see diagram above). To put this in context, the wingspan of a pigeon is about 64 to 72 cm (25–28 inches), and its body is about 10 cm (4 inches) wide.

It is an instructive exercise to put yourself in the pigeon's place and see if you would make the same decisions. Imagine that you are traveling at speed down a corridor you know well from previous unobstructed transits, and you suddenly have to find a way through a randomly placed "artificial forest" to get to safety on the other side. Your choices would seem to be the following: (1) Turn back to the start; (2) go as directly as possible toward the destination and skirt around any obstacles

This slow shutter-speed exposure of a Rock Pigeon (*Columba livia*) emphasizes the morphing and large-amplitude movements of the wings during a climb.
Poole Harbour, UK. March. IUCN category: Least Concern

regardless of the space available; or (3) look for the largest gap, regardless of direction, and aim to go through it. Having successfully navigated the first obstacle, you might look again for the biggest gap and use the same strategy continuously until you are in the clear.

What did you choose? If you decided to go for the biggest gap, you made a very pigeon-like decision; the researchers found that pigeon strategies were biased toward this solution. Surprisingly, the pigeons made their first steering decision very late in their flight, not until they had already covered 85 percent of the unobstructed run up to the initial obstacle. This gave them approximately one-third of a second to execute their first turning maneuver. It is interesting that wing collisions with the "trees" were tolerated by the birds, indicating that flying in real forests is likely a source of wing wear and tear for wild birds. The pigeons hesitated when approaching the obstacles, flew more slowly than in unobstructed transits, and tended to be more variable in their height off the ground.

Curiously, a subsequent study of pigeons flying through a course of horizontal obstacles found that their main strategy was to keep flying in the initial direction and avoid the obstacles as they appeared. The birds obviously had a high degree of confidence that they could cope with whatever challenges came along. Once they decided on a target gap, there was evidence of a similar guidance law at work to that of the Peregrine Falcon mentioned earlier. Predictive computation of flight trajectories using higher-order feedback than just following the line of sight may turn out to be a widely shared avian skill.

The actual flight mechanics involved in obstacle avoidance by Rosy-faced Lovebirds (*Agapornis roseicollisus*) is something we have encountered many times: repurposing the lift and drag vectors through large and unusual wing movements to accelerate in an avoidance path away from the obstacle. Conversely, when turning around a 90-degree corner, pigeons have been described as "turning like helicopters," where their body orientation changes in the direction of the turn and their wing movements remain relatively unchanged. The wing forces then accelerate the bird in the new body-direction. (See From the Lab opposite.)

There are still many mysteries regarding obstacle avoidance, particularly in birds such as the hawks, which excel at barreling through a forest at high speed, barely touching a leaf. The pace of research into avian in-flight maneuvers has been quite dramatic in the last decade, and there will be many more surprises to come soon.

How do pigeons turn in slow flight?

THE QUESTION	Do pigeons turn by redirecting aerodynamic forces relative to their bodies or by rotating the body itself?
THE AUTHORS	Ivo G. Ros, Lori C. Bassman, Marc A. Badger, Alyssa N. Pierson, and Andrew A. Biewener
THE SOURCE	"Pigeons Steer Like Helicopters and Generate Down- and Upstroke Lift During Low-Speed Turns," *Proceedings of the National Academy of Sciences of the United States of America* 108, no. 50 (2011): 19990-5, PMID: 22123982, DOI: 10.1073/pnas.1107519108.
THE HYPOTHESIS	Turning pigeons generate aerodynamic forces in a uniform direction relative to their bodies.

THE EXPERIMENT

A distributed mass model of the pigeon used to estimate the inverse dynamics of wing forces. The volume of the blue spheres is proportional to the mass of the body part.

Redrawn from Ros et al.

- Three pigeons were trained to fly around a 90-degree corner 5 m (16½ ft.) from their perch in a laboratory while maintaining height off the ground.
- Sixteen reflective markers were attached to the birds, and motion-capture cameras acquired their positions during flight.
- Researchers estimated the position of the bird's center of mass from the mass distribution model (left).
- They used Newtonian mechanics to calculate the forces acting on the bird's center of mass throughout five wingbeats.
- They compared the orientation of the calculated net aerodynamic force vector with the orientation of the body.

THE RESULTS

Redrawn from Ros et al.

Left: Arrows indicate the mean aerodynamic force vectors from the three pigeons during downstroke in relation to the bird's body.

The cones represent variability around the mean.

Although large body rotation occurred during the turns, the downstroke aerodynamic force vectors remained closely aligned in relation to the body.

THE CONCLUSIONS	"Pigeons achieve low speed turns much like helicopters, by using whole-body rotations to alter the direction of aerodynamic force production to change their flight trajectory."

CHAPTER NINE

> Birds are endlessly fascinating, partly because they are so diverse.
> — IRBY LOVETTE AND JOHN FITZPATRICK (2016)

Flight Specialists

ONE GLIMPSE OF A HUMMINGBIRD HOVERING IN front of a flower is powerful evidence that all birds do not fly the same way. While hummers are undoubtedly the most exceptional group of avian fliers, many other novel and fascinating ways to fly have also evolved. Unique flight styles are usually facilitated by complementary adaptations to the bird's flight equipment, which gives us snapshots of evolution at work.

The Silent Flight of Owls

A wise old owl lived in an oak,
The more he saw, the less he spoke
The less he spoke, the more he heard,
Now, wasn't he a wise old bird?
— Nursery rhyme (c. 1875)

Although owl hoots can be extremely loud, the old nursery rhyme is correct: The remainder of an owl's life is characterized by silence, including, for nocturnal owls, their flight. The brush of an owl wing has surprised many a midnight birder who never heard the bird approaching. That astonishment must be shared by the small mammals that owls identify as an impending meal. What a contrast this is to the noisy rush of a kit of pigeons rising from the ground or a skein of geese whirring and cackling overhead!

202

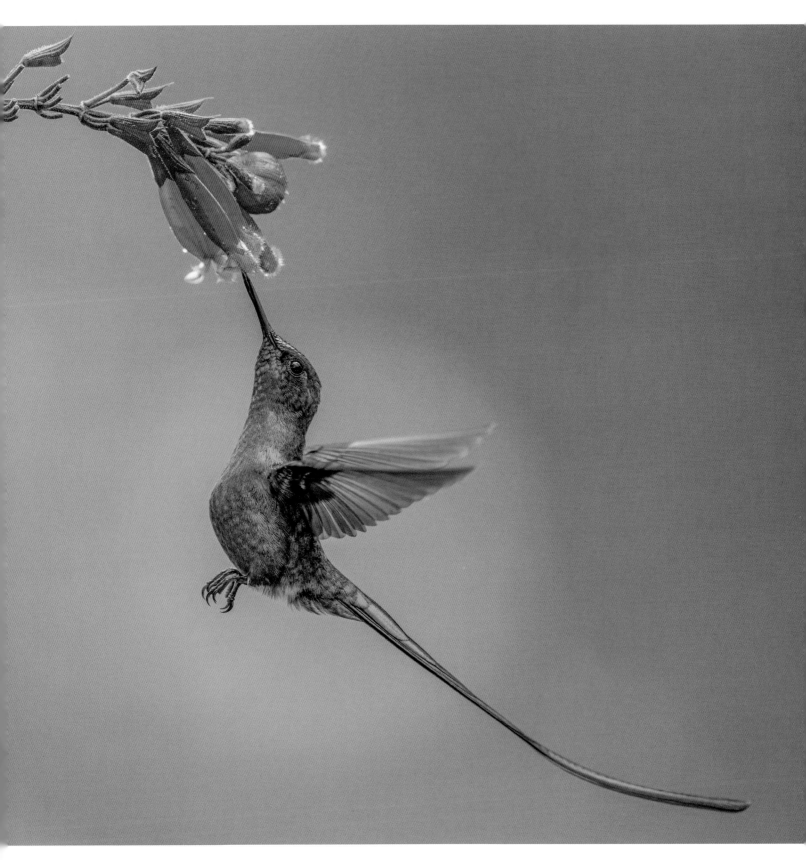

Like other hummingbirds, this male Long-tailed Sylph (*Aglaiocercus kingii*) can maintain its head stationary with respect to the flower while hovering to feed, even in windy conditions.
Bosque del Niebla, Colombia. January. IUCN category: Least Concern

Several theories exist as to why, and how, owls have such silent flight.[1] Nocturnal owls find their food by acoustic rather than visual information. In addition to the obvious need for stealth when approaching relatively mobile and fast-moving prey, some have proposed that the owl's acute sense of hearing needs low background noise to be effective. Barn Owls are known to locate prey through sound in complete darkness, so noisy fluttering of their own feathers could sound thunderous compared to the sound of a mouse rustling in the midnight grass.

Scientists have found at least four separate specialized adaptations that are likely to reduce flight noise in the owl, including the fluffy feathers that cover not only the underside of its body but also its legs and feet. Let's look at two of the others in more detail.

Leading-Edge Serrations

The illustration to the right compares the outer feathers (10th primaries) that form the leading edge of the wing in a Barn Owl and a Rock Pigeon. The razor-sharp edges of the pigeon feather are in stark contrast to the spiny, serrated front edge and fluffy back edge of the Barn Owl's feather.[2] Other owls that are active at night, such as the Ural Owl (*Strix uralensis*), also have leading-edge serrations. This has prompted research into the quiet flight of owls using the kind of methodology usually reserved for aircraft wings.[3]

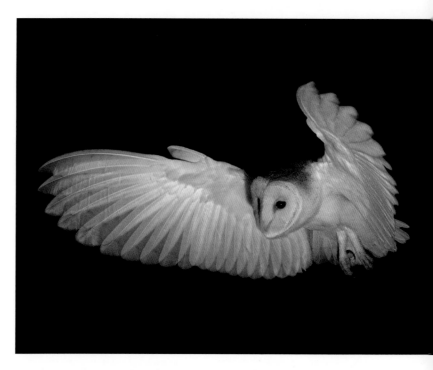

With its quiet flight, the Barn Owl (*Tyto alba*) is a specialist at surreptitiously approaching prey. The sound of my shutter releasing was much louder than the sound from this bird's wings.
Norfolk, UK. April. IUCN category: Least Concern

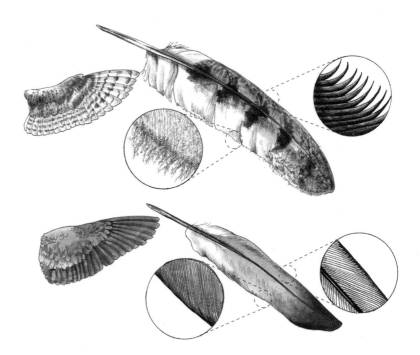

The 10th primary feather of a Barn Owl (*Tyto alba*), top, and a Rock Pigeon (*Columba livia*), bottom, with enlargements of the leading edges (right insets) and trailing edges (left insets) of these feathers. Note the contrast between the specialized projections on the leading edge of the owl's wing with the razor-sharp leading edge of the pigeon. The owl's trailing edge is "fluffy," while the pigeon's wing has a straight edge.

Illustration by Sarah Drummond

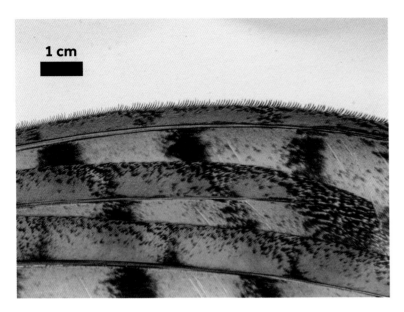

1 cm

The leading edge of a Barn Owl (*Tyto alba*) wing. The serrations on the outer edge of the 10th primary feather (top) are visible. There are about 19 serrations per centimeter (48 per in.).

Wing from the Burke Museum collection, University of Washington, Seattle

Aerodynamics and Acoustics

A computer model of air flowing across a simulated owl wing established that the serrations not only dampen the noise of airflow, they also have the positive aerodynamic effect of increasing the wing's lift-to-drag ratio. The serrations induce tiny vortices over the top of the wing, which are responsible for these changes. But there is a trade-off between lift production and noise suppression: The serrations reduce noise at all wing orientations (angles of attack), but they only give an aerodynamic benefit when the wing is tilted up greater than 15 degrees. The Barn Owl in the photograph on page 204 is likely getting both benefits, with an angle of attack greater than 45 degrees.

The serrations look very fragile, and studies have found that they become damaged and degraded over time.

The Hairspray Experiment

When you hold an owl's wing in your hands, as I did when taking the left photograph, there are two initial impressions. The first is its uncanny lightness. For me, it was reminiscent of the wings of tissue-paper-covered balsa-wood gliders that I made as a boy. The second is the velvety feel of the upper surface of the wing, quite different from touching the crisp, functional wing of a Golden Eagle, for example.

The velvet feel comes from elongated filaments, called pinnulae, that are about 1 mm (about 1/20 inch) long and project from the top surface of the wing feathers. You can see them in the close-up view of feathers on page 206. The top surface of an owl's tail also has the same features.

Krista LePiane and Christopher Clark from the University of California Riverside untangled the competing theories, which posit that these structures are either designed to reduce the low-frequency aerodynamic sounds of swirling air on the downstroke, when airflow over the wing is greatest, or that they damp down sound across all frequencies, caused by the wing feathers rubbing against each other on the upstroke.[4]

The rather cunning tool that these researchers used in their experiments was a can of hairspray. After control flights with no spray, the upper surfaces of five flight feathers in the middle of the wing (primary no. 1 through secondary no. 4) were stiffened by a thin layer of hairspray. The birds then flew a 9 m (29½-foot) course and passed two high-quality microphones during

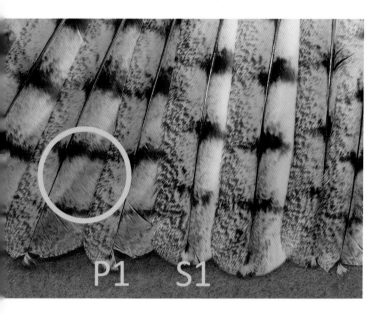

Filamentous projections from feathers on top of a Barn Owl's wing, which give the wing a velvety feel. The first primary and secondary feathers are labeled.

Wing from the Burke Museum collection, University of Washington, Seattle

slow flapping flight. The results showed conclusively that the second hypothesis was correct: The sprayed wings were much noisier on the upstroke than the unsprayed wings. We now know that a major amount of owl flight noise is due to the feathers rubbing together on the upstroke and that their velvet cloak is designed to prevent prey from hearing their approach.

Evolutionary Adaptation

An owl's quiet wings are a superb example of an evolutionary adaptation that facilitates the bird's preferred feeding ecology. The bill of the Sword-billed Hummingbird, the hooked beak of raptors, and the long legs of waders are other good examples of what evolution has wrought over more than 100 million years of experimentation.

Hummingbirds

For bird lovers, everything about each one of the 363 species of hummingbirds is a source of wonder: their bejeweled, iridescent heads and throats; their long, sometimes curved bills; the blur of their wings as they hover; their diminutive size; the torpor that enables them to turn down the thermostat of their turbocharged metabolism. These characteristics, and many others that are equally astounding but invisible, mostly derive from the hummingbirds' preferred diet being the nectar of flowers. In our journey to understand the flight mechanics of hummingbirds, we need to discover the physiological infrastructure that makes their unique flight patterns possible.

A 1982 postage stamp from Cuba showing the endemic Bee Hummingbird (*Mellisuga helenae*). The male bird is the smallest flying vertebrate in the world, at 5–6 cm (2–2½ in.) long and weighing 1·6–2.6 g ($^6/_{100}$–$^9/_{100}$ oz.)
IUCN category: Near Threatened

DBI Studio / Alamy Stock Photo

The Metabolic Consequences of Nectarivory

Nectarivory, living primarily on flower nectar, carries onerous consequences. Nectar has been described as the prey that wants to be eaten, due to birds' beneficial role in flower pollination. But

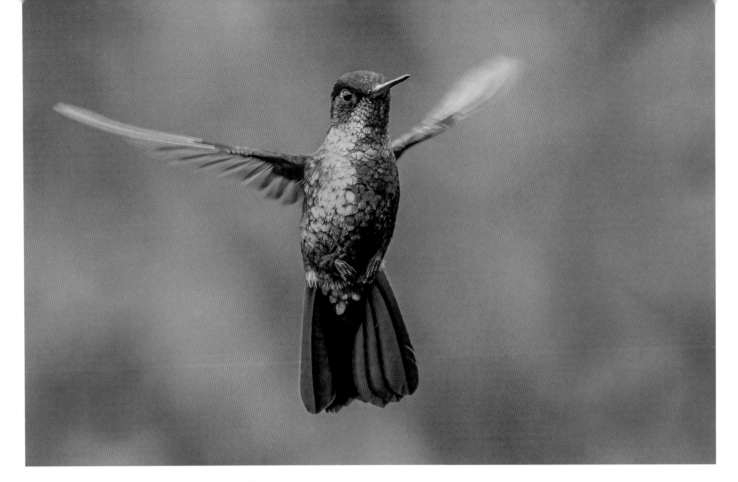

A Fiery-throated Hummingbird (*Panterpe insignis*) hovering.
San Gerado de Dota, Costa Rica. May. IUCN category: Least Concern

nectar can rarely be harvested while perching. It must be taken on the wing while hovering in front of a flower. This is a highly costly activity, and, consequently, hummingbirds have evolved mechanisms that have crowned them the world champions in the vertebrate metabolism division. Hummers consume more energy per unit of body mass than any other vertebrate group of animals, and they do it through startlingly novel biochemical methods. (It is also worth noting that most hummingbirds supplement their diet with insects, as flower nectar is deficient in essential amino acids they require.)

In a fascinating article on hummingbird metabolism, Raul Suarez and Kenneth Welch, Jr., coined the term "sugar oxidation cascade" to highlight the unique process that allows hummers to use the sugar they have harvested directly in their muscles.[5] The authors likened a hummingbird stop at a flower to the aerial refueling of an aircraft, when "fuel 'ingested' from a flying tanker is directly combusted to fuel flight." This is definitely not the way exercise is fueled in humans and most other vertebrates. Hummers have special pathways to move sucrose, the primary sugar that they harvest, across their gut and into their muscle mitochondria, so they can use it immediately and power their fast-twitch flight muscles.

Hummingbirds as Athletes

Everything about the physiology and biochemistry of hummingbirds calls them out as nature's best endurance athletes.[6] They feed at least 100 times per day, their heart rates during hovering can be 1,300 beats per minute, and their two major flight muscles represent about

30 percent of their total body mass, the largest proportion of any group of birds. Typical wingbeat frequencies are 30 to 40 times per second but can be up to 80 beats per second in smaller hummingbirds like Bee Hummingbirds and woodstars, which buzz like insects as they approach. While they are hovering, hummingbirds use the main energy source in muscle (ATP) at 10 times the rate of human marathon runners exercising close to their maximum capacity. Some hummers also have the capacity for long sustained flights during migration, which are fueled by more conventional energy sources, most notably fat. Hummingbird size varies over about a tenfold body-weight range, from the tiny Bee Hummingbird, at 1.6–2.6 g ($^6/_{100}$–$^9/_{100}$ ounce) and with a wingspan of 7.5 cm (about 3 inches), to the Giant Hummingbird (*Patagona gigas*), weighing in at 20 g (¾ ounce) and with a wingspan of about 30 cm (11.8 inches).

A recent study has identified a gene that was deleted during hummingbird evolution, which facilitates their high-energy lifestyle.[7] We usually think of genes as adding to function, but in this instance, the loss of a gene redirected hummingbirds' metabolism away from manufacturing glucose toward sucrose metabolism, which is more efficient. When this gene was "knocked out" of an avian muscle cell line in the lab, the cells became more hummingbird-like in their metabolism. The timing of the loss of this gene in the hummingbird genome matches the time when hovering flight emerged (between 34 to 46 million years ago).

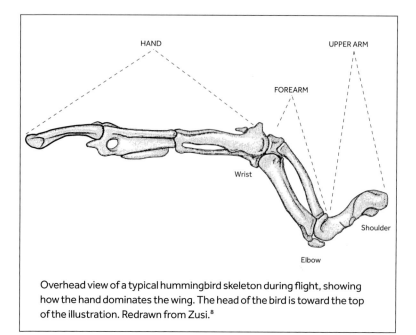

Overhead view of a typical hummingbird skeleton during flight, showing how the hand dominates the wing. The head of the bird is toward the top of the illustration. Redrawn from Zusi.[8]

The Hummingbird Wing

The hummingbird wing is dominated by a massive hand. As the illustration above shows, the fused bones of the hand occupy more than 70 percent of the outstretched wingspan when the elbow is slightly flexed.

A hummer's primary feathers are all attached to the hand, and these feathers dominate the lift-generating capacity of the bird's wings. The wings of the White-booted Racket-tail (*Ocreatus underwoodii*), shown at the top of page 209, are a good example of this: The tiny secondary feathers, squeezed in between the primaries and the body, seem like an aerodynamic afterthought.

The hummingbird wrist and hand are unusually mobile, lacking the restraining ligaments of some of its relatives. The two bones in the forearm allow pronation and supination, just as they do in the human arm. The

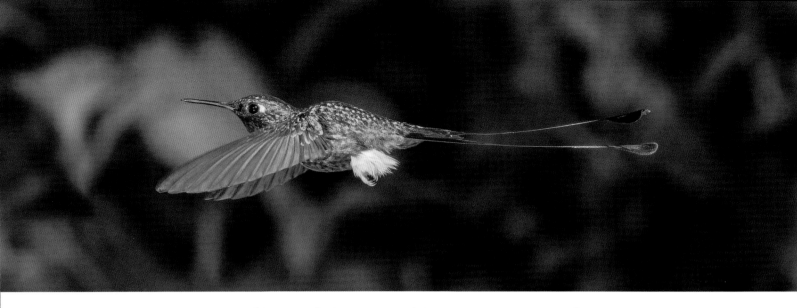

The long blades of the primary feathers contrast with the tiny secondaries in the wing of a White-booted Racket-tail (*Ocreatus underwoodii*) flying between two feeding locations.
Tandayapa, Ecuador. March. IUCN category: Least Concern

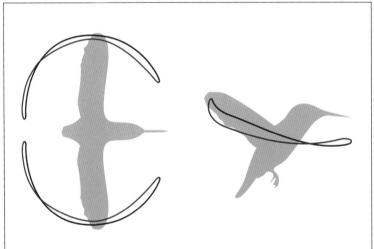

The path of the wing tips of a hovering hummingbird viewed from overhead and from the side, with the wings swept backward and forward through an expansive arc. The upstroke is shown in red, and the down-stroke in blue. Redrawn from Tobalske.[9]

humerus (the upper arm bone) also rotates around its long axis. Hovering exploits all these degrees of freedom.

The Mechanics of Hovering

Hummingbirds, like swifts, are "stiff wing" fliers: They do not flex their wings during recovery as most other birds do. Under some conditions, the wing tips can almost draw a 180-degree arc when viewed from overhead. In a side view, the wing-tip path makes a compressed figure eight, following a slightly lower path on the upstroke than the forward stroke. During the upstroke, the arm is rotated at the shoulder and by pronation at the hand and wrist so the undersides of the primary feathers are now facing upward, trailing behind the leading edge. The wings bend and morph as they are swept back. It is also possible that the wing muscles store and recover elastic energy as they stretch and shorten, which would increase the efficiency of the movement.

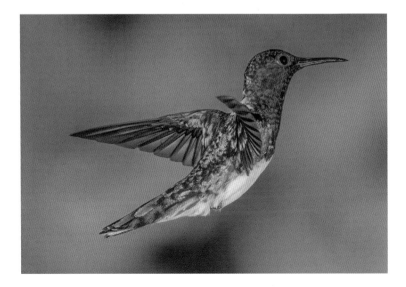

The undersides of the primary feathers on this wing during a mid-upstroke are turned upward, and the wing morphs as the feathers trail the leading edge of the wing as it moves backward.

White-necked Jacobin (*Florisuga mellivora*)
Rancho Naturalista, Costa Rica. April. IUCN category: Least Concern

209

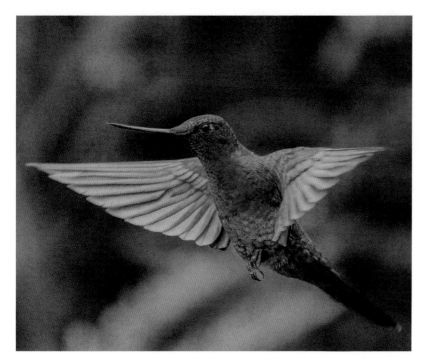
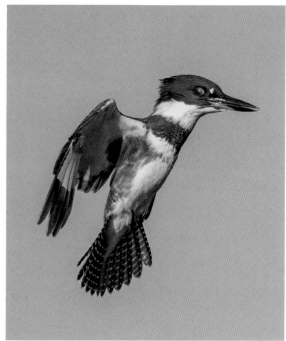

The upstroke in the symmetric hovering of a Great Sapphirewing, left, and the asymmetric hovering of a Belted Kingfisher, right. The terminology refers to whether or not substantial lift is developed during the upstroke.

Great Sapphirewing (*Pterophanes cyanopterus*) Thermales, Colombia. January.

Belted Kingfisher (*Megaceryle alcyon*) Lopez Island, Washington, USA. July.

IUCN category for both species: Least Concern

Many other birds incorporate brief periods of hovering into their flight repertoires. On a summer day near my home, I can see Belted Kingfishers (*Megaceryle alcyon*), Ospreys (*Pandion haliaetus*), and Caspian Terns (*Hydroprogne caspia*) hovering briefly above potential prey before they dive. Some small birds "clap" the top surfaces of their wings together at the top of their backstroke. However, all of these birds hover differently from hummers. They emphasize lift during the downstroke and quick wing recovery, so they can start another lift-producing downstroke before they lose too much height. This type of hovering is referred to as "asymmetric" in contrast to the "symmetric" hovering of hummingbirds.

When hovering, the hummingbird's goal is to keep its bill in the same position relative to the flower for as long as it takes to harvest an aliquot of nectar. Ornithologists call this behavior "docking." To remain docked, the bird would ideally be able to generate a constant upward lift force to counteract the steady pull of gravity, but this is not possible. A hummingbird hovering in still air must create its own airflow across its wings to generate lift, and the amount of lift generated will depend on the wings' velocity and their angle of attack, among other factors.

The illustration on page 211 shows that lift is far from being constant throughout the wingbeat cycle. It rises to a peak of almost twice the bird's body weight during the downstroke but does not quite reach body weight

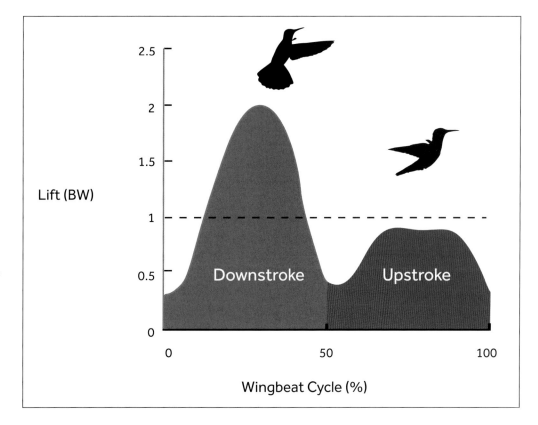

Net lift, expressed as a fraction of body weight, during one cycle of hovering flight in a typical hummingbird. Peak lift is greater than body weight during the downstroke but does not reach full body weight support during the upstroke. Redrawn from Ingersoll et al.[10]

during the upstroke. Nevertheless, this ability to generate substantial upstroke lift is unique to hummingbirds and is not shared by other birds or by most bats that hover. The lift is greater than zero at both extremes of the cycle because the circulation of air around the wings still generates lift at these points of stroke reversal.

Newton's second law (F = ma) tells us that variable lift force will lead to fluctuations in the vertical velocity of the bird's center of mass, meaning the bird will bob up and down in front of the flower. This, however, is certainly not readily visible to the unaided eye. What the bird is probably doing is accommodating the drop in its neck and vertebral column so that its head remains relatively fixed.

I got some direct experience of varying lift while on a photoshoot in the Colombian rainforest. I saw something odd about the behavior of a bird I was photographing, so I quickly switched to high-speed video, shooting 240 frames per second. I was rewarded with some unusual footage of a Velvet-purple Coronet (*Boissonneaua jardini*) that took occasional breaks while hovering. It did this by briefly dwelling at the end of its backstroke, hanging in the air almost stationary for about one-third of a second. Tracking the bird's head and body positions on the video revealed that, although the bird was solidly docked on the flower throughout the pause, its body fell slightly during and shortly after the pauses in flapping and rose once flapping started again (see page 212). Looking closely at its head and neck confirmed that it accommodated the drop of its body by straightening out the curvature of its neck.

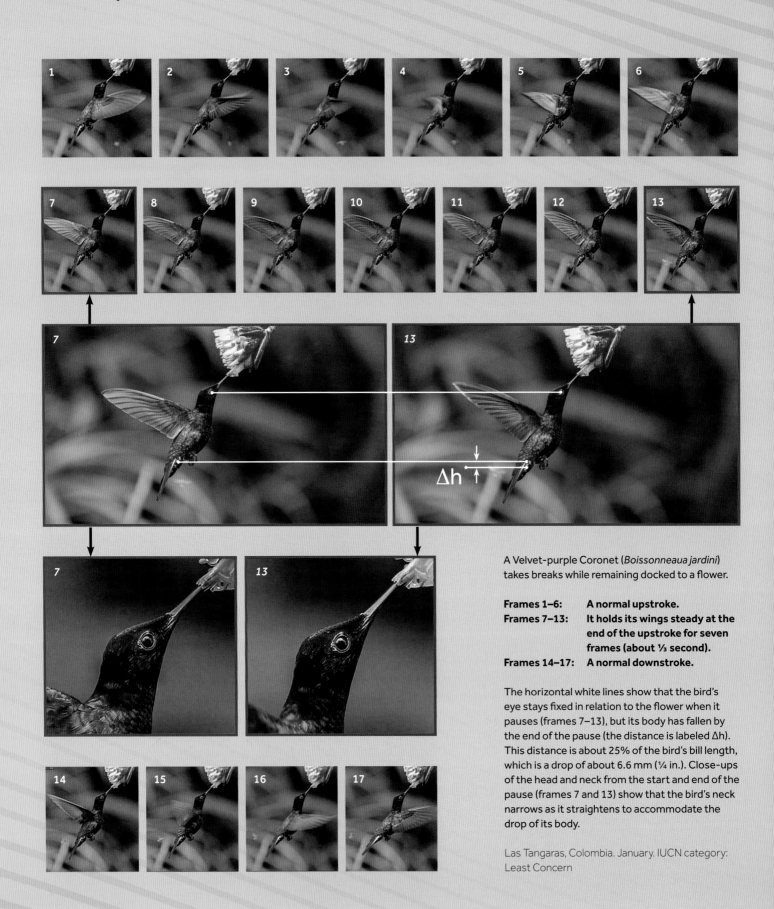

A Velvet-purple Coronet (*Boissonneaua jardini*) takes breaks while remaining docked to a flower.

Frames 1–6:	A normal upstroke.
Frames 7–13:	**It holds its wings steady at the end of the upstroke for seven frames (about ⅓ second).**
Frames 14–17:	A normal downstroke.

The horizontal white lines show that the bird's eye stays fixed in relation to the flower when it pauses (frames 7–13), but its body has fallen by the end of the pause (the distance is labeled Δh). This distance is about 25% of the bird's bill length, which is a drop of about 6.6 mm (¼ in.). Close-ups of the head and neck from the start and end of the pause (frames 7 and 13) show that the bird's neck narrows as it straightens to accommodate the drop of its body.

Las Tangaras, Colombia. January. IUCN category: Least Concern

The Aerodynamics of Hovering

The air swirling around the wings of a hovering hummingbird resembles a torrent of water careering across boulders in a raging river. We know this from studies in which birds hovered in smoke-filled chambers and from computational models that predict airflow. A snapshot from the graphical output of one of these models, built by Jialei Song and his team at Vanderbilt University and colleagues from Duke University, is shown below.[11] The wings move large amounts of air on both the downstroke and the upstroke. Vortices are shed at the wing tip and trailing edge, but a leading-edge vortex is also present, which keeps the flow attached to the wing, provides lift, and prevents stalling at key moments of slow wing movement with high angles of attack in the hovering cycle. It is a rather ironic outcome that hummingbirds have taken this characteristic that was once thought to be restricted to insect flight as their own, since their whole evolution has been designed to take over the domain of nectarivory that once belonged to insects alone.

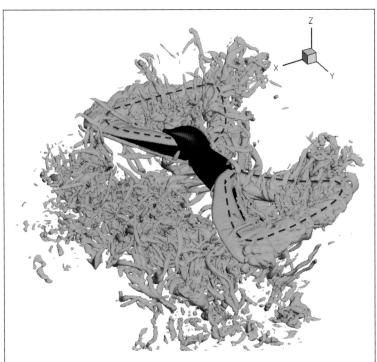

Air swirling around the wings at an instant during the downstroke of a simulated hovering Ruby-throated Hummingbird (*Archilochus colubris*). The dotted lines show leading-edge vortices (LEVs) that provide additional lift.[11]

Image courtesy of Haoxiang Luo and Jialei Song

Stabilizing Head Position

If you have watched hummingbirds feed from a flower on a breezy day, you may have noticed how they seem to automatically drift as the flower moves, so they remain docked to the flower and can continue to feed. This behavior has been well studied by Douglas Altshuler and his colleagues at the University of British Columbia. While the birds were hovering, the researchers projected moving grids on the walls of the enclosure, changing the optic flow that the birds use for stabilization. The birds moved in every direction that the pattern did, including a "looming pattern" where the image got larger, causing the bird to back off. These adjustments are facilitated by an optomotor reflex — a linkage between optical and movement centers in the brain that is innate and rapid-acting.

Swifts: A Life on the Wing

Swifts are magical in the manner of all things that exist just a little beyond understanding.
— Helen Macdonald,
Vesper Flights (2020)

Mysterious Lives

Swifts live very private lives, shrouded in mystery and concealed by their constant movement. Historically, swifts were known as the Devil's Bird because of their sudden appearances and disappearances, their lightning-fast flight, and their twilight climbs, known as vesper flights, when they climb miles above the ground, particularly on moonlit nights. Their high-frequency vocalizations add a layer of menace: One of the collective nouns for a flock of swifts is a "scream." But the persistence of ornithologists has rolled back the curtain on the swifts' peripatetic lifestyle, confirming some of the early myths and adding intriguing new facts about their impressive flight repertoire.

Cigars with Wings

Roger Tory Peterson, a legend in the birding and conservation communities, described swifts as "cigars with wings." This apt visual metaphor captures not only the shape of the bird's body but also the absence of visible feet in its profile and the dominance of its swept-back wings. There are 112 species of swifts. They all have very similar body plans, they all eat insects, but there are some remarkable

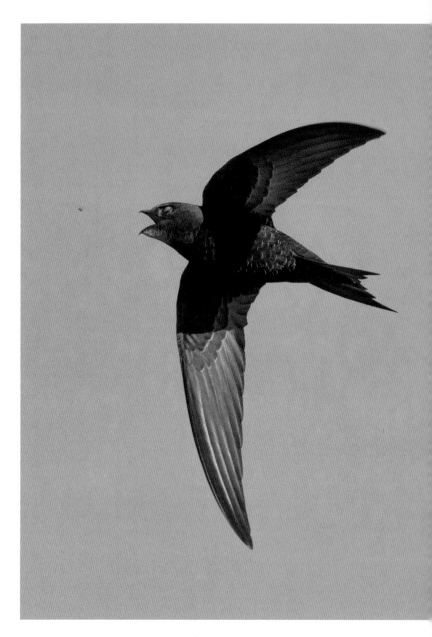

There is nothing common about the flight of Common Swifts (*Apus apus*), which have been recorded to fly for 10 months with minimal or no landings.
Florence, Italy. April. IUCN category: Least Concern

Buiten-Beeld / Alamy Stock Photo

specializations, such as echolocation by cave-nesting swiftlets. Swifts are found on every continent except Antarctica.

Swifts and hummingbirds are closely related, and they share a common ancestor from about 54 million years ago, which makes them sister groups. The structural characteristic that these two groups share is the dominance

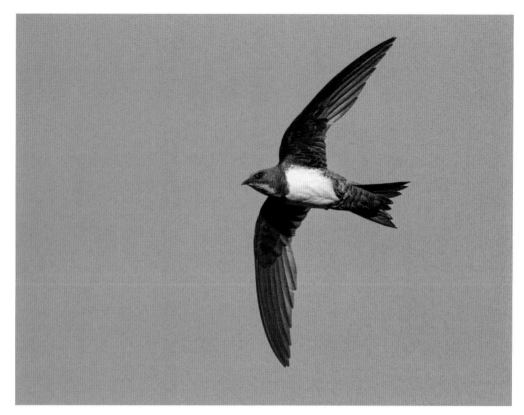

Alpine Swifts (*Apus melba*) tracked for an entire breeding and migration season were found to spend six continuous months in flight without touching down.
Campania, Italy. July. IUCN category: Least Concern

Saverio Gatto / Alamy Stock Photo

of the hand wing. Although swallows and swifts have many similar external, flight, and dietary preferences, they are distantly linked and appear to have developed their similarities through convergent evolution. The Latin name for the swift family, Apodidae, means "no feet." While this is not literally true (swifts do have rudimentary legs and feet capable of powerful grasping), it does reflect that a swift's life is dominated by its scythe-shaped wings. These wings power them to feats of avian athleticism that are not seen in any other group of birds.

Where Do the Swifts Go?

Many species of swifts pull a disappearing act before winter that mystified ornithologists for years. A case in point is the Black Swift (*Cypseloides niger*), the largest swift in North America, whose seasonal disappearance

from the western United States was once explained by the myth that it hibernated in clouds. The reality was somewhat less fanciful: In 2012, Jason Beason and his colleagues from the Rocky Mountain Bird Observatory reported that small geolocators attached to three birds before they left Colorado had been retrieved after a round-trip migration of some 7,000 km (4,350 miles).[12] The sensors revealed that the birds traveled 341 to 393 km (212–244 miles) per day on their journey between Colorado and northwestern Brazil. Although this work answered a long-standing mystery, much bigger swift news was about to break.

World Record Flights

The folklore surrounding swifts always held that they spend much of their lives in the air. The first evidence of exactly how much time came in 2013, when

Felix Liechti and his team from the Swiss Ornithological Institute attached geolocation tags to free-flying Alpine Swifts (*Apus melba*).[13]

The researchers trumpeted their results in a paper with the dramatic title "First Evidence of a 200-Day Non-stop Flight in a Bird." During the non-breeding season, the birds were airborne for at least 200 continuous days, performing all of their functional activities — migrating, foraging, dynamically roosting (gliding for long periods without wing flaps), and presumably sleeping — on the wing.

But there was more to come! Unknown to anyone at the time, some Common Swifts (*Apus apus*) were flying nonstop for 10 months during their non-breeding time, a fact discovered in 2016 by Anders Hedenström and his colleagues at the University of Lund in Sweden.[14] Several birds they studied did take brief rest periods on the ground, up to a maximum of 0.64 percent of their total flight time. Otherwise, the birds landed only to breed.

Feeding and Drinking in Flight

Swifts are often described as feeding on "aerial plankton," which is all the small organisms that are swept up on air currents, including insects and microorganisms such as viruses, bacteria, and fungi. Vaux Swifts (*Chaetura vauxi*) have been estimated to need about one insect every 15 seconds throughout a 24-hour period just to nourish their nestlings. Swifts typically have a huge gape, with their open mouth stretching from ear to ear.

They take water on the wing like a firefighting aircraft scooping water from a lake. It has recently been shown that swifts brake significantly before their bill hits the water.[15] This has been interpreted as a safety measure to prevent falling into the water, which may be a life-threatening event. The slowing down often entails a sharp turn and flight into the wind before drinking (see diagram below). Despite the braking action, the speed at water contact in the approaches shown was a brisk 12.2 m/s (about 27 miles per hour) compared to typical gliding speeds of 13–16 m/s (29–36 miles per hour).

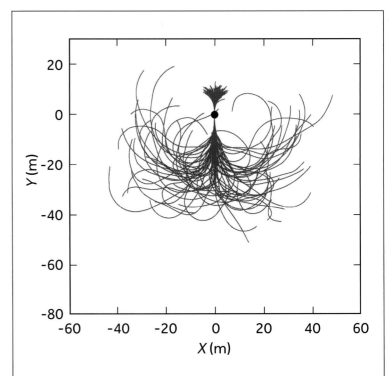

An overhead view of the trajectories used by Common Swifts (*Apus apus*) in 72 different touch-and-go drinking events. The scale is in meters. Note that the approach was never "straight in" but always involved a turn into the final course to lose speed. The tracks have all been rotated and translated so that the final approach is in the same direction and the water contact is at the same point. Redrawn from Ruaux et al.[15]

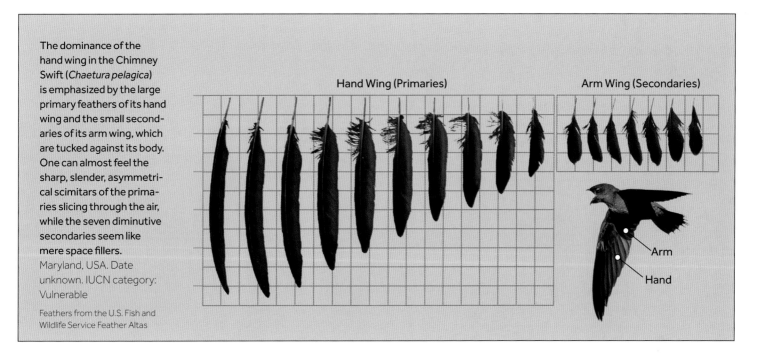

The dominance of the hand wing in the Chimney Swift (*Chaetura pelagica*) is emphasized by the large primary feathers of its hand wing and the small secondaries of its arm wing, which are tucked against its body. One can almost feel the sharp, slender, asymmetrical scimitars of the primaries slicing through the air, while the seven diminutive secondaries seem like mere space fillers. Maryland, USA. Date unknown. IUCN category: Vulnerable

Feathers from the U.S. Fish and Wildlife Service Feather Altas

Hand Wing (Primaries)

Arm Wing (Secondaries)

Arm

Hand

Sleeping Half a Brain at a Time?

It would seem obvious that a swift flying for 10 months without a pause must be sleeping on the wing, but, surprisingly, this is quite a controversial topic. It is complicated by the fact that the gold-standard method for identifying sleep is from direct recording of the electrical activity of the brain (the electroencephalogram, or EEG). So far, no one has been able to build an EEG sensor small enough to fit into a swift-sized backpack. It is believed from eye-movement studies that killer whales (orcas) and dolphins may go without sleep for 90 days, so could the assumption that swifts must sleep be false?

What is known from lab studies of perching birds opens a window onto some fascinating possibilities for swift sleep.[16] Birds experience the same two kinds of sleep (defined based on EEG signals) as mammals, including humans: slow-wave sleep (SWS) and rapid eye movement (REM) sleep. A fascinating fact is that birds can engage in slow-wave sleep one side of the brain at a time. So one half of the brain could be active and one eye (on the opposite side) open, gathering visual information for navigation and prey avoidance. Some aspects of swift flight behavior, such as their evening climbs and morning dives of many thousands of feet (the vesper flights, which inspired the title of Helen Macdonald's book of essays[17]), provide tantalizing hints that this may be a manifestation of sleep. Clarification of the swift sleep cycle, if it exists, awaits the development of suitably sized sensors.

Swift Flight Mechanics

Swifts, as their name suggests, are fast fliers: They have been measured during novel flights called "screaming parties" at 30.8 m/s (69 miles per hour),[18] although they typically cruise at much slower speeds. We perceive these speeds as being even faster because of the bird's small size. Henk Tennekes pointed out that a swift cruising at

top speed is flying at 40 wingspans per second, while a Boeing 747 on approach to landing has a relative speed of only 2 wingspans per second.[19]

As with their sister hummingbirds, swifts' flight is dominated by enlarged hand wings. But unlike hummingbirds, the swift hand and wrist lack the flexible joints that give the hummers their ability to hover. Instead, the swift's feathers are arranged in a swept-back blade that morphs through a wingbeat cycle involving flexion on the upstroke. Swifts are versatile fliers that use soaring, flapping, gliding, and flap-gliding, depending on their requirements. As their flying style changes, one of the most consequential modifications the bird makes is changing the sweep of its wings. Swifts are stiff-wing fliers that do not fold their wings on the upstroke.

David Lentink and his colleagues in the Netherlands studied isolated wings of Common Swifts (*Apus apus*) in a wind tunnel.[20] They found that straighter wings, such as the 5-degree sweep shown above, can increase lift, halving sink speed during a glide. Conversely, a swept-back configuration can triple the rate of turning, which is a characteristic flight pattern for swifts. The best glide speed predicted by the study, 8–10 m/s (about 18–23 miles per hour) matches the speed that these birds choose for their dynamic night roosting. These observations emphasize that we should consider the wings of swifts as adjustable lift-generating devices that can be tuned to meet the requirements of different flight

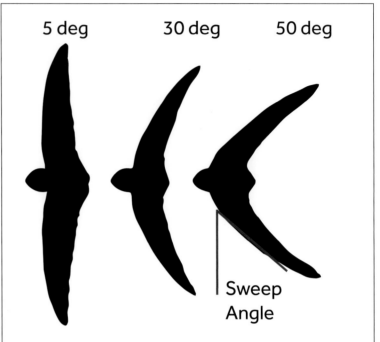

One of the ways in which swifts morph their wings during gliding is by altering the sweep angle. A small sweep angle, such as 5 degrees, provides more lift. A high angle, such as 50 degrees, gives the bird more maneuverability. Redrawn from Lentink et al.[20]

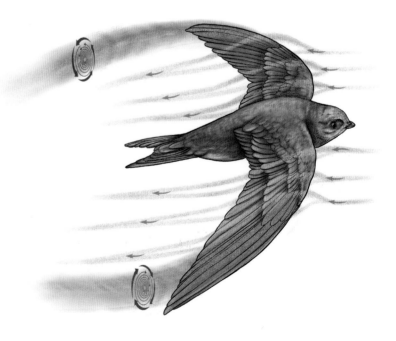

Leading-edge vortices on a swift's wings.[21]

conditions. This is true for most birds to some degree, but swifts offer a master class in wing morphing.

The sharp leading edge of the swift's wing has been shown by another Dutch researcher, John Videler, to generate the kind of leading-edge vortex (LEV) that was previously identified in insects, hummingbirds, many other birds, and delta-wing airplanes, such as the Concorde.[22] (See lower illustration on page 218.) This vortex increases lift at high angles of attack and can also prevent stall. One study has suggested that LEVs could support up to 60 percent of a Common Swift's body weight during gliding.[23]

Foraging for Free

Just because swifts are highly capable avian athletes with many potential flight styles and maneuvers, it does not mean that their daily lives are filled with aerodynamic excitement. In fact, it appears to be quite the opposite. The title of a report by Tyson Hedrick from the University of North Carolina at Chapel Hill, "Gliding for a Free Lunch,"[24] sums up previously unknown aspects of swift flight. Hedrick and his team studied free-flying Common Swifts (*Apus apus*) hawking for insects and found the birds spent almost three-quarters of their flight time in wings-extended gliding. In addition, the birds appeared to have another expert talent, exploiting rising air masses to minimize their cost of transport. The authors concluded that "gliding swifts extracted sufficient environmental energy to pay the cost of flight during foraging." There really is a free lunch!

Albatrosses

"God save thee, ancient Mariner!
From the fiends, that plague thee
 thus! —
Why look'st thou so?" — With my
 cross-bow
I shot the ALBATROSS.
 —Samuel Taylor Coleridge,
 "The Rime of the Ancient
 Mariner" (1797–98)

The frontispiece of the 1903 edition of "Rime of the Ancient Mariner," illustrated by William Strang. It depicts the moment when the dead albatross is hung around the mariner's neck.

Wikimedia Commons, public domain

Albatrosses are among the most endangered birds in the world, frequently snared in longline fishing rigs. They lay a single egg and don't start breeding until the age of 7, which makes their reproductive success very precarious. Their flight skills are phenomenal and serve as a case study in specialization, allowing the birds to survive in extreme southern latitudes.

The tiny former whaling station of Grytviken in South Georgia stands on the frozen, crenelated shore of a fjord inside the Antarctic Convergence zone. It is best known as the final resting place of British polar explorer Ernest Shackleton, and where I, and almost every other visitor on their way to Antarctica, have raised a glass of Scotch whisky in memory of "The Boss." But it is not this hero's desolate grave nor the stirring words by Robert Browning that are inscribed on his tombstone ("I hold … that a man should strive to the uttermost for his life's set prize") that have lingered as the dominant memories of my two visits to Grytviken.

What grabbed my attention was a mounted specimen of a Snowy Albatross (*Diomedea exulans*) making a steep-banked turn (see photograph below right). It looks at you in the eye as you enter the small but excellent South Georgia Museum in Grytviken. I had photographed these birds in flight using a long lens from the deck of a heaving boat in the Southern Ocean, but that somehow kept me from appreciating how large a 3.5-m (11½-foot) wingspan really is. There is no reality gap when you stand shoulder to shoulder with this enormous bird.

Many-Feathered Arms

Albatrosses are hyper-evolved for their role as oceanic gliders and soarers. The visible signs are an extremely long and thin arm wing that, in the Snowy Albatross, anchors an astonishing 32 secondary feathers (compared to the paltry collection of five or six secondaries in a

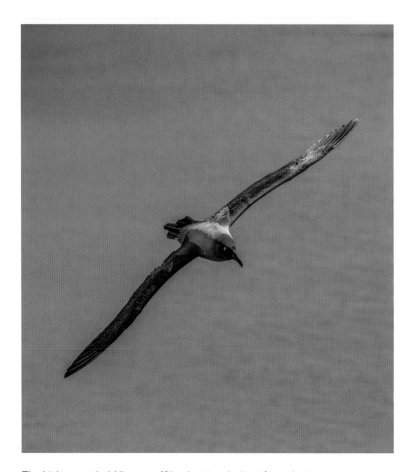

The Light-mantled Albatross (*Phoebetria palpebrata*) is a sleek gliding machine with advanced flight skills.
Elsehul, South Georgia. October. IUCN category: Near Threatened

A curator cleans a mounted specimen of a Snowy Albatross (*Diomedea exulans*).

Photo courtesy of the South Georgia Museum, Grytviken

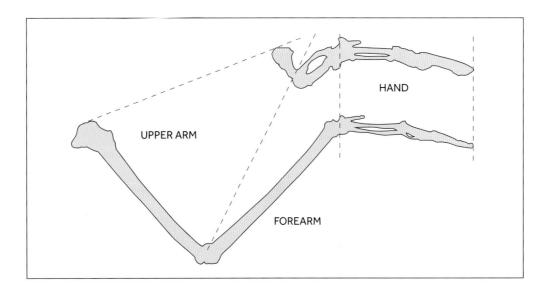

A schematic drawing of the wing bones of a Black-chinned Hummingbird (*Archilochus alexandri*) and a Laysan Albatross (*Phoebastria immutabilis*) scaled so that the length of the hand is the same in each bird. The dominance of the hand in the hummingbird and the arm in the albatross is striking.[25]

typical hummingbird). In the illustration above, the wing bones of a hummingbird and an albatross have been scaled so that the hand is the same length in both birds. The albatross's forearms and upper arms are proportionately 4.3 and 6.5 times larger than the same segments in the hummingbird. These differences reflect the functional dominance of the different parts of the wing in flight for these birds. The secondary feathers on the hummingbird's forearm contribute little to lift during hovering, but the huge area of the outstretched albatross wings gives them a large aspect ratio (length divided by average width) and the consequent high lift-to-drag ratio, making albatrosses very efficient gliders.

A Unique Wing Lock

In addition to the enhanced efficiency of their wings, albatrosses have two other secret weapons to decrease the energy cost of their flight, one behavioral and the other anatomical. The behavioral adaptation is a flight pattern called "dynamic soaring." The anatomical advantage was discovered by C.J. Pennycuick in 1980, while he was doing research on Bird Island in South Georgia.[26] In manipulating the wings of albatross carcasses, he noticed that "The shoulder joint appeared to come up against a positive mechanical lock when raised to the horizontal position."

This does not occur in most other birds, which need shoulder mobility to raise their wings high during flapping flight. Pennycuick provided no anatomical sketches to illustrate his find, but subsequent research has found a deep band of tendon underneath the muscle that is the major wing depressor (the pectoralis major).[27] This is not a classical lock, in the sense that there is no "key," and it is not two bones impinging against each other, as happens in our own elbow. It is a bit like the flexible door strap that I have on my vintage MG car, which prevents the door from opening too far. This lock allows albatrosses to "hang" their body weight from the wings during gliding with little or no muscle activity. The mechanism is likely responsible for the startling finding that gliding flight is barely costlier for an albatross than sitting on the water.

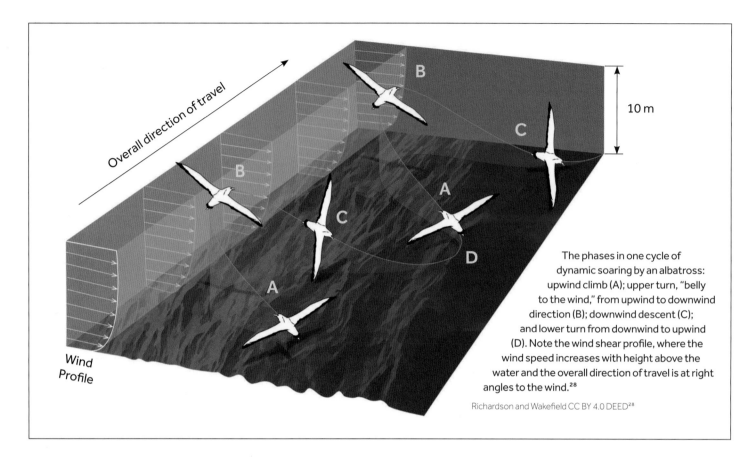

10 m

Overall direction of travel

B

C

B

C

A

A

D

Wind Profile

The phases in one cycle of dynamic soaring by an albatross: upwind climb (A); upper turn, "belly to the wind," from upwind to downwind direction (B); downwind descent (C); and lower turn from downwind to upwind (D). Note the wind shear profile, where the wind speed increases with height above the water and the overall direction of travel is at right angles to the wind.[28]

Richardson and Wakefield CC BY 4.0 DEED[28]

Dynamic Soaring

The second secret is hiding in plain sight. Since the days of the Ancient Mariner, seafarers in the Southern Ocean have noticed something really odd about the flight of albatrosses as they follow a ship: The birds often seem to be going the wrong way, flying at right angles to the ship rather than alongside it, like most other avian ship followers. And albatrosses almost never flap, but they always end up in the right place, just in front of the ship.

This behavior is called dynamic soaring. It has long been a subject of fascination for biologists and aerodynamicists alike. We know that gliding always results in either a loss of altitude or a loss of speed because of the relentless forces of gravity and drag. But in one cycle of dynamic soaring, albatrosses, soaring about 10 m (33 feet) above the ocean surface, descend, execute a turn, and climb back to their original height without flapping. In the language of physics, at the end of the cycle they have the same energy (potential energy due to height and kinetic energy due to velocity) as they had at the start, despite having experienced the forces of drag and gravity along the way.

There is no simple, mathematics-free explanation of the physics of the energy harvesting that the albatross is achieving through its intricate, carefully directed turns, climbs, and descents.[28] The presence of wind shear — low wind speeds at the surface boundary layer and higher winds above — is key to the technique. Although the overall direction of flight in dynamic soaring is usually described as cross-wind, birds can travel at other angles to the wind by a process similar to tacking in sailing.

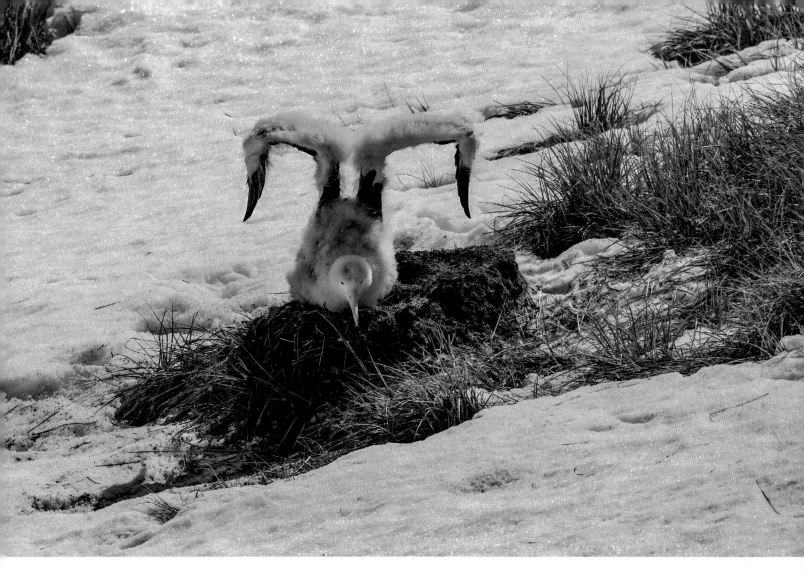

A Snowy Albatross (*Diomedea exulans*) chick, still covered in down, awaits the return of its peripatetic parent in a rudimentary ground-scrape of a nest. Also note the clear view of the three parts of the wing. Prion Island, South Georgia. October. IUCN category: Vulnerable

Foraging for Food

Equipped with this array of energy-saving tools (low-drag, high-lift wings, wing locks, and dynamic soaring), Snowy Albatrosses travel the Southern Ocean in the service of a single egg and, hopefully, a single chick. I photographed the young chick shown above on Prion Island, South Georgia, while it waited impatiently, in a mere scrape of a nest, for its itinerant parents to return and regurgitate a hard-won food cargo. Unlike many young birds, who are ready to fly and feed themselves within weeks of hatching, Snowy Albatross chicks will not fledge until they are 8 to 10 months old, at which time they will weigh about 9 kg (almost 20 pounds).

We know a lot about what happens on these long foraging trips from studies of six adult Snowy Albatrosses that were fitted with some pretty significant monitoring hardware, including satellite transmitters, activity recorders, and stomach temperature sensors, by Henri Weimerskirch and his colleagues from the Centre d'études biologiques de Chize, in France. With this equipment, the investigators could tell not only

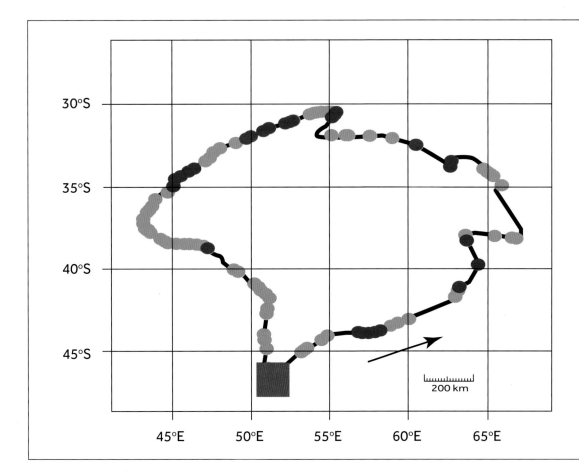

The path of a Snowy Albatross on a multi-day foraging round trip that covered at least 7,200 km (about 4,500 mi.) from Crozet Island (brown square) in the Indian Ocean. Filled ovals represent water landings (blue during daylight, red at night). Redrawn from Weimerskirch et al.[29]

where the birds were, but whether they were in the air or on the water and if they had swallowed prey.[29]

On trips of between 1,318 km (819 miles) and an astonishing 13,240 km (8,227 miles), the birds divided their time 60:40 between flight and sitting on the water, which they did about every hour on average. In the daylight, they flew for long stretches of 200 km (124 miles) or more before searching more intensely for food in one area. Some birds flew for over 11 hours continuously. But during the night, the preferred strategy was sitting on the water and waiting for prey to appear. The yield for all this effort was pretty minimal — less than seven squid swallowed per day. The map above gives a summary of an albatross's single 14-day trip of 7,243 km (4,500 miles) from its nest in the Crozet Islands. Even though, at the larger scale, the bird seems to be traveling in a straight line, zooming in would show the characteristic S-shaped paths of dynamic soaring.

Do male and female Snowy Albatrosses forage differently?

THE QUESTION	Is there a sex difference in the foraging choices of Snowy Albatrosses?
THE AUTHORS	Thomas A. Clay, Rocío Joo, Henri Weimerskirch, Richard A. Phillips, Olivier den Ouden, Mathieu Basille, Susana Clusella-Trullas, Jelle D. Assink, and Samantha C. Patrick from the School of Environmental Sciences, University of Liverpool, England
THE SOURCE	"Sex-Specific Effects of Wind on the Flight Decisions of a Sexually Dimorphic Soaring Bird," *Journal of Animal Ecology* 89, no. 8 (August 2020): 1811–1823, DOI: 10.1111/1365-2656.13267.
THE HYPOTHESIS	Because of their higher wing loading, male albatrosses would prefer to fly in high winds while females would seek calmer air.
THE EXPERIMENT	Over seven seasons, GPS loggers were attached to incubating birds of known sex on Crozet Island (46°24'S; 51°46'E). Latitude and longitude coordinates were recorded every 15 minutes on 347 foraging trips. Estimates of winds at 10 m (about 33 ft.) above the surface were obtained from various weather services.

THE RESULTS

- A map of an area between the Cape of Good Hope and Antarctica showing paths taken on foraging trips by female (blue) and male (black) Snowy Albatrosses. The separation by sex of the geographical areas used is striking.
- Male birds experienced significantly stronger winds than female birds during their foraging flight.
- Males were much more likely to take off from the surface in high winds, exceeding 20 m/s (44 mph).

Clay et al. CC BY 4.0 DEED

THE CONCLUSIONS	"Due to differences in flight morphology, males were more likely to modulate flight decisions to wind than females. Their reliance on stronger winds for energy-efficient flight may also explain the preference of males for windier habitats."

"

Reverence for this extraordinary bird and the millions
more like it, which by obeying their ancient rhythms
knit up on the scattered and beleaguered wild places of
the world into a seamless whole through the simple act
of flight. May it always be so.

— SCOTT WEIDENSAUL, *A WORLD ON THE WING* (2021)

Migration

Zugunruhe

YOU MAY BE UNFAMILIAR WITH THE GERMAN
word *Zugunruhe*, but you have likely experi-
enced the emotion that it invokes: a restless
urge to move or migrate. After a winter in the
Pacific Northwest, I definitely have the urge
to take my camera to warmer places, to shed
layers of fleece and feathers, and to enjoy long hours of summer
sunlight. I am not sure if I unconsciously point southward,
move more frequently from room to room, down-regulate some
key hormones, and start taking on additional calories for my
journey. Birds, however, do all these things as they experience
the *Zugunruhe* of "migratory syndrome" and prepare themselves
physically, and perhaps psychologically, for their epic journeys.

Why Do Birds Migrate?

It has been estimated that about 40 percent of bird species
migrate on an annual basis. As I contemplate the astonishing
long-distance flights of these billions of migratory birds that we
are about to explore, I cannot suppress a recurrent question

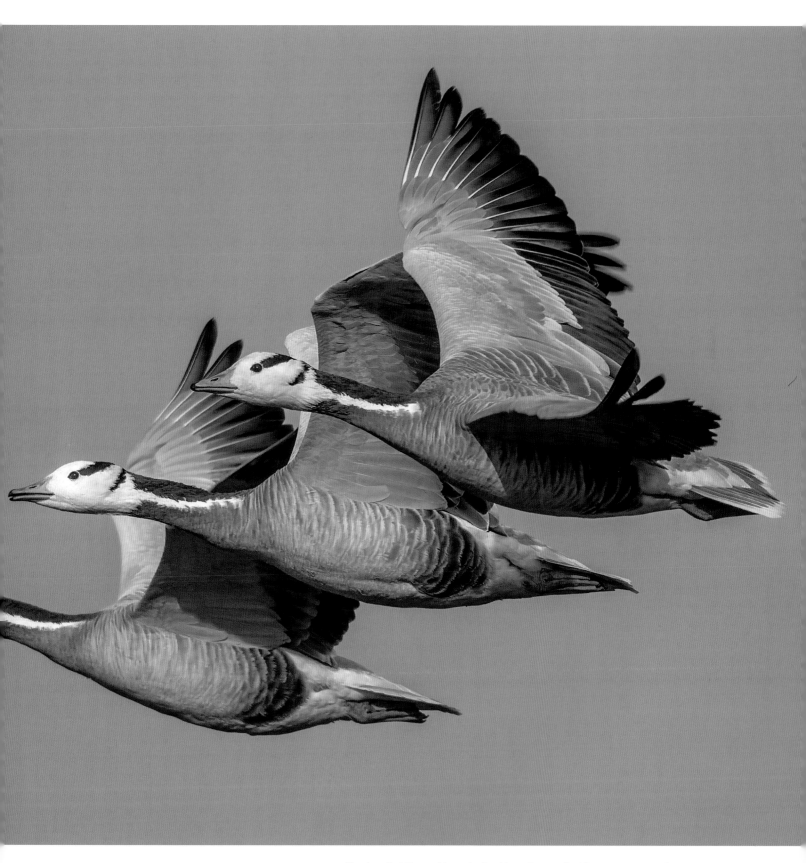

Bar-headed Geese (*Anser indicus*) have been called "avian astronauts"
for their high-altitude trans-Himalayan migration flights.
Uttar Pradesh, India. March. IUCN category: Least Concern

Photo courtesy of Nitin Chandra

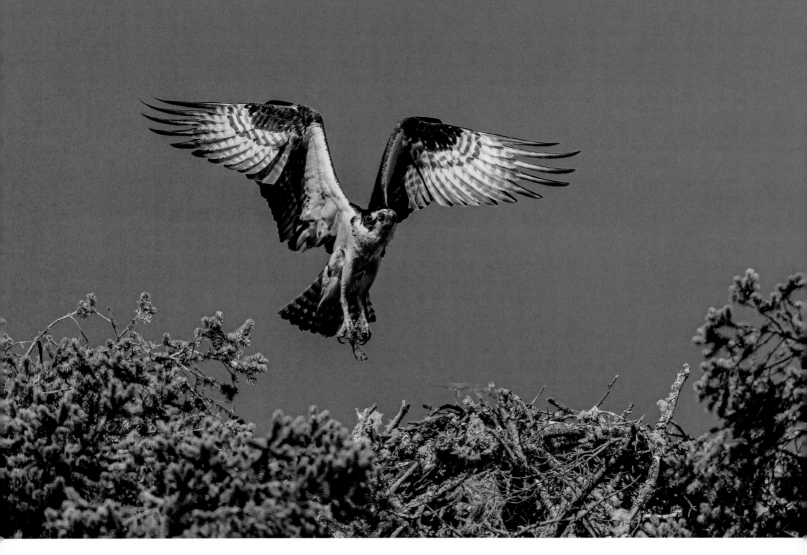

An Osprey (*Pandion haliaetus*) lands on a nest to which it has returned repeatedly, and successfully raised young, after southbound migrations for the winter. Lopez Island, Washington, USA. August. IUCN category: Least Concern

that keeps surfacing in my mind: Why can't these birds be like the robins in my backyard and just find a home for all seasons to save the enormous energy expenditure involved in migration? The answer that conventional wisdom has typically provided is that the origins of migration lie in dispersal, an ancient quest to find a better homeland — somewhere with more food, better resources for nesting, and freedom from predators.

But Benjamin Winger and his colleagues from the University of Michigan have proposed a different solution: They believe that the most important thing in a bird's life is to continue to use a nesting environment that has a proven track record of optimal reproductive success.[1] If this means moving out for a while when conditions are not conducive to survival, so be it. Think of it as an alternative to hibernation (which Aristotle thought birds did in winter) or periods of torpor. This theory certainly resonates with the notion that the ultimate goal of all organisms is to pass on their genes. From the bird's perspective, once you have found a place to nest successfully, the rest of life must be adapted in service of reproductive success, even if it means flying across vast oceans to feed and survive between mating cycles back at the ideal nest site.

The Turkey Vulture (*Cathartes aura*) migrates almost exclusively by thermal soaring, with only the occasional wing flap.
Lopez Island, Washington, USA. May. IUCN category: Least Concern

How Do Birds Travel When Migrating?

Migrating birds primarily travel in one of two ways: They divide into the energetic species that flap for virtually the entire trip, sometimes nonstop for days on end, and the more leisurely and energy-wise soaring birds that (with the exception of orthographic soarers) thread their way along "thermal streets" of rising air, gliding between adjacent thermals. Both modes of transportation depend greatly on the weather, and birds will use all the tools available to them to start their migration in favorable weather conditions. Some, however, have less flexibility. For example, once godwits, which favor the first mode, are committed, there is no turning back on their nonstop flights, whereas storks and other soaring birds can find a convenient stopover site to wait out bad weather.

Within the community of soaring migrators, different strategies are employed. Gil Bohrer and his colleagues from Ohio State University used GPS tags and analyzed publicly available weather databases to follow Golden Eagles (*Aquila chrysaetos*) and Turkey Vultures (*Cathartes aura*) during their autumn migrations in eastern North America. They found that Turkey Vultures "nearly exclusively" used

thermal lift, but the eagles primarily used orthographic lift from air moving over rising terrain.

How Do We Know Which Goes Where?

Banding Birds

The Calf of Man is a small green speck of land in the Irish Sea, separated from its larger northern neighbor, the Isle of Man, by a channel that can concentrate blustery Atlantic winds, raising an impenetrable curtain of foaming sea. It was, therefore, with considerable relief that after a morning of stiff breezes, my companion William Jeffcoate and I nosed past the harbor wall of Port St. Mary after the captain of our seasoned wooden boat, the *Scraayl* (the Manx name for a shearwater), declared the crossing to be possible.

As we plied onward for a short trip to the south, passing towering walls of guillemot nests and flushing noisy huddles of Razorbills and Common Murres into the emerald-green water, a squadron of pounding hearts, large and small, were heading northward, approaching the Calf with relief of a much more consequential nature. For these birds, the Calf of Man offered a respite: landfall on a migratory journey from their winter home in sub-Saharan Africa to their northern European breeding grounds.

The Calf has been a bird observatory for the last 64 years. The primary structure on the island is a well-preserved stone farmhouse, built in

A Willow Warbler (*Phylloscopus trochilus*) caught in a mist net after a flight of over 8,400 km (5,220 mi.) from sub-Saharan Africa. It was banded, weighed, measured, and released to continue its migration within an hour of its brief entanglement. Calf of Man Bird Observatory, Calf of Man. April. IUCN category: Least Concern

1878, with door lintels not much higher than 1.5 m (5 feet) to accommodate the average stature of a 19th-century farmer. Early each morning, William and I emerged from the house cautiously — our knees sufficiently flexed to avoid painful head contact — to find the warden, Aron Sapsford, already making rounds of a network of fine mist nets encircling the property, catching the breeze like translucent prayer flags. The small canvas bags hanging from Aron's belt were already full of birds that he had skillfully disentangled from the nets in which they had become trapped (see photograph above). The temporary captives seemed resigned to this short interruption in their migration, rarely struggling until handled.

Mist netting allows ornithologists to detain migrating birds for a short time so they can attach a tracking device that will record the birds' migration timing, strategy, and life history. Traditionally, and currently in Aron Sapsford's hands, this involves attaching a small metal ring to the bird's leg that identifies it permanently to scientists should they encounter it again at either end of its annual journey or at any of the network of bird observatories around the world, some of which were established in the late 19th century. The ring typically carries codes to identify the ringing station and the date when the bird was ringed. Each spring, Aron and his team encounter birds bearing rings that they have attached during previous seasons, and they carefully document the details to add one more strand to the ever-developing web of migration knowledge. This is not birding for the faint-hearted: The ringers use specialized texts, such as the arcane and intensely detailed *Identification Guide to Birds in the Hand* by Laurent Demongin, to recognize the faintest distinctions in coloration, size, or shape, which can provide clues as to the bird's species, age, and sex. All the details are faithfully logged. At wrap-up team meetings each evening, reports of unusual sightings ("I saw the first cuckoo of the year this morning") can lead to applause and commendation.

It is worth stating that mist netting and other forms of temporary capture of birds (and other animals) closely hew to ethical guidelines established by professional biological societies, such as those published by the British Ecological Society.[2] When practiced by skilled professionals, mist netting has an extremely low risk of injury or death to the birds. However, it is definitely not something that an amateur should attempt. If you see a bird that is ringed, never attempt to capture it. In most countries, it is illegal to capture birds without appropriate permits.

One situation in which citizen scientists can be helpful is by reporting color coded or numerical tags that are visible using binoculars. The example at left shows an endangered Whooping Crane (*Grus americana*) at the southern point of its annual migration. A large number 30 can clearly be seen on its tibial rings. The director of conservation

A group of Whooping Cranes (*Grus americana*) in their winter quarters. The bird on the right has a large ring on its leg, and the number 30 is visible.
Aransas National Wildlife Refuge, Texas, USA. December. IUCN category: Endangered

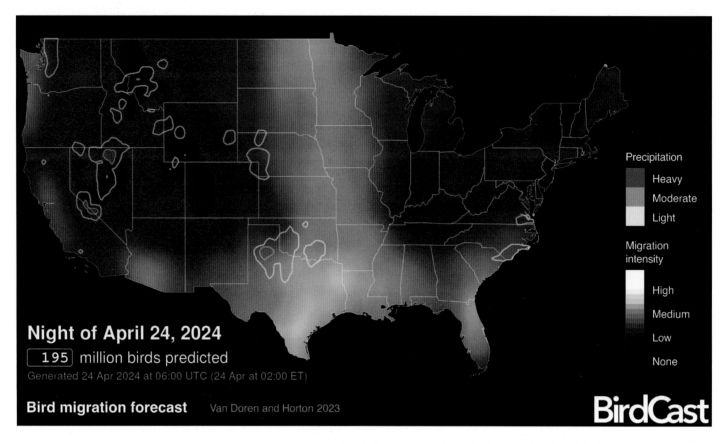

Night of April 24, 2024

$\boxed{195}$ million birds predicted

Generated 24 Apr 2024 at 06:00 UTC (24 Apr at 02:00 ET)

Bird migration forecast Van Doren and Horton 2023

BirdCast

Precipitation
Heavy
Moderate
Light

Migration intensity
High
Medium
Low
None

A real-time snapshot from BirdCast of migrating birds during an evening in April. BirdCast uses a network of weather radar installations.[3] On this night, there were an estimated 195 million birds in the air, moving primarily northward, in the central United States.

medicine for the International Crane Foundation, Barry Hartup, was able to identify this bird for me as a male that was ringed just over 4,800 km (almost 3,000 miles) away in Wood Buffalo National Park, northern Canada, just four months before I took the photograph. A satellite transmitter had also been attached to the bird, but it is not visible in the photograph and was probably lost on the bird's long, multi-day flight to Texas.

Electronic Tracking

During the mid- to late 20th century, ground-based weather radar provided new insights into group migration dynamics and issues such as the influence of climate on birds' departure decisions. Such radar is currently the basis for live web-based migration

displays such as the snapshot from BirdCast above, but advances in micro-electronics have vastly increased the level of fine-grain detail about individual migrating birds. Body-mounted sensors are now de rigueur for tracking bird migration.

The sensors used to study migrating birds can be grouped in various ways: according to their reporting methods, such as onboard storage, wireless, satellite, or GSM cell communication; their data collection rates, including samples every few seconds or minutes; the duration of their on/off cycles; the specifics that they measure, such as light level, movement dynamics, GPS coordinates, temperature, or altitude; or their power

sources, such as onboard battery, solar cells, or radio frequency identification (RFID). Sensors can be attached to the bird's leg (similar to conventional rings) using tiny "bird backpacks" mounted with adhesive tape, with leg loops, or to the legs of the birds like conventional rings (see the photograph below and on pages 237 and 238 of birds with sensors attached). Any sensor that stores data in onboard memory obviously requires recapturing the bird, known as "capture/mark/recapture studies." Many attached sensors are never retrieved, which increases the cost of tracking studies because low recovery must be factored into the sample-size requirements. Recovery rates can be

greatly enhanced by studying birds on foraging trips for their chicks, since they will dependably return to the nest, but migration studies do not have that luxury. Ingenious methods of safely releasing and retrieving trackers without further handling of the birds have been devised, such as UV light degrading rubber bands, but retrieval remains a limiting factor in long migration studies.

Light-level sensors measure the brightness of ambient light, from which geographical position can be estimated by consulting tables based on the length of the day (from which latitude is calculated) and the time of solar noon (which provides longitude). Results can be contaminated by weather, bird behavior, and habitat differences, but these sensors' major advantage is their light weight and low cost.

Sensors that measure birds' movement (acceleration) can, with the help of artificial intelligence, determine what the bird was doing at any sampling time (flapping, gliding, feeding, etc.). A long stream of GPS coordinates is like gold to a migration researcher because of their unambiguous readout.

Multi-sensors combine many or all of the above modalities into a single package that provides deep insights into many aspects of the bird's life during migration. Åke Lindström and his colleagues at the University of Lund in Sweden studied migrating Great Snipes (*Gallinago media*) wearing multi-sensor packs. They found the birds climbed at dawn to heights of about 5,000 m (16,404 feet) above sea level and then descended for night travel to an

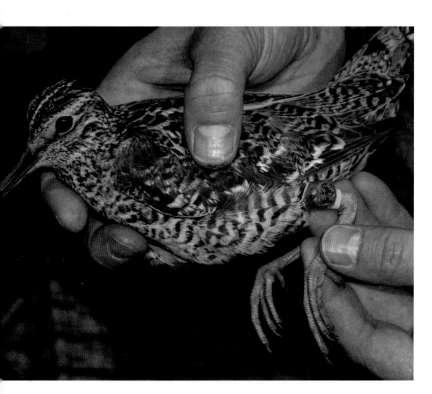

One of the Great Snipes (*Gallinago media*) in the migration study by Lindström and his colleagues. The small multi-sensor weighing about 1.5g (1/20 oz.) is shown attached to the bird's tibia. It measures acceleration, pressure, temperature, and light level and has a real-time clock and onboard memory.

Photo courtesy of Åke Lindström

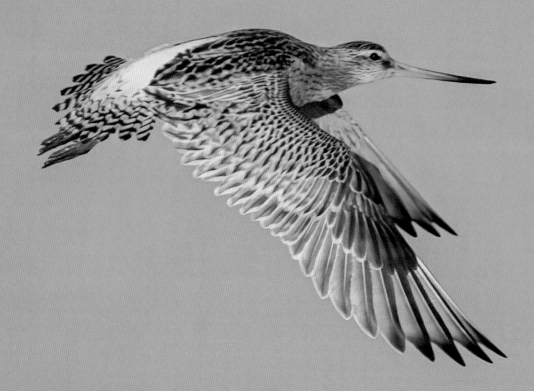

Godwits are a group of long-distance migrants.
Bar-tailed Godwit (*Limosa lapponica lapponica*). Holkham Beach, Norfolk, UK.
December. IUCN category: Near Threatened

The International Cooperation for Animal Research Using Space (ICARUS)[4]

"In September 2020, a tag on the back of a Eurasian blackbird (*Turdus merula*) tagged in Belarus, which had migrated to its wintering grounds in Albania, switched on its transmitter as the International Space Station (ISS) passed 410 km (255 miles) above. The tag sent GPS location data on the bird's recent whereabouts as well as onboard sensor data, which the ICARUS receiver aboard the ISS's Russian *Zvezda* module picked up and returned to scientists back on Earth. While only 223 bytes in size, this transmission rang in a new epoch for space-based Earth observations and biological sensing. The new system, based on digital Internet of Things (IoT) technology, allows position and behavior information to be relayed from myriad low-cost miniaturized tracking tags — now 4 g (about ⅛ ounce), soon to be 3 g (¹⁄₁₀ ounce), optionally solar powered — at an almost global scale and in near-real time. A connected global system of thousands of mobile "animal sensors" has the potential to provide a quantum leap for the biological understanding and monitoring of our planet."[4] The project was temporarily halted in March 2022.

living organisms (including people), these studies often involve considering the risk-benefit ratio for the research subject. The risks to birds in tracking studies include injury during capture, marking, and recapture; less fitness to travel because of the added load; and reduced reproductive success. The potential benefits are not to the individual bird but to the species, which may benefit from better conservation efforts because of the knowledge gained from the study.

Ethical guidelines for avian research suggest that any mass added to a bird should be no more than 3 to 5 percent of its body mass, preferably less, and in practice it is usually much less. This means that a Golden Eagle weighing 3.5 kg (about 8 pounds) could be fitted with a sensor package weighing 175 g (about 6 ounces), while the maximum load for a Ruby-throated Hummingbird that weighs 3 g (¹⁄₁₀ ounce) would be 0.15 g (⁵⁄₁,₀₀₀ ounce). Some studies have shown that even geolocators weighing about 1 g (³⁄₁₀₀ ounce) can have negative effects on the bird's performance under certain conditions.[5]

One sensor that is so small it has been used to track large insects as well as small birds is the NanoTag, which can be used with the MOTUS system from Birds Canada. The tags weigh as little as 0.1 g (³⁄₁,₀₀₀ ounce), and their proximity to any one of the more than 1,600 receivers in 31 countries can be uniquely detected. This device therefore brings the potential of hummingbird tracking within reach. The MOTUS system is also used to compile data for

altitude of about 2,000 m (6,562 feet) on their nonstop flight from Sweden to sub-Saharan Africa. One bird reached an altitude of 8,700 m (28,543 feet), where the air temperature was –21.3°C (–6.3°F) and stayed above 8,000 m (2,6247 feet) for five hours. (See From the Lab on page 249.) This definitely qualifies these birds as extreme athletes and raises the possibility that Bar-headed Geese are not unique in their high-altitude excursions.

How Do Birds Manage the Extra Weight of the Sensor?
Migration researchers continue to debate the ethics of adding extra loads to birds on such exhausting and onerous journeys. Like most research on

the Audubon Society's Bird Migration Explorer.[6]

One of the most exciting developments in tracking technology is the ICARUS project (International Cooperation for Animal Research Using Space).[4] This international consortium plans to make tracked animals, including birds, part of the Internet of Things (IoT), where real-time information on position and behavior would be available. With 1 to 2 g ($^{35}/_{100}$–$^7/_{10}$ ounce) sensors, it is likely that lifetime tracking of many bird species will soon be feasible. An app is already available that shows the locations of some early-adopter birds. On my first test-drive, I found the real-time location of a Bateleur (*Terathopius ecaudatus*) in southern Tanzania and the coordinates needed to retrieve and return a transmitter from a White Stork in Morocco that was possibly deceased.

Meet the Migration Champions

Bar-tailed Godwits (*Limosa lapponica*)

A bird now affectionately known as B6 hatched in the summer of 2022 on the Alaskan tundra. A mere four months later, it garnered a great deal of international attention when the story of its record-breaking migration flight went viral.

After being fitted with a 5-g (¼-ounce) satellite transmitter on July 15, 2022, this svelte 186-g (6½-ounce) young Bar-tailed Godwit spent quality time in Alaska's Kuskokwim Delta eating every invertebrate, insect, spider,

and berry in sight until its body was over 50 percent fat by weight. On October 13, 2002, likely weighing around 400 g (14 ounces) and having drastically shrunk the size of its non-flight-essential organs (kidneys, liver, gut, reproductive organs, etc.), B6 took to the air on favorable winds, sending signals to an overhead satellite, and flew on a southwesterly heading out over the Bering Sea.

B6 was unfamiliar with the route, and the knowledgeable elders that had made the trip in previous years were probably already well into their own trans-Pacific passage by the time it got airborne. Nevertheless, 11 days and 13,269 km (8,245 miles) later, B6 landed in the Tasmanian austral summer to claim the world record for the longest ever recorded nonstop avian flight. Among godwits, B6 is probably just a run-of-the-mill athlete: others before it have been recorded just a few hundred miles short of the new record, and unrecorded flights have likely exceeded it.

These colossal feats of endurance merit measurement in more than just kilometers and miles. If we suppose that B6 flapped its wings at a rate of six times per second and its heart rate during exercise was 10 beats per second,[7] then it flapped its wings almost 6 million times without a break, while its heart was beating more than 9.5 million times at twice to four times its resting heart rate. Anthropomorphic comparisons are often overdone, but I can't help making the observation that 6 million strides would carry an average

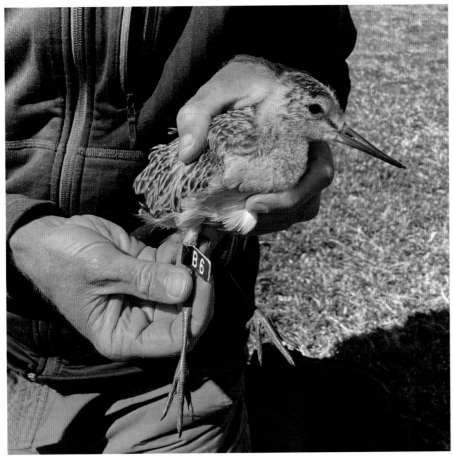

The 4-month-old Bar-tailed Godwit (*Limosa lapponica baueri*) known as B6, and the fragile wings (below) that carried it to the world-record 11 days and nights of nonstop flight, totaling 13,558 km (8,425 mi.) from Alaska to Tasmania, shown on the map.

July. IUCN category: Near Threatened

Photos by Dan Ruthrauff/U.S. Geological Survey

Map reproduced with permission of Jesse Conklin, Mihai Valcu, and Bart Kempenaers from the Department for Ornithology at the Max Planck Institute for Biological Intelligence.

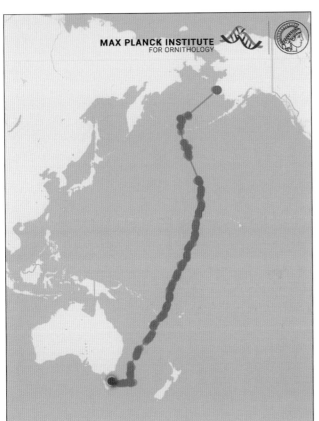

One of the Arctic Terns (*Sterna paradisaea*) that was tracked during a 50,000 km (31,069 mi.) migration with the light-level geolocator on its back.

Month unknown. IUCN category: Least Concern

Photo courtesy of Thomas Alerstam, University of Lund

human runner about 11,500 km (7,109 miles), and that's without, of course, rest or refreshment. This puts the vast superiority of avian endurance over human capabilities into perspective. Races of 100 miles are considered close to the limit of human endurance, and these involve only 1.4 percent as many leg cycles as the godwit makes wing cycles during its nonstop migration.

Arctic Terns (*Sterna paradisaea*)

While Bar-tailed Godwits lead the pack in nonstop distance, there are many other notable avian migratory performances. Arctic Terns are the longest round-trip migrators of any animal on the planet. They live a life of perpetual motion.

Arctic Terns and their new offspring leave their Arctic and Palearctic nesting sites (including the northern United States and Canada, northern Europe, Greenland, and northern Russia) in mid-July, hopscotching their way with multiple feeding stopovers and weather diversions along either the Pacific or Atlantic coast. When the birds from the Baltic Sea finally arrive in Antarctica, about three months later, they will have flown 25,840 km (16,056 miles), although the grand circle distance is only 15,244 km (9,472 miles).[8] Once in Antarctica, there is no rest for the weary, as the terns move west to east, sometimes as far as 11,000 km (6,835 miles) along the 60-degree S parallel, as they feed along the pack ice and molt.

By mid-March, after a three- to four-month sojourn in the Antarctic, the birds head north with serious intent. Following a much more direct route, they return to the Baltic Sea in a six-week sprint, capping a round-trip journey of about 50,000 km (about 31,000 miles). The difference between nest-outbound and nest-inbound travel times (which is also quite common in other species) is sometimes referred

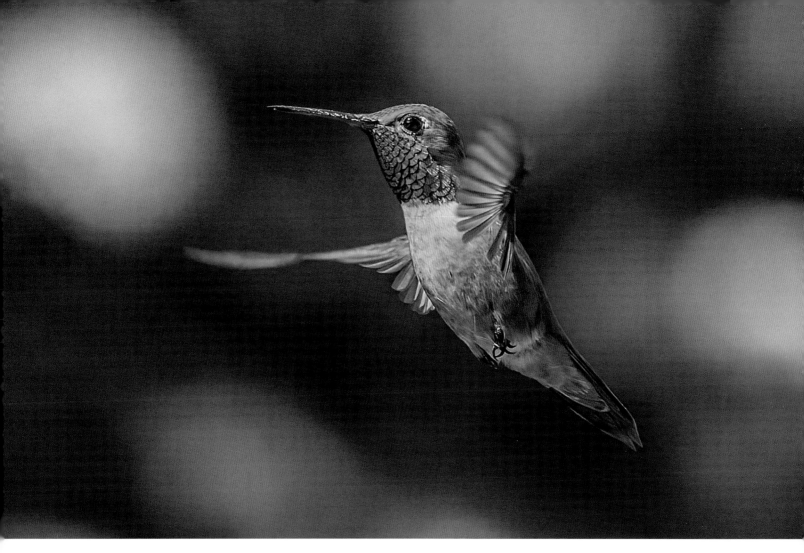

Some Rufous Hummingbirds (*Selasphorus rufus*) migrate from Alaska to Mexico.
Lopez Island, Washington. May. IUCN category: Near Threatened

to as an energy-minimization strategy when traveling toward winter quarters and a time-minimization strategy when returning to breeding grounds.

We know the details of the Baltic Arctic Terns' movements from a study in which Thomas Alerstam and his colleagues from the University of Lund attached 1.5–2 g ($^2/_{100}$–$^1/_{100}$ ounce) light-level geolocators and colored rings to 47 birds before migration. They retrieved only 10 of the devices, in one case after seeking the bird in the nesting area for six years. (See photograph opposite.)

It is astounding to contemplate that in the 30-year lifespan of a Baltic Arctic Tern, a bird weighing about as much as a stick of butter — 110 grams (3½ ounces) — will have rolled its odometer around to 1,500,000 km (932,057 miles), the equivalent of two round trips to the moon. As global climate change causes altered winds and warmer oceans, this resilient species will likely need to make modifications to the timing and/or route of its annual odyssey.

Rufous Hummingbirds (*Selasphorus rufus*)

I am fortunate that my home is on the migration route of Rufous Hummingbirds, so I was able to take the photograph above in my garden. I had no

way of knowing if this unbanded bird and I were going to share a summer place or if it was a gold rush bird, heading further north. The term "Alaskan hummingbird" sounds like an avian oxymoron, but Rufous Hummingbirds are the most adventurous of all hummers; they inhabit latitudes up to 62 degrees north in their summer visits to Anchorage. Adventure always brings risk, and it has been estimated that only 60 percent of these diminutive birds that summer in Alaska survive the 11,513 km (7,150-mile) migration round trip to northern Mexico.

It is instructive to measure the distance of an avian journey in units relative to its body dimensions, rather than simply in kilometers or miles. The round-trip migration for the Rufous Hummingbird is about 137 million body-lengths, which almost measures up to the Arctic Tern's journey of 151 million body-lengths, and it exceeds that of the Bar-tailed Godwit, which makes a 71 million body-length round trip. This perspective suggests that we should look at Rufous Hummingbirds with the same veneration that we give to the other migration champions, perhaps even more admiration, since their tiny wings and bodies, no heavier than a penny, feel the buffeting of the wind and weather more acutely.

White Storks (*Ciconia ciconia*)

The three species that we have just followed on their migratory journeys share a common flight strategy: They most likely flap their wings continuously from takeoff until landing. Many

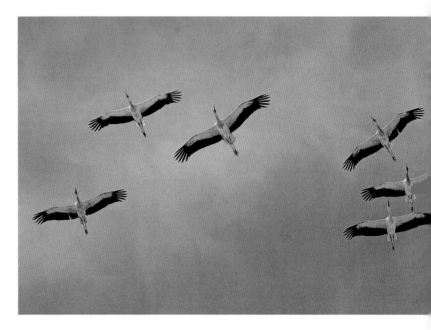

White Storks (*Ciconia ciconia*) soaring during migration.
West of Salalah, Oman. IUCN category: Least Concern

Photo courtesy of Hans Jensson

The White Stork (*Ciconia ciconia*) known as Prinzesschen being fitted with a transmitter in Loburg, Germany, by researcher Uli Querner before one of her migration flights to South Africa.

Image supplied by Wolfgang Fiedler and reproduced with permission of the Max Planck Institute of Animal Behavior, Radolfzell, Germany

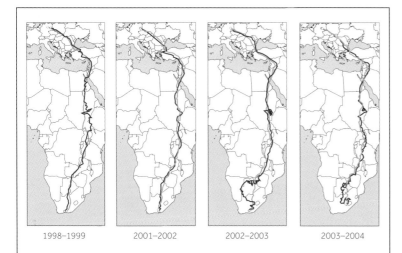

The tracks of four out-and-back migrations (red southbound, green northbound) between Germany and South Africa by Prinzesschen over a five-year period. The round-trip journeys averaged 23,564 km (14,633 mi.). The many periods of "thermaling" are not shown in this point-to-point display. Redrawn from Berthold et al.[9]

IUCN Category: Least Concern

The trajectories of a small flock of White Storks "thermaling" upward. The birds are following similar spiraling paths in their energy-efficient climbs within the confines of the thermal. As the rising air fades, they flap-glide out of the updraft and glide to the next thermal. Scale bars of 500 m (1,640 ft.) along each axis are shown, as is the projection of the paths on the ground.[10]

Image courtesy of Mate Nagy and Andrea Flack

large migratory birds cannot sustain this type of flight and rely on the energy-saving flight techniques that we explored earlier. A dramatic example of this inability to sustain flapping flight is the report of a Eurasian Griffon (*Gyps fulvus*) drowning in the Strait of Gibraltar after several failed attempts to make the 14-km (8¾-mile) sea crossing that is a migration bottleneck from Europe to Africa.

The charismatic soaring migrator that has drawn the most scientific attention is the White Stork. This large, graceful bird, red legged and red billed, stands over 1 m (just over 3 feet) tall. A dense cloud of broad black-and-white wings circling in the sky, etching out the boundaries of an otherwise invisible thermal, is a common site in the fall in northern Africa, as storks spiral, spill, and glide their way from their European and Mediterranean summer homes to the winter warmth of sub-Saharan Africa.

White Storks are large birds, and they were targets for early body-mounted GPS satellite transmitters, which were still too bulky for smaller species. One bird, known to her observers as Prinzesschen ("little princess"), had a personal hand in improving generations of tracking devices. She wore an original 95-g (3-ounce) unit in 1994, was upgraded to a 45-g (1½-ounce) device in 1997, and finally graduated to a 38-g (about 1-ounce) solar-powered unit in 1998. During her career as a perpetual research subject, Prinzesschen gave up the secrets of 12 round-trip journeys from Germany to South Africa over

10 years, totaling more than 125,000 km (77,671 miles). The results were fascinating, both in the similarities and differences between years. She frequently made crossings and visited places that were just a few kilometers from previous flight paths and stopovers. (See maps on page 241, top.) Then, in her outbound journey in 2002, shortly after crossing the border between Zimbabwe and Botswana, she flew more than 800 km (497 miles) west, visiting central Namibia before turning back southeastward to her winter home along South Africa's Indian Ocean coast. The locations of her final overwintering sites varied by more than 700 km (435 miles) over the years.

The investigators concluded that "white storks are entirely capable of navigating precisely back to previously selected winter quarters, and if in some years they do not do that, it is probably because of external circumstances." Prinzesschen was, however, completely faithful to her nesting site, returning every year to Loberg, Germany. This site fidelity, known as philopatry, is a behavior common to many migrating species.

Modern GPS trackers allow the seemingly straight lines of Prinzesschen's path to be seen in all their spiraling complexity. Andrea Flack and her colleagues from the Max Planck Institute's Department of Migration and Immuno-Ecology attached high-resolution GPS devices and accelerometers to a group of young migrating storks.[10] They were able to chart the interactions between the birds and identify the "thermal finders" that would locate the rising air. The birds then spiraled upward (see diagram on page 241, bottom), closely following the path of the leaders, flap-gliding away to find the next stop in the "thermal street" when the updraft diminished. This is an extremely economical way to travel, quite in contrast to the heroics of Bar-tailed Godwits and other birds that furiously flap to their destinations.

Many other fascinating secrets have been revealed by the plethora of White Stork tracking studies. These birds travel with their parents to learn the ropes on their first migration, which is their riskiest: Those that migrate shorter distances and fledge early experience lower mortality risks. At first, juvenile birds flap much more than adults. They are still novice thermal riders and find the journey much more energetically costly. But it was found that as the juvenile's migration progresses, if they are still with their parents, their efficiency improves measurably. Sadly, stopovers at garbage sites created by humans have become a regular feature of migration for some storks. The easy availability of food at these sites may cause some birds to give up completely on fall migration. Birds were recorded as overwintering at garbage dumps in northern Morocco rather than continuing south across the Sahara. Satellite tracking has transformed our knowledge of the migration ecology of White Storks and many other birds.

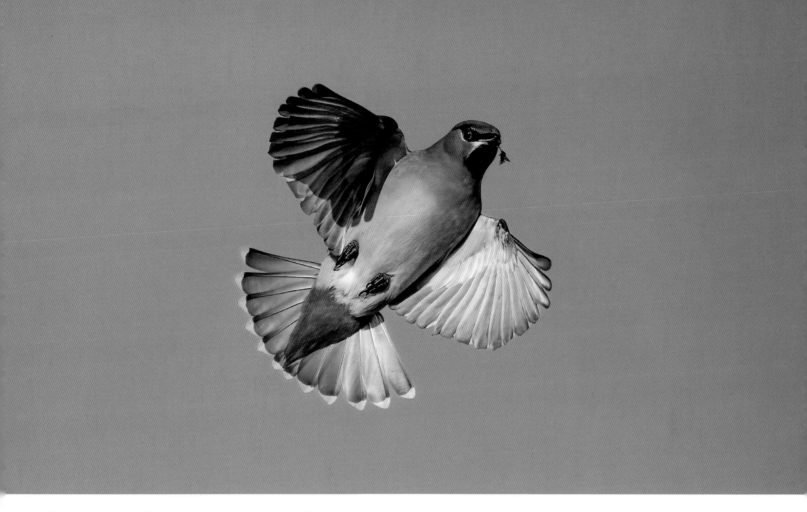

A Bohemian Waxwing (*Bombycilla garrulus*) takes an insect in-flight. Large groups of this species irregularly migrate south from New and Old World northern latitudes in search of food — primarily fruits and berries. Norfolk, UK. December. IUCN category: Least Concern

Soaring over Water

It has long been an ornithological axiom that thermal soaring during migration over large bodies of water is not possible because the differential heating of adjacent regions does not exist as it does on land. The proof of this was said to be migration routes that converge on the narrowest water crossings, such as the Strait of Gibraltar. Recently, a team led by Sasha Pekarsky from the Hebrew University of Jerusalem[11] challenged this thinking and showed that migrating Common Cranes (*Grus grus*) can exploit thermals over water that are caused by changes in weather — such as the rapid movement of cyclones resulting in large water-to-air temperature differences. This is another reason (in addition to wind and temperature) why waiting for the right weather conditions during migration can be energetically beneficial.

The Energetics of Migration

The late Herschel Leibovitz, my good friend and mentor, never tired of asking me the same riddle: "How many Mets are in the Yankees?" he would ask almost every time we met. The answer (as of today, since rules do change) is 26, because one MET is defined as the metabolic rate during rest, and there are 26 players on the Yankees baseball team. The MET is a very intuitive unit

of energy expenditure, and it provides a useful way to assess how hard a person or animal is working. When I am in the gym pedaling a cycle ergometer at a setting that I can keep up for 30 minutes, the indicator tells me that I am exercising at about 6–7 METS. A runner completing a three-hour marathon will be exercising at about 12 METS, meaning she will be using 12 times more oxygen that she would use at rest.

We can use this approach to get a feel for how hard migrating birds are working, and it turns out that a medium-sized bird in flapping flight is exercising at 12 METS, just like the three-hour marathoner. The difference is that B6 (see pages 236–38) maintained this level of exercise for 11 days — 88 times longer than the marathoner.

The energy to fuel these extreme ultra-marathon flights comes mostly from unsaturated fatty acids stored primarily in adipose tissue. Canadian biologist Christopher Guglielmo called birds about to depart on migration "obese super athletes" because they take off with up to 60 percent of their body weight stored as fat.[12] He also refers to in-flight migrators as "fat burning machines" due to their enhanced ability to mobilize, transport, and utilize fat as fuel. While many humans spend their lives trying to shed fat, migrating birds cannot get enough of this most energy-dense of all exercise fuels. Among all of the available fuels (i.e., carbohydrate, fat, and protein), fat produces the highest yield of adenosine triphosphate (ATP), the energy currency needed to activate

muscles. Although carbohydrate stores in the muscles and liver are enhanced at takeoff, they would power only a few minutes of flight. Migrating birds also use some protein as fuel, but a cascade of enhancements to their digestive, metabolic, and force-generating machinery enables them to use fat stores at prolonged rates that humans can only dream about.[12]

Although a migratory bird has the same outward appearance at different stages of its journey, important changes are taking place at the molecular level. Patrick Douglas Corrêa Pereira from the Instituto Federal de Educação in Bragança, Brazil, and his colleagues found changes in gene expression in the brains of Semipalmated Sandpipers (*Calidris pusilla*) between when they arrived for wintering and departed for nesting. These changes facilitated metabolic adaptations, an enhanced defense against viral infections, and the growth of new connections in the brain.[13]

The gargantuan effort of a long migration flight takes its toll. Stopovers to refuel are critical for many migrating birds, and that is why the loss of en route wetlands and the commercialization of river deltas are so damaging to birds that migrate. In Scott Weidensaul's masterful elegy to bird migration, *A World on the Wing*, he recounts a fruitless search for the critically endangered Spoon-billed Sandpiper (*Calidris pygmaea*) on the mudflats of the Yellow Sea in China, which are shrinking because of land reclamation.[14]

Stopovers last until energy stores are replenished and the weather is fair.

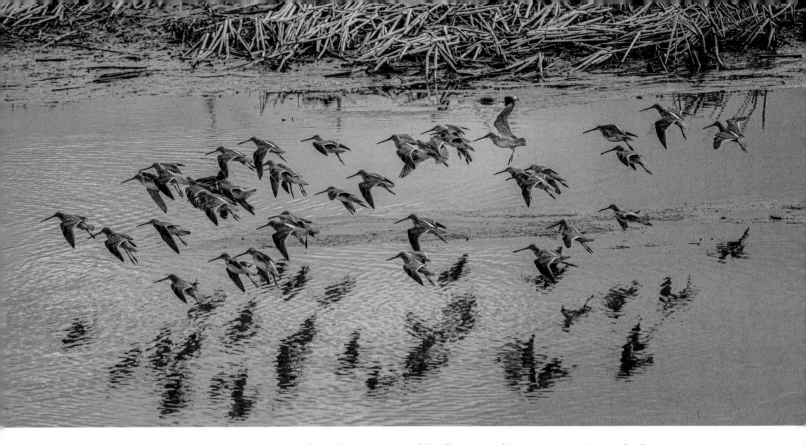

Refueling stopover: A small flock of migrating Long Billed Dowitchers (*Limnodromus scolopaceus*) still in winter plumage move in synchrony like a corps de ballet on the mudflats in Skagit County, Washington, USA. They are about halfway between their Mexican winter home and their Alaskan summer home. This species is only seen in Washington State during migration seasons. March. IUCN category: Least Concern

Migrants often arrive in their wintering homes with atrophied muscles and organs and very little remaining stored energy. It is not surprising that the risk of death increases drastically during migration: Hawks migrating across the Sahara had six times the risk of death compared to non-migrating birds.[15] Severe weather can also be disastrous; it can take several years for populations to be restored after a mass mortality event. However, the risks associated with migration must be outweighed by the reproductive benefits of returning to a favored nesting site for the billions of birds that continue to migrate long distances annually.[16]

Stopovers in remote environments also have risks. They may expose the bird to disease, and, conversely, the bird itself may be a vector for the dispersal of disease. Analysis of blood

meals from mosquitos at wetland stopover sites have shown that birds are frequent targets for these insects. In a single season of what must have been exhausting work, Jonas Waldenström and his colleagues from Kalmar University in Sweden screened 13,260 migrating birds at the Ottenby Bird Observatory, Sweden. They found that 450 of these birds (3.4 percent) were infested with ticks, and four birds carried ticks infected with an encephalitis virus. The epidemics of Highly Pathogenic Avian Influenza viruses in recent years also point to interactions during migration as one mechanism that spreads the disease.

From an evolutionary perspective, there may be some price to pay for a lifetime of flapping migration. Kozue Shiomi from Tohoku University in Japan has proposed that species that

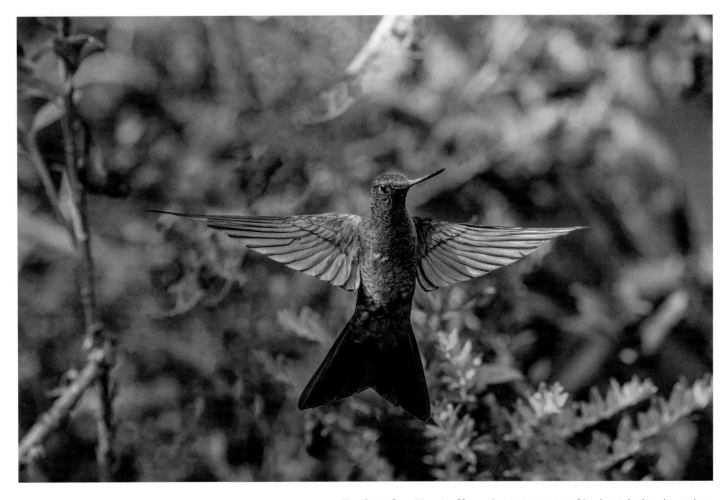

The Great Sapphirewing (*Pterophanes cyanopterus*) is a large Andean humming-bird that migrates by changing elevation to follow the flowering of its favored plants. Thermales, Colombia. January. IUCN category: Least Concern

migrate using flapping flight have smaller relative brain sizes than soaring migrators.[17] The explanation for this is that the brain is an energetically expensive organ, and flapping is also metabolically demanding. The soarers, so the theory goes, saved flight costs and were able to direct that energy elsewhere on the evolutionary time scale.

Altitudinal migration

Migration does not always involve flight over oceans and across continents. For many species, migration is a simple change in elevation, a short journey called altitudinal migration, which is defined as a seasonal movement of, and subsequent return to, the bird's home range involving a change of elevation and one that does not exceed 10 km (just over 6 miles). This form of migration is surprisingly common. Luciana Barçante and her colleagues from the Universidade do Estado do Rio de Janeiro reviewed all available reports and identified 1,238 species — more than 10 percent of all bird species — as being altitudinal migrants. They found that most had a diet of invertebrates. The number includes at least 25 percent of hummingbird species. I encountered one of these, the Giant Sapphirewing (*Pterophanes cyanopterus*),

at 3,500 m (11,428 feet) in Colombia in January, during the winter, despite the fact that this species is sometimes known to move lower during this season. Its movement up and down to various elevations follows insect density and the nectar production of its favorite flowers, notably the bromeliad *Puya clava-herculis*.

Navigation

One hazard of migration that we have not yet mentioned is getting lost along the way. This happens so rarely that the presence of a "vagrant" or "accidental" bird — one not in its wintering or breeding area or somewhere in between — is often cause for excitement among birders. Notable vagrants include a Steller's Sea Eagle (*Haliaeetus pelagicus*), usually seen in Russia and Japan, that traveled across the northern United States in 2021, and a White-throated Sparrow (*Zonotrichia albicollis*) from North America that was 4,828 km (3,000 miles) off course in the United Kingdom in 2008. Both birds attracted thousands of spectators.

Special Avian Senses

To comprehend current theories of avian navigation, we need to set aside our anthropocentric prejudices and consider mechanisms that are completely outside the human experience. It is almost certain that even the smallest bird has access to sensory modalities that enhance or add to the seven human senses. (I am counting vestibular sensation and proprioception in addition to the usual five: vision, hearing, smell, taste, and touch.) For example, birds might hear distant weather by perceiving infrasound at or below the low frequencies (20 Hz). Birds may also be able to "see" direction, through activation of cells in the retina that respond to magnetic fields. This is in addition to a separate system for sensing magnetic fields that is potentially facilitated by magnetite, a magnetic iron oxide, contained in skin cells above the beak.[18] The avian eye may also be sensitive to the direction of light polarization.

Multisensory Navigation

It is likely that birds use all available sensory modalities at some stage during their migration flights. It starts before takeoff. Birds seem to have the extraordinary ability to time the start of their migration for when it will be favorable for both departure and arrival. Once the length of the day (the photoperiod), background hormonal changes, and nutritional status indicate that the departure window has arrived, wind and temperature seem to be key factors that birds consider when choosing their takeoff time. Once en route, birds may visually sense landmarks and the position of the sun during the day and the stars at night, likely combining this information with their magnetic navigation tools to chart their course.

Just as mariners needed a chronometer to make their sextant sightings of the sun, birds require an internal clock to navigate using the position of the shifting sun. When using stars to navigate, birds do not seem to share our fascination with the signs of the zodiac. They likely detect the apparent rotation

of stars around the polestars rather than the spatial configuration of the stars in relation to each other. Night migrations not only allow birds to use celestial cues, they also benefit from cooler air and freedom from predators.

The First Migration

There continues to be debate over the relative roles of learning and genetics in the acquisition of avian navigational skills. Birds seem to learn some visual navigation skills, perhaps watching the movement of the sun and the stars from their nests, even before fledging. But how do first-time migrators find their way to a wintering site? Young White Storks follow their parents, but many songbirds head off on their first migration alone and under the cover of darkness. Marta Lomas Vega from the University of Copenhagen in Denmark and her colleagues found that juvenile Common Cuckoos (*Cuculus canorus*) traveled later, faster, and more directly to the same wintering grounds as their parents "guided only by their innate migration programme." [19]

Recent genomic research on Swainson's Thrushes (*Catharus ustulatus*) has identified a potential "package" of over 60 adjacent genes that control various migratory characteristics, including the direction of migration. [20] This insight into the heritability of migration knowledge builds on a classic early experimental study by Kasper Thorup and his colleagues from Princeton University on White-crowned Sparrows (*Zonotrichia leucophrys*), a similar species to the bird that got hopelessly lost in the United Kingdom. Young birds were displaced during their migration (by being carried right across the United States), and when they were released, they resumed their flight according to their prior direction rather than to their prior destination. Similarly displaced adult birds were able to make appropriate corrections and flew toward their intended destination on a corrected course heading. As with most nature vs. nurture disputes, it seems both factors play important roles for migrations.

FROM THE LAB
What is the altitude profile of a migration flight?

THE QUESTION	What is the altitude profile of the 60- to 90-hour nonstop migration flights of Great Snipes (*Gallinago media*) from Sweden to sub-Saharan Africa?
THE AUTHORS	Åke Lindström, Thomas Alerstam, Arne Andersson, Johan Bäckman, Peter Bahlenberg, Roeland Bom, Robert Ekblom, Raymond H.G. Klaassen, Micha Korniluk, Sissel Sjöberg, and Julia K.M. Weber from the Department of Biology, Lund University, Sweden
THE SOURCE	"Extreme Altitude Changes Between Night and Day During Marathon Flights of Great Snipes," *Current Biology* 31 (2021): 3433–3439, PMID: 34197730, DOI: 10.1016/j.cub.2021.05.047.
THE HYPOTHESIS	The snipes would exhibit systematic altitude changes during a migratory flight.
THE EXPERIMENT	Multi-sensor data-loggers (accelerometer, pressure sensor, temperature sensor, light-level sensor, real-time clock, and memory) weighing 1.4–1.7 g (5/100 to 6/100 oz.), about 1% of the bird's total body mass, were attached to a plastic ring mounted on the tibia of 107 birds before their southbound migration. A total of 36 of the birds were recaptured in the subsequent three years.
THE RESULTS	

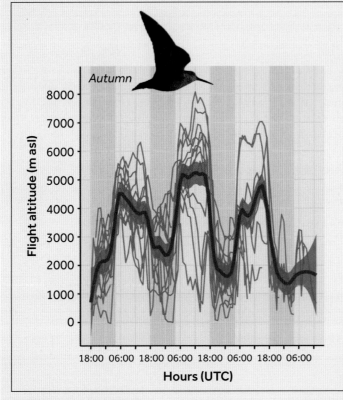

Lindstrom et al. CC BY 4.0 DEED

- The illustration on the left shows flight altitude in meters vs. time in universal coordinated time (UTC). Daylight hours are shaded yellow, and nighttime is in gray.
- Flight altitudes followed a diurnal cycle, with night altitudes about 2,000–3000 m (6,562–9,843 ft.) higher than daytime values. Birds typically changed flight altitudes at dawn and dusk. Researchers could not explain the change by the geographical features being overflown.
- Most birds flew above 6,000 m (19,685 ft.) at some time during the flight. One bird reached 8,700 m (28,543 ft.), where the air temperature was −21.3°C (−6.3°F). This bird stayed above 8,000 m for five hours.

THE CONCLUSIONS	"Improved view for orientation by landmarks, predator avoidance, and not least, seeking cold altitudes at day to counteract heating from direct sunlight are the most plausible explanations for the diel [diurnal] altitude cycle."

CHAPTER ELEVEN

*Don't it always seem to go
That you don't know what you've got
Till it's gone*
—JONI MITCHELL, "BIG YELLOW TAXI" (1970)

Losing Flight

Seeing the Dodo

FLIGHTLESS BIRDS ALMOST CERTAINLY EVOLVED FROM ancestors that flew to their present locations, but this was not the dominant view for the largest group of flightless birds until relatively recently. In fact, science appears to have gotten that story dead wrong until the early 21st century.

There are about 60 species of living birds that have lost the ability to fly, which represents approximately 0.55 percent of the 11,017 currently recognized species of birds globally. But the fossil record tells us that flightlessness has been a widespread phenomenon in avian evolution. One authoritative report suggests that it has occurred as an independent evolutionary response more than 150 times in a total of 581 species in more than half of the bird orders.[1]

I am fortunate to have seen and photographed a number of extant flightless birds in the field, but I have also been jarred and unsettled by seeing the infamous Oxford Dodo display and other evidence of anthropogenic extinctions that point to the uncertain futures of many flightless birds.[2]

King Penguins (*Aptenodytes patagonicus*) gathering near the water's
edge before taking an early morning swim. Volunteer Point, East Falkland,
Falkland Islands. February. IUCN category: Least Concern

A Common Ostrich (*Struthio camelus*) running across the savanna.
Etosha National Park, Namibia. September. IUCN category: Least Concern

Ratites

Ratites' ancestors are one of three groups of early birds who crossed the Rubicon of the great extinction 66 million years ago. In contrast to the groups that eventually diversified into over 11,000 species, many with a worldwide distribution, the surviving ratites are a lonely, flightless band of only 12 species occupying widely distributed niches in the southern hemisphere. However, they command outsized attention because, well, most of them are supersized. The name for this group comes from their flat sternum (breastbone), which is devoid of the usual keel where flight muscles attach. The ratite sternum is broad and dished, such that it resembles a raft (*ratis* is Latin for raft, a vessel without a keel).

Common Ostriches (*Struthio camelus*)

One of the world's most emblematic ratites is the sub-Saharan Common Ostrich. I encountered the bird above running at high speed across the savanna during an early-morning game drive in Etosha National Park in Namibia. The Common Ostrich is a world-champion bird in three categories: it is the tallest, at 2.75 m (9 feet); the heaviest, weighing up to 156 kg (342 pounds); and the fastest overground, capable of a top speed of 70 km/h (43½ miles per hour). The Common Ostrich is also thriving; the related Somali Ostrich (*Struthio molybdophanes*) is faring less well, a result of hunting and habitat loss, and is classified as Vulnerable. There may be 150,000 Common Ostriches alive today, despite living in the presence

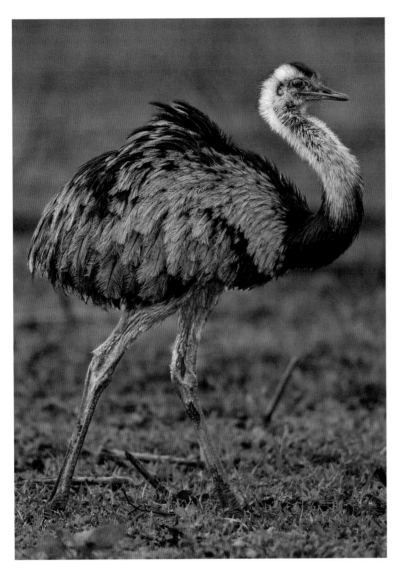

A flightless Greater Rhea (*Rhea americana*) from South America.
Pantanal, Brazil. July. IUCN category: Near Threatened

Greater Rheas (*Rhea americana*)

A continent away, another flightless ratite — the Greater Rhea — is widely distributed throughout southern and eastern South America. I photographed the bird at left while it was foraging in a fertile riverine area on the northern fringe of the Pantanal region of Brazil, sharing ground with a small herd of the world's largest extant rodent, the Capybara (*Hydrochoerus hydrochaeris*). The overall similarity of the rhea's body plan to that of the ostrich is striking, although the rhea is shorter, at 1.5–1.7 m (5–5½ feet), and much lighter, weighing 20–40 kg (44–88 pounds). The Common Rhea is classified as Near Threatened because of loss of connected habitat and its harvesting as food and for its feathers.

Elephant Birds

Madagascar, an island about the size of France, has been called the eighth continent because it is home to a huge number of endemic species of plants and animals. There used to be many more, not just in deep time but when humans arrived on the island some 2,000 years ago. The remains of recently extinct animals have been excavated as "subfossils" — bones that are not old enough to have become truly fossilized. These have included skeletal material from massive flightless birds in the extinct genus *Aepyornis* (from the Greek "high bird"), known as elephant birds. These birds would have dwarfed the ostrich with their 3-m (almost 10-foot) stature and estimated body mass of 650 kg

of many potential predators, such as hyenas, lions, jackals, cheetahs, and wild dogs. Ostriches can easily outrun most of these predators, although they do occasionally fall prey to lions. They can also inflict considerable damage with a powerful leg kick that makes predators wary.

Right: An articulated elephant bird (*Apeornis maximus*) skeleton similar to the one now on display in the Musée national d'histoire naturelle in Paris. Note the absence of even rudimentary wings. The spectators (represented by the artist somewhat smaller than they should be!) seem to be right out of a Manet painting.

Left: A restoration of the bird in front of the now extinct Madagascan Pygmy Hippopotamus.

(1,433 pounds) in the largest known specimen (*Vorombe titan*).

By a curiously appropriate coincidence, I met an elephant bird in Paris while spending several days waiting for a flight to Madagascar. It was the culmination of an absorbing summer afternoon spent at the magnificent Musée national d'histoire naturelle. After admiring articulated pterosaur skeletons and restorations of *Archaeopteryx* flying, I climbed a narrow staircase to a crowded corner of the upper gallery, to be confronted by a towering glass case containing an *Apeornis maximus* skeleton and a collection of its eggs, which were the size of gigantic hyperinflated rugby balls. I was flabbergasted by the bird's size and couldn't stop a movie of a tiny hummingbird playing simultaneously in my brain. Accepting the fact that these two vastly disparate groups of birds have a common ancestor is truly a leap of faith, even for my Darwin-infused neurons.

Ratites of Oceania

Almost 9,500 km (6,000 miles) away from Madagascar, Oceania has its own collection of extinct and extant flightless ratites, several of them extremely large. Subfossil evidence shows that New Zealand was home to at least nine species of moas, slow-moving herbivores that ranged in size from large turkeys to enormous birds twice the weight of an ostrich, such as the South Island Giant Moa (*Dinornis robustus*), which weighed 300 kg (660 pounds). (Current opinion suggests that the moa

held its neck more horizontal than vertical, as might be expected for a ponderous forager.) In most moa species, the female was much larger than the male, which was perhaps related to the fact that the male bird incubated the eggs. One estimate puts the population of all species of moa alive 1,000 years ago at up to 1.4 million birds. Humans arrived in New Zealand some 800 years ago and began the process of extermination that is continuing apace globally today. By about 600 years ago, the last moa had been hunted into extinction.

On the other end of the size spectrum from the moa, five living species of small iconic flightless ratites — the kiwis (the Apterygidae family) — make their home in New Zealand. *Birds of the World* describes kiwis as "perhaps the birds that most resemble mammals. They have a mammal-like body temperature, poor vision, almost no wings, and non-feathery, hair-like plumage."[3]

Kiwis are uniformly small nocturnal birds, about 60 cm (2 feet) tall and weighing from 880–3,570 g (about 2–8 pounds), with females larger than males. They have long, sharp bills suited to foraging for small invertebrates on the forest floor. All five species are classified as Vulnerable or Near Threatened because of habitat fragmentation and introduced predators. Intensive monitoring, intervention, and relocation programs are in place as part of a national effort to maintain breeding populations of these birds, which are the national emblems of their country. New Zealanders themselves are known the world over as Kiwis.

To meet the final two members of Oceania's ratite clan, we need to travel just over 2,000 km (about 1,300 miles) northwest across the Tasman Sea to Australia. The flightless Emu (*Dromaius novaehollandiae*) is widely distributed across open country in Australia, with an estimated population of 630,000 to 725,000 birds. Emus forage on plants and insects and are about as tall as the Greater Rhea, up to 140 cm (almost 5 feet), but considerably heavier, weighing in at up to 55 kg (121 pounds).

Australia is also home to the large, flightless Southern Cassowary (*Casuarius casuarius*). Females can weigh 58.5 kg (129 pounds). The bird has a small foothold in northern Queensland but is more widespread in New Guinea, as is the Northern Cassowary (*Casuarius unappendiculatus*). Although globally categorized as of Least Concern, the Southern Cassowary has been declared locally endangered in parts of Queensland. This handsome black bird has a casque, a cobalt-blue neck, pale blue facial skin, and a red wattle. It is known for its aggressiveness and, similar to the ostrich, for its fearsome kick.

How and Why Did Ratites Lose Flight?
The morphological similarity of the large ratites might suggest that they are all derived from a recent common flightless ancestor. Traditional ornithological orthodoxy taught that this common ancestor traveled — more specifically, walked — across Gondwanan land bridges to the other landmasses before tectonic forces isolated them and rafted them to their current

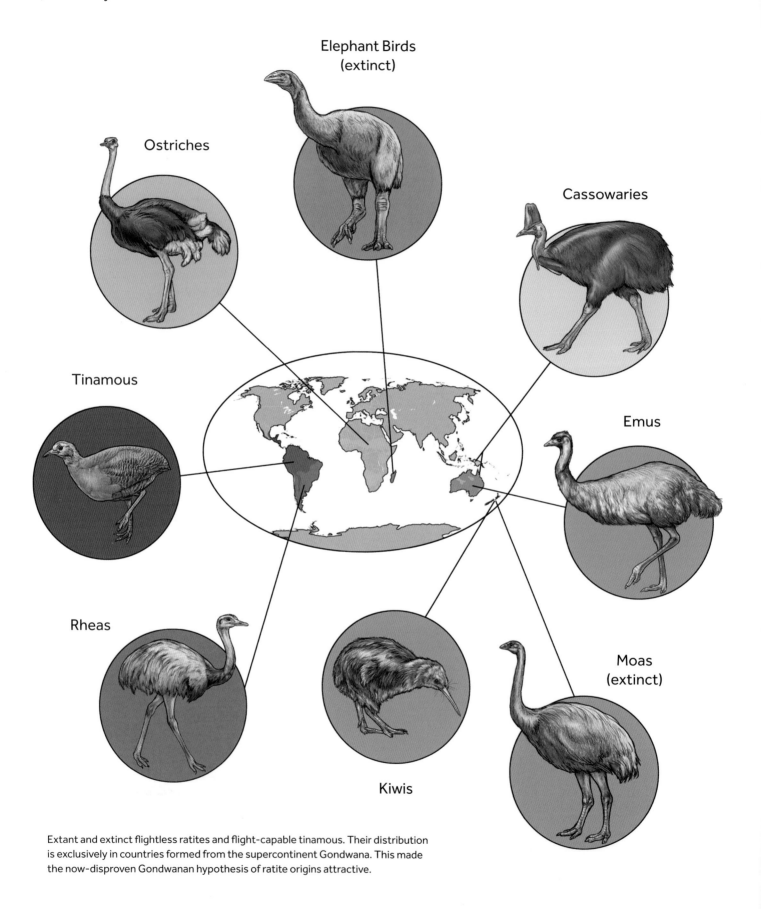

Extant and extinct flightless ratites and flight-capable tinamous. Their distribution is exclusively in countries formed from the supercontinent Gondwana. This made the now-disproven Gondwanan hypothesis of ratite origins attractive.

locations.[4] This view, called the Gondwanan hypothesis, changed in 2008 when a power team of 18 researchers led by John Harshman at the University of Florida analyzed 20 genes from the ratites that we have met and from four flighted tinamous.[5] Their seismic finding was that multiple losses of flight appear to have occurred in the history of the ratites and that many physically similar birds do not share the same flighted ancestor.

The different flighted ancestors of the various ratites flew to locations that represented ecological niches where they could live comfortably all year round and experience little competition for their particular food sources. It is also likely that potential predators in these locations were casualties of the K-Pg extinction — so the surviving ratite precursors had landed in bird-safe places to live. Three of my six reasons for flight introduced in chapter 1 were, therefore, no longer in play. If, in addition, the birds were herbivores with no need to hunt their prey, a fourth reason to fly also became irrelevant.

Because flight is an energetically expensive form of transport, the evolutionary selection pressure now favored birds that did not fly. Over time, the musculoskeletal framework and machinery of flight diminished until the birds were left with rudimentary or altered wings, and a breastbone that no longer exhibited the prominent keel for flight muscle attachment. The many superficial similarities among the large ratites turned out to be the "red herring" of convergent evolution rather than close genetic relationships. For the morphologist, this is a hard pill to swallow, particularly given, for example, the similarities in the head shapes of the ostriches, emus, and rheas. But it is now clear that these different birds evolved similar features as adaptations to similar lifestyles. Recent studies have located common regulatory regions in the genomes of different flightless birds that slow down the expression of genes controlling development of the wings.

To understand the huge body sizes in this group of birds we need to turn to a concept known in evolutionary biology as Foster's Rule, or sometimes the Island Rule. This theory proposes that two opposite trends can occur in animals that are isolated in predator-free locations, such as islands. Small animals can, over time, evolve larger sizes because of freedom from predation and abundance of food. Other species may evolve toward smaller sizes because of limitations of food supply. So, for the same price, we get Island Giantism and Island Dwarfism!

There are no known examples of species regaining flight once they have lost it, but we do know that loss of flight has occurred multiple times throughout birds' long history, and many of these occurrences were in species only known from the fossil record because they became extinct. However, while flight is essential for the survival of 99.45 percent of bird species, the remaining 0.55 percent are, mostly, doing quite well without it, unless humans disturb their equilibrium.

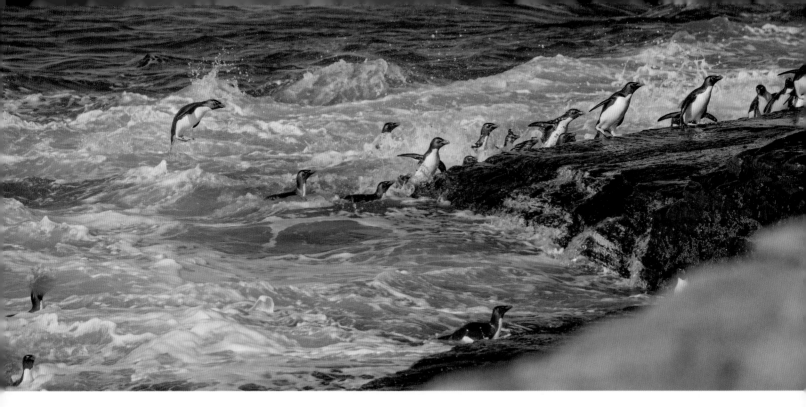

Southern Rockhopper Penguins (*Eudyptes chrysocome*) emerge from a roiling ocean to start their trek to a colony several hundred feet above the water. Saunders Island, Falkland Islands. October. IUCN category: Vulnerable

Penguins

Photographing Penguins

Long before I knew the first thing about penguin biology, I developed an obsession with photographing these charismatic communal aquatic birds. My first penguin encounter was in Chile, where captivating Magellanic Penguins (*Spheniscus magellanicus*) on Magdalena Island in the Strait of Magellan played their hilarious games at my feet. That experience ignited a multi-year journey during which I photographed eight other species, culminating in several visits to the nirvana of King Penguin (*Aptenodytes patagonicus*) colonies — Salisbury Plain on the sub-Antarctic island of South Georgia.

Penguin colonies have attributes that most people want to avoid: They are cold, noisy, foul-smelling places. But for biologists and photographers, they are deeply fascinating destinations.

The attraction is the drama of life and death that plays out in full view on a thousand separate stages. Closely packed adults gently turn outsized eggs with their feet, lunging aggressively at neighbors that violate an invisible cordon. Juveniles cluster in a kindergarten, Brown Skuas (*Stercorarius antarcticus*) swoop in to steal momentarily unguarded eggs, carnivorous Southern Giant-Petrels (*Macronectes giganteus*) blind and disembowel wayward chicks. Particularly boisterous penguins inflate to their maximum heights and trumpet loudly to the apparent disdain of their peers. The inquisitive inhabitants of the colony largely ignore a photographer but warily skirt around Southern Elephant Seals (*Mirounga leonina*), which exhale clouds of toxic breath onto their assembled harem. A constant stream of single-file traffic flows from colony to ocean and back again along well-worn paths in the beach or on muddy snow.

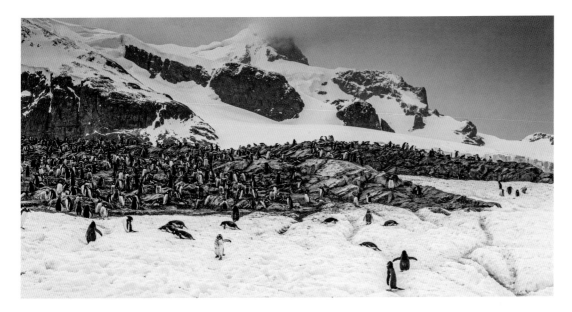

Part of a Gentoo Penguin (*Pygoscelis papua*) colony of more than 6,500 birds on Cuverville Island in Antarctica. It was a particularly dirty, muddy place on this relatively warm summer day in late November.
IUCN category: Least Concern

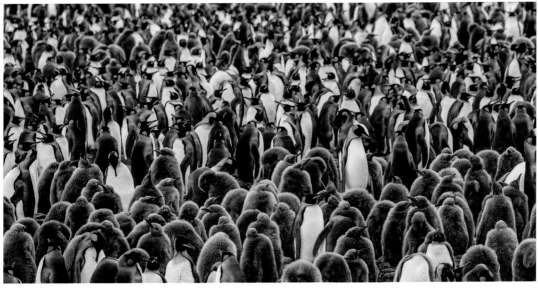

A small segment of the King Penguin (*Aptenodytes patagonicus*) colony on Salisbury Plain, South Georgia, that is variously estimated to contain 100,000 to 250,000 birds. The dark brown chicks were thought by early whalers to be a separate species and were called "oakum boys."
IUCN category: Least Concern

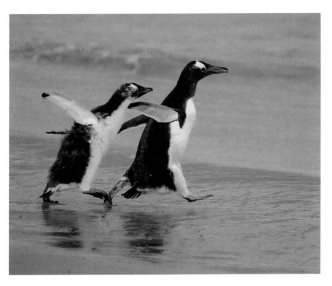

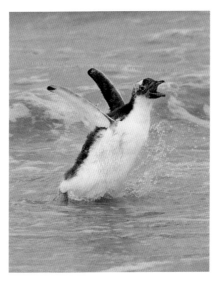

A Gentoo Penguin (*Pygoscelis papua*) chick chases its parent from the colony into the water, seeking to be fed. After its parent disappeared under the waves, the hungry chick, which could not yet swim, let out a prolonged shriek of displeasure.
Carcass Island, Falkland Islands. January. IUCN category: Least Concern

259

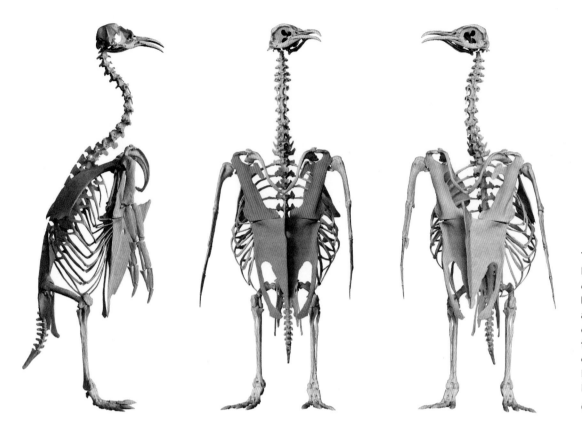

The skeleton of an Emperor Penguin (*Aptenodytes forsteri*). Note the long, keeled sternum (blue) and the extremely robust coracoid bones (pink). Both features support the powerful swimming muscles. IUCN category: Near Threatened

Claus Lunau / Science Photo Library

Penguin Anatomy

There is a total of 18 penguin species in six genera in the family Spheniscidae. They all live in the southern hemisphere, although the Galápagos Penguin (*Spheniscus mendiculus*) does occasionally put a flipper in the water north of the equator. All penguins are, of course, flightless in the conventional sense, but they can be said to fly in water, where they generate lift and thrust by vigorous movement of their flippers.

Whereas the anatomical equipment for flight has atrophied in most other flightless birds, in penguins it is amplified because the biomechanical demands of "flying" in water can exceed those of flying in air. Most penguins have an extended sternum with a prominent keel to which flipper muscles are attached, and the bones linking the sternum to the shoulder (the coracoids) are massively robust. Whereas lightweight bones are an advantage for flying birds, penguins need ballast for extended dives, and many of their long bones are dense and thickened, with only narrow central canals. Similarly, penguin arms and hands show none of the weight-reduction features of flying birds and favor a rigid framework for flipper attachment.

Flightless (Galápagos) Cormorants

Did Charles Darwin Overlook a Clue to Evolution?

In late September 1835, King William IV's good ship *Beagle* rode a light breeze into the Bolivar Channel,

Penguin Evolution

Penguins are assumed to have had a flighted ancestor before the K-Pg extinction 66 million years ago, although no fossil evidence of such a bird has yet been found. The earliest known penguin fossils date to about 60 million years ago, exemplified by the large New Zealand penguin *Waimanu*.

Over the next 40 million years, fossil evidence shows that there were approximately 50 other species of penguins — experiments in evolution — all but one of which became extinct. Twenty-two million years ago the (as yet unknown) survivor became the common ancestor of all living penguins when all prior penguins were "replaced," leading to the crown group of penguins that are alive today. Penguins made their transition to extreme environments as new species acquired a series of genetic modifications that have recently been uncovered. These included genes that enhance thermoregulation, oxygenation, diving, vision, diet, immunity, and body size

A Southern Rockhopper Penguin (*Eudyptes chrysocome*) living up to its name by executing a two-footed hop down a rocky step about equal to its own height. Bleaker Island, Falkland Islands. January. IUCN category: Vulnerable

A pair of curious Chinstrap Penguins (*Pygoscelis antarcticus*) standing on an iceberg. Hydrurga Rocks, Antarctica. November. IUCN category: Least Concern

— all good things for birds living inside the Antarctic circumpolar current and heading out on deep-diving fishing trips often lasting several days.

The King and Emperor Penguins (Genus no. 1, *Apenodytes*) are direct descendants of the transitional bird, which makes them a sister genus to all other penguins. Most other new species appeared in the last 2 million years.

Genus #2	*Eudyptes*	Rockhoppers and allies (7 species)
Genus #3	*Megadyptes*	Yellow-eyed Penguin (1 species)
Genus #4	*Eudyptula*	Little Penguin (1 species)
Genus #5	*Spheniscus*	Galápagos and allies (4 species)
Genus #6	*Pygoscelis*	Adélies, Chinstraps, and allies (3 species)

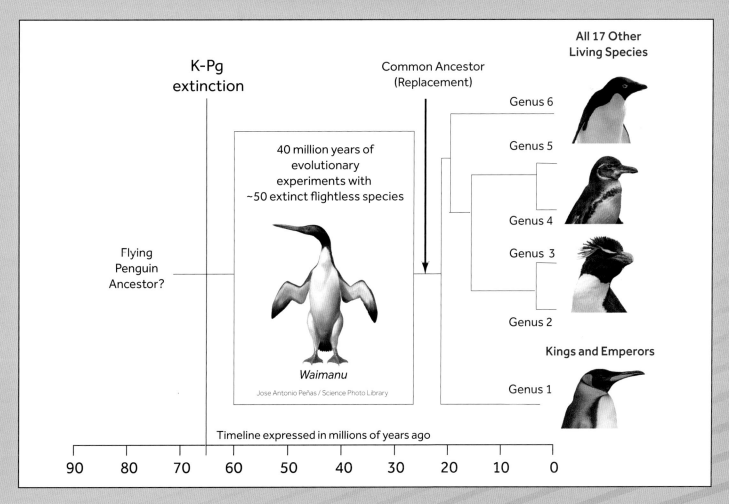

K-Pg extinction

Common Ancestor (Replacement)

All 17 Other Living Species

Genus 6

Genus 5

40 million years of evolutionary experiments with ~50 extinct flightless species

Genus 4

Genus 3

Flying Penguin Ancestor?

Waimanu

Jose Antonio Peñas / Science Photo Library

Genus 2

Kings and Emperors

Genus 1

Timeline expressed in millions of years ago

90 80 70 60 50 40 30 20 10 0

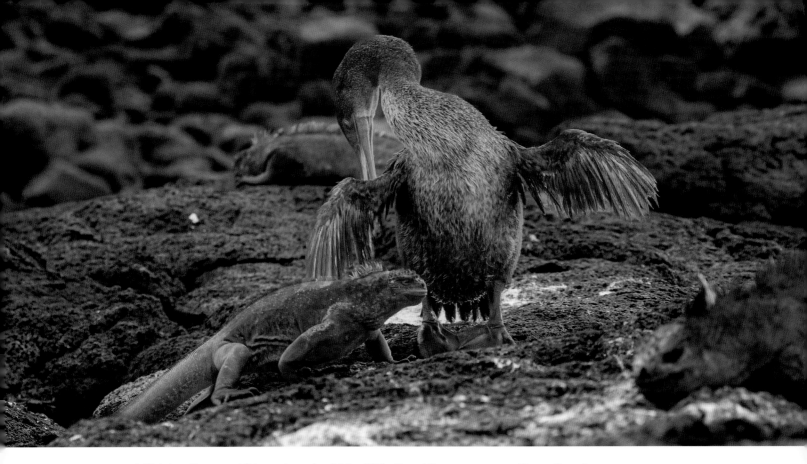

A Flightless Cormorant (*Nannopterum harrisi*), backlit by the setting sun, preens and hangs its rudimentary wings out to dry on a black lava platform. Another vulnerable Galápagos endemic species, the Marine Iguana (*Amblyrhynchus cristatus*), glides slowly by.
Fernandina Island, Galápagos Islands, Ecuador. October. IUCN category for both: Vulnerable

between the islands of Fernandina and Isabela, on the western fringe of the Galápagos Islands.[6] The ship's most famous crew member, Charles Darwin, stood on deck watching steam issue from one of Isabela's six volcanos, possibly the one now bearing his name.

After spending time on shore, where Darwin chronicled the geology and collected finches and doves, the ship's crew attempted to sail northward on October 2, 1835, but was becalmed in the Bolivar Straight for an entire day.[7] How Darwin spent this day is a mystery to me, since these waters host a bird that displays incontrovertible evidence of rapid evolution to flightlessness — evidence that could have accelerated Darwin's thinking on the "transmutation of species" much more quickly than the eponymous Darwin's finches.

Almost exactly 180 years later, I found myself thinking of Darwin's day as I gazed across this same stretch of the Bolivar Channel, which was as calm as it had reportedly been in early October 1835. We nosed gently forward in an inflatable Zodiac toward the abrasive black volcanic rock that forms a defensive rim around the shore of Fernandina Island. As the boat edged closer to the island, what had at first seemed like turrets along a castle wall transformed into oblivious broad-bellied birds that stared down at us from their lava perch with obvious disdain. These birds were not unlike the Double-crested Cormorants (*Nannopterum auritum*) that I see daily perching on deck pilings in front of my home in Washington's San Juan Islands. But there was one striking difference. The rather pathetically

262

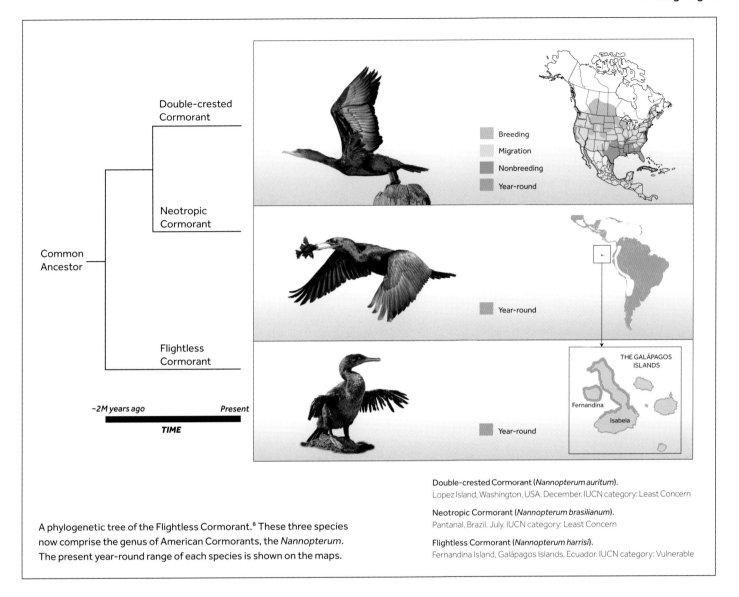

A phylogenetic tree of the Flightless Cormorant.[8] These three species now comprise the genus of American Cormorants, the *Nannopterum*. The present year-round range of each species is shown on the maps.

Double-crested Cormorant (*Nannopterum auritum*).
Lopez Island, Washington, USA. December. IUCN category: Least Concern

Neotropic Cormorant (*Nannopterum brasilianum*).
Pantanal, Brazil. July. IUCN category: Least Concern

Flightless Cormorant (*Nannopterum harrisi*).
Fernandina Island, Galápagos Islands, Ecuador. IUCN category: Vulnerable

abbreviated rudimentary wings with widely spaced, bedraggled feathers that these birds hung out to dry made a clear statement about their locomotor abilities: flying is not an option.

Ancestors of the Galápagos Islands Cormorants

Thanks to two important studies, we know the fascinating and insightful story of where the ancestors of Flightless Cormorants came from, approximately when they arrived in the Galápagos, and how their genome has evolved to generate the bird's altered skeleton.[8] Martyn Kennedy and his colleagues from the University of Otago in New Zealand showed that, about 2 million years ago, the Galápagos Cormorant shared a common ancestor with the Double-crested Cormorant (*Nannopterum auritum*) of North America and the Neotropic Cormorant (*Nannopterum brasilianum*) of South America.

The sequence of events probably went something like this: About 2 million years ago, a few now-extinct ancestors of modern-day cormorants were blown off course by stormy weather during a migratory flight along

the Pacific coast. The Double-crested Cormorant went on to colonize North America, the Neotropic Cormorant thrived in Central and South America, and the Flightless Cormorant established a tenuous foothold in the Galápagos Islands. At that time, Fernandina and Isabela Islands, which today make up the Flightless Cormorant's tiny territory, were not yet formed, but volcanic activity had pushed the easterly island of Santa Cruz up above the ocean. This probably became the "center of colonization."[8] As new and more favorable fishing locations emerged, in particular the upwelling currents of the Bolivar Channel, the birds' territory shifted and they lost the ability to fly, since it was not necessary on an island where all their food was readily available throughout the year.

As the Flightless Cormorant thrived in the Galápagos Islands, it evolved a body-plan that suited its new lifestyle, with short wings, a reduced keel, and a bulkier body. A team of molecular geneticists from Leonid Kruglyak's lab at UCLA explored genetic control of the altered skeleton, in a massive undertaking in which the entire genomes of the Flightless Cormorant and its two closest relatives were sequenced. Although there were thousands of small differences, the most consequential were four missing protein building blocks that are in the critical path for bone growth in the limbs. We now have a fairly complete roadmap to a remarkable example of rapid avian evolution and loss of flight.

Back to Darwin

Which, of course, brings us back to Darwin and his becalmed day in the Bolivar Straight on October 2, 1835. We cannot be certain, but it is very likely that Flightless Cormorants occupied the same range in 1835 as they do today. If that were the case, then it is very probable that Darwin set eyes upon this bird. But there is no mention of such a sighting in his notebook or in his diary. If he saw a Flightless Cormorant in the water, then perhaps he mistook it for one of the two close relatives he had certainly encountered on earlier legs of the voyage. Perhaps the *Beagle* never got close enough to the shore of Fernandina or Isabela Island, where the rudimentary wings of the bird announce its flightlessness. Or perhaps there had been a recent El Niño event that had drastically reduced the population by the time of his passage through the Bolivar Channel. Or was Darwin below deck the entire day, cataloging his burgeoning collection of specimens or writing letters or journal entries? He was a notoriously seasick sailor, and the prospect of an almost completely roll-free day was perhaps a strong incentive for him to work. We shall never know which, if any, of these explanations is correct. But it is reasonable to suggest that the span of 24 years that elapsed between Darwin's day in the Bolivar Channel and the publication of the first edition of *Origin of the Species* might have been considerably shortened had Darwin and a Flightless Cormorant come face to face.

How do penguins swim underwater?

THE QUESTION	How do penguins swim underwater?
THE AUTHORS	Brian D. Clark and Willy Bemis
THE SOURCE	"Kinematics of Swimming of Penguins at the Detroit Zoo," *Journal of Zoology* 188, no. 3 (1979): 411–428.
THE HYPOTHESIS	The movements of penguin "wings" while swimming are not similar to those of birds flying in air.
THE EXPERIMENT	Videos at 60 frames per second (fps) and Super 8 and 16 mm film at 24 fps of seven individual penguins from different species were collected as birds swam underwater at steady speeds along a 2-m (6½-ft.) segment of a straight course in a 15-m (about 49-ft.) channel.
THE RESULTS	Below are tracings of an Emperor Penguin (*Aptenodytes forsteri*) at equally spaced intervals of 0.084 seconds. Start at the top left, move left to right, and then continue with the bottom row, starting on the left. (Vertical movement is not shown.) In this species, the downstroke is much longer than the upstroke.

Redrawn from Clark and Bernis

- Penguins usually beat their wings continuously when swimming horizontally at constant speed.
- However, at swimming speeds less than 1–2.5 m/s (about 2–6 mph), all species glide between single beats or groups of beats.
- King Penguins (*Aptenodytes patagonicus*), Emperor Penguins, and Adélie Penguins (*Pygoscelis adeliae*) typically glide between wing strokes over a much wider range of speeds.
- In smaller penguins, such as the Little Penguin (*Eudyptula minor*), lift was directed upward and forward on the downstroke and downward and forward on the upstroke.
- In larger species, such as Emperor Penguins and King Penguins, the wings bend to a marked degree during the beat cycle. During the upstroke, the wing shows a pronounced downward curvature from base to tip.
- Penguins use their tail, feet, and wings to control direction.

THE CONCLUSIONS	Penguin "flight" in water differs from typical bird flight in the air in several ways: 1. As predicted from the anatomy of the large penguin wing elevator muscle (the supracoracoideus), penguins derive thrust during both up and down phases of the stroke cycle. 2. Penguins often exhibit a gliding phase between strokes or groups of strokes similar to the birds that use "flap and glide" locomotion. 3. Penguins flap at a relatively constant frequency regardless of speed, whereas most birds flap faster as speed increases.

> In a society accustomed to dominating or "improving" nature, this respectful imitation is a radically new approach, a revolution really. Unlike the Industrial Revolution, the Biomimicry Revolution introduces an era based not on what we can extract from nature, but on what we can learn from her.
>
> —JANINE M. BENYUS (2009)

Bioinspired Flight

If It Works, Copy It

WHEN YOU SEE A DESIGN IN NATURE THAT seems to be working flawlessly, why not copy it? That is the premise of bioinspired design, which explores and exploits nature for clues to help design engineered structures. The thinking runs along the following lines: if millions of years of evolution have optimized living organisms to function perfectly in their environments, why not use this accumulated data to design and build devices? Colin Pennycuick called it reverse engineering. There is even a scientific journal devoted to this field. *Bioinspiration and Biomimetics* is published by the Institute of Physics in the United Kingdom.

Modern-day engineers interested in mimicking the flapping flight of birds are the latest in a long procession of similarly preoccupied individuals.[1] The mythological Icarus was an early member of this group, and in the late 19th century, inventors aspired to fly on flapping wings. More recently, attention has shifted to ornithopters, small flapping-wing robots that can fly autonomously and perform tasks such as examining large

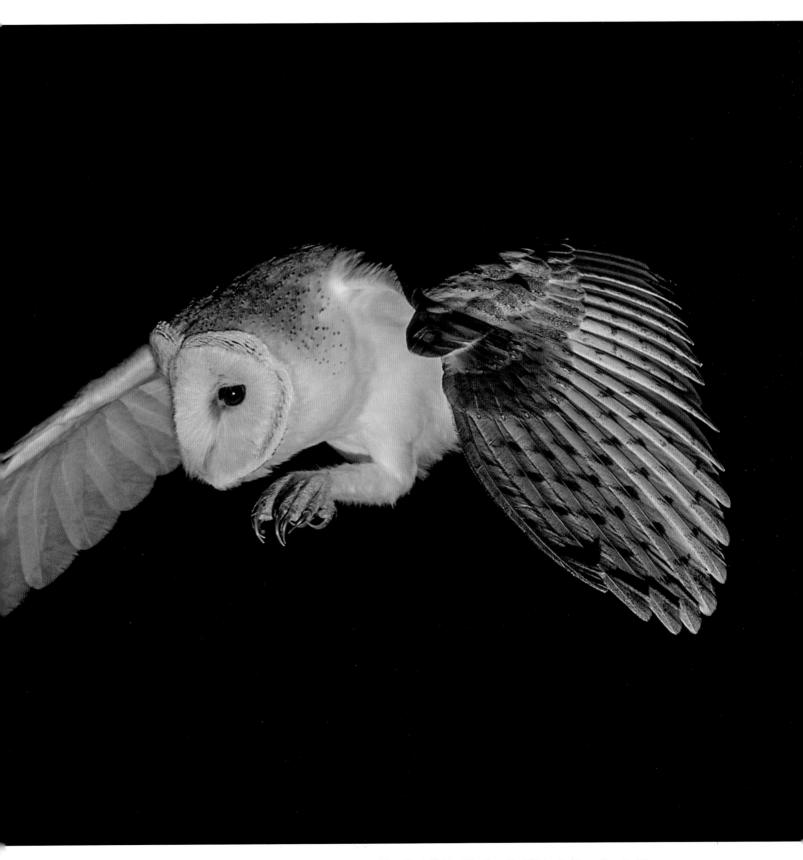

The silent flight of the Barn Owl (*Tyto alba*) has attracted the
attention of acoustic engineers who would like to mimic the
sound-attenuating properties of the bird's wings and tail.
Norfolk, UK. April. IUCN category: Least Concern

buildings for structural defects, flying in contaminated atmospheres, and conducting surveillance in battlefield conditions with a minimal noise signature.

A Flapping, Perching Robot

Duplicating the flapping flight of birds turned out to be the easy part for the designers of large flying robots, even though the flight paths they achieved were quite rudimentary. The hard part was getting a large ornithopter to land with anything other than a belly flop on the ground.

Late in 2022, a group of engineers led by Raphael Zufferey at the University of Seville in Spain announced that they had designed and built the holy grail of ornithopters: Their flapping-wing robot could land securely on a simulated branch.[2] (See image above right.)

The research team broke down the engineering challenges to achieving perching into three segments, based on their observations of birds. First, they concluded that the flight control system, which incorporated a pitch (nose up/down) and yaw (side-to-side) controller, had to bring the ornithopter into a final approach close to the branch in a tail-down attitude, to help bleed off speed and expose the leg mechanism to the branch. One big assist given to the robot, which birds have to work out on their own, is the perch's three-dimensional coordinates. When the ornithopter is close to a branch, the legs deploy to a forward position so that the claw is ready for impact.

Zufferey's perching ornithopter, with its 1.5 m (about 5-foot) wingspan, is ready to land on a branch. The design has obvious avian roots but has a single leg (A) able to extend and rotate, a vision sensor (B) used to locate the branch during final approach, and a fearsome energy-storing claw (C) with a contact trigger, compressible padding, and terminal spikes.[2]

Zufferey et al. CC BY 4.0 DEED[2]

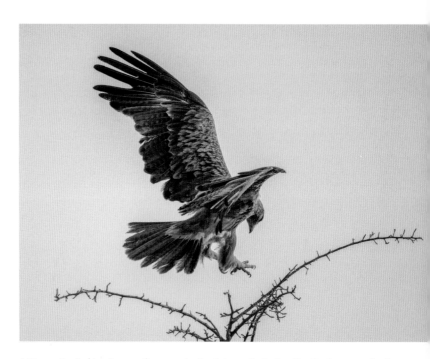

A Tawny Eagle (*Aquila rapax*) concentrates intensely during the final pre-contact moments before landing on a fragile thorn-encrusted perch.
Etosha National Park, Namibia. September. IUCN category: Vulnerable

The second system they conceived was a simulation of bird vision. The Tawny Eagle (*Aquila rapax*) on the opposite page exemplifies the importance of visual sensing in live birds. As it approaches a very slender branch covered in thorns, it lowers its head, its gaze riveted on its chosen landing location. The designers of the ornithopter replicated this visual guidance with a vision sensor that was used in "last-meter correction," the final course adjustment that is part of a feedback loop to move the claw into position so it can land on a branch. Flapping is stopped about 20 cm (8 inches) before impact as the ornithopter glides in to land.

Finally, when the claw impacts a branch, it has to snap shut very quickly because there is a tendency for the craft to pitch forward and rotate around the perch. To solve this issue, the designers used a contact sensor to report impact and a stretched spring to snap the claw from a stable open position to a fully locked grasp very rapidly, within 25/1,000 of a second. The claw's high-friction lining and engagement of the terminal spikes help to stabilize the craft after landing. These many functions are coordinated by an onboard flight computer.

Despite this technological full-court press, the ornithopter nailed only about two-thirds of its landings, well below the almost 100 percent success that live birds seem to achieve. The authors described their failed landing attempts as "narrow misses." The genius of the live bird brain is that it can calculate and execute adaptations for changing environmental conditions, such as gusty winds and swaying perches, interference from other birds on approach, and harsh weather conditions like rain and snow. These are early days for perching ornithopters, and we can expect to see more functionality in future generations.

Perching robots open a number of doors for remote applications. They could retrieve biological samples, track humans and animals, or use sensors to analyze structures such as power lines and pipelines. But in a field application, the robot will have to recognize suitable perching locations autonomously. Also, birds typically land and then readjust their posture, often performing a hopping 180-degree turn to get a better view of their surroundings. And then there is the issue of taking off again. At present, the robot's claw requires a 20-second burst from a leadscrew that releases the grip and re-tensions the claw spring for the next rapid closure. During this time, the robot is vulnerable to being blown off its perch or simply falling off it. Nevertheless, perching does represent one more step toward a robotic bird with a range of avian abilities.

Winglets

I recently booked a short-hop flight on Alaska Airlines, and in the email confirming my booking, the airline boasted that the flight would be on a "Boeing 737-800 with winglets." I found this more than a little odd, because winglets,

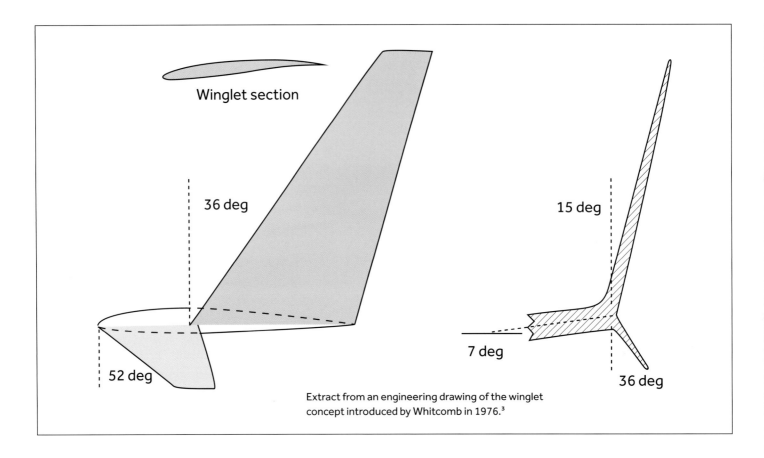

Winglet section

36 deg

52 deg

15 deg

7 deg

36 deg

Extract from an engineering drawing of the winglet
concept introduced by Whitcomb in 1976.[3]

the upturned ends of an airplane's wings, are now such a common feature that it was almost like the airline telling me (reassuringly) that the plane would have two engines. While winglets have been a feature of bird wings for many millions of years, the first airplane with winglets fitted as standard equipment did not roll off the production line until 1989.

In 1976, aeronautical engineer Richard T. Whitcomb published 13 pages of text and a handful of tables and diagrams, designated NASA Technical Note TN D-8260. This report was destined to change the look and performance of the wing of every passenger jet in the skies. It also made them look just a little more bird-like.

Whitcomb found, based on wind tunnel tests, that if upward wing-tip extensions (as seen in many bird wings,

including the Black-footed Albatross, seen opposite) were incorporated into the wing, induced drag during cruise flight could be reduced by about 20 percent and the lift-drag ratio increased by about 9 percent.[3] For a world still reeling from the 1973 oil crisis, during which the price of oil increased by a factor of 2.7 in six months, these findings were a potential lifesaver. Flight tests conducted by NASA and the U.S. Air Force a few years later using a KC-135 aircraft (a modified Boeing 367-80) showed that winglets could reduce fuel consumption by 6 to 7 percent. By the mid-1980s, winglets in various configurations began appearing on all new airliners, and they were retrofitted to many existing planes.[4]

Richard Whitcomb was not the first person to consider aircraft wing

A Black-footed Albatross (*Phoebastria nigripes*) shows its upturned wing tips during a downstroke as its primary feathers are deflected by aerodynamic forces.
Fifty km (31 miles) west of Tofino, British Columbia, Canada. October.
IUCN category: Near Threatened

Photo courtesy of Blair Dudeck

The winglet of an Airbus A350 airplane.

tip modifications. In 1897, before the Wright brothers first successful powered flight, British engineer F.W. Lanchester proposed a truncated wing with a flat vertical end plate. The stated function then was "to minimise the loss of energy due to air circulation around the wing extremities." Today the purpose is more directly stated as the reduction of induced drag, which is a consequence of lift. Current estimates are that winglets improve fuel consumption by 4 to 6 percent and help reduce in-flight noise by up to 6 percent.

Winglets reduce induced drag, and — under the right conditions with the right design on the right airplane — they also increase lift so that the wing becomes more efficient as the lift-to-drag ratio increases. As a result, the wing tip sheds a weaker vortex.

The aerodynamics of winglet action is complex and non-intuitive, so explanations are often fuzzy. A favorite of mine is that winglets prevent air from "turning the corner," from the underside of the wingtip to the top surface. But this account turns out to be only partially correct. Experts also argue over whether or not flow over a winglet can actually produce thrust — a force propelling the bird or aircraft forward. A NASA web page says that it does, while a distinguished aerodynamicist says that it does not.[5] Given this debate among the pros, it is little wonder that a layperson finds it all a bit confusing. So, what better authority than the Boeing Aircraft Company which, in a communication

directed at potential customers of winglets on its 737-800 aircraft, put it this way: "winglets increase the spread of the vortices along the trailing edge [of the wing], creating more lift at the wingtips. The result is a reduction in induced drag."[6]

Put another way, winglets work by spreading out the trailing vortex, increasing lift, and reducing induced drag on the outer part of the wing. The net result is that the wing-tip vortices are smaller.

One difference between the winglets on a plane and the upturned wing tips of a bird is that the former are fixed while the latter are variable. This has not gone unnoticed by aircraft designers, and many studies have explored "morphing winglets" that can be altered, for example, by changing the angle with respect to the wing, in order to tune winglet characteristics to suit the phase of flight (takeoff, cruise, landing, etc.). So far, this modification has not made it into passenger airliners.

The historic report from Whitcomb was also notable for the omission of the word "bird," despite the assertion by NASA historians that "his design inspiration came, in part, from studying the ways in which birds in flight curled their wingtip feathers upward when seeking greater lift."[7]

Whitcomb does not appear to have written an autobiography, and I have searched in vain through various tributes and obituaries to identify his avian muse. We may never know if the winglet was truly bioinspired or just the product of creative engineering.

A schematic view of wing-tip vortices without (left) and with (right) winglets.

Copying Owl Wings

Owls are the keepers of some fascinating flight secrets. Their quiet flight, which allows them to stealthily approach unsuspecting prey, has attracted the attention of a squadron of would-be emulators: engineers who want to reduce the noise from airplane wings and the blades of cooling fans and wind turbines.

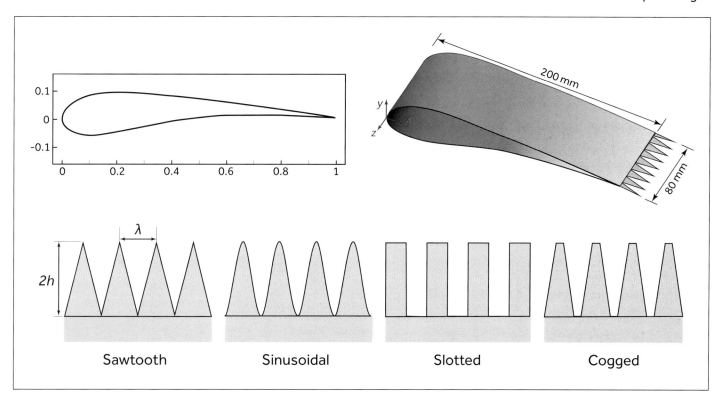

Above (top): The wing cross section and a geometric model of a wing section with an owl-like serrated trailing edge.

Above (bottom): Experimental variables included the height and spacing of the serrations ($2h$ and λ respectively) as well as their shape. By changing these design parameters, many virtual patterns could be tested. Redrawn from Li et al.[8]

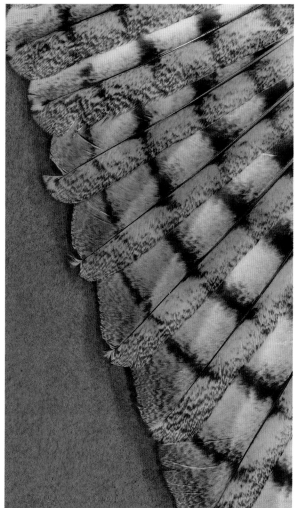

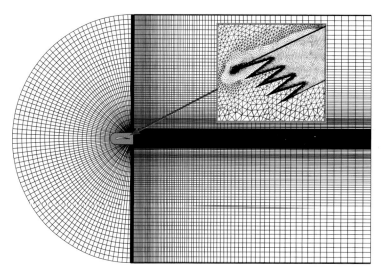

The mesh for a computational model of an owl-inspired trailing edge wing section and the surrounding air made up of thousands of tiny elements. The wing and the air immediately surrounding the wing are modeled in much finer detail than the more distant air. There were more than 5 million discrete elements in the largest model used. Redrawn from Li et al.[8]

Left: A section of the trailing edge of a Barn Owl (*Tyto alba*) wing.

Wing from the Burke Museum collection, University of Washington, Seattle

Mimicking the Trailing Edge

Dian Li and colleagues from Xi'an Jiaotong University in China went back to basics and chose both trailing edge serrations and an owl-like cross section for their experimental airfoil (see diagrams, page 273).[8] They did not make any physical wings but built geometric models to describe the shape of wing sections and then used a technique called computational fluid dynamics to predict the aerodynamics of the flow across various trailing edge configurations.

There are also ways of mathematically predicting the sound generated by swirling vortices of air, using a very nerdy formulation called the Ffowcs Williams-Hawkings equation. An image of what the starting point for such a computational model looks like is shown on page 273. The surrounding air is modelled by tiny six-sided solid elements (hexahedrons), while the higher level of detail in the wing is represented by many four-sided solids (tetrahedrons). Notice that a broad volume of air around the wing is simulated, since air flowing across an airfoil disturbs the air at surprisingly large distances from the wing. A set of what are called "boundary conditions" is used to characterize the airflow.

The results of the simulations showed that significant reductions in noise were achieved, particularly when the trailing edge was modeled as saw-tooth or sinusoidal patterns, which are quite similar to those seen in the owl wing. The amount of sound reduction (the attenuation) was approximately 85 percent compared to a wing without striations. What happens aerodynamically is that the large vortex trailing from the wing is broken up into many smaller vortices, resulting in less overall noise. (On a smaller scale, this is similar to the vortex spreading from separated terminal primary feathers that was discussed on page 113.)

Focus on the Leading Edge

A second group of researchers, led by Chen Rao from Shanghai Jiao Tong University in China, decided to explore the same issues of aerodynamics and noise, but they focused their efforts on the leading edge.[9] The species on which this study was based was the Ural Owl (*Strix uralensis*). In addition to using computer models quite like those in the trailing edge study, this team also conducted wind tunnel experiments at flight-like speeds that allowed them to visualize the flow over physical models. The experiments showed that a serrated leading edge plays a crucial role in controlling the flow separation over the wing, meaning it keeps the air attached to the wing over a larger distance, which provides more lift and creates less noise than a clean, straight-edged wing (see illustration of the vortex strength in the upper diagram on page 276). The effects, however, were not the same at all angles of attack. At low angles (less than 15 degrees), the striations reduced noise but decreased the wing's efficiency. At high angles of attack, which owls typically use when swooping for prey, the striations improved both noise control and aerodynamic efficiency.

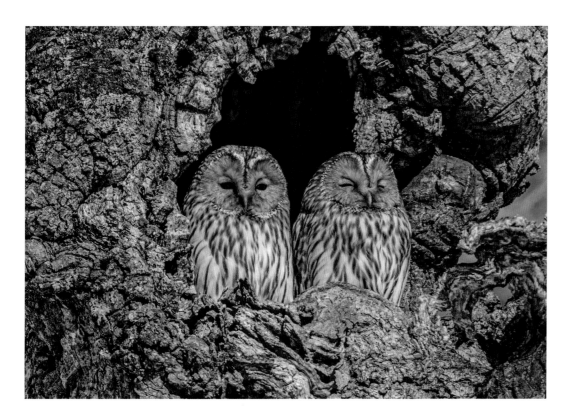

A pair of Ural Owls (*Strix uralensis*), the species that inspired the study that mimicked the striations on a wing's leading edge.
Hokkaido, Japan. February.
IUCN category: Least Concern

An example of the geometry used to model the leading edge of a Ural Owl wing. Redrawn from Rao et al.[9]

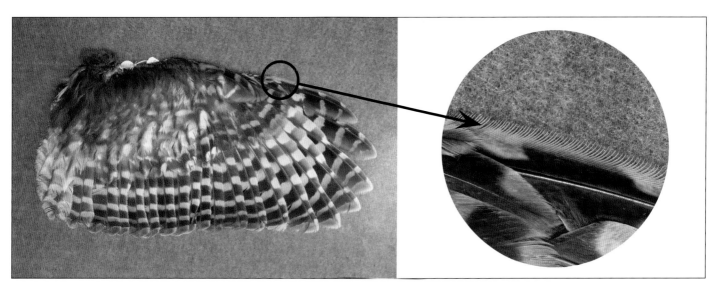

Leading-edge serrations on a Ural Owl wing.

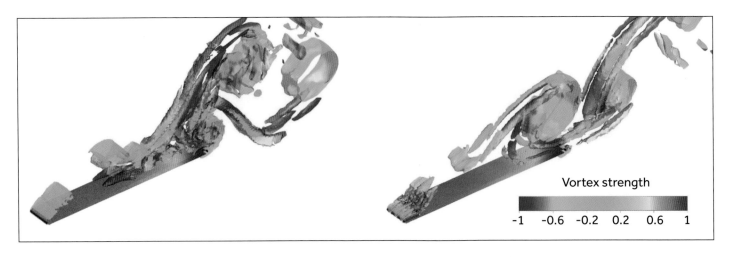

A heat map of the strength of the vortices generated from the leading edge of the simulated wing. **Left:** A wing with a straight leading edge. **Right:** A wing with leading edge striations. Note the marked reduction in vortex strength in the wing with striations.

Rao et al.[9] Used with permission

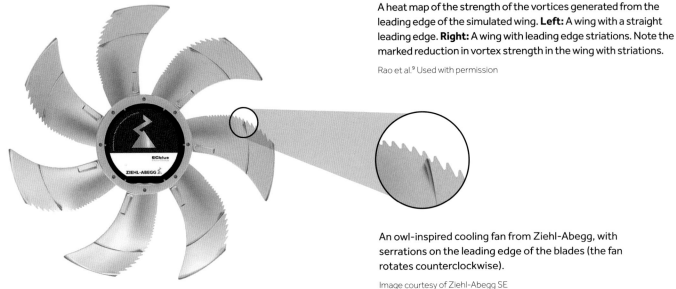

An owl-inspired cooling fan from Ziehl-Abegg, with serrations on the leading edge of the blades (the fan rotates counterclockwise).

Image courtesy of Ziehl-Abegg SE

From Research to Product

Chen Rao's research team concluded that "owl-inspired leading-edge serrations may provide a useful biomimetic design for flow control and noise suppression in wind turbines, aircraft, multi-rotor drones as well as other fluid machinery."

At least one company, Ziehl-Abegg, has taken this advice, and it is selling a cooling fan that "uses the owl wing as its model." With a nod of gratitude in the branding (it's called the Owlet fan), this product is advertised as having "optimum efficiency with minimum noise emissions." It is interesting that there is no trailing-edge modification. Perhaps that will be a future enhancement!

Bioinspired Wing Color

The image on page 277 (top left) of the albatross and its chick was taken during a memorable stay on Saunders Island in the Falkland Islands. I landed in a nine-seater Britten-Norman Islander on a dirt strip next to a sheep farm. After stocking up on provisions and photographing a couple of Barn Owls

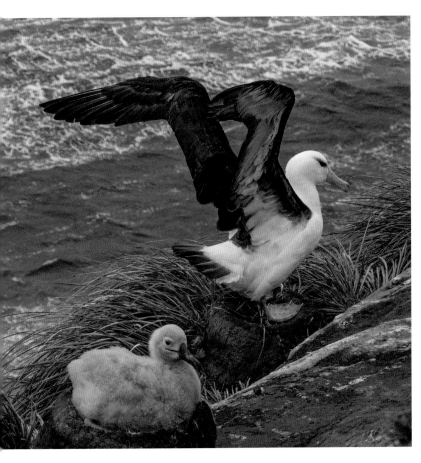

A Black-browed Albatross (*Thalassarche melanophris*) with its chick, showing a light right underwing and a dark left upper wing.
Saunders Island, Falkland Islands. January. IUCN category: Least Concern

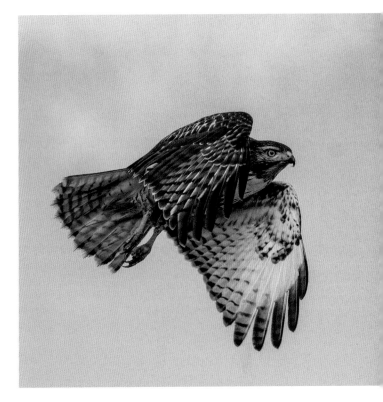

The dark topside and lighter underside of the wing of this juvenile Red-tailed Hawk (*Buteo jamaicensis*) is advantageous both for aerodynamic efficiency and for camouflage when hunting terrestrial prey.
Skagit County, Washington, USA. December.
IUCN category: Least Concern

roosting in the eaves of a rambling farm building, I boarded a Land Rover for the off-road drive to a small hilltop cabin, where I was the only inhabitant. The cabin overlooked a Black-browed Albatross (*Thalassarche melanophris*) colony, and for three days I was the sole witness to events in the daily lives of hundreds of these birds as they raised their new families.

There is a striking difference between the color of the upper and lower surfaces of the albatrosses' wings — black on top and mostly white underneath. At the time, this color difference struck me as nothing more than an attractive pattern. But. like owls, albatrosses are the keepers of important flight secrets.

Dynamic soaring allows albatrosses to travel huge distances with minimal energy consumption, but it's not just the structure of their wings that is impressive; their colors also serve a purpose. Undergraduate student Victoria Pellerito from Lawrence Tech University in Michigan was more interested in mimicking the color of albatross wings than the way in which they were used. She led a research project that showed that the color patterns of albatross wings have important functional consequences, making an already efficient bird an even better flier, and that these patterns also that have fascinating applications for drones.[10]

Mostafa Hassanalian, a coauthor

277

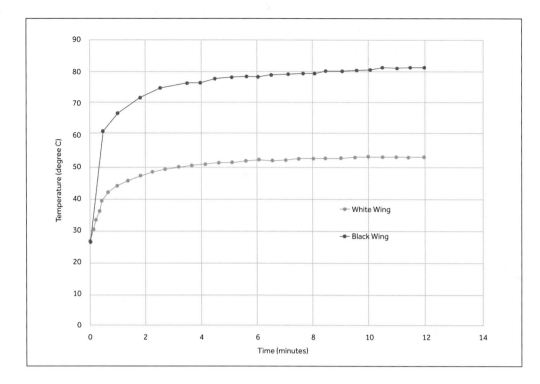

A black wing was approximately 30°C (86°F) hotter than a white wing at the end of 12 minutes of exposure under a radiating heat lamp. Redrawn from Pellerito et al.[10]

of the study, had previously shown that the boundary layer of air around birds' wings with a dark-colored dorsal (upper) surface was hotter, less dense, and more viscous, which are all characteristics that can affect aerodynamic performance. Pellerito's experiment aimed to quantify these effects. First, both black and white wings were placed under a radiating heat lamp, and, as expected, the surface temperature of the black wings was higher after 12 minutes of exposure — 30°C (86°F) hotter!

With a view to incorporating this design into drone wings, the experiment was repeated with two aluminum plates, one black and one white. The difference was still there, this time 22°C (72°F), smaller because the conductivity of metal is greater than that of feathers. The next step was to put an aluminum airfoil with a heating pad on the upper surface into a wind tunnel, where direct measurements of lift and drag coefficients could be made. For

angles of attack up to 24 degrees, the lift-to-drag ratios were substantially greater when the wing was heated, showing that heating of the upper surface made the wing more efficient.

Albatrosses are not the only bird family to display this pattern. Svana Rogalla at the University of Ghent in Belgium and her colleagues studied the wing color and other characteristics of an astonishingly large group of 324 species of oceanic birds.[11] These authors predicted flight efficiency from a model devised by Pennycuick and performed wind tunnel experiments that confirmed heated wings are more efficient. They put their results in an evolutionary context, showing that selection for dark upper-wing surfaces evolved in seabirds to facilitate their flight under challenging conditions. These researchers also suggested that the black wingtips of birds with white wings (such as the African Sacred Ibis opposite) cause convection currents during solar heating that increases wing lift.

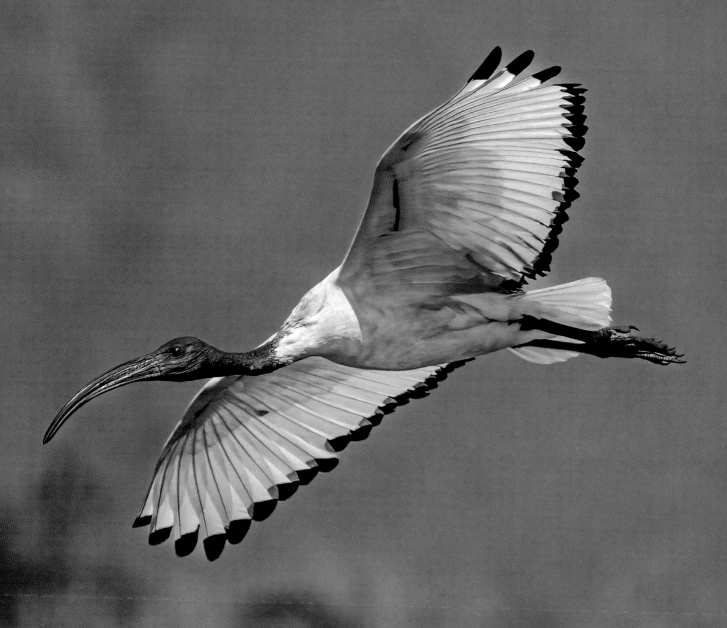

Black wingtips may increase wing lift.
African Sacred Ibis (*Threskiornis aethiopicus*)
Ngorongoro Crater, Tanzania. July. IUCN category: Least Concern

It is likely that drones and possibly slow-flying, heavy electric airplanes with heated upper-wing surfaces will soon make an appearance, borrowing an advantage that birds like the Black-browed Albatross have been exploiting for many millions of years.

Inspiration from Feathers

Flight feathers are one of the great avian evolutionary success stories. Their many unique properties — they are lightweight, resistant to deformation and fracture, waterproof, and interlocking — have attracted the attention of biologists and engineers anxious to copy these characteristics for use in human-made designs. In 2019, Tarah Sullivan and her colleagues from the University of California San Diego published a fascinating review of biomimetic flight feathers that discusses potential engineering applications inspired by natural feathers.[12] She used a 3-D printer to render new biomimetic feather designs into real objects that could be manipulated, tried out, and improved upon.

I have picked up many dead birds during my beach walks, but I cannot ever recall seeing a wing with a broken feather shaft (called a rachis). This speaks to the rugged properties of feathers, which can bend during use and then snap back into their original configuration once the deforming force has been removed. This can often be seen during a vigorous downstroke, when the wing tips curl under the pressure of air (see the Black-footed Albatross on page 271). Feathers are, of course, dead structures, like nails, scales, or hair, so their physical properties are fixed after initial growth. Strength depends on both material properties and geometry, but in feathers it has been shown that geometry — in particular cross-sectional areas and the way material is distributed — is the most important factor in stiffness.[13]

One of the secrets of feather strength is that, although the region of the thin keratin shaft that inserts into skin (called the calamus) is hollow, the remainder of the shaft is filled with a dense but lightweight foam-like material. Another biological design feature is that the keratin is arranged differently along the length of the rachis so that the feather is stiffer toward the tip. Also, the resistance to bending changes with direction, something that scientists call anisotropy.

To mimic these properties, Sullivan and her colleagues tried four different cylindrical designs (with and without a foam filling) and also fabricated feather shafts with square cross sections. They tested their constructs under load using what is called a three-point bending protocol: the cylinder is supported close to each end and the load is applied in the center. Fiberglass-epoxy composites were used for the shells. All of these designs can be encountered in an actual feather; for example, the circumferential fibers appear to keep the long bundles of keratin in the shaft from splitting when being bent, while the fibers at 45 degrees increase the feather's twisting (or torsional) stiffness. Each design

Four designs that mimic a feather's calamus. Each has the same foam core, but they differ in the construction of their outer shell as follows:

(a) has fibers running longitudinally along the shaft;

(b) contains fibers running circumferentially around the shaft;

(c) has fibers that run at a 45° angle along the shaft;

(d) consists of two inner layers running along the axis of the shaft and two outer layers running circumferentially around the foam.[12]

Sullivan et al.[12] Used with permission

(bending moment per unit cross section) was 134 percent greater with a foam filling. The foam filling did not, however, change the bending stiffness of the manufactured feathers.

3-D Printed Barbules

In terms of complexity, the rachis is the simple part of a bird's feather. It is, therefore, the easiest component to mimic at the actual size found in birds. However, the elegantly designed mechanism of interlocking barbules represents more of a challenge, in part because of the telescoping hierarchy of its parts. The individual barbs to which the barbules are attached can be 10 mm (just under ½ inch) or more long and 100 microns (¹⁄₁₀ mm) in diameter. You can see them, feel them, and rearrange them, but the barbules themselves have interlocking tips that are only a few microns in size, which is much smaller than the approximately 100-micron resolution limit of the unaided eye. This means that the paradigm for biomimicry is to copy the interlocking action of the barbules and use their functionality at a much greater size than in the actual wing. Two examples are shown on the following pages.

Even at the larger scale, manufacturing proved to be a challenge because the hook-and-groove element that mimics the barbules sometimes broke. Different materials and hook designs were incorporated in an attempt to give the model the kind of elastic response found in an actual feather.

may find a place in particular biomimetic applications, for example, when twisting is encountered in one setting and sideways bending in another.

The researchers found that the most important mechanical properties reflecting the strength of the biomimetic feather shafts were all greatly improved when the 3-D printed shaft was filled with foam compared to the hollow shell. For example, the load to failure increased by 70 percent, and the maximum bending stress tolerated

A biomimetic locking structure at about 100 times the scale of that found in a bird's flight feather. The thin terminal hooks lock into grooves on the broad, flat strips.

Sullivan et al.[12] Used with permission

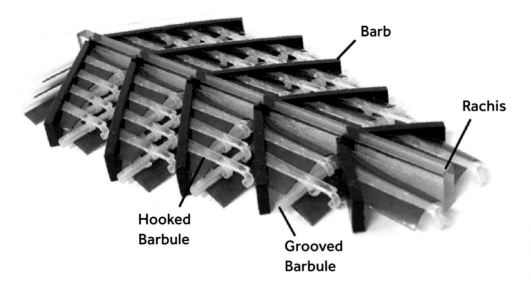

Barb

Rachis

Hooked Barbule

Grooved Barbule

A larger, more flexible section of a biomimetic feather, including a rachis and thinner "barbule" hooks and grooves.

Sullivan et al.[12] Used with permission

Open
channels

Sliding channels that open like valves to allow
the passage of air when the wing is stretched
in one direction.

Sullivan et al.[12] Used with permission

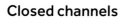

Closed channels

A flexible chain-mail-like structure with chan-
nels that can stretch open in two directions.

Sullivan et al.[12] Used with permission

One-Way Airflow

Buried in the complex array of barbules is an often-ignored feature of bird wings: They have a preferred direction for airflow. Air flows more easily from the top to the bottom surface than from the bottom to the top. This makes sense during flapping flight, when it may reduce drag during the recovery stroke. Sullivan's team mimicked this behavior by providing sliding channels that will open, or not, depending on the direction in which the mimetic wing is stretched. They also explored stretching in two dimensions, and this resulted in a structure that was likened to chain mail in its appearance (see page 283).

Designs Waiting for Applications

While these are all ingenious bioinspired designs, the cynic might reasonably observe that, with the exception of winglets and the owl-inspired fan, they represent attempts to understand avian flight characteristics and flight equipment but do not offer designs that can be put immediately into practice. This kind of criticism was advanced in the early days of biomimicry by influential biologist and bioengineer Steven Vogel. In 2000, he wrote:

> Nature's mechanical contrivances are certainly impressive, but only occasionally have they provided useful models for human technology. Several of the commonly cited successes in biomimetics prove on close examination to be apocryphal. The handful of cases that survive scrutiny suggest that copying nature is the most promising where: 1) we do not attempt slavish imitation, 2) our understanding of the underlying science is weak or 3) either we want to make something akin to what is common in nature or the natural model happens to be close to what is typical of our own technology.[14]

Since Vogel's words were written, the field of biomimicry has evolved and expanded dramatically. A search of a major bibliographic database (PubMed) using the search string "biomimicry OR bioinspiration" yielded four results for the year 2000 but 1,943 research papers in 2022 (this search was for all organisms, not just birds). This is clearly an exploding field, and I think that we can expect to see, and perhaps use, many avian-inspired designs in the not-too-distant future.

Can drone performance be improved by morphing wings and tail?

THE QUESTION	Can the flight of drones be improved by adding bird-like morphing of the control surfaces?
THE AUTHORS	Enrico Ajanic, Mir Feroskhan, Stefano Mintchev, Flavio Noca, and Dario Floreano from the School of Engineering, Swiss Federal Institute of Technology Lausanne, Lausanne, Switzerland
THE SOURCE	"Bioinspired Wing and Tail Morphing Extends Drone Flight Capabilities," *Science Robotics* 5, no. 47 (2020), DOI: 10.1126/scirobotics.abc2897.
THE HYPOTHESIS	Maneuverability during fast flying could be improved by adding wing and tail morphing.

THE EXPERIMENT

Figures used with permission

- Based on the structure of a Northern Goshawk (*Accipiter gentilis*), a robotic drone was developed weighing 284 g (10 oz.) with a maximum wingspan of 1.05 m (about 3½ ft.).
- A propeller provided thrust (rather than the flapping wings of a bird).
- The morphing surfaces were feather-like plates.
- An elastic tendon actuated the "feathers."
- The hand wing could be extended by about 90° and wing area reduced by 41%, independently on the left and right sides.
- Morphing the tail changed its area by 214% between tucked and extended positions.
- The drone was flown in a wind tunnel and in free air.

THE RESULTS

Redrawn from Ajanic et al.

t: tucked
e: extended

- Lift and drag coefficients could be varied over a broad range, particularly at higher angles of attack.
- Unfolding the wing and tail improved maneuverability by increasing the maximum lift by more than 70% and the corresponding drag by more than 60%.
- When both wings and the tail were tucked, the tail's upward deflection generated a small and gradual increment in linear and pitch accelerations.
- Flight tests confirmed the increased responsiveness of the drone when wing morphing was actuated.

THE CONCLUSIONS	"Avian-inspired morphing of the drone's wing and tail can notably improve flight performance in two diverse flight regimes, namely, cruise and aggressive flight."

> We hope that we have proved to the reader that nothing is impossible in the analysis of movements connected with the flight of a bird.
> — ÉTIENNE-JULES MAREY (1874)

Flight Stories

EVERY FIELD OF HUMAN ENDEAVOR HAS ITS LEGACY OF founder's stories. In the science of bird flight, there are many fascinating people who, over the centuries, tried to understand the mystery of how birds fly. Some, like the 19th-century French scientist Étienne-Jules Marey, did it for the sheer joy of scientific discovery. Others, including Leonardo da Vinci and the Wright brothers, wanted to steal secrets from birds to enable human flight.

Otto Lilienthal: Human Flight Pioneer

> It had just been confirmed once and for all by a particularly learned government-appointed commission that man could not fly, which did not particularly lift the spirits of those working on the problem of flight.
> — Otto Lilienthal (1893)

A Combination of Factors

The morning of Sunday, August 9, 1896, had started badly. As with most aircraft accidents, a combination of factors led to the disaster. Otto Lilienthal's younger brother and coworker Gustav had planned to be at their aerodrome to help close up for the season, but he had a biking accident and did not make the trip.

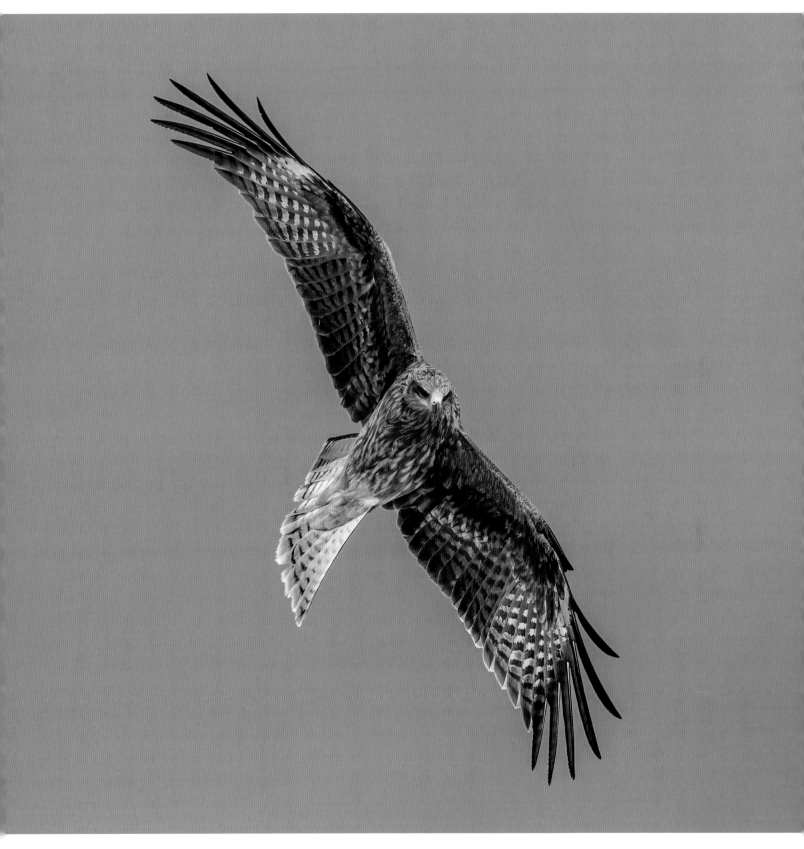

A Black Kite (*Milvus migrans*), which is believed to be the species that
Leonardo da Vinci observed for his studies of bird flight.
Akune, Japan. January. IUCN category: Least Concern

Left: Otto Lilienthal in an undated portrait.
Right: Lilienthal in action, about to launch in one of his flapping flying machines.

Photos courtesy of the Otto Lilienthal Museum, Anklam, Germany

Otto wanted to make one last change to the rudder of his flying machine. On his first flight of the day, he had taken off into "uncertain" winds, probably stalled, and plummeted to the ground. Previous editions of their plane had incorporated some form of shock absorber, but, for unknown reasons, it was not fitted to the craft used on Otto's final flight. Had Gustav been there, he might have insisted that this safety feature be installed.

Otto sustained a cervical spine fracture and was transported to Berlin for treatment. Otto Lilienthal expired 36 hours after the crash, at the age of 48. His (possibly apocryphal) last words were "*Opfer müssen gebracht werden!*" (sacrifices must be made), a text that was later inscribed on his gravestone. Through his many contributions, he left an enduring legacy in both flight science and sport flying.

An Informed Inventor

Otto Lilienthal was not the first person to die attempting to fly. In addition to the mythical Icarus, a troupe of "tower divers" was spawned in medieval times by the availability of tall ecclesiastical towers. Eilmer, an early 11th-century English monk, reportedly broke both his legs while trying to fly from an abbey tower with wings attached to his hands and feet.

But it would be a huge injustice to put Lilienthal in the same category as these daredevils, who were all ambition and no science. The arc of Lilienthal's commitment to, and knowledge about, bird flight is documented in his landmark 1889 volume *Birdflight as the Basis of Aviation*[1] and in the extensive archive of his published papers, speeches, and patents that is maintained at the museum devoted to his life's work in Anklam, Germany.[2]

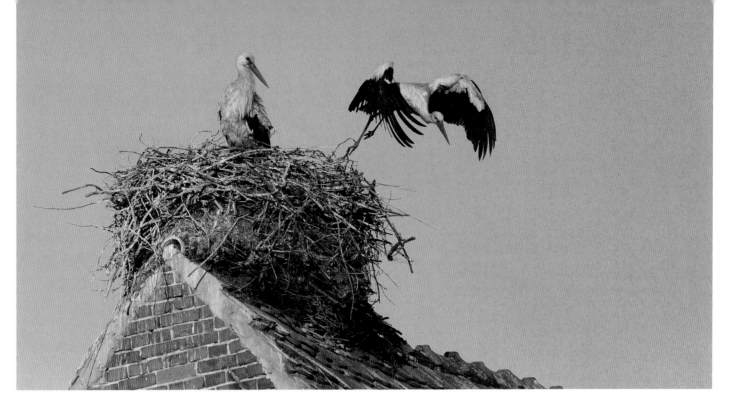

A pair of White Storks (*Ciconia ciconia*) nesting on a rooftop in Germany.
Ruehstaedt, Germany. June. IUCN category: Least Concern

Inspiration from Storks

Birds exerted a profound influence on Lilienthal throughout his life. To be more precise, however, it was not birds in general but the White Stork (*Ciconia ciconia*), which migrates from Africa to Western Europe, including to the town of Anklam in northern Germany, where Lilienthal was born and raised. It is not hard to see why the White Stork inspired the two young brothers. These birds arrived each spring from Africa to inhabit huge nests, many built on the rooftops of human-made structures. In his book, Otto described how they would sneak up on a foraging stork from upwind, knowing that it would take off toward them to maximize lift.

This image of two flight-obsessed young boys looking skyward, seeing the flash of black and white feathers and sometimes feeling the rapid movement of air from the bird's wings, is compelling. Soon they were building full-scale mock-ups of stork wings, complete with feathers. This experimentation continued into adulthood and was eventually accompanied by world-class scholarship in the rapidly developing field of late 19th-century aerodynamics.

The transition from curious youngster to pioneer in aerodynamics came after Otto attended the Provincial Technical School in Potsdam, which led to his enrolment in 1867 in the Berlin Technical Academy to study engineering. His education was interrupted by the Franco-Prussian War (July 1870–May 1871), but his engineering career flourished after the hiatus, driven by inventions to automate the process of coal mining and a patent for a new boiler. Over the next 25 years, Otto was responsible for what the historian of aerodynamics John D. Anderson called "a leap forward in applied aerodynamics"

Otto Lilienthal was a talented engineer with multiple strands to his

intellectual curiosity. But despite the common thread of determination to achieve heavier-than-air flight, these various strands sometimes seemed in opposition to each other. For example, Lilienthal was a dedicated experimentalist who provided data on the performance of airfoils, having a major impact on practice. He also built many gliders that performed well. And yet he was so influenced by his theories of bird flight that it was not his own data and experience but rather a closely held emotional belief that led him to conclude flapping wings were needed for humans to achieve powered flight.

In the manner of Leonardo da Vinci, Lilienthal was — with one notable exception — an observer of birds rather than an experimenter with birds. His observations were keen and his interpretations ahead of his time. For example, in the sketches at right from his book, Lilienthal represents the difference in wing configuration in gulls during the downstroke and the upstroke. He noticed that the leading edge is higher than the trailing edge on the upstroke and the opposite on the downstroke. He correctly deduced that wing warping allowed the hand wing to generate thrust on the downstroke. Anticipating modern-day avian biomechanists, he also proposed that generation of lift on the upstroke was possible. Lilienthal correctly deduced that the outer part of the wing (the hand wing) was generating thrust on the downstroke.

FIG. 78. (Gull in Flight.)

Two images of flapping flight in a gull as viewed from behind. The wings are sketched approximately horizontal during the upstroke (above) and downstroke (below). Reproduced from Lilienthal's book.[1]

FIG. 32.

An experiment in which the wing feathers of a pigeon were progressively tied together to determine the minimum wing configuration required for flight.

One of the few experiments on birds that Lilienthal reported would almost certainly not comply with modern-day ethics. To find out the absolute minimum wing configuration required for flight, he altered the wings of pigeons either by clipping feathers or tying feathers together. The sketch above was said to represent "the limits at which the pigeon is still able to fly rapidly and high for a prolonged period of time."

A Beating-Wing Machine

The erroneous interpretation of an elaborate human experiment confirmed Lilienthal's beliefs about lift generation during flapping, and it continued to propel his thinking in the wrong direction. It was designed to show that "the principle (of utilization of the inertia of the air by the beating movements of the wings) is of the very greatest advantage to flying creatures [and] is not the privilege of birds alone."

This human-powered contraption (shown below) was a "beating wing device" suspended from a pulley system by a 40 kg (88¼-pound) weight. The rider and the rig on the other end of the suspending rope weighed a total of 80 kg (176½ pounds). There were three

A beating-wing machine that Otto Lilienthal built to investigate lift generated by flapping wings. This led him to an incorrect conclusion.[1]

sets of reciprocating wings oscillating up and down about a horizontal axis. Each outer set had three blades, and the inner set was six-bladed. As a wing section reached the bottom-most point of its travel, slats on the wing rotated like an open venetian blind for the upstroke. As the wings changed direction at the top, the slats closed and the rider's leg was forcefully extended to drive the wing down — to "beat on the air." If lift greater than 40 kg (88 pounds) was generated by this reciprocating process, then the operator and his wings would be lifted by the counterweight.

Lilienthal reported that "After a little practice we were able to lift half our weight so that a 40 kg counterweight sufficed to just balance the machine and operator, weighing 80 kg. The requisite effort, however, was so great, that we could maintain ourselves at a certain level for only a few seconds."

These results reinforced his belief that the mechanism of lift generation in birds was simply a result of rapid up-and-down wing movement. He believed that "on sudden [downward wing] motion [the air] is compressed in front of and attenuated behind the surface [...] the ultimate pressure on the surface is the resultant of the two effects."

What Lilienthal was actually measuring was the drag created by the rapid acceleration of the flat surface into stationary air in a manner that is quite unlike the actual flapping movement of bird wings. It is possible that some lift was generated by the upward

Illustrations from Otto Lilienthal's patent number 77916, issued on September 3, 1893, in Berlin. This craft was a flapping-wing glider.

movement of the wings with open slats, similar to the lift created by wing-tip reversal in the recovery stroke of some birds. Last, there may have been some lift developed on the downstroke as a function of "plunge," which can occur in bird flight.

Lilienthal's Table

Sometime before 1895, Lilienthal conducted a very consequential series of outdoor experiments to measure the lift and drag generated by the wind on fixed wing sections. In addition to confirming the superiority of cambered airfoils, this campaign led to a set of elegant diagrams from which he assembled a table of "aerodynamic coefficients" — normalized lift and drag at different angles of attack— which he widely disseminated to his contemporaries. Among the readers of the table were the Wright brothers, who were still struggling to generate enough lift from their own gliders. We will return to a discussion of this table when we talk about the Wright brothers later.

Otto Lilienthal never abandoned the idea that flapping like a bird would be necessary for human flight: "The problem of why a flying bird does not drop to the ground [...] may be considered fully solved [...] this can only consist of air resistance produced through the movement of the bird's wings."[1]

Just like the Wright brothers, he was working to incorporate motors into his gliders, but his intention was for the motor to be used to flap wings rather than to rotate a propellor.

Lilienthal is likely to be best

Figure 2 shows the very bird-like airfoil of the wings.

Figure 3 demonstrates the relatively high positioning of the pilot. This imposed limitations on the use of body weight shifts to influence the flight path.

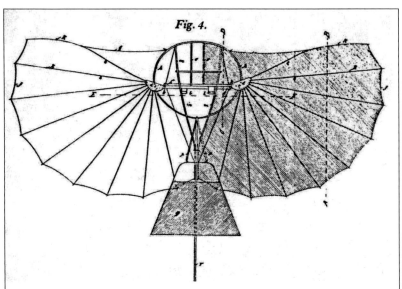

Figure 4 is an overhead view that emphasizes the raptor-shaped, avian-like tail and the very low aspect ratio of the wings. This was imposed by the need to keep the wingspan low so that the pilot could flap the wings with a reasonable mechanical advantage.

Figure 6 shows (not very clearly!) two options for the wing-flapping mechanism. On the left wing, the pilot stepped into leather slippers fixed to a vertical slider and forced the wings down by a leg extensor thrust. On the right wing, a system of chains and rollers led to a motor (not shown). In each case, the elevation of the wings was assisted by "the springing of the wing ribs and the air pressure acting from below."

remembered as the father of hang gliding (see sketches from one of his patents at left). The elegantly designed hang gliders of today are direct descendants of his flying machines. This is not, I am sure, the legacy that he would have wished for — he had his sights set on a loftier goal. His untimely death occurred only seven years before Wilbur and Orville Wright unlocked the secrets of powered flight. Whether or not Otto Lilienthal would have stepped onto the winner's podium with a successful first powered flight will always be a topic of conjecture.

Maria Koepcke: The Ornithologist Who Broke the Glass Ceiling

"Now it's all over."
　　—Maria Koepcke to her daughter as their Lockheed Electra aircraft broke up in mid-air on Christmas Eve, 1971

Maria Koepcke holding a museum specimen of a bird that she discovered in 1954: the White-cheeked Cotinga (*Zaratornis stresemanni*).
IUCN category: Near Threatened

Illustration by Ann Vandervelde

María Emilia Ana von Mikulicz-Radecki Koepcke's career was riding high when she was tragically killed in the mid-air breakup of LANSA Flight 502 on Christmas Eve 1971. This devastating story, with one remarkably inspirational thread, has been told and retold in movies, books, and newspaper articles.[3]

Establishing a Foothold in Ornithology
Born in 1924, Maria earned her doctorate in natural sciences at the age of 25 from the venerable Christian Albrechts University in Kiel, Germany. She moved to Lima, Peru, where she married a former classmate, Hans-Wilhelm Koepcke, in 1950. Soon they both became department heads at the Museum of Natural History in Lima; Maria oversaw the bird and mammal section, and Hans-Wilhelm was at the helm of ichthyology. In 1954, their only daughter, Juliane, was born. They traveled widely, documenting the fauna of Peru, and they also served as the de facto wardens of the Neotropical hinterlands for a generation of foreign ornithologists who billeted with them at Casa Humboldt, the Koepcke's house in Miraflores, a vibrant suburb of Lima, before departing on their own field expeditions. The fellowship that the Koepckes established there was recalled in 1995 by the ornithologist Francois Vuilleumier:

> Ah, the intensity of these meetings at Casa Humboldt, over a cup of hot tea and munching German pastries! These were heated, passionate exchanges of

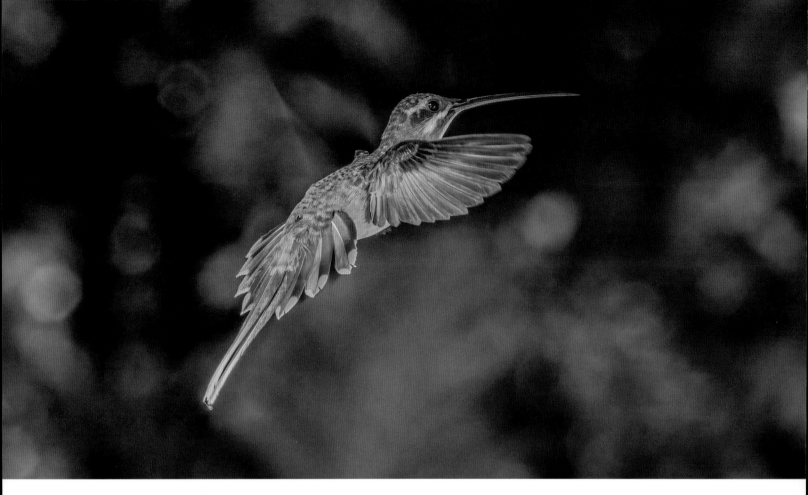

Koepcke's Hermit (*Phaethornis koepckeae*), one of four birds named for Maria Koepcke.
Amazonia Lodge, Peru. April. IUCN category: Near Threatened

observations, new distributional records, or critical reviews of the new species Maria had described, like *Zaratornis stresemanni*, *Asthenes cactorum*, or *Synallaxis zimmeri*. Our conversations were uttered in a quickfire mixture of German and Spanish, plus the Latin names of birds and other creatures. As the evening went on, Maria's normally pale cheeks would become rosy and her eyes aglow with excitement. After an entire evening of such discussions, I staggered to bed, my head spinning with ideas, and crawled under the dank sheets in the cool and moist atmosphere of Lima's peculiar climate, exhausted but eager to go in the field as soon as

possible [...] Maria Koepcke had a burning interest in the animal world and pleasure in discussions of natural history problems.[4]

Among Maria Koepcke's accomplishments was the discovery of 10 new avian subspecies and two new species of ovenbirds and woodcreepers (family Furnariidae), in addition to the cotinga. She wrote several guidebooks and published over 30 scientific articles. She was also an accomplished artist and illustrator who published many sketches of birds and produced illustrations for a series of postage stamps, issued after her death, depicting iconic Peruvian birds (see opposite page).

What was so notable about Maria's rise to become a guru in Neotropical

Green-backed Trogon
(*Trogon viridis*)

Amazonian Umbrellabird
(*Cephalopterus ornatus*)

Andean Cock-of-the-rock
(*Rupicola peruvianus*)

White-throated Toucan
(*Ramphastos tucanus*)

Andean Motmot
(*Momotus aequatorialis*)

Peruvian airmail postage stamps in denominations from 2 to 8.50 soles, with illustrations drawn by Maria Koepcke. The Spanish and Latin bird names appear in the lower right together with the location where the bird was seen. The stamps were issued on June 19, 1972, almost six months after Koepcke's death.

Scans of stamps courtesy of Kjell Scharning, birdtheme.org

ornithology is the fact that, as a woman, she had almost no role models of her own gender.[5] Through her own intellect and energy, she shattered a glass ceiling that had existed since the discipline of ornithology was founded. As Bob Montgomerie points out in "The Invisible Women," "women ornithologists were scarce before about 1960. Even those women who contributed to the history of ornithology tend to be relatively invisible."[6]

Notes from Her Publications

I have two of Maria Koepcke's publications in my library. The first is a 1961 pamphlet published by the American Museum of Natural History in New York titled *Birds of the Western Slope of the Andes of Peru*. It is a dry, scholarly review of 76 species, and it is devoid of illustrations. Each bird is referenced to a museum "skin" number and the place, date, and elevation where it was "taken." Maria collected many of the

specimens herself. In a small departure from the academic rigor of the publication, there is a humorous account of "English Sparrows" (presumably House Sparrows [*Passer domesticus*]), which must have arrived as stowaways on ships from Europe, being sold as exotic pets in Lima marketplaces for a higher price than native Amazonian parakeets.

The second volume is a small hardcover book titled *The Birds of the Department of Lima, Peru*. The printing of this translation of her 1964 Spanish book was sponsored by the Cornell Laboratory of Ornithology and was intended as "a field guide for the ornithologist as well as the student or hobbyist." It details the 331 species of birds "presently established" that Maria had observed during her many trips around the environs of Lima. A sample entry (top right) for the Cape Petrel (*Daption capense*) shows Koepcke's own sketches, many started in the field. It is one of the 121 species in the book that have sketches of birds in flight.

One Life Foreshortened, Another Saved

In 1967, the Koepcke family made what turned out to be a fateful decision to leave Lima and relocate to a small, newly established field station in Peru's Huánuco region. They called the site Panguana, after the nickname for the Undulated Tinamou (*Crypturellus undulatus*), which was common at the site. Like most tinamous, this bird lives up to its genus name ("hidden

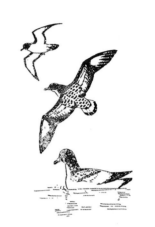

> **PETRELS, DIVING-PETRELS** **23**
>
> ### CAPE (or PINTADO) PETREL
> *Daption capense* (Paloma del Cabo)
> The size of a gull, black and white, unmistakable with its checkered back (which gives it its other local name: Damero). In flight, two large light patches show in the wing. A common species in the southern seas which follows ships for great distances, sometimes gathering in large flocks. Nests in the Antarctic continent and on various islands of the south, such as the South Shetlands and Kerguelen. Lays its one egg in crevices or among stones or rocks close to the sea. Does not nest in burrows as do many petrels and shearwaters. It is a migratory bird on all of the Peruvian coast, at times in considerable numbers, feeding on fish, cuttlefish, crustaceans and garbage from ships.

An entry in Maria Koepcke's book *The Birds of the Department of Lima, Peru*, with her sketches of the Cape Petrel (*Daption capense*).

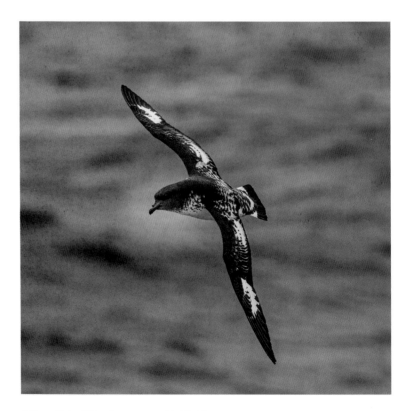

A Cape Petrel (*Daption capense*) in flight.
South Atlantic. November. IUCN category: Least Concern

small-tail") and is often heard rather than seen.

In the days before the Christmas holidays in 1971, Hans-Wilhelm was already at Panguana and the family planned to join him. Their flight left Lima just before noon on Christmas Eve, but it encountered severe turbulence at 6,096 m (20,000 feet) over Puerto Inca. After what has been described as the deadliest lightning strike in aviation history, the plane broke apart just after Maria had turned to her daughter and calmly intoned, "Now it's all over."

All six crew members and 85 of the 86 passengers were killed. Miraculously, Juliane was the sole survivor, despite a fall of more than 3,048 m (10,000 feet) still strapped to her seat. Others may have also survived the fall, only to die before being found. With minor injuries (a fractured collarbone, a sprained knee, lacerations, and limited vision caused by swelling and loss of her glasses), Juliane walked for more than 11 days through the very jungle that she and her parents revered, until she was found by forest workers and returned to civilization. During her heroic walk to safety, she vowed that if she stayed alive, she would devote her life to a cause that served nature and humanity, and she was true to her word.[3] After completing a doctorate in biology at her parents' alma mater, she enjoyed a vibrant academic career and devoted herself to the preservation and expansion of Panguana, which is now a formal conservation area, through an international foundation.[7]

Koepcke's Legacy

Maria Koepcke's ornithological legacy has been cemented by the four bird species named posthumously for her. These are Koepcke's Hermit (*Phaethornis koepckeae*), the Sira Curassow (*Pauxi koepckeae*), Koepcke's Screech-Owl (*Megascops koepckeae*), and the Selva Cacique (*Cacicus koepckeae*).

Her own flight story had a tragic ending, and her bird flight stories are almost entirely told through her drawings, which is reflective of ornithology in the 20th century, when the emphasis was on structure and taxonomy rather than function. I have found only scattered mention of flight in Koepcke's writings, even in her descriptions of albatrosses and hummingbirds. She knew her audience, what they were interested in, and it was not flight behavior. Koepcke was clearly a charismatic and important figure who left footprints that today's scientists, particularly women scientists, can follow with admiration and respect.

Étienne-Jules Marey: Experimenter Extraordinaire

All intervention by mathematics is premature, so long as the study of nature and experiment has not furnished the precise data which alone can serve as a sound starting point for calculations.
　—E.-J. Marey,
　　La machine animale (1874)

Étienne-Jules Marey in a portrait c. 1880. He was a revered scientist and a prolific inventor who had a passion for learning how birds fly.

New Tools to Study Bird Flight

Imagine if Rembrandt had needed to invent the paintbrush before he could produce his groundbreaking masterpieces. When Étienne-Jules Marey (1830–1904) began studying animal locomotion, visual observation was his primary tool. In a long career of invention and innovation in many fields, Marey designed new ways to collect data on bird flight and to demonstrate the results in graphical form. His book *La machine animale* [*Animal mechanism*] published in 1873, documents many of these seminal achievements.[8]

Marey was born in the town of Beaune in the Burgundy region of France. He eventually became a professor at the Collège de France, where he held the chair in natural history of organic bodies. There is a street in Beaune named in his honor — Rue Marey.

Marey's interests were expansive, ranging from infectious diseases to the motion of horses. But from this wide spectrum of intellectual curiosity, bird flight was a particular passion. In his 1894 book *Le mouvement* [*Movement*] he remarked that "of all kinds of locomotion, as existing among vertebrates, that of birds has remained the longest unexplained." In a voluminous output of more than 250 scientific papers and many books, bird flight was the only non-human form of locomotion to which Marey devoted an entire book, the 1890 volume *Le vol des oiseaux* [*The flight of birds*]. He called bird flight "one of the finest problems for which a solution can be pursued."[9]

It was in chasing this solution that Marey's ingenuity led to advances in photography, some of which were foundational in the birth of cinema. He pioneered chronophotography (literally "time photography"), in which multiple images of successive postures of a flying bird or other animal appeared on the same photographic plate. He also designed a gun with a rotating photographic plate on which images could be captured on a disk of film as it moved past the shutter (anticipating by almost 100 years the Kodak Disc cameras of the 1980s; see page 311). He also designed a system of pneumatic drums to measure movements and muscle activity and then recorded the data in charts. One of Marey's most ambitious projects was a rotating gantry that followed a tethered bird as it flew and used tubes carrying air from pneumatic sensors to measure various signals from the bird.

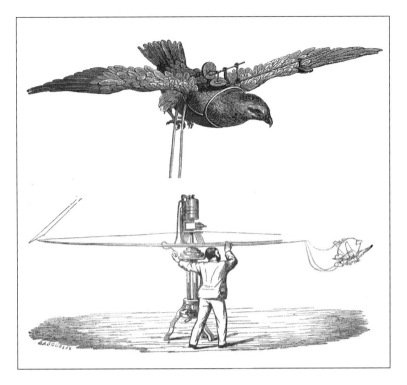

Marey's rotating gantry to study bird flight. A buzzard is wearing a dual pneu-matic sensor designed to measure two degrees of freedom in the movements of the bird's arm wing.

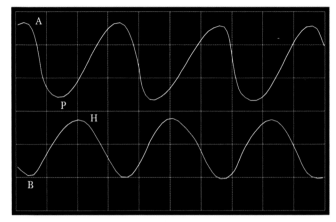

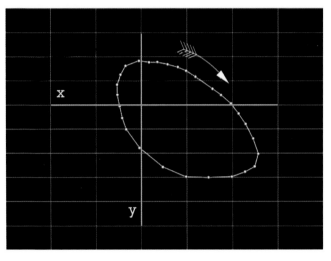

Marey's experimental results for the movement of a pigeon's wings, redrawn from his 1874 book.

Top: The forward-backward (upper curve) and up-down movements (lower curve) of a point on the bird's wrist. The baselines represent a wing's level and outstretched condition.

Bottom: The graph shows one cycle of movement. The forward-backward position of the wrist is on the horizontal axis (forward to the right) and the up-down movement on the vertical axis. The arrow shows the direction of movement.[8]

Measuring Wing Motion

With this array of technology, Marey began to answer questions that had defied the old method of visual observation. He reported the wingbeat frequency of several species of bird, something that was unknown before his work. After a nod to flap-bounding ("Some birds as we know keep their wings perfectly still for a time"), he provided the following table of the number of wingbeats per second during level flight:

Species	Wing Flaps per Second
Sparrow	13
Wild Duck	9
Pigeon	8
Moor Buzzard	5¾
Screech Owl	5
Buzzard	3

The estimates for the pigeon were close to modern values (9.4 Hz), but those for his sparrow are much lower than the more than 20 Hz reported by today's scientists, so it is likely that the accuracy of Marey's devices was limited at higher frequencies.

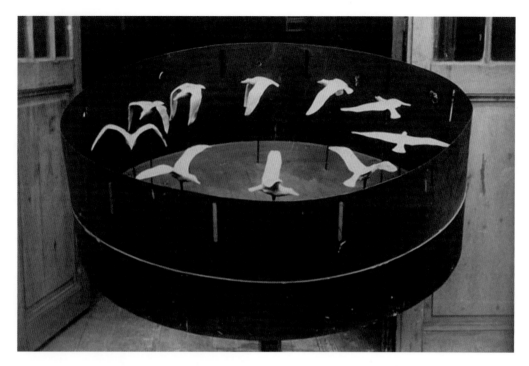

Marey built this zoetrope (from Greek for "life turning") in 1887. When the rotating drum containing plaster figures of gulls in different flight postures was viewed through narrow vertical slits, the gull's flight was reanimated.

Using his new graphic method, Marey showed the up-down and forward-backward movements of a point on the wing as separate traces on his recorder. Then, in a creative step that is still used by modern investigators,[10] he derived the elliptical two-dimensional path of a point on the wing in space.

New approaches always incite the scientific Luddites, and Marey had his detractors. A notable opponent was Dr. Gabriel Colin, who argued that the graphic method contributed nothing that could not be seen with the naked eye. Marey's response was priceless: "If he can estimate the duration of events that only last one hundredth of a second [...] I dare not argue with people who are so exceptionally gifted."[11]

Marey was a passionate communicator who, in addition to writing many books and articles, used novel ways to reveal bird flight to his colleagues and the general public. Some of these were mechanical, such as the zoetrope shown above, in which accurate models of a flying bird mounted in a rotating drum were viewed through slots that reanimated the flight. Others were more artistic, such as a beautiful bronze sculpture showing different stages in the flight of a gull.

Marey was that rare scientist who could create his own methodologies, conduct groundbreaking experiments, and communicate his results effectively. In many ways, this 19th-century genius laid the foundation for the study of bird flight, using experiments and methodologies that were not equaled until the middle of the 20th century. It is also known that Wilbur Wright read *La machine animale* before 1899, so Marey was likely one of the pillars on which the first powered flight by humans was built.

The Wright Brothers: Avian Emulation or Human Innovation?

Extract from a letter from Wilbur Wright to the Smithsonian Institution (May 30, 1899)

The works on the subject to which I have had access are Marey's and Jamieson's books published by Appleton's and various magazines and cyclopaedic articles. I am about to begin a systematic study of the subject [mechanical and human flight] in preparation for practical work to which I expect to devote what time I can spare from my regular business. I wish to obtain such papers as the Smithsonian Institution has published on this subject, and if possible a list of other works in print in the English language.

Yours truly
Wilbur Wright

Send Me Everything!

By modern-day standards of etiquette in science, the letter on the left from Wilbur Wright to the Smithsonian Institution is an audacious request. An equivalent ask today (for example, "Dear Smithsonian, Please send me everything that is known about the Grand Unified Theory of Physics") might be met with a polite demurral or even no answer at all. But at the end of the 19th century, there were no online databases and the library at Ohio State University, which had an enrollment of only 1,252 students at the time, probably lacked the resources that Wilbur Wright was seeking. In that context, his request seems entirely appropriate. The Smithsonian was happy to oblige, and only three days later, the assistant secretary sent Wilbur a veritable Rosetta Stone of sources on "aerial navigation." It is absolutely astonishing that only 1,661 days after making this request, Orville Wright piloted the first heavier-than-air powered flight at Kitty Hawk, North Carolina. This is aeronautical engineering on a supersonic fast track!

Wilbur often mentioned birds in his correspondence. In the Smithsonian letter, he stated his belief that "ordinary" human flight would be simpler than what birds can accomplish:

> Birds are the most perfectly trained gymnasts in the world and are specially well fitted for their work, and it may be that man will never equal them, but no one who has watched a bird chasing an insect or another

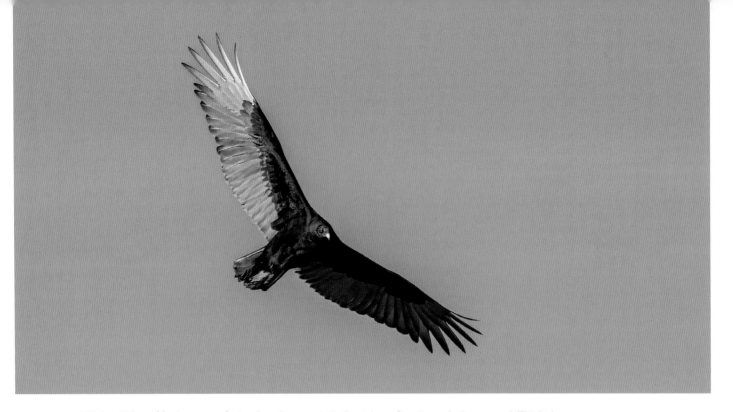

A Turkey Vulture (*Cathartes aura*) wheeling characteristically without flapping or losing control. This behavior caught Wilbur Wright's attention and inspired him to design a wing-warping feature for the Wright brothers' aircraft. Lopez Island, Washington, USA. April. IUCN category: Least Concern

bird can doubt that feats are performed which require three or four times the effort required in ordinary flight. I believe that simple flight at least is possible to man and that the experiments and investigations of a large number of independent workers will result in the accumulation of information and knowledge and skill which will finally lead to accomplished flight.

Wing Warping

Once the Wright brothers started experimenting with prototype kites and gliders, Wilbur's references to bird flight became more specific, and he pointed to the flight of a particular bird, the Turkey Vulture (*Cathartes aura*), often commonly called a buzzard, as a solution to the critical flight dynamics issue of maintaining equilibrium when buffeted by crosswinds. This bird is

a master at exploiting updrafts as it soars and turns for minutes on end, often without so much as a wing flap — catching rising air and managing shifting winds. This has been called contorted soaring.

A letter to frequent correspondent Octave Chanute set out the problem and identified the flight characteristics of the Turkey Vulture as a potential solution:

I also conceive Lilienthal's apparatus to be inadequate not only from the fact that he failed, but my observations of the flight of birds convince me that birds use more positive and energetic methods of regaining equilibrium than that of shifting the center of gravity.

My observation of the flight of buzzards leads me to believe that they regain their lateral balance when partly overturned by a gust of wind, by a torsion of the

A sketch of the wing-warping system the Wright brothers installed on a test kite. This approach eventually helped them achieve roll control of their piloted craft and was a part of their landmark 1903 U.S. patent no. 821,393 for a "Flying Machine," which described control about all three flight axes.

A page from the Wright brothers' primary patent for a "Flying Machine," featuring the wing-warping system.

tips of the wings. If the rear edge of the right wing tip is twisted upward and the left downward the bird becomes an animated windmill and instantly begins to turn, a line from its head to its tail being the axis. It thus regains its level even if thrown on its beam's end, so to speak, as I have frequently seen them. I think the bird also in general retains its lateral equilibrium, partly by presenting its two wings at different angles to the wind, and partly by drawing in one wing, thus reducing its area. I incline to the belief that the first is the more important and usual method.

These thoughts on using wing warping to enhance roll stability were soon translated into action. The design involved attaching cables to the trailing edges of the wings (see illustrations above). Warping made the wings asymmetrical, so that the aircraft would turn in the direction of the low-lift wing, since one wing had greater lift than the other. This approach to roll stability did not survive subsequent developments. In particular, the use of ailerons, small tabs on the trailing edge of a wing that move in opposite directions (e.g., left up, right down for a turn to the left), is now a feature of almost every airplane. Experimental aircraft have incorporated more ambitious warping techniques,

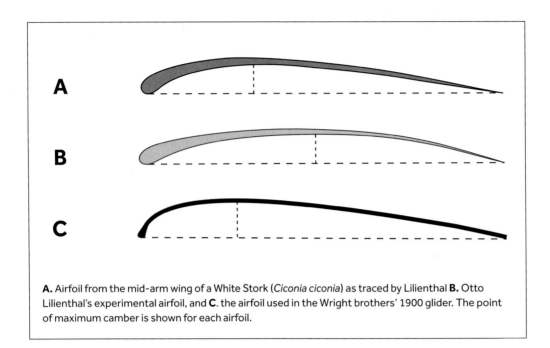

A. Airfoil from the mid-arm wing of a White Stork (*Ciconia ciconia*) as traced by Lilienthal **B.** Otto Lilienthal's experimental airfoil, and **C.** the airfoil used in the Wright brothers' 1900 glider. The point of maximum camber is shown for each airfoil.

particularly for supersonic flight. But for birds, wing warping is an everyday feature of coping with shifting wind conditions and one that gave the Wright brothers an important breakthrough in their pursuit of powered flight.

Wings Like a Bird

One of the reasons the Wright brothers progressed so rapidly was their careful study of evidence left by flight pioneers who came before them. Notable in this regard was the work of Otto Lilienthal in Germany and Samuel Pierpoint Langley in the United States. Of the several legacy aspects of Lilienthal's work adopted by the Wrights was the airfoil, the cross-sectional shape that formed the basis for the wing of their aircraft. Lilienthal traced the cross sections of a White Stork's wing and based his experiments on a cross section of the hand wing. The mid-arm wing cross section from the stork is shown above, as is the airfoil that Lilienthal described

as having "Specially favorable properties [...] namely, great lifting and very little retarding pressure [drag]."

The similarity of the airfoil in the 1900 glider flown by the Wright brothers at Kitty Hawk to both Lilienthal's favored wing and the wing of the White Stork is apparent in the diagrams above. All are cambered wings (arch-shaped, concave downward), but they differ in the amount of camber and the location of the maximum camber.

In the interval between the 1900 glider trials and the successful first powered flight in December 1903, the Wrights developed a unique database on airfoil performance from their innovative wind tunnel experiments. They undertook these experiments because the airfoil above underperformed in terms of lift compared to the predictions from Lilienthal's data. (The reasons for this and the eventual solution make a fascinating detective story that is well told by John Anderson in his book *A History*

of Aerodynamics.[12]) Based on their wind tunnel tests, the Wright brothers changed the wing profile on the 1903 flier to reflect the shape they found to have the best lift-to-drag ratio.

Wings with airfoils that looked bird-like persisted through the first decade or so of powered flight, but they were soon replaced by shapes that were more symmetrical about the chord line rather than the thin sheets that are shown opposite. These new shapes were shown to produce a more laminar (smoother) flow under the conditions in which emerging faster aircraft were flown.

Orville Discounts Avian Influence

There were clearly elements of avian inspiration in some of the Wright brothers' designs, but this does not mean that they succeeded because they copied how birds fly. When he was approaching 70 years old, Orville was asked by the correspondent Horace Lytle of Dayton to elucidate the role that understanding bird flight played in the invention of flight. Orville responded:

> I cannot think of any part bird flight had in the development of human flight excepting as an inspiration. Although we intently watched birds fly in the hope of learning something from them I can not think of anything that was first learned in that way. After we had thought out certain principles, we then watched the bird to see whether it used the same principles. In a few cases

we did detect the same thing in the bird's flight.

Learning the secret of flight from a bird was a good deal like learning the secret of magic from a magician. After you once know the trick and know what to look for you see things that you did not notice when you did not know exactly what to look for.

So that is a fairly hard "no" on copying bird flight. Wilbur died from typhoid in 1912. It would have been good to hear his views on the matter, particularly in light of his early discussion of Turkey Vulture flight with Octave Chanute. In his contrarian biography *Wright Brothers, Wrong Story*, William Hazelgrove proposes that the official narrative of joint invention is not accurate.[13] He believes that it was Wilbur who "possessed the imaginative intuition" and calls their roles "the difference between the poet and the scribe." Could it be that Wilbur did not share his early thoughts regarding the Turkey Vulture, and perhaps other musings, with Orville?

On balance, I think Orville's statement must carry the day. So much of the Wright brothers' success was due to good engineering, persistence, and their unique ability to respond to obstacles by generating new insights and new experiments. They were certainly not bird-obsessed as Lilienthal had been. But for those of us with a fondness for birds, it is nice to know that Orville Wright, near the end of his life, still thought of bird flight as an inspiration.

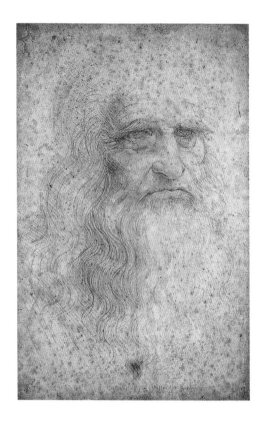

Left: A red chalk sketch believed to be a self-portrait of Leonardo da Vinci drawn in 1512.

Above: Sketches of flying birds, possibly Black Kites (*Milvus migrans*) from the margins of Leonardo's *Codex on the Flight of Birds*.

Leonardo da Vinci: Polymath and Student of Bird Flight

The great bird will take the first flight, above the back of his great Cicero, filling the universe with amazement, filling all writings with his fame, and eternal glory to the nest where he was born.

—**Leonardo da Vinci,**
Codex on the Flight of Birds

Dreams of a Black Kite

As a child, Leonardo da Vinci is said to have had a recurring nightmare in which he was attacked by a Black Kite (*Milvus migrans*) while lying in his crib. This dream caught the attention of Sigmund Freud, who, in a monograph published in 1910, interpreted the dream, the symbolism in some of Leonardo's paintings, and (you might have guessed) da Vinci's relationship with his mother to weave an elaborate psychoanalytic web regarding his personality, his "repression, fixation, and sublimation."[14]

Da Vinci himself was much more sanguine about the dream and its effects on the trajectory of his bird-watching career. He later wrote, "This [dream] is about the Black Kite which seems to be my destiny." He had, in fact, gone on to make hundreds of sketches of the bird performing various maneuvers, which gave clues that he applied to his own desire to fly.

Da Vinci's Notebooks

Paging through Leonardo da Vinci's notebooks is to peer inside a mind with

A page from da Vinci's *Codex on the Flight of Birds* (right) and an English translation. Da Vinci moves from instructions for the pilot of a flying machine to calculations and observations regarding a bird in descending and turning flight.[17]

A man in a flying machine must be free from the waist up in order to balance himself, as he does in a boat, so that his center of gravity and that of the machine can balance and change as necessity demands, according to shifts in the center of resistance.

When a bird is descending the line of its open wings with a speed of four units, and the wind, which strikes it from below, with a power of two, it flies in a straight line. So we will say then that the descent of such a bird will be by a median line between the straightness of the course of the wind and the gradient on which the bird was already flying at a speed of four. For example, let the gradient of such a bird be the line ADC and the wind be BA. So, if the bird ABC had a speed of four, and the wind BA had a power of two, the bird would not cross either the final point of the wind F, nor by its own gradient G, but will fall by the median line AE. This can be proved in this way.

And if the bird's oblique descent has a power of four, and the wind that meets it has a power of 8....
When the bird wants to turn to the right or to the left by beating its wings, then it will beat lower the wing on the side to which it wants to turn. In this way, the bird will change its movement by following the wing which has moved downward most.

boundless curiosity, immense inventive talent, and a fleeting attention span. Da Vinci has been described as an "architect, musician, inventor, engineer, sculptor, and painter [...] perhaps the most diversely talented person ever to have lived."[15] To this list we should add that he was a close observer of nature, a lifelong student of flight, and a person who longed to become the inventor of the first human-piloted machine to take to the skies. His notebooks reflect all these talents and aspirations, sometimes simultaneously.

No space is wasted on the tightly packed notebook pages, where ornate paragraphs of da Vinci's stream of consciousness thoughts in Italian are illuminated with sketches, sometimes neatly arranged in the margins but

This sketch of birds flying into a headwind has been interpreted to be the first documentation of dynamic soaring.[16]

occasionally thrust into the text, which then flows around them. Any one notebook page might feature a discussion of methods for casting medals, a discourse on the origins of gravity, or a declaration of his intent to become famous. The same page might show a drawing of a purported perpetual motion machine, anatomical studies of the human body, a mechanism for ringing a bell, a portrait of an old man, or a sketch of a bird rising on the wind.

Da Vinci mentions bird flight, and his desire to imitate it, in many of his notebook entries. But one collection of pages, known as the *Codex on the Flight of Birds*, has a concentration of his avian observations, and I was fortunate to have read an English translation that was generated when the *Codex* was exhibited at the National Air and Space Museum in Washington, DC, in 2013.[17] The *Codex* must be read with the realization that the science of aerodynamics did not exist and that da Vinci was creating the theory and language of physics as his observations progressed.

Da Vinci believed that flapping wings created a wedge of air that lifted the bird, and his notion of thrust generation relied on terrestrial comparisons: "For this reason, nature has provided birds with a large finger fitted with a very strong bone, to which are joined very strong ribs and short feathers which have greater resistance than all others. In fact, the bird rests on this part of the wing, above the air it has compressed, by exerting all its power and strength of its wings, because that is what allows the bird to move forward, in the same way as a cat uses its claws to climb trees."

We know he was also a keen student of avian anatomy who dissected wings and illustrated wing skeletons in his notebooks. This knowledge informed his observations and prompted his questions: "Those feathers that are farthest from their roots can bend the most. Thus the tips will always be higher than their roots. So we can reasonably assume that the bones in the wings will always be lower than any part of the wings […] I wonder at what point in the lower part of the

wing of a bird the air exerts the greatest pressure."

Bird behavior was da Vinci's particular forte. He appreciated the fine control of wing morphing that occurs as birds maneuver in flight and knew that the pilot of a flying machine would have to emulate these: "The limbs of a bird will certainly respond to the needs of its soul much better than those limbs responding

One of da Vinci's flying machines illustrated in "Paris Manuscript B" (1488–90). The reciprocating rotors were to be powered by the pilot's arm, leg, and neck muscles.

to the soul of a man separated from them, and from their almost imperceptible movements; but the many subtle movements we observe in birds, for the most part, can be learned by man and this will keep the machine, for which the man is the soul and the driver, from crashing."

Philip Richardson from the Woods Hole Oceanographic Institution in Massachusetts has made a convincing case that da Vinci was the first to observe dynamic soaring in birds. Da Vinci's drawings of birds making undulating progress into a wind are very reminiscent of Richardson's own explanation of dynamic soaring in albatrosses (see sketch on the opposite page and chapter 9).

Flying Machines

Most of da Vinci's observations about flight were directed toward his goal of constructing flying machines that he called his "birds." In several places, he directly addresses the future pilot and gives instructions to the manufacturer: "The above said bird ought with the help of the wind to rise to a great height, and this will be its safety, because, even if all of the above mentioned revolutions were to happen to it, it has time to return to a state of balance, provided that its limbs are of great resistance, so that they can safely resist the fury and impetus of the descent with the aforementioned remedies, and its joints have strong tanned leather and its nerves of very strong raw silk."

We lack contemporary accounts of any flight tests da Vinci may have conducted in his time, and many of his contraptions were so heavy they would have had little chance of leaving the

ground even in the strongest of winds. One invention that fits into this category is the flying machine on page 309, which was to be powered by the pilot's leg, arm, and neck muscles. For me this illustration, with its hunched and active pilot, has echoes of the Gossamer Condor,[18] which 481 years later was to win the Kremer Prize for the first human-powered figure-eight course. This vast span of time indicates just how advanced da Vinci's thinking was.

Da Vinci considered both flapping flight and gliding as models for his flying machines. I had an unexpected encounter with one of his gliders during a trip to Italy, where I visited the Leonardo Interactive Museum in Florence, which is overflowing with hand-made period-appropriate reconstructions of Leonardo's designs. The museum is so interactive that no one seemed to mind in the least as I maneuvered a replica of one of his gliders into a better position for the photograph above. Leonardo studied bat wings as well as bird wings, and it is bats that seem to have informed this particular design, which follows his instructions for "a very resistant [framework], its joints constructed with strong leather laces and its ribs of very strong raw silk so that they can withstand the stresses of descent."

Did da Vinci Fly?

There are scattered corners of the Internet where proponents proclaim that Leonardo da Vinci actually flew in one of his machines. Their primary "evidence" is a pen, ink, and watercolor drawing called *Bird's-Eye View*

A reconstruction of Leonardo da Vinci's design for a gliding machine at the Leonardo Interactive Museum in Florence, Italy.

of a Landscape, painted in 1502 and currently in the Royal Collection at Windsor Castle.[19] This is an extremely unlikely supposition. Given da Vinci's dream of worldwide fame for the first flight, surely he would have trumpeted his success from the rooftops. The notion that such technology, once invented, would lie dormant for more than 350 years, until Sir George Cayley's glider made its maiden flight (and crash landing), is untenable. There are indications that da Vinci knew flapping fight would not be possible for humans. He remarked that "birds flap wings with a force man does not have," but of course that did not preclude gliding. Leonardo da Vinci did not fly, but he did come remarkably close to some basic truths about flight that informed future pioneers of lesser genius but more fortunate timing.

How can images of free-flying birds be obtained in the field?

THE QUESTION	Can a device be designed and built to photograph flying birds in flight? (c. 1870)
THE AUTHORS	Étienne-Jules Marey
THE SOURCE	*Le vol des oiseaux* [*The flight of birds*] (Paris: Librairie de l'Académie de Médecine, 1890; reprint, Whitefish, MT: Kessinger Publishing) 132–138.
THE HYPOTHESIS	Building a camera in the form of a gun would allow the photographer to follow the bird, similar to a duck hunter.
THE EXPERIMENT	A gun capable of taking up to 12 images per second was made. An octagonal photographic plate rotated after each image was taken.

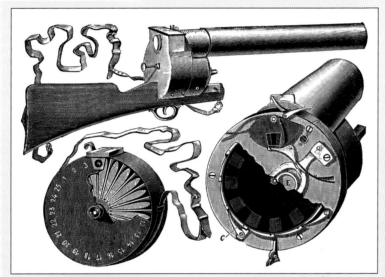

history_docu_photo / Alamy Stock Photo

INTERFOTO / Alamy Stock Photo

THE RESULTS	"In the usual case, the bird stands out against a bright sky. The images are then only silhouettes, but, with a little practice, we managed to find the necessary details to understand the different positions of the bird."

Above: *Silhouettes of a flying gull taken with the gun.*

Left: *The photographic plate with 12 images of a bird flying.*

Bilwissedition Ltd. & Co. KG / Alamy Stock Photo

THE CONCLUSIONS	"With this easily portable instrument, a traveler will be able to take images of a soaring Eagle, a Frigate, a Condor, a Pelican, the large sailing birds that are carried by the wind without beating their wings."

Endnotes

Chapter 1
WHY BIRDS FLY

1 H. Weimerskirch et al., "Foraging Strategy of Wandering Albatrosses Through the Breeding Season: A Study Using Satellite Telemetry," *The Auk* 110 (1993): 325.

Chapter 2
THE EVOLUTION OF BIRD FLIGHT

1 Luis M. Chiappe, *Glorified Dinosaurs: The Origin and Early Evolution of Birds* (Hoboken, NJ: John Wiley and Sons, 2007).

2 The following book describes every specimen of *Archaeopteryx* and includes a discussion of the place of *Archaeopteryx* in the bird tree of life:

Peter Wellnhofer, *Archaeopteryx: The Icon of Evolution* (Munich, Germany: Verlag Dr. Friedrich Pfeil, 2009).

3 This account of the discovery of *Aurornis xui* is one of many to raise questions about the place of *Archaeopteryx* in the bird tree of life:

Pascal Godefroit et al., "A Jurassic avialan dinosaur from China resolves the early phylogenetic history of birds," *Nature* 498 (2013): 359–362, PMID: 23719374, DOI: 10.1038/nature12168.

4 Gerhard Heilmann, *The Origin of Birds* (London: H. F. & G. Witherby, 1926).

A recent discussion of Heilmann's career can be found at "Scientist of the Day — Gerhard Heilmann," Linda Hall Library, accessed March 9, 2022, https://www.lindahall.org/about/news/scientist-of-the-day-gerhard-heilmann/.

5 J.H. Ostrom, "The Ancestry of Birds," *Nature* 242 (March 9, 1973): 136.

6 Rui Pei et al., "Potential for Powered Flight Neared by Most Close Avialan Relatives, but Few Crossed Its Thresholds," *Current Biology* 30, no. 20 (2020): 4033–4046, PMID: 32763170, DOI: 110.1016/j.cub.2020.06.105.

7 An excellent illustrated book written as a field guide to early birds is here:

Juan Benito and Roc Olivé Pous, *Birds of the Mesozoic: An Illustrated Field Guide* (Barcelona, Spain: Lynx Edicions, 2023).

8 D.W. Fowler et al., "The Predatory Ecology of *Deinonychus* and the Origin of Flapping in Birds," *PLOS One* 6, no. 12 (December 14, 2011): e28964, DOI: 10.1371/journal.pone.0028964.

9 The illustration of the tails of early birds is reproduced from here:

Dana Rashid et al., "From Dinosaurs to Birds: A Tale of Evolution." *EvoDevo* 5, no. 25 (July 2014): 1–20, DOI: 10.1186/2041-9139-5-25.

10 Othniel Charles Marsh, *Odontornithes: A Monograph on Extinct Birds of North America*, Yale College Peabody Museum, 1880, https://www.google.com/books/edition/Odontornithes/fzFYAAAAYAAJ?hl=en&gbpv=1&dq=Odontornithes&printsec=frontcover.

11 Lida Xing et al., "A Mid-Cretaceous Enantiornithine (Aves) Hatchling Preserved in Burmese Amber with Unusual Plumage," *Gondwana Research* 49 (2017): 264.

12 The illustration of the skull is reproduced from:

Daniel J. Field et al., "Complete *Ichthyornis* Skull Illuminates Mosaic Assembly of the Avian Head," *Nature* 557, no. 7703 (2018): 96–100, PMID: 29720636, DOI: 10.1038/s41586-018-0053-y.

13 Julia A. Clarke, "Morphology, Phylogenetic Taxonomy, and Systematics of Ichthyornis and Apatornis (Avialae, Ornithurae)," *Bulletin of the AMNH* 286 (2004), https://digitallibrary.amnh.org/handle/2246/454.

14 Juan Benito et al., "Forty New Specimens of *Ichthyornis* Provide Unprecedented Insight into the Postcranial Morphology of Crownward Stem Group Birds," *PeerJ* 10 (2002): e13919, PMID: 36545383 PMCID, DOI: 10.7717/peerj.13919.

15 Amy Balanoff et al., "Quantitative functional imaging of the pigeon brain: implications for the evolution of avian powered flight," *Proceedings of the Royal Society Series B, Biological Sciences* 291 (2015): 20232172, PMID: 38290541, DOI: 10.1098/rspb.2023.2172.

16 An excellent presentation of the pros and cons for the arboreal and cursorial origins of flight can be found here:

J.J. Videler, "The Evolution of Bird Flight," in *Avian Flight* (Oxford, UK: Oxford University Press, 2005).

17 T. Alexander Dececchi and Hans C.E. Larsson, "Assessing Arboreal Adaptations of Bird Antecedents: Testing the Ecological Setting of the Origin of the Avian Flight Stroke," *PLOS One* 6, no. 8 (August 9, 2011): e22292, PMID: 21857918, DOI: 10.1371/journal.pone.0022292.

18 Luis V. Alvarez et al., "Extraterrestrial Cause for the Cretaceous-Tertiary Extinction," *Science* 208, no. 4448 (June 6, 1980): 1095, PMID: 17783054, DOI: 10.1126/science.208.4448.1095.

19 D. Schluter, *The Ecology of Adaptive Radiation* (Oxford, UK: Oxford University Press, 2000).

20 A very accessible and engaging book (which won a Pulitzer Prize) about the Grants and their study of Darwin's finches:

Jonathan Weiner, *The Beak of the Finch: A Story of Evolution in Our Time* (New York: Knopf, 1994).

This is a more academic treatment of speciation:

Peter Grant and Rosemary Grant, *How and Why Species Multiply: The Radiation of Darwin's Finches* (Princeton, NJ: Princeton University Press, 2011).

21 Daniel T. Ksepka et al., "Tempo and Pattern of Avian Brain Size Evolution," *Current Biology* 30, no. 11 (8 June 2020): 2026–2036, PMID: 32330422, DOI: 10.1016/j.cub.2020.03.060.

22 The diagram is redrawn from here:

W. Jetz, G.H. Thomas, J.B. Joy, K. Hartmann, and A.O. Mooers, "The Global Diversity of Birds in Space and Time," *Nature* 491, no. 7424 (2012): 444–448, PMID: 23123857, DOI: 10.1038/nature11631.

23 Edward Braun and Rebecca Kimball, "Data Types and the Phylogeny of Neoaves," *Birds* 2, no. 1 (2021): 1–22, DOI: 10.3390/birds2010001.

A linear version of the bird "Wheel of Life" from the same authors is shown, slightly rearranged, below. The Roman numerals identify the groups known as the Magnificent Seven. Dashed lines indicate relationships that are not supported by at least one of the three major methods of computation.

24 Santiago Claramunt and Joel Cracraft, "A New Time Tree Reveals Earth History's Imprint on the Evolution of Modern Birds,"

Science Advances 1, no. 11 (2015): e1501005, PMID: 26824065, DOI: 10.1126/sciadv.1501005.

25 Carl H. Oliveros et al., "Earth History and the Passerine Superradiation," *Proceedings of the National Academy of Sciences of the United States of America* 116, no. 16 (2017): 7916–7925, PMID: 30936315, DOI: 10.1073/pnas.1813206116.

Chapter 3
FLIGHT EQUIPMENT

1 https://biosphera3d.com/product/3d-bird-anatomy-software/

2 Andrew A. Biewener, "Biomechanics of Avian Flight," *Current Biology* 32, no. 20 (2022): R1110–R1114, PMID: 36283375, DOI: 10.1016/j.cub.2022.06.079.

3 S.P. Sullivan et al., "The 3D Muscle Architecture of the Pectoral Muscles of European Starling (*Sturnus vulgaris*)," *Integrative Organismal Biology* 1, no. 1 (2019), PMID: 33791517, DOI: 10.1093/iob/oby010.

4 Andrew A. Biewener, "Muscle Function in Avian Flight: Achieving Power and Control," *Philosophical Transactions of the Royal Society Series B, Biological Sciences* 366, no. 1570 (2011): 1496–1506, PMID: 21502121, DOI: 10.1098/rstb.2010.0353.

5 Two studies of the propatagium by the same group of authors can be found here:

Richard E. Brown, Julian J. Baumel, and Robert D. Klemm, "Mechanics of the Avian Propatagium: Flexion-Extension Mechanism of the Avian Wing. *Journal of Morphology* 225 (1995): 91–105.

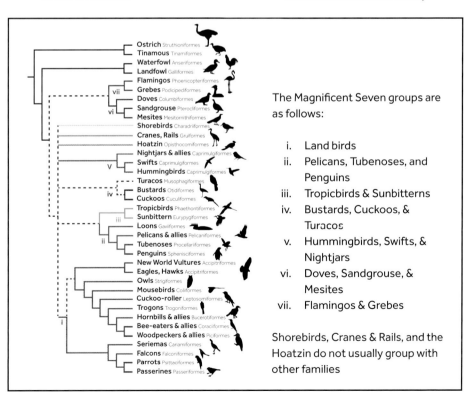

The Magnificent Seven groups are as follows:

i. Land birds
ii. Pelicans, Tubenoses, and Penguins
iii. Tropicbirds & Sunbitterns
iv. Bustards, Cuckoos, & Turacos
v. Hummingbirds, Swifts, & Nightjars
vi. Doves, Sandgrouse, & Mesites
vii. Flamingos & Grebes

Shorebirds, Cranes & Rails, and the Hoatzin do not usually group with other families

Richard E. Brown, Julian J. Baumel, and Robert D. Klemm, "Anatomy of the Propatagium: The Great Horned Owl (*Bubo virginianus*)," *Journal of Morphology* 219 (1994): 205–224.

6 Sergio Martínez Nebreda, Guillermo Navalón, Iris Menéndez, et al., "Disparity and Macroevolutionary Transformation of the Maniraptoran Manus," *Bulletin of the American Museum of Natural History* 440, no. 1 (2020): 183–203.

7 There is a remarkable anatomical study of the pigeon hand that identifies the action of every muscle and the motion possibilities of every joint:

R.J. Vazquez, "Functional Anatomy of the Pigeon Hand (*Columba livia*): A Muscle Stimulation Study," *Journal of Morphology* 226, no. 1 (October 1995): 33–45, PMID: 29865332, DOI: 10.1002/jmor.1052260104.

8 The illustration of the pigeon's hand is from the following:

Noble S. Proctor and Patrick J. Lynch, *Manual of Ornithology: Avian Structure and Function* (New Haven, CT: Yale University Press, 1998), 137.

9 Elizabeth R. Dumont, "Bone Density and the Lightweight Skeletons of Birds," *Proceedings of the Royal Society Series B, Biological Sciences* 22, no. 277 (2010): 2193–2198, PMID: 20236981, DOI: 10.1098/rspb.2010.0117.

10 Roger B.J. Benson, Richard J. Butler, Matthew T. Carrano, and Patrick M. O'Connor, "Air-Filled Postcranial Bones in Theropod Dinosaurs: Physiological Implications and the 'Reptile'–Bird Transition," *Biological Reviews of the Cambridge Philosophical Society* 87, no. 1 (2012): 168–193, PMID: 21733078, DOI: 10.1111/j.1 469-185X.2011.00190.x.

11 A video of the experiment where astronaut David Scott dropped a Peregrine Falcon feather and a hammer to the surface of the moon can be viewed here: https://www.youtube.com/watch?v=Oo8TaPVsn9Y (viewed July 11, 2022).

12 The description of the feather on the moon is here:

Thor Hansen, *Feathers: The Evolution of a Natural Miracle* (New York: Basic Books, 2011), 131–135.

13 The Feather Atlas: Flight Feathers of North American Birds, curated by the U.S. Department of Fish and Wildlife: https://www.fws.gov/lab/featheratlas/.

Featherbase was assembled from the personal collections of a number of German scientists and, at the time of writing, contains information on 1,717 species, 5,821 exhibits, 14,779 photos, and 7,5746 measurements. It is less standardized, with more variable photographic quality, than the USDFW collection: https://www.featherbase.info/en/home.

The Wing and Tail Image Collection of the Puget Sound Museum of Natural History at the University of Puget Sound is a curated and searchable collection of 3,852 wing and tail feather images: https://digitalcollections.pugetsound.edu/digital/collection/slaterwing.

14 The photograph of the histological section of the chick embryo wing appears in Mao Kondo et al., "Flight Feather Development: Its Early Specialization During Embryogenesis," *Zoological Letters* 4, no. 2 (2018), DOI: 10.1186/s40851-017-0085-4.

15 Tarah N. Sullivan, Bin Wang, Horacio D. Espinosa, and Marc A. Meyers, "Extreme Lightweight Structures: Avian Feathers and Bones," *Materials Today* 20, no. 7 (2017): 377–391, DOI: 10.1016/j.mattod.2017.02.004.

16 Teresa J. Feo, Daniel J. Field, and Richard O. Prum, "Barb Geometry of Asymmetrical Feathers Reveals a Transitional Morphology in the Evolution of Avian Flight," *Proceedings of the Royal Society Series B, Biological Sciences* 282, no. 1803 (March 22, 2015): 20142864, PMID: 25673687, DOI: 10.1098/rspb.2014.2864.

17 The formal definition of aspect ratio is wingspan squared divided by wing surface area. Surface area is easier to measure than average wing width (chord).

18 The distances shown on this figure are used as follows:

Aspect ratio is [100 × wingspan/average wing width] = 100 × (a/b). When wing surface area A is available, it is calculated as a2/A.

The Hand-Wing Index = 100 × (d − c)/d. It is used on museum specimens as a measurement of the aspect ratio of the hand-wing.

Kipp's distance is: wrist to longest primary tip minus wrist to tip of first secondary = [d − c]. This difference is usually measured directly on the folded wings of a "bird in the hand" during ringing.

19 Stephen M. Gatesy and Kenneth P. Dial, "Locomotor Modules and the Evolution of Avian Flight," *Evolution* 50, no. 1 (1996): 331, PMID: 28568886, DOI: 10.1111/j.1558-5646.1996.tb04496.x.

20 Benjamin W.C. Rosser et al., "Muscle Fiber Types in the Pectoralis of the White Pelican, a Soaring Bird," *Acta Zoologica* 75, no. 4 (1994): 329–336.

21 Howard E. Evans, "Avian Anatomy," in *The Cornell Laboratory Handbook of*

Bird Biology, eds. Irby J. Lovette and John W. Fitzpatrick (Chichester, UK: John Wiley and Sons, 2016), 190.

Chapter 4
THE AERODYNAMICS OF BIRD FLIGHT

1 The Reynolds number (Re) characterizes a specific set of flight conditions. It is based on the velocity of the airflow, the dimensions of the wing, and the density and viscosity of the air. It is defined this way:

Re = (u × L)/V where Re is the Reynolds number
u is the speed of the airflow
L is the wing chord length
V is the kinematic viscosity, a measure of how hard it is for a fluid to flow (the "stickiness" of the fluid or its dynamic viscosity) divided by air density.

A large aircraft landing may be flying with a Reynolds number that differs by a factor of more than 1,000 compared to a large bird (Reynolds numbers of 24,000,000 and 200,000, respectively) because of differences in flight speed and wing size. This will markedly change the patterns of airflow and the aerodynamic behavior of the wings.

An excellent presentation of the importance of the Reynolds number in a biological context:

Steven Vogel, *Life in Moving Fluids: The Physical Biology of Flow* (Princeton, NJ: Princeton University Press, 1994), 84–105.

2 The three books on aerodynamics that I like to refer to when I need aerodynamic authority are weighty tomes, with a total of 1,800 pages between them:

Doug McLean, *Understanding Aerodynamics: Arguing from the Real Physics* (Chichester, UK: John Wiley and Sons, 2013).

John D. Anderson Jr., *Fundamentals of Aerodynamics*, 4th ed. (New York: McGraw-Hill, 2007).

This book, designed for student pilots and beginning undergraduates, is written in a very understandable style:

H.C. Skip Smith, *The Illustrated Guide to Aerodynamics*, 2nd ed. (New York: McGraw-Hill, TAB Books, 1991).

3 Details of the wind tunnels and force balances made by the Wright brothers in 1901 can be found here: https://www.grc.nasa.gov/www/k-12/airplane/wrights/test1901.html.

A discussion of their findings can be found here: https://www.grc.nasa.gov/www/k-12/airplane/wrights/results.html.

4 Airspeed is calculated as the difference between the speed of the bird or airplane relative to the ground and the wind speed (also relative to the ground). For example, a ground speed of around 9 m/s (20 mph) with a direct headwind of around 4.5 m/s (10 mph) results in an airspeed of 13.5 m/s (30 mph). Note that the "velocity vectors" are in opposite directions and therefore have opposite signs. You will remember from algebra that the product of 2 minuses is a plus. So the calculation is + 20 − (−10) = + 20 + 10 = 30.

If the same wind shifted to be directly behind the tail, the airspeed reduces to around 4.5 m/s (10 mph).

See this site for further explanation: https://www.grc.nasa.gov/www/k-12/airplane/move.html#:~:text=For%20a%20reference%20point%20picked,mph%20wind%20from%20the%20east.

5 During their extensive wind tunnel tests in the fall of 1901, the Wright brothers measured the performance of more than 200 airfoils and then conducted more extensive tests on the 57 shapes below. No. 12 airfoil was the best performer, and it was

subsequently used on their aircraft (from https://www.wright-brothers.org/, accessed May 9, 2023).

6 Frank M. White, *Fluid Mechanics*, 8th ed. (Boston: McGraw-Hill Series in Mechanical Engineering, 2015).

7 When a model of an airfoil is tested in a wind tunnel, a scaling parameter called the Reynolds number should be matched in the tunnel and real-life situations. If atmospheric conditions (including density, viscosity, temperature, and pressure) remain the same in the simulation and in real life, the Reynolds number in each case reduces to the product of a constant, the length of the wing chord for example, and the airspeed in appropriate units. For the Wright brothers' tests, the numbers would be as shown on the table at the top of the next column.

A replication of the Wright brothers' experiments showed that, because of this mismatch in Reynolds number, their wind tunnel results underestimated the lift coefficient of the small model wing by about 17% and overestimated the drag coefficient by about 58%. These combined errors underestimated the efficiency of the model by a factor of about 2.8.

8 Doug McLean. "Aerodynamic Lift, Part 1: The Science," *The Physics Teacher* 56, no. 8 (November 2018): 516, DOI: 10.1119/1.5064558.

Doug McLean, "Aerodynamic Lift, Part 2: A Comprehensive Physical Explanation," *The Physics Teacher* 56, no. 8 (November 2018): 52, DOI: 10.1119/1.5064559.

9 The reader can make these kinds of calculations easily using the lift calculator here: https://www.ajdesigner.com/phpwinglift/wing_lift_equation_force.php.

Table for Note 7

Test Location	Airspeed	Wing Cord Length	Reynolds Number*
Kitty Hawk, NC	13.4 m/s (30 mph)	2.1 m (7 ft.)	1,926,859
Lab in Dayton, OH	12.1 m/s (27 mph)	0.0254 m (1 in.)	21,045

*Assuming the kinematic viscosity in both situations was 1.46E-05 m2/s

10 The calculation of wing loading for the Atlantic Puffin and the Laughing Gull:

	Mass (kg)	Wingspan (m)	Wing Area (m²)	Wing Loading (kg/m²)
Atlantic Puffin	0.443	0.568	0.037	12.0
Laughing Gull	0.299	0.59	0.1014	2.9
Ratios (Puffin to gull)	148%	96%	36%	4.1

11 It is not intuitively obvious that lower wing loading implies lower takeoff speeds, but a little algebra with the lift equation clarifies this. The lift equation is: $L = \frac{1}{2}\,\rho.C_L.v^2$. A with the following meaning:

Symbol	Quantity	Units
L	Lift force	newtons
ρ	Density of the air at given temperature and elevation	kg.m^{-3}
C_L	Lift coefficient of the wing at the chosen angle of attack	unitless (dimensionless)
v	Airspeed (taking into account groundspeed and windspeed)	m.s^{-1}
A	Area of both wings	m²

At takeoff, lift will be equal to body weight, so we can replace L and A in the lift equation with the wing loading:

W_L = body weight/wing area. The equation now looks like this:
$W_L = \frac{1}{2}\,\rho.C_L.v_{TO}^2$ (where v_{TO} is the velocity at takeoff)

This can be rearranged to predict airspeed at takeoff:
$V_{TO} = \mathrm{sqrt}[2.W_L/(\rho.C_L.)]$ (where sqrt means the square root of the quantity in brackets)

This equation shows that airspeed at takeoff varies with the square root of wing loading (since we can assume that the density of the air [ρ] and the lift coefficients [C_L] are the same in a bird-to-bird comparison).

Comparing the Atlantic Puffin and the Laughing Gull using the data in note 10 tells us that the airspeeds at takeoff will be proportional to sqrt (12) for the puffin and sqrt (2.9) for the gull, a ratio of 3.5:1.7 or about 2:1.

12 Thomas Linehan and Kamran Mohseni, "Scaling Trends of Bird's Alular Feathers in Connection to Leading-Edge Vortex Flow over Hand-Wing," *Scientific Reports* 10, no. 1 (2020): 7905, PMID: 32404925, DOI: 10.1038/s41598-020-63181-7.

13 Ian A. Stokes and Andrew J. Lucas, "Wave-Slope Soaring of the Brown Pelican," *Movement Ecology* 9 (2021): 13, PMID: 33752747, DOI: 10.1186/s40462-021-00247-9.

14 The similarity between the streamlined shape of a trout and an airfoil, whether intentional or not, was pointed out by the famous aerodynamicist Theodore von Karman in 1954: Theodore von Karman, *Aerodynamics* (New York and Cornell, NY: Cornell University Press, 1954).

15 https://www.grc.nasa.gov/www/k-12/airplane/shaped.html.

16 John D. Anderson Jr., *A History of Aerodynamics* (Cambridge, UK: Cambridge University Press, 1997), 321–323.

17 Roelof D. Coertze and Arie M. Rijke, "Viscous Drag Reduction and Contour Feather Geometry in Water and Land Birds," in *Birds: Challenges and Opportunities for Business, Conservation and Research* (IntechOpen Print), https://www.intechopen.com/chapters/75909.

18 Illustration redrawn from Doug McLean, *Understanding Aerodynamics: Arguing from the Real Physics* (Chichester, UK: John Wiley and Sons, 2013), 361.

19 The technique, called particle tracking velocimetry, is described in this article, from which the images of the goshawk vortices were reproduced:

James R. Usherwood et al., "High Aerodynamic Lift from the Tail Reduces Drag in Gliding Raptors," *Journal of Experimental Biology* 223, no. 3 (2020), PMID: 32041775, DOI: 10.1242/jeb.214809.

20 Hank Tennekes, *The Simple Science of Flight: From Insect to Jumbo Jets* (Cambridge, MA: MIT Press, 2009), 120–121.

21 A short history of the development and implementation of winglet technology is here: https://spinoff.nasa.gov/Spinoff2010/t_5.html (accessed May 13, 2022).

22 Marco Klein Heerenbrink, L. Christoffer Johansson, and Anders Hedenström, "Multi-cored Vortices Support Function of Slotted Wing Tips of Birds in Gliding and Flapping Flight," *Journal of the Royal Society Interface* 14, no. 130 (2017): 20170099, PMID: 28539482, DOI: 10.1098/rsif.2017.0099.

Chapter 5
TAKEOFF AND LANDING

1 K.D. Earls, "Kinematics and Mechanics of Ground Take-Off in the Starling *Sturnis vulgaris* and the Quail *Coturnix coturnix*," *Journal of Experimental Biology* 203, no. 4 (2000): 725–739, PMID: 10648214, DOI: 10.1242/jeb.203.4.725.

2 Angela M. Berg and Andrew A. Biewener, "Wing and Body Kinematics of Takeoff and Landing Flight in the Pigeon (*Columba livia*)," *Journal of Experimental Biology* 213, no. 10 (2010): 1651–1658, PMID: 20435815, DOI: 10.1242/jeb.038109.

3 Diana D. Chin and David Lentink, "Birds Repurpose the Role of Drag and Lift to Take off and Land," *Nature Communications* 10, no. 5354 (2019), PMID: 31767856, DOI: 10.1038/s41467-019-13347-3.

4 Bret W. Tobalske, Douglas L. Altshuler, and Donald R Powers, "Take-Off Mechanics in Hummingbirds (Trochilidae)," *Journal of Experimental Biology* 207, no. 8 (March 2004): 1345–1352, PMID: 15010485, DOI: 10.1242/jeb.00889.

5 S. Tonia Hsieh and George V. Lauder, "Running on Water: Three-Dimensional Force Generation by Basilisk Lizards," *Biophysics and Computational Biology* 101, no. 48 (2004): 16784–16788, PMID: 15550546, DOI: 10.1073/pnas.0405736101.

6 Kari R. Taylor-Burt and Andrew A. Biewener, "Aquatic and Terrestrial Takeoffs Require Different Hindlimb Kinematics and Muscle Function in Mallard Ducks," *Journal of Experimental Biology* 223, no. 16 (2020), PMID: 32587070, DOI: 10.1242/jeb.223743.

Videos can be viewed at: http://movie.biologists.com/video/10.1242/jeb.223743/video-1.

7 John G. Whitehead, Terrell Worrell, and John J. Socha, "Mallard Landing Behavior on Water Follows a Tau-Constant Braking Strategy," *The Journal of Experimental Biology* 226, no. 5 (2023), PMID: 36807532, DOI: 10.1242/jeb.244256.

8 Here are the steps to calculate the bird's approach speed. Ignore the effects of drag and assume that the conversion between energy forms is 100% efficient.

Mass of the bird 2 kg (4½ lb.)
Height of the dock 6.1 m (20 ft.)

Potential energy on reaching the dock:

PE = mass × acceleration due to gravity × height

 Mass of the bird = 2 kg

 Acceleration due to gravity = 9.81 m/s²

 Height = 6.1 m

PE = 2 × 9.81 × 6.1 = 119.6 joules

Let v be the velocity of the approach in m/s

Kinetic energy during approach = ½ × mass × v²

Kinetic energy from the approach is converted to potential energy at landing so:

 ½ × mass × v² = 119.6

 v = square root of (119.6 × 2/2)

 = 10.93 m/s

9 Marco Klein Heerenbrink, Lydia A. France, Caroline H. Brighton, and Graham K. Taylor, "Optimization of Avian Perching Manoeuvres," *Nature* 607, no. 7917 (2022): 91–96, PMID: 35768508, DOI: 10.1038/s41586-022-04861-4.

10 William R.T. Roderick, Diana D. Chin, Mark R. Cutkosky, and David Lentink, "Birds Land Reliably on Complex Surfaces by Adapting Their Foot-Surface Interactions upon Contact," *eLife* 8 (2019): e46415, PMID: 31385573, DOI: 10.7554/eLife.46415.

Some great landing video from the experiment can be viewed at https://doi.org/10.7554/eLife.46415.004.

11 Sang-im Lee, Jooha Kim, Hyungmin Park, Piotr G. Jabłoński, and Haecheon Choi, "The Function of the Alula in Avian Flight," *Scientific Reports* 5 (2015): 9914, PMID: 25951056, DOI: 10.1038/srep09914.

Chapter 6
GLIDING AND SOARING

1 A bibliography of some of C.J. Pennycuick's scientific papers on bird flight: "C.J. Pennycuick's Research While Affiliated with University of Bristol and Other Places," accessed January 12, 2023, https://www.researchgate.net/scientific-contributions/CJ-Pennycuick-83406110.

2 C. Harvey, V.B. Baliga, P. Lavoie, and D.L. Altshuler, "Wing Morphing Allows Gulls to Modulate Static Pitch Stability During Gliding," *Journal of the Royal Society Interface* 16, no. 150 (2019): 20180641, PMID: 30958156, DOI: 10.1098/rsif.2018.0641.

3 C.J. Pennycuick, "A Wind-Tunnel Study of Gliding Flight in the Pigeon *Columba livia*," *Journal of Experimental Biology* 49 (1968): 509–526.

4 The data for the gliding characteristics of the Wandering Albatross are taken from: C.J. Pennycuick, *Modelling the Flying Bird* (London: Academic Press, 2008), 273.

5 There are, in fact, two "best" gliding speeds depending on the objectives:

a) The best gliding speed for maximum time in the air corresponds to the minimum sink rate. In aeronautical terminology, this speed is called V_{MS}.

b) The best gliding speed for maximum distance is found by the tangent of a line from the origin of the glide polar to the sink rate vs. airspeed curve shown in the diagram. This speed is called V_{BG}.

The table below compares these two speeds for the Snowy Albatross, starting a glide at about 300 m (1,000 ft.) above ground in still air. The calculations show a 20% increase in flying time when using V_{MS} and a 16% increase in distance flown when using V_{BG}.

	Air Speed (m/s)	Sink Rate (m/s)	Glide ratio : 1	Time in Air (s)	Horizontal Distance Traveled (m)
V_{MS}	11.5	0.64	18.4	160.3	1,842.9
V_{BG}	16	0.75	21.3	133.3	2,133.3

6 Daniel T. Ksepka, "Flight Performance of the Largest Volant Bird," *Proceedings of the National Academy of Sciences of the United States of America* 111, no. 29 (2014): 10624–10629, PMID: 25002475, DOI: 10.1073/pnas.1320297111.

7 Olivier Duriez et al., "How Cheap Is Soaring Flight in Raptors? A Preliminary Investigation in Freely-Flying Vultures," *PLOS One* 9, no. 1 (2014): e84887, PMID: 24454760, DOI: 10.1371/journal.pone.0084887.

8 Hannah J. Williams, Andrew J. King, Olivier Duriez, Luca Borger, and Emily L.C. Shepard, "Social Eavesdropping Allows for a More Risky Gliding Strategy by Thermal-Soaring Birds," *Journal of the Royal Society Interface* 15 (2018): 0578, PMID: 30404907, DOI: 10.1098/rsif.2018.0578.

9 C.J. Pennycuick, "Thermal Soaring Compared in Three Dissimilar Tropical Bird Species, *Fregata magnificens, Pelecanus occidentalis* and *Coragyps atratus*," *Journal of Experimental Biology* 102, no. 1 (1983): 307–325, DOI: 10.1242/jeb.102.1.307.

10 Todd E. Katzner et al., "Use of Multiple Modes of Flight Subsidy by a Soaring Terrestrial Bird, the Golden Eagle *Aquila chrysaetos*, When on Migration," *Journal of the Royal Society Interface* 12, no. 112 (2015): 20150530, PMID: 26538556, DOI: 10.1098/rsif.2015.0530.

11 R.A. Meyers, J.C. McFarland, "Anatomy and Histochemistry of Spread-Wing Posture in Birds. 4. Eagles Soar with Fast, Not Slow Muscle Fibres," *Acta Zoologica* 97, no. 3 (July 2016): 319–324, PMID: 27616780, DOI: 10.1111/azo.12125.

12 Julie M. Mallon, Keith L. Bildstein, and Todd E. Katzner, "In-flight Turbulence Benefits Soaring Birds," *The Auk* 133, no. 1 (2015): 79–85, DOI: 10.1642/AUK-15-114.1.

13 Ian A. Stokes and Andrew J. Lucas, "Wave-Slope Soaring of the Brown Pelican," *Movement Ecology* 9 (2021): 13, PMID: 33752747, DOI: 10.1186/s40462-021-00247-9.

14 Philip C. Withers, "Aerodynamics and Hydrodynamics of the 'Hovering' Flight of Wilson's Storm Petrel," *Journal of Experimental Biology* 80, no. 1 (1979): 83–91.

Chapter 7
FLAPPING FLIGHT

1 Two studies of flapping frequency in birds:

 C.J. Pennycuick, "Predicting Wingbeat Frequency and Wavelength of Birds," *Journal of Experimental Biology*, 150 (1990): 171–185, DOI: 10.1242/jeb.150.1.171.

 C.J. Pennycuick, "Wingbeat Frequency of Birds in Steady Cruising Flight: New Data and Improved Predictions," *Journal of Experimental Biology* 199, pt. 7 (1996): 1613–1618, PMID: 9319516, DOI: 10.1242/jeb.199.7.1613.

2 A study of the interactions between flapping frequency, amplitude, and flight speed:

 K. Krishnan et al., "The Role of Wingbeat Frequency and Amplitude in Flight Power," *Journal of the Royal Society Interface* 19 (2022): 20220168, PMID: 36000229, DOI: 10.1098/rsif.2022.0168.

3 A good discussion of the power requirements for flying, as well as many other interesting aspects of bird flight, can be found here:

 Bret W. Tobalske, "Avian Flight," chap. 5 in *The Cornell Lab of Ornithology Handbook of Bird Biology*, eds. Irby J. Lovette and John W. Fitzpatrick (Princeton, NJ: Princeton University Press, 2016).

 A more in-depth article about the power requirements of flight by the same author:

 Bret W. Tobalske, "Biomechanics of Bird Flight," *Journal of Experimental Biology* 210, no. 18 (2007): 3135–3146, DOI: 10.1242/jeb.000273.

4 T. Alerstam, M. Rosén, J. Bäckman, P.G. Ericson, and O. Hellgren, "Flight Speeds Among Bird Species: Allometric and Phylogenetic Effects," *PLOS Biology* 5, no. 8 (2007): e197, PMID: 17645390, DOI: 10.1371/journal.pbio.0050197.

5 A comparison of the bird's wing to a helicopter rotor is made by David Alexander in chapter 4 in the following book. He attributes the first use of this analogy to Steven Vogel: David E. Alexander, *Nature's Flyers* (Baltimore: Johns Hopkins University Press, 2002), 71.

6 C.J. Pennycuick, Susanne Åkesson and Anders Hedenström. "Air Speeds of Migrating Birds Observed by Ornithodolite and Compared with Predictions from Flight Theory," *Journal of the Royal Society Interface* 10, no. 86 (2013): 20130419, PMID: 23804440, DOI: 10.1098/rsif.2013.0419.

7 Images of wing chord orientation during the flapping cycle are from Jialei Song, Bret W. Tobalske, Donald R. Powers, Tyson L. Hedrick, and Haoxiang Luo, "Three-Dimensional Simulation for Fast Forward Flight of a Calliope Hummingbird," *Royal Society Open Science* 3, no. 6 (2016): 160230, PMID: 27429779, DOI: 10.1098/rsos.160230.

8 Smoothed paths are extrapolated from the data of B. Tobalske and K. Dial, "Flight Kinematics of Black-billed Magpies and Pigeons over a Wide Range of Speeds," *Journal of Experimental Biology* 199, pt. 2 (1996): 263–280, PMID: 9317775, DOI: 10.1242/jeb.199.2.263.

9 These studies reported on the aerodynamic benefits of tip-reversal upstroke:

Ivo G. Ros, Lori C. Bassman, Marc A. Badger, Alyssa N. Pierson, and Andrew A. Biewener, "Pigeons Steer Like Helicopters and Generate Down- and Upstroke Lift During Low Speed Turns," *Proceedings of the National Academy of Sciences of the United States of America* 108, no. 50 (2011): 19990–19995, PMID: 22123982, DOI: 10.1073/pnas.1107519108.

Kristen E. Crandell and Bret W. Tobalske, "Aerodynamics of Tip-Reversal Upstroke in a Revolving Pigeon Wing," *Journal of Experimental Biology* 214, pt. 11 (2011): 1867–1873, PMID: 21562173, DOI: 10.1242/jeb.051342.

10 The reconstruction of the wake was taken from Hadar Ben-Gida, Roi Gurka, and Alex Liberzon, "OpenPIV-MATLAB – An Open-Source Software for Particle Image Velocimetry; Test Case: Birds' Aerodynamics," *SoftwareX* 12 (2020): 100585, DOI: 10.1016/j.softx.2020.100585.

11 Per Henningsson, G.R. Spedding, and A. Hedenstrom, "Vortex Wake and Flight Kinematics of a Swift in Cruising Flight in a Wind Tunnel," *Journal of Experimental Biology* 211, no. 5 (2008): 717–730.

12 James Richard Usherwood, "Physiological, Aerodynamic and Geometric Constraints of Flapping Account for Bird Gaits, and Bounding and Flap-Gliding Flight Strategies," *Journal of Theoretical Biology* 408, no. 7 (2016): 42–52, PMID: 27418386, DOI: 10.1016/j.jtbi.2016.07.003.

13 C.M. Bishop et al., "The Roller Coaster Flight Strategy of Bar-headed Geese Conserves Energy During Himalayan Migrations," *Science* 347, no. 6219 (2015): 250–254, PMID: 25593180, DOI: 10.1126/ science.1258732.

Chapter 8
IN-FLIGHT MANEUVERS

1 This schematic diagram of the red-shank turning indicates the moments of the resultant lift forces (L1 and L2) on each wing around the bird's center of mass (red filled circle). They are calculated as the product of the force multiplied by the perpendicular distance of the force line of action from the center of mass. By convention, a counterclockwise moment is positive. At the instant shown, there is a net clockwise moment tending to make the bird bank to the right because $|(L1 \times d1)| > |(L2 \times d2)|$ where $|\ |$ denotes size, irrespective of sign. When these moments are equal and opposite, the banking turn will stop.

2 Jorn A. Cheney et al., "Raptor Wing Morphing with Flight Speed," *Journal of the Royal Society Interface* 18, no. 180 (2021): 0349, PMID: 34255986, DOI: 10.1098/ rsif.2021.0349.

3 C. Harvey, V.B. Baliga, P. Lavoie, and D.L. Altshuler, "Wing Morphing Allows Gulls to Modulate Static Pitch Stability During Gliding," *Journal of the Royal Society Interface* 16, no. 150 (2019): 20180641, PMID: 30958156, DOI: 10.1098/ rsif.2018.0641.

4 Jorn A. Cheney et al., "Bird Wings Act as a Suspension System that Rejects Gusts," *Proceedings of the Royal Society Series B, Biological*

Sciences 287, no. 1937 (2020): 20201748, PMID: 33081609, DOI: 10.1098/rspb.2020.1748.

5 C.H. Brighton, A.L.R. Thomas, and G.K. Taylor, "Terminal Attack Trajectories of Peregrine Falcons Are Described by the Proportional Navigation Guidance Law of Missiles," *Proceedings of the National Academy of Sciences of the United States of America* 114, no. 51 (2017): 13495–13500, PMID: 29203660, DOI: 10.1073/pnas.1714532114.

6 The guidance law called proportional navigation (PN) is described as a simple differential equation relating the angle to be flown by the bird, γ, and the line-of-sight angle between the bird and prey λ. The bird must turn with a rate γdot proportional to a constant, N, called the "navigation constant," times the rotation rate of the line-of-sight angle, λdot (where dot denotes the first derivative of the angle with respect to time). The navigation constant that resulted in a best fit to the trajectory of the bird was generally less than 3.

The actual equation is:
γdot$(t) = N\lambda$dot(t) where t denotes that quantities are functions of time and "dot" denotes that the proceeding quantity is a first derivative.

7 S. Portugal et al., "Upwash Exploitation and Downwash Avoidance by Flap Phasing in Ibis Formation Flight," *Nature* 505 (2014): 399–402, PMID: 24429637, DOI: 10.1038/nature12939.

8 "Rome's Starlings Create a Stunning Spectacle," *Washington Post*, https://www.washingtonpost.com/world/interactive/2023/rome-starlings-birds-murmuration/.

9 G.F. Young, L. Scardovi, A. Cavagna, I. Giardina, and N.E. Leonard, "Starling Flock Networks Manage Uncertainty in Consensus at Low Cost," *PLOS Computational Biology* 9, no. 1 (2013): e1002894, PMID: 23382667, DOI: 10.1371/journal.pcbi.1002894.

M. Ballerini et al., "Interaction Ruling Animal Collective Behavior Depends on Topological Rather than Metric Distance: Evidence from a Field Study," *Proceedings of the National Academy of Sciences of the United States of America* 105, no. 4 (2008): 1232–1237, PMID: 18227508, DOI: 10.1073/pnas.0711437105.

10 Fabian Arnold et al., "Vision and Vocal Communication Guide Three-Dimensional Spatial Coordination of Zebra Finches During Wind-Tunnel Flights," *Nature Ecology and Evolution* 6, no. 8 (2022): 1221–1230, PMID: 35773345, DOI: 10.1038/s41559-022-01800-4.

11 Details of lovebird and pigeon visual guidance during turning are here:

Daniel Kress, Evelien van Bokhorst, and David Lentink, "How Lovebirds Maneuver Rapidly Using Super-Fast Head Saccades and Image Feature Stabilization," *PLOS One* 10, no. 6 (2015): e0129287, PMID: 26107413, DOI: 10.1371/journal.pone.0129287.

Ivo G. Ros and Andrew A. Biewener, "Pigeons (*C. livia*) Follow Their Head During Turning Flight: Head Stabilization Underlies the Visual Control of Flight," *Frontiers in Neuroscience* 11 (2017): 655, PMID: 29249929, DOI: 10.3389/fnins.2017.00655.

12 H.T. Lin, I.G. Ros, and A.A. Biewener, "Through the Eyes of a Bird: Modelling Visually Guided Obstacle Flight," *Journal of the Royal Society Interface* 11, no. 96 (2014): 20140239, PMID: 24812052, DOI: 10.1098/rsif.2014.0239.

Ivo G. Ros, Partha S. Bhagavatula, Huai-Ti Lin, and Andrew A. Biewener, "Rules to Fly By: Pigeons Navigating Horizontal Obstacles Limit Steering by Selecting Gaps Most Aligned to Their Flight Direction," *Interface Focus* 7, no. 1 (2017): 20160093, PMID: 28163883, DOI: 10.1098/rsfs.2016.0093.

I.G. Ros, L.C. Bassman, M.A. Badger, A.N. Pierson, and A.A. Biewener, "Pigeons Steer Like Helicopters and Generate Down and Upstroke Lift During Low Speed Turns," *Proceedings of the National Academy of Sciences of the United States of America* 108, no. 50 (2011): 19990–19995, PMID: 22123982, DOI: 10.1073/pnas.1107519108.

Chapter 9
FLIGHT SPECIALISTS

1 Christopher J. Clark, Krista LePiane, and Lori Liu, "Evolution and Ecology of Silent Flight in Owls and Other Flying Vertebrates," *Integrative Organismal Biology* 2, no. 1 (2020): obaa001, PMID: 33791545, DOI: 10.1093/iob/obaa001.

2 T. Bachmann et al., "Morphometric Characterisation of Wing Feathers of the Barn Owl *Tyto alba pratincole* and the Pigeon *Columba livia*," *Frontiers in Zoology* 4 (2007): 1–15.

3 Chen Rao, Teruaki Ikeda, Toshi-yuki Nakata, and Hao Liu, "Owl-Inspired Leading-Edge Serrations Play a Crucial Role in Aerodynamic Force Production and Sound Suppression," *Bioinspiration & Biomimetics* 12, no. 4 (2017), PMID: 28675148, DOI: 10.1088/1748-3190/aa7013.

4 Krista LePiane and Christopher J. Clark, "Evidence That the Dorsal Velvet of Barn Owl Wing Feathers Decreases Rubbing Sounds During Flapping Flight," *Integrative and Comparative Biology* 60, no. 5 (2020): 1068–1079, PMID: 32525524, DOI: 10.1093/icb/icaa045.

5 The following article describes the many notable features of hummingbird metabolic pathways:

Raul K. Suarez and Kenneth C. Welch, Jr., "Sugar Metabolism in Hummingbirds and Nectar Bats," *Nutrients* 9, no. 7 (2017): 743, PMID: 28704953, DOI: 10.3390/nu9070743.

6 R.K. Suarez, "Hummingbird Flight: Sustaining the Highest Mass-Specific Metabolic Rates Among Vertebrates," *Experientia* 48, no. 6 (1992): 565–570, PMID: 1612136, DOI: 10.1007/BF01920240.

7 E. Osipova et al., "Loss of a Gluconeogenic Muscle Enzyme Contributed to Adaptive Metabolic Traits in Hummingbirds," *Science* 379, no. 6628 (2023): 185–190, PMID: 36634192, DOI: 10.1126/science.abn7050.

8 This illustration has been reproduced from Richard L. Zusi, "Introduction to the Skeleton of Hummingbirds (Aves: Apodiformes, Trochilidae) in Functional and Phylogenetic Contexts," *Ornithological Monographs* 77 (2013).

9 The diagrams of hummingbird wingtip paths are reproduced from Bret W. Tobalske, "Avian Flight," chap. 5 in *The Cornell Lab of Ornithology Handbook of Bird Biology*, eds. Irby J. Lovette and John W. Fitzpatrick (Chichester, UK: John Wiley and Sons, 2016).

10 This diagram was redrawn from Rivers Ingersoll, Lukas Haizmann, and David Lentink, "Biomechanics of Hover Performance in Neotropical Hummingbirds versus Bats," *Science Advances* 4, no. 9 (2018): 2375–2548, PMID: 30263957, DOI: 10.1126/sciadv.aat2980.

11 J. Song, H. Luo, and T.L. Hedrick, "Three-Dimensional Flow and Lift Characteristics of a Hovering Ruby-Throated Hummingbird," *Journal of the Royal Society Interface* 11, no. 98 (2014): 20140541, PMID: 25008082, DOI: 10.1098/rsif.2014.0541.

12 Jason P. Beason, Carolyn Gunn, Kim M. Potter, Robert A. Sparks, and James W. Fox, "The Northern Black Swift: Migration Path and Wintering Area Revealed," *Wilson Journal of Ornithology* 124, no. 1 (2012): 1–8, DOI: 10.1676/11-146.1.

13 Felix Liechti et al., "First Evidence of a 200-Day Non-stop Flight in a Bird," *Nature Communications* 4 (2013): 2554, PMID: 24104955, DOI: 10.1038/ncomms3554.

14 Anders Hedenström et al., "Annual 10-Month Aerial Life Phase in the Common Swift *Apus apus*," *Current Biology* 26, no. 22 (2016): 3066–3070, PMID: 28094028, DOI: 10.1016/j.cub.2016.09.014.

15 Geoffrey Ruaux et al., "Drink Safely: Common Swifts (*Apus apus*) Dissipate Mechanical Energy to Decrease Flight Speed Before Touch-and-Go Drinking," *Journal of Experimental Biology* 226, no. 6 (2023): jeb24496, PMID: 36806419, DOI: 10.1242/jeb.244961.

16 Niels C. Rotenberg, "Do Birds Sleep in Flight?," *Naturwissenschaften* 93, no. 9 (2006): 413–425, PMID: 16688436, DOI: 10.1007/s00114-006-0120-3.

17 Helen Macdonald, *Vesper Flights* (New York: Grove Press, 2020), 158–167.

18 The flight speeds of swifts are reported in the following paper:

Per Henningsson, L. Christoffer Johansson, and Anders Hedenström, "How Swift Are Swifts *Apus apus*?," *Journal of Avian Biology* 41, no. 1 (2010): 94–98, DOI: 10.1111/j.1600-048X.2009.04850.x.

19 Henk Tennekes, *The Simple Science of Flight*, rev. ed. (Cambridge, MA: MIT Press, 2008), 111.

20 D. Lentink et al., "How Swifts Control Their Glide Performance with Morphing Wings," *Nature* 446 (2007): 1082–1085, PMID: 17460673, DOI: 10.1038/nature05733.

21 The illustration is redrawn from John J. Videler, *Avian Flight* (Oxford, UK: Oxford University Press, 2005), 86.

22 J.J. Videler, E.J. Stamhuis, and G.D.E. Povel, "Leading-Edge Vortex Lifts Swifts," *Science* 306, no. 5703 (2004): 1960–1962, PMID: 15591209, DOI: 10.1126/science.110468.

23 Hadar Ben-Gida and Roi Gurka, "The Leading-Edge Vortex over a Swift-like High-Aspect-Ratio Wing with Nonlinear Swept-Back Geometry," *Bioinspiration and Biomimetics* 17, no. 6 (2022): 066016, PMID: 36261048, DOI: 10.1088/1748-3190/ac9bb5.

24 Tyson L. Hedrick, Cécile Pichot, and Emmanuel de Margerie, "Gliding for a Free Lunch: Biomechanics of Foraging Flight in Common Swifts (*Apus apus*)," *Journal of Experimental Biology* 221, no. 22 (2018): jeb186270, PMID: 30455382, DOI: 10.1242/jeb.186270.

25 This illustration was inspired by a more extensive diagram in Kenneth P. Dial, "Avian Forelimb Muscles and Nonsteady Flight: Can Birds Fly Without Using the Muscles in Their Wings?," *The Auk* 109, no. 4 (1992): 874–885, DOI: 10.2307/4088162.

26 C.J. Pennycuick, "The Flight of Petrels and Albatrosses (Procellariiformes), Observed in South Georgia and Its Vicinity," *Philosophical Transactions of the Royal Society Series B, Biological Sciences* 300 (1982): 75–106, DOI: 10.1098/rstb.1982.0158.

27 Ron A. Meyers and Eric F. Stakebake, "Anatomy and Histochemistry of Spread-Wing Posture in Birds. 3. Immunohistochemistry of Flight Muscles and the 'Shoulder Lock' in Albatrosses," *Journal of Morphology* 263 (2005): 12–29, PMID: 15536648, DOI: 10.1002/jmor.10284.

28 P.L. Richardson and E.D. Wakefield, "Observations and Models of Across-Wind Flight Speed of the Wandering Albatross," *Royal Society Open Science* 9 (2022): 211364, PMID: 36465680, DOI: 10.1098/rsos.211364.

29 Henri Weimerskirch, Rory P. Wilson, and Patrice Lys, "Activity Pattern of Foraging in the Wandering Albatross: A Marine Predator with Two Modes of Prey Searching," *Marine Ecology Progress Series* (1997): 245–254.

Chapter 10
MIGRATION

1 Benjamin M. Winger, Giorgia G. Auteri, Teresa M. Pegan, and Brian C. Weeks, "A Long Winter for the Red Queen: Rethinking the Evolution of Seasonal Migration," *Biological Reviews* 94 (2019): 737–752, PMID: 30393938, DOI: 10.1111/brv.12476.

2 Carl D. Soulsbury et al., "The Welfare and Ethics of Research Involving Wild Animals: A Primer," *Methods in Ecology and Evolution* 11 (2020): 1164–1181, DOI: 10.1111/2041-210X.13435.

3 A.M. Dokter, BirdCast, Cornell Lab of Ornithology, accessed April 24, 2024, https://birdcast.info/migration-tools/migration-forecast-maps.

4 The plan to add tracked animals to the Internet of Things (IoT) is introduced in Walter Jetz et al., "Biological Earth Observation with Animal Sensors," *Trends in Ecology and Evolution* 37, no. 4 (2022): 293–298, PMID: 35610062, DOI: 10.1016/j.tree.2022.04.012.

 More information is available at Icarus: Global Monitoring with Animals, accessed May 21, 2023, https://www.icarus.mpg.de/29143/animal-tracker-app.

 There is also a smartphone app called Animal Tracker. A YouTube video showing the app can be viewed at https://www.youtube.com/watch?v=fp17MQ48YJM.

5 David Costantini and Anders Pape Møller, "A Meta-analysis of the Effects of Geolocator Application on Birds," *Current Zoology* 59, no. 6 (2013): 697–706, DOI: 10.1093/czoolo/59.6.697.

 The study concluded that there were "negative effects of geolocators on aerial foragers, smaller species, species with smaller migration distances and in studies where geolocators were attached with a ring. These results suggest that geolocator studies should be interpreted with caution, but also raise questions whether it is ethically defensible to use geolocators on aerial foragers or small species without carrying out robust pilot studies."

6 National Audubon Society, Migration Journeys, accessed May 21, 2023, https://explorer.audubon.org/.

7 Nathan R. Senner et al., "High-Altitude Shorebird Migration in the Absence of Topographical Barriers: Avoiding High Air Temperatures and Searching for Profitable Winds," *Proceedings of the Royal Society, Biological Sciences* 285, no. 1881 (2018): 20180569, PMID: 30051848, DOI: 10.1098/rspb.2018.0569.

 M. Berger, J.S. Hart, and O.Z. Roy, "Respiration, Oxygen Consumption and Heart Rate in Some Birds During Rest and Flight," *Zeitschrift für vergleichende Physiologie* 66 (1970): 201–214, DOI: 10.1007/BF00297779.

8 Thomas Alerstam et al., "Hypotheses and Tracking Results About the Longest Migration: The Case of the Arctic Tern," *Ecology and Evolution* 9, no. 17 (2019): 9511–9531, PMID: 31534672, DOI: 10.1002/ece3.5459.

9 P. Berthold, M. Kaatz, and U. Querner, "Long-Term Satellite Tracking of White Stork (Ciconia ciconia) Migration: Constancy Versus Variability," *Journal of Ornithology* 145 (2004): 356–359, DOI: 10.1007/s10336-004-0049-2.

10 Andrea Flack et al., "From Local Collective Behavior to Global Migratory Patterns in White Storks," *Science* 360, no. 6391 (2018): 911–914, PMID: 29798883, DOI: 10.1126/science.aap7781.

11 Sasha Pekarsky et al., "Cranes Soar on Thermal Updrafts Behind Cold Fronts As They Migrate Across the Sea," *Proceedings of the Royal Society Series B, Biological Sciences*, 291 (2015): 20231243, PMID: 38229520, DOI: 10.1098/rspb.2023.1243.

12 This phrase originated in the following paper, which is an excellent review of issues related to fueling bird migration:

Christopher G. Guglielmo, "Obese Super Athletes: Fat-Fueled Migration in Birds and Bats," *Journal of Experimental Biology* 221 (Pt Suppl 1), (2018): PMID: 29514885, DOI: 10.1242/jeb.165753.

13 P.D.C. Pereira et al., "Molecular Changes in the Brain of the Wintering *Calidris pusilla* in the Mangroves of the Amazon River Estuary," *International Journal of Molecular Sciences* 24, no. 16 (2023): 12712, PMID: 37628893, DOI: 10.3390/ijms241612712.

14 Scott Weidensaul, *World on the Wing: The Global Odyssey of Migratory Birds* (New York: W.W. Norton, 2021).

15 Raymond Klassen et al., "When and Where Does Mortality Occur in Migratory Birds? Direct Evidence from Long-Term Satellite Tracking of Raptors," *Journal of Animal Ecology* 83, no. 1 (2014): 176–184, DOI: 10.1111/1365-2656.12135.

16 I. Newton, "Weather-Related Mass-Mortality Events in Migrants," *Ibis* 149, no. 3 (2007): 453–467.

17 Kozue Shiomi, "Possible Link Between Brain Size and Flight Mode in Birds: Does Soaring Ease the Energetic Limitation of the Brain?," *Evolution* 76, no. 3 (2022): 649–657, PMID: 34989401, DOI: 10.1111/evo.14425.

18 R. Wiltschko and W. Wiltschko, "Animal Navigation: How Animals Use Environmental Factors to Find Their Way," *European Physical Journal Special Topics* 232 (2022): 237–252, DOI: 10.1140/epjs/s11734-022-00610-w.

19 Marta Lomas Vega et al., "First-Time Migration in Juvenile Common Cuckoos Documented by Satellite Tracking," *PLOS One* 11, no.12 (2016): PMID: 28005960, DOI: 10.1371/journal.pone.0168940.

20 Hannah Justen and Kira E. Delmore, "The Genetics of Bird Migration," *Current Biology* 32, no. 20 (2022): R1144-R1149, PMID: 36283382, DOI: 10.1016/j.cub.2022.07.008.

Chapter 11
LOSING FLIGHT

1 F. Sayol et al., "Anthropogenic Extinctions Conceal Widespread Evolution of Flightlessness in Birds," *Science Advances* 6, no. 49 (2020): eabb6095, PMID: 33268368, DOI: 10.1126/sciadv.abb6095.

2 The Oxford University Museum of Natural History (which uses a cartoon of the dodo as its symbol) has "the only surviving remains of dodo soft tissue that exists (sic) anywhere in the world." A 21st-century reexamination of the mummified remains revealed that the specimen was shot in the head with a bird-hunting rifle. More information can be found at https://oumnh.ox.ac.uk/learn-the-oxford-dodo.

3 The Cornell Lab of Ornithology is my go-to source for authoritative information on birds. A subscription is required for full access. https://birdsoftheworld.org/bow/home.

4 E.M. Prager, A.C. Wilson, D.T. Osuga, and R.E. Feeney, "Evolution of Flightless Land Birds on Southern Continents: Transferrin Comparison Shows Monophyletic Origin of Ratites," *Journal of Molecular Evolution* 8, no. 3 (1976): 283–294, PMID: 978751, DOI: 10.1007/BF01731001.

5 John Harshman et al., "Phylogenomic Evidence for Multiple Losses of Flight in Ratite Birds," *Proceedings of the National Academy of Sciences of the United States of America* 105, no. 36 (2008): 13462–13467, PMID: 18765814, DOI: 10.1073/pnas.0803242105.

6 In this view from space, we can imagine the emergence of Fernandina Island (opposite) and Isabela

Bolivar Channel

Island from the eruption of undersea volcanos. The islands formed about 500,000 and 1 million years ago, respectively. The small craters of Tagus and Darwin Bays are visible on the eastern shore of the Bolivar Channel, separating the two islands.

7 Charles Darwin kept a day-by-day account of the entire voyage of *The Beagle* in his diary, which is available online at http://darwin-online.org.uk/content/frameset?itemID=F1925&viewtype=text&pageseq=1.

The account of his time in the Bolivar Channel begins on page 357. Darwin refers to Isabela and Fernandina Islands by their prior names, Albermarle and Narborough, respectively.

8 Alejandro Burga et al., "A Genetic Signature of the Evolution of Loss of Flight in the Galapagos Cormorant," *Science* 356, no. 6341 (2017): eaal3345, PMID: 8572335, DOI: 10.1126/science.aal3345.

Martyn Kennedy, Carlos A. Valle, and Hamish G. Spencer, "The Phylogenetic Position of the Galápagos Cormorant," *Molecular Phylogenetics and Evolution* 53, no. 1 (October 2009): 94–98, PMID: 19523526, DOI: 10.1016/j.ympev.2009.06.002.

Chapter 12
BIOINSPIRED FLIGHT

1 Benjamin J. Goodheart, "Tracing the History of the Ornithopter: Past, Present, and Future," *Journal of Aviation/Aerospace Education and Research* 21, no. 1 (2011): 30–44, https://commons.erau.edu/cgi/viewcontent.cgi?article=1344&context=jaaer.

2 Raphael Zufferey, Jesus Tormo-Barbero, and Daniel Feliu-Talegón, "How Ornithopters Can Perch Autonomously on a Branch," *Nature Communications* 13, no. 1 (2022): 7713, PMID: 36513661, DOI: 10.1038/s41467-022-35356-5.

3 Richard T. Whitcomb, "A Design Approach and Selected Wind-Tunnel Results at High Subsonic Speeds for Wing-Tip Mounted Winglets," National Aeronautics and Space Administration, Technical Note NASA TN D-8260, accessed April 7, 2023, https://ntrs.nasa.gov/api/citations/19760019075/downloads/19760019075.pdf.

4 Mohamed Anas Maaz, "The History and Differences Between Airbus and Boeing Winglets," Simple Flying, accessed April 7, 2023, https://simpleflying.com/airbus-boeing-winglets-history-differences/.

5 The following NASA website states that winglets can generate increased thrust:

"Whitcomb Designed Winglets to Decrease Drag at the Tips of an Aircraft's Wings and, to a Degree, Convert It into Thrust," NASA, accessed April 17, 2023, https://appel.nasa.gov/2014/07/22/this-month-in-nasa-history-winglets-helped-save-an-industry/.

The aerodynamicist Doug McLean states in his book that this is a misunderstanding:

Doug McLean, *Understanding Aerodynamics: Arguing from the Real Physics* (Chichester: UK, John Wiley and Sons, 2013), 396.

6 Boeing Aircraft Company, "Blended Winglets," accessed April 15, 2023, https://www.boeing.com/commercial/aeromagazine/aero_17/winglet_story.html#fig4.

7 NASA Appel Knowledge Services, "This Month in NASA History: Winglets Helped Save an Industry," accessed April 7, 2023, https://appel.nasa.gov/2014/07/22/this-month-in-nasa-history-winglets-helped-save-an-industry/.

8 Dian Li, Xiaomin Liu, Fujia Hu, and Lei Wang, "Effect of Trailing-Edge Serrations on Noise Reduction in a Coupled Bionic Aerofoil Inspired by Barn Owls," *Bioinspiration and Biomimetics* 15 (2020): 016009, PMID: 31665715, DOI: 10.1088/1748-3190/ab529e.

9 Chen Rao et al., "Owl-Inspired Leading-Edge Serrations Play a Crucial Role in Aerodynamic Force Production and Sound Suppression," *Bioinspiration & Biomimetics* 12 (2017): 046008, PMID: 28675148, DOI: 10.1088/1748-3190/aa7013.

10 Victoria Pellerito et al., "Performance Analysis of a Bioinspired Albatross Airfoil with Heated Top Wing Surface: Experimental Study," *American Institute of Aeronautics and Astronautics Propulsion and Energy 2019 Forum*, accessed April 28, 2023, https://par.nsf.gov/servlets/purl/10187214.

11 Svana Rogalla et al., "The Evolution of Darker Wings in Seabirds in Relation to Temperature-Dependent Flight Efficiency," *Journal of the Royal Society Interface* 18, no. 180 (2021): 20210236, PMID: 34229457, DOI: 10.1098/rsif.2021.0236.

12 Tarah N. Sullivan et al., "Bioinspired Avian Feather Designs," *Materials Science and Engineering* 105 (December 2019): 110066, PMID: 31546447, DOI: 10.1016/j.msec.2019.110066.

13 Thomas Bachmann et al., "Flexural Stiffness of Feather Shafts: Geometry Rules over Material Properties," *Journal of Experimental Biology* 215, no. 3 (2012): 405–415, PMID: 22246249, DOI: 10.1242/jeb.059451.

14 S. Vogel and J.G. Vogel, "Copying Life's Devices," *Current Science* 78, no. 12 (2000): 1424–1430.

Chapter 13
FLIGHT STORIES

1 Otto Lilienthal, *Birdflight as the Basis of Aviation: A Contribution Towards a System of Aviation* (Hummelstown, PA: Markowski International Publishers, American Aeronautical Archives, 2001).

2 The museum devoted to Otto Lilienthal has an extensive collection of documents and photographs that can be perused online here: http://www.lilienthal-museum.de/olma/ehome.htm, accessed May 20, 2023.

3 Franz Lidz, "She Fell Nearly 2 Miles, and Walked Away," *New York Times*, June 18, 2021, accessed March 12, 2023, https://www.nytimes.com/2021/06/18/science/koepcke-diller-panguana-amazon-crash.html.

4 François Vuilleumier, "Five Great Neotropical Ornithologists: An Appreciation of Eugene Eisnmann, Maria Koepcke, Claës Olrog, Rudulpho Philippe, and Helmut Sick," *Ornitologia Neotropica* 6 (1995): 97–111.

5 Grace Serva, Irma Franke, and John Terborgh, "Maria Koepcke and Her Contribution to Peru and Neotropical Ornithology," *Ornitologia Neotropical* 23 (2012): 399–404.

6 Bob Montgomerie, American Ornithological Society, "The Invisible Women," September 3, 2018, https://americanornithology.org/the-invisible-women/.

7 The research station established by Maria and Wilhelm Koepcke is now a conservation area supported by an international foundation here: https://panguana.de/?lang=en.

8 E.-J. Marey, *Animal Mechanism: A Treatise on Terrestrial and Aerial Locomotion* (New York: D. Appleton, 1874).

9 E.-J. Marey, *Le vol des oiseaux* (Whitefish, MT: Kessinger Publishing, 1890).

10 Marey's wrist position plots are similar to those made by Tobalske and Dial almost 100 years later:

B. Tobalske and K. Dial, "Flight Kinematics of Black-billed Magpies and Pigeons over a Wide Range of Speeds," *Journal of Experimental Biology* 199, pt. 2 (1996): 263–280, PMID: 9317775, DOI: 10.1242/jeb.199.2.263.

11 Marta Braun, *Picturing Time: The Work of Étienne-Jules Marey* (1830–1904) (Chicago: University of Chicago Press, 1994), 40.

12 The fascinating story about the underperforming wings of the Wright brothers' 1900 glider is well told here:

John D. Anderson. *A History of Aerodynamics and Its Impact on Flying Machines* (Cambridge University Press, 1998), 216–234.

13 William Hazelgrove, *Wright Brothers, Wrong Story: How Wilbur Wright Solved the Problem of Manned Flight* (Amherst, NY: Prometheus Books, 2018).

14 *The Standard Edition of the Complete Works of Sigmund Freud*, vol. 11 (1910): *Five Lectures on Psycho-Analysis: Leonardo da Vinci and Other Works*, University of Pennsylvania, accessed March 10, 2023, https://www.sas.upenn.edu/~cavitch/pdf-library/Freud_Leonardo.pdf.

15 Leonardo da Vinci's Notebooks, Victoria and Albert Museum, accessed March 10, 2023, https://www.vam.ac.uk/articles/leonardo-da-vincis-notebooks.

16 Philip L. Richardson, "Leonardo da Vinci's Discovery of the Dynamic Soaring by Birds in Wind Shear," *Notes and Records of the Royal Society of London* 73, no. 3 (2019): 285–301.

17 *Codex on the Flight of Birds*, National Air and Space Museum, accessed March 10, 2023, https://airandspace.si.edu/exhibitions/codex/.

An earlier English translation is available here: *The Codex on the Flight of Birds in the Royal Library at Turin*, ed. Augusto Marinoni (New York: Johnson Reprint Corporation, Harcourt Brace Jovanovich, 1982).

18 This human-powered flight machine, designed by Paul MacCready, won the Kremer prize in 1977. It was the first human-powered aircraft to complete a figure-eight course that included two 10-foot (3.05 m) obstacles. Its successor, the Gossamer Albatross, later flew across the English Channel under pedal power. Ben Shedd, "The Flight of the Gossamer Condor," accessed March 10, 2023, https://gossamercondor.com/.

19 The below drawing has been used by some commentators as a basis to claim that Leonardo da Vinci had flight experience:

Leonardo Da Vinci, *Bird's-Eye View of a Landscape* (1502).
(Pen, ink, and watercolor on paper. Windsor Castle, Windsor, United Kingdom)

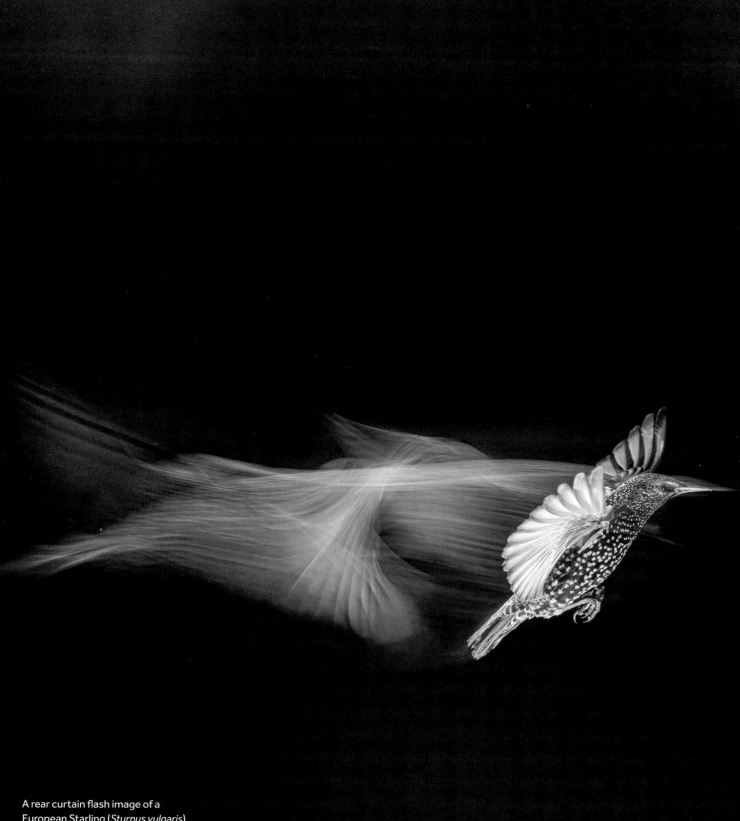

A rear curtain flash image of a
European Starling (*Sturnus vulgaris*).
Lincolnshire, UK. December.
IUCN category: Least Concern.

Index

Acknowledgments

It has been said that writing a book is a lonely, solitary enterprise. While that may be true at the outset, the project rapidly morphs into a team sport as help, advice, and support flow to enrich the book like rivers filling an ocean.

My primary debt is to the hundreds of scientists around the world whose work has informed my writing. I make reference in the notes to more than 500 individuals who collectively have authored over 200 academic papers. I have been in personal contact with many of them and have been rewarded by their generosity in sharing information, results, and images. They are as anxious as I am that the fruits of their scientific endeavors have a life outside the siloed world of scientific journals. As the aggregator and reporter of their work, any errors in interpretation are my responsibility. In addition, several photographers shared their images with me, and I am pleased to showcase their work in the book.

I am grateful to Santiago Claramunt of the University of Toronto, who read a draft of the manuscript and saved me from several missteps. Chris Wood and Kevin Epperly, the Ornithology Collection managers at the University of Washington's Burke Museum, were always eager and ready to retrieve specimens for my use from the Burke's vast collection of bird wings and skeletons. Andrew Biewener at Harvard's Concord Field Station was a dependable and authoritative sounding board for my avian biomechanical ideas.

My photographic adventures have been facilitated by many guides who helped me find good birds, excellent light, and great sites. These include Mohamed Omari and Adam Judica in Tanzania, Enock Cheruiyot in Kenya, Gavin Sims in Namibia, Mark Thomas and Roger Munoz in Costa Rica, Glen Bartley in Colombia, Carl Donohue in Alaska, Tom Robinson and Marcus Nash in the UK, Joe Van Os and his crew in South Georgia and Antarctica, Bruce Lawson and Elly Gearing in South Africa, Tui De Roy in the Galápagos Islands, and Jóhann Óli Hilmarsson in Iceland. I have valued the friendship of fellow photographers Bruce Silverstein, Robert Harrison, Leslie Richter, and the late Steve Horn. Many good birding outings with Beth St. George and Joe Behnke expanded my knowledge and led to new bird photographs. I am grateful to several Audubon Society affiliates in the Pacific Northwest, which have provided me with a forum where I could expound my ideas on bird flight and share my bird photographs and stories with their members.

In the transformation of the raw manuscript into a finished book, I have benefited greatly from a first-class team at Firefly Books. Publisher Lionel Koffler recognized the potential of a book that brings science to bird lovers, and editors Darcy Shea and Julie Takasaki ran with that vision, skillfully managing a multifaceted manuscript and helping shape it into the book in your hands. Nancy Foran was a fearless copy editor, proofreader Gillian Watts found scores of corrections, and Siusan Moffatt generated the comprehensive index.

It is always a joy to witness how professional artists and designers can generate work that leaps off the page. George A. Walker produced crisp and attractive line art. Hartley Millson used his finely tuned compositional skills to blend photographs, illustrations, art, and words into a coherent and attractive finished product. In a *tour de force* of digital creation, Laurie O'Keefe generated original artwork for the book, including depictions of early birds in flight, detailed illustrations of birds riding thermals, shedding vortices, and taking off, and a masterful presentation of ratite distribution. Sarah Drummond and I first talked about this book on a small wooden boat plying along Alaska's Inside Passage almost a decade ago, and I am delighted that one of her illustrations is also in the book.

My family is an anchor in the sea that is my peripatetic life. I am grateful for their support, love, and encouragement, which made this book possible, and which elevates me every day.

About the Author

Peter Cavanagh is a scientist, author, and bird photographer who lives in the San Juan Islands of Washington State, USA. He was born, raised, and educated in England, receiving his doctorate in anatomy and biomechanics at the Royal Free Medical School of the University of London. Peter's migration to bird photography, and to becoming a student of bird flight mechanics, is a natural evolution of his life-long interest in photography, his study of flight aerodynamics as an instrument-rated private pilot, his professional training in the anatomy and biomechanics of locomotion using high-speed motion capture, and his passion for nature and the outdoors. His images have been featured in the Audubon Society's Top 100 Bird Photographs of the Year. He is a member of the American Birding Association, BirdLife International, the North American Nature Photography Association, Birds Connect Seattle, and the Royal Society for the Protection of Birds.

Peter has published seven books and more than 200 papers in scientific journals. He is the recipient of the Muybridge Medal from the International Society of Biomechanics and the Borelli Award from the American Society of Biomechanics for his studies on locomotion. He was awarded NASA's Distinguished Public Service Medal, the highest civilian honor given by NASA, for work that has contributed to an understanding of bone loss in astronauts during long-duration space flight. Peter was also the recipient of the International Diabetic Foot Award for his work on the biomechanics of foot ulcer prevention in people with diabetes. He is Past President of both the American and International Societies of Biomechanics, a Distinguished Professor Emeritus at Penn State University, and Professor Emeritus at the University of Washington. He is a former Chairman of the Department of Biomedical Engineering at the Cleveland Clinic's Lerner Research Institute and an Honorary Fellow of the Royal College of Physicians and Surgeons (Glasgow).

Peter has traveled widely to photograph birds on every continent. His work can be found at www.petercavanagh.us, on Instagram @petercavanaghbirds, on Facebook at *Peter Cavanagh Birds*, and on X at @howbirdsfly. He shoots with Sony gear.

Photograph by Leslie Richter